THE RUSKINS AND THE GRAYS

THE RUSKINS
AND THE GRAYS

MARY LUTYENS

JOHN MURRAY

Printed in Great Britain by
Butler & Tanner Ltd,
Frome and London

0 7195 2719 8

'I never wrote a letter in my life which all the world are not welcome to read if they will.'
Ruskin in *Fors Clavigera*, Letter 59 (1875)

CONTENTS

Contents

ILLUSTRATIONS

❊

Illustrations

FOREWORD

In my two previous books about John Ruskin's marriage to Effie Gray—*Effie in Venice* and *Millais and the Ruskins*—I have for the most part made use of Effie's own letters and those of John Everett Millais whom she married in 1855, a year after her marriage to Ruskin was annulled. In this book I have principally used Ruskin's letters, most of them unpublished, and also many unpublished letters from his father, John James Ruskin, and some from his mother. These letters clearly bring out Ruskin's relationship with his parents as well as the relationship between the Ruskin and Gray families. The connection between earlier generations of the two families, and the social distinctions of the time, must also be considered for a full understanding of the many aspects of the marriage; the one that has been most stressed, Ruskin's sexual failure, is only a single factor in a complex situation and by no means the most important.

Ruskin's grandmother had married beneath her; a minister's daughter, she had eloped with a grocer; her son, John James Ruskin, was very close to his mother and, if circumstances had allowed, he would assuredly have climbed back into the professional class to which he felt he rightly belonged. Indeed, such were his talents and diligence that he might well have made a name for himself in almost any sphere. His father's improvidence, however, interfered with his education, and his health was permanently impaired as a young man by having to work long hours in a London business house for nine years without a holiday, often half starved. The more one learns about John James Ruskin the more apparent it becomes that the genius of John Ruskin was not a mutation: he was very much the son of his father.

John James was determined to remove his own son from all taint of trade and made up his mind that he should go into the church, but at twenty-three John Ruskin's genius was generally recognised

with the publication of the first volume of *Modern Painters* and there-
after all social barriers were lowered for him. Although Mr Ruskin,
as a tradesman, was socially inferior to Effie Gray's father, a pro-
fessional man, Mr Ruskin well knew that Mr Gray was only one
generation removed from trade. Moreover, at the time of John
Ruskin's marriage to Effie, Mr Gray had put himself in a position
to be despised by Mr Ruskin because of his disastrous speculation
in railway shares, just when Mr Ruskin himself, through sheer hard
work, was making a fortune out of his wine business. But more
despicable still in Mr Ruskin's eyes, Mr Gray, on the verge of bank-
ruptcy, was trying to shed financial responsibility for his eldest son
by steering the boy away from law and starting him in business, and
even hoping for Mr Ruskin's help in doing so. To back-slide into
trade was a reversal of all John James Ruskin's lifetime endeavours.

The purpose of this book is to let the story of the first eighteen
months of Ruskin's marriage run against the social and financial
background which, I believe, had more influence on him than he
himself knew. An original talent such as his often develops more
freely when rooted in the deep security of parental conformity.

Throughout the book I have retained Ruskin's spelling and
punctuation and that of his father and mother, but I have written
the word 'and' in full as I find the ampersand as irritating in print
as the long S they invariably used. I have, however, for the sake of
clarity put some punctuation into Effie's letters, for she used
virtually none. All omissions in the middle of the letters are indicated
by dots.

Numbers in the text refer only to the Source Notes, p. 267, where
are also to be found abbreviations for sources in the footnotes.

ACKNOWLEDGEMENTS

First I should like to thank Mr James Dearden, Curator of the Ruskin Galleries, Bembridge School, for his unfailing kindness. His prompt response to my many questions and his generosity in sharing his expert knowledge have made his help invaluable over the past ten years. I am also greatly indebted to Sir Ralph Millais, Bt., for lending me unpublished material in his possession.

Thanks are also due to Mr Guy Barton, Mr Noel Blakiston, Miss Jane Boulenger, Mr Herbert Cahoon, Lord Doune, Miss Shiela Esler, Mr T. Hendry, Miss Marion Lochhead, Barbara, Countess Moray, Mrs Charlotte Shepherd, Mrs Virginia Surtees, Professor Helen Viljoen and Miss Marjorie G. Wynne.

Permission to quote from published and unpublished letters has been kindly granted by Messrs George Allen and Unwin, Ruskin's Literary Trustees, and by Sir Ralph Millais, Bt. I should also like to express my gratitude to the following for permission to quote from manuscripts in their possession: the Trustees of the Beinecke Library at Yale University, the Bodleian Library, the Chairman of the Education Trust Ltd (Bembridge), Mr Luis Gordon, the Trustees of the Pierpont Morgan Library and the Directors of the John Rylands Library; and to the Clarendon Press, Messrs John Murray, the University of Illinois Press and the Yale University Press for permission to quote from published books.

Last but by no means least, I wish in this my third and final volume about Ruskin's marriage to thank Mr John Carter who first started me on this road.

TRAGEDIES AT BOWERSWELL

John Ruskin married Effie Gray because his parents, on whom he was entirely dependent financially, did not dare to thwart him. They feared not only severe physical illness if he did not get his own way but a mental breakdown. Ruskin's grandfather, John Thomas Ruskin, had gone mad; Ruskin's parents were first cousins, and, moreover, their relationship stemmed from the Ruskin side. Ruskin's mother had nursed her uncle, John Thomas, through the worst of his derangement, so it is not surprising that she was constantly looking out for signs of mental instability in her son, her only child.

John Thomas Ruskin had been born in 1761 in the parish of St Bartholomew-the-Great, London, second son of John Ruskin, the Parish Clerk. At the age of fifteen John Thomas was indentured for seven years to a vintner but was allowed to give up his apprenticeship after only four years, when his father died in 1780. He then went to Edinburgh where he became a grocer. A year or two later he made a runaway marriage with Catherine Tweddale, and on November 20, 1783, their first child, Janet (always called Jessie), was born. Catherine Tweddale, two years younger than her husband, was the orphaned daughter of a Scottish Minister, James Tweddale, and his wife Janet Adair who came from the landed gentry of Galloway. Thus Catherine, in Ruskin's words, 'brought with her what dim gleam of ancestral honour I may claim for myself'.[1]

It is not known how John Thomas and Catherine came to meet. It was understandable that she should fall in love with him for he was, judging from two miniatures, very good looking, as well as spirited and dashing. He was also determined to get on in the world, and by the time their next child, John James, was born on May 10, 1785,

John Thomas had acquired a shop and was able to register the boy as the son of a 'merchant'. In 1794 Catherine came into a legacy of £1,800 in trust for her children;[2] on the strength of this John Thomas moved his shop and family to a better part of Edinburgh, 15 St James's Square, New Town, and sent their son John James, at the age of ten, as a paying pupil to the Royal High School, where he remained for six years and received an excellent education. His mother wished him to take up a profession as befitted the members of her own family, but his father insisted on his going to London at the age of sixteen to start a mercantile career. As well as being a clever boy he was, as his son afterwards averred, 'no mean drafts-man',[3] and had studied art under Alexander Naysmith, a friend of Raeburn.* He never got over his disappointment at being made to go into trade and, when the time came, determined that his own son should not follow in his footsteps.

By 1802, when John James first went to London, John Thomas had become agent for Scotland and the north of England to a Mr Moore of London.† Since the move to St James's Square John Thomas's extravagance had been a cause of growing concern to his family, for he liked to entertain with a largesse he could not afford; now, rather than cut down his expenses, he was endeavouring to increase his income by travelling as a salesman while at the same time continuing to run his own business. In sending his son to London when the boy was not yet seventeen, John Thomas no doubt foresaw the need for early independence for his children. This is borne out by the fact that in 1804 he induced his daughter Jessie, a most beautiful girl from all accounts, to marry Patrick Richardson (always called Peter in the family), a tanner with a good business in Perth, eleven years older than herself, whom she did not love.

Catherine was often lonely now that her daughter was married, her son away in London and her husband travelling a great deal for

* John James was painted by Raeburn c. 1804. This portrait (reproduced *Praeterita*, p. 15) is now at Brantwood, Coniston. Four of John James's own pictures are at Bembridge.

† Mr Moore's initials are known to be J.J. (Bodleian) but the nature of his business is uncertain. Effie's great-aunt in her old age referred to 'a large grocery business' (p. 5 below) and it has been suggested (Viljoen, p. 226) that he was 'a trader in small wear'. Contemporary directories are inconclusive and it must be assumed that his was a wholesale business which, like many of its time, dealt in commodities of various kinds.

Mr Moore; therefore a niece was sent for from England to keep her company. This niece was to become the mother of John Ruskin.

John Thomas had an older sister, Margaret, who, far from marrying out of her class as he had done, had married William Cock, the landlord of the King's Head at Croydon. She was now a widow with two daughters, the younger of whom was already married so it was the elder, Margaret, born on September 2, 1781, who was sent for to be her aunt's companion.

When Margaret went to Edinburgh she changed her name from Cock to Cox. She lived for thirteen years with her uncle and aunt as closely as a daughter and she and her Aunt Catherine became devoted to each other. Margaret soon fell in love with her cousin, John James, and in 1809, when he was twenty-four and she twenty-eight, they became engaged.

But before this, in February 1808, Catherine was obliged to tell her son in London that his father's grocery business had failed. The news could not have come as any great surprise to John James, and he immediately undertook to meet his father's debts, thereby almost certainly saving him from bankruptcy. John Thomas's chief creditor was Mr Moore. Mr Moore knew that he could trust John James (the boy had stayed in his house when he first went to London) and therefore he allowed John Thomas to carry on as his agent. Margaret Cox vowed that she would never leave her aunt, and John James vowed that he would never marry until all his father's debts were paid, a sacrifice his mother would not allow. She pointed out that she had £86 a year for life which her husband could not touch—more than ample for her needs if it were not for her husband's improvidence. Dearly as she loved John Thomas, as did also his son, such epithets about him as *extravagant, untrustworthy, hot-tempered, unsteady, impious, unstable* and *unmindful of his family*, were used in letters exchanged between her and John James. John Thomas may also have been dishonest, the reason why John James was so insistent on paying his debts against the advice of friends who assured him it was quite unnecessary.

In October 1809 the Ruskins left Edinburgh for good after almost thirty years, taking Margaret Cox with them. They went first to Dysart on the coast of Fife and then, a few years later, to Perth, John Thomas continuing the while to travel for Mr Moore. At Perth they rented a pleasant Regency house, Bowerswell (or Bower's Well as it

B

is pronounced), on the east side of the Tay, a little way up the hill of Kinnoull, and close to where their daughter, Jessie, and her husband, Patrick Richardson, lived at Bridgend.

Although John James does not seem to have been in love with Margaret, and, of course, delay was inevitable until he could afford to marry, he appears to have pinned all his hopes on her. She meanwhile, deeply in love with him and fearful of losing him, waited with a fair share of outward patience, trying by reading and learning all she could of gentle ways from Catherine, to fit herself for the joy and honour of becoming his wife. Only after they had been engaged for six years did his father begin to make objections to the marriage. Margaret was certainly a bad match—she was penniless and lowly born as well as a first cousin— and John Thomas may well have felt that his son, now extremely handsome, could save the family fortunes by marrying an heiress. A cri de coeur from John James in April 1815 makes clear his own feelings as well as Margaret's despair. It is a strange letter for a man of thirty to have written: '. . . oh my dear Mother as you have always loved me will you and my Dear Father assure Margt that you have both become reconciled to our union and be happy—or you will see her and me both fall sacrifices to this anxiety—Neither her constitution nor mine are fit for a long struggle—I have already said that if it leads to eternal Ruin I will fulfil my engagement with Margt—I hope my dear Father will therefore no longer cause us any uneasiness . . . she is dying and no one cares.'[4]

A few weeks after this John James heard from his mother that John Thomas was no longer of sound mind. John James wrote back in great distress, praying that his father might be cared for at home; if not, he said, money, though scarce, could be found for a private asylum. From this time, as well as continuing to pay off his father's debts, John James allowed his mother £200 a year.

John Thomas *was* looked after at home, most of the burden falling on Margaret, but how his insanity showed itself is not clear. A letter of September 1817 from Catherine to a friend tells that her husband 'is better just now thank God, but quite unable to do any business and still subject to fits of low spirits'.[5]

On September 24 of that year, 1817, Margaret Cox's mother died at Croydon. Margaret went to the funeral and may still have been away when on October 13 Catherine herself died suddenly of

apoplexy. On October 30 John Thomas also died. On his death certificate no cause was given for his death but there is little doubt that he committed suicide.

An account of his death and of Catherine's was narrated sixty years later by Mrs Andrew Gray, the great aunt by marriage of Effie Gray who married John Ruskin, and it is also from this old lady, when she was ninety-one, that we learn how the Ruskins and Grays first became acquainted. According to her account,[6] her husband, Andrew Gray, and his brother, George Gray (Effie's grandfather), were in business with Jessie Ruskin's husband, Patrick Richardson, who kept a leather shop next door to the George Inn at Perth. They were partners in a shipping enterprise and also lessees of the Tay salmon fishings. Mrs Andrew Gray had been Jean Morrison, and had married Andrew in 1811, and although four years younger than Jessie Richardson became her intimate friend. Jessie, she recalled, 'was of a very sweet and amiable disposition, very much like her mother'. Peter Richardson, as she called Patrick, 'had visited the Ruskins in Edinburgh and had admired their only daughter Jessie. The latter did not reciprocate, but as the father thought the match a good one and pressed her accordingly, she consented to become Mrs Richardson. Richardson lived with his mother, who was a coarse woman as he was a coarse man, and with a sister Moll Richardson, an ugly girl, vain enough to consider herself handsome, and to wear petticoats short enough to display her ankles.'

When the Ruskins lived at Dysart, Mr Ruskin was 'a traveller for a large grocery business and this kept him much from home. Old Ruskin was tall, of a moody temperament, which broke out into open wrath occasionally, as when on one occasion coming home from one of his rounds a day earlier than he was expected, and finding his wife having a tea party, he in a fit of anger swept off the array of china into the fireplace.'

Mrs Andrew Gray confirmed that after they left Dysart the Ruskins rented 'old Bowerswell House, which stood a little bit in front of the present one. The Richardsons lived in Rose Terrace.'* John James

* Mrs Gray mentions three times in her narrative that the Richardsons lived at Rose Terrace, whereas Ruskin states (*Praeterita*, p. 62) that when he first stayed with the Richardsons as a boy their house was at Bridgend, on the Kinnoull side

Ruskin, she went on, 'was brought up as a wine merchant in London, but when young suffered much bad health (scrofula). Once he had a very bad illness at Rose Terrace. At that time his cousin Margaret Cox was living with his father and mother. She was older than he was, of a curious character, a commanding self-willed temper, determined in carrying out her designs. She was of a tall figure, and her chief characteristic was a squint (or skellie) in her eyes. She was minded to win the young Ruskin. During his illness she was almost his only attendant, and did everything that a nurse would have done for the patient, and even slept in the same room. When he became convalescent, she took him up to Dunkeld to recruit and there again she was equally economical [sharing a room]. This conduct gave rise to many rumours and scandals, and some thought they were already married. When he was quite restored to health he returned to his business in London, and there it is supposed he had no desire to continue the intimacy with his cousin. But she plied him with letters, reminding him that she had sacrificed her reputation for him and besought him to return and marry her. Soon after, the time of Mrs Richardson's confinement* was drawing near, and she was advised by her doctor to go and stay at Bowerswell with her father and mother. She went and there gave birth to a boy [in fact a girl], the smallest infant ever seen, and described by its father as a penny doll. It was not considered likely to survive, so on the day of its birth Richardson went to secure a parson to come and baptise it and secure for its eternal happiness. The laws or customs of the church forbade baptism on the day of birth, but permitted it the day after. Accordingly a considerable assemblage of friends met at Bowerswell to celebrate the ceremony. Old Mrs Ruskin [Catherine was fifty-four] was bedecked in her best, a magnificent display of lace and other ornaments. Just before the ceremony and so attired she went upstairs to her daughter's room and informed her that all was ready,

of the Tay, with its garden sloping steeply to the river, some fifty yards north of the bridge—i.e. the Perth Bridge, the only bridge across the Tay at Perth in those days. It was not until the death of Patrick Richardson, according to Ruskin, that his aunt moved to Rose Terrace on the opposite side of the river. It is possible that the Richardsons lived at Rose Terrace while they were living with Patrick's mother and then moved to the much larger house at Bridgend, and that Jessie returned to Rose Terrace after Patrick's death, not necessarily to the same house.

* Jessie Richardson had by that time already had five children, two boys and three girls. Three of the children had died that year, 1817, and the baby she was expecting lived only 3 weeks. (See Appendix 1 for Richardson tombstone.)

the guests assembled and the parson waiting, and telling her to keep her mind easy she shut the door. Hardly had the sound of the shut door been heard than it was succeeded by a cry and the first comer (a midwife) found Mrs R. lying dead at the door. The woman got a pair of scissors and at once slit up her dress with its fine lace up the back. Doctor McFarlane* was sent for but all was over.'

The narrative continues: 'The death of his wife was a terrible shock to old Ruskin. It made him feel lonely in the world. He had heard the rumours of his son's conduct with Margaret Cox, and he had declared vehemently against such a marriage—Margaret had not apparently given him much reason to suspect hitherto that she was thwarting him, but now that John James had returned from London for his mother's funeral, she recommenced her old advances. They used to shut themselves up in the sitting room away from the old man, and she acted as though she ignored his existence. This went on during the days succeeding Mrs Ruskin's death. A fortnight after, Margaret Cox was in the room upstairs when suddenly old Mr Ruskin made his appearance before her with a fearful gash in his throat and unable to utter a word. She then displayed the strength of her character. She at once seized a towel and bound up the wound and despatched a servant for the Doctor. She then appears to have got the old man into the bedroom, for Dr McFarlane found her there leaning over the bed and keeping the wound closed with her two hands. The Doctor sewed up the wound, Margaret the while holding the skin in position for him to operate more easily. She displayed throughout, it is said, the coolness and calm demeanour of a trained doctor. The old man died in 2 or 3 days. The suicide had caused such excitement that the family had to take counsel and arrange a speedy and unpublished funeral. It was the season of the winter Sacrament, and Mr P. Richardson consulted with Mr A. Gray and it was decided to have the funeral secretly on the Monday of Sacrament week at 12 noon while all other people were in church.

'After this catastrophe, as soon as she could be moved, Mrs Richardson was taken back to her home in Rose Terrace: Miss Cox betook herself to her own friends and young Ruskin to his business in London. Within two months they were married in London—February 1818. John Ruskin was born 1819. Margaret Cox was past

* James McFarlane, M.D. (1770–1846), of 1 Rose Terrace, Perth.

forty at her marriage [in fact only thirty-eight] and never had another child.'

From the foregoing account it appears that the narrator's husband, Andrew Gray, was sufficiently intimate with the Richardsons and Ruskins to be consulted on the delicate matter of disposing as unobtrusively as possible of the body of John Thomas, so Mrs Andrew Gray would have heard the details of the suicide direct from her husband if not from her friend Jessie who was in the house at the time. In confirmation of her story John Thomas was buried on November 3 and the 3rd that year fell on a Monday.

Catherine had died on October 13 but had not been buried until the 20th. This delay of a week was no doubt to allow for the news of her death to reach John James in London and for him to get to Perth for the funeral. Jessie's baby, Helen, born on October 12, died at three weeks old, which means that it must have died during the four days that elapsed between John Thomas's suicide and his burial. Mrs Andrew Gray states that Jessie was taken back to her own home as soon as she could be moved, so while all these terrible things were going on at Bowerswell she was a semi-invalid in the house. Poor Jessie; in this one year of 1817 she had lost four children and both her parents.

Mrs Andrew Gray evidently disliked Margaret Cox. What were Jessie's feelings about her? Did she dislike her too? Could she have played any part in trying to prevent her brother from marrying Margaret? Jessie seems so entirely passive and shadowy that it is difficult to imagine her taking any *active* part in anything. According to Ruskin she was 'utterly religious, in her quiet Puritan way'; he also gives instances of her foreseeing the deaths of three of her children.[7]

In one particular Mrs Gray's narrative was inaccurate for it has now been established that 'John Rusken' and 'Margaret Cock' were married on February 2, 1818, by the Rev. John Findlay, Minister of St Paul's Parish Church, Perth, in the presence of Patrick Richardson, Elder. It seems, therefore, that Ruskin's account of his parents' marriage in *Praeterita* was correct except in one particular: '. . . the engagement lasted nine years; at the end of which time, my grandfather's debts having been all paid,* and my father established in a

* John Thomas's debts were not paid until 1823. In 1829 a claim was made against John James for Legacy Duty and he consulted George Gray, Effie's father,

business gradually increasing, and liable to no grave contingency, the now not very young people were married in Perth one evening after supper, the servants of the house having no suspicion of the event until John and Margaret drove away together next morning to Edinburgh'.[8]

Did Margaret return to Croydon during those three months between her uncle's suicide and her wedding or did she remain in Perth? As she was married in Perth it seems more likely that she remained there with the Richardsons and was married from their house. John James would no doubt have got rid of Bowerswell as soon as possible, not only on account of its painful associations but because of the expense. After his mother's death he and Jessie came into their inheritance from her of about £1,800 between them; John James also had for himself now the £200 a year he had been giving his mother, so he could afford to marry, and three months was no more than a decent interval to wait after his double bereavement. But to Margaret it must have seemed a very long wait indeed. That she never got over her horror of Bowerswell is understandable, and her superstitious dread of the place extended to the whole of Scotland, feelings which must be borne in mind when considering her refusal, thirty years later, to attend her son's marriage to Effie Gray at Bowerswell.

John Ruskin was born in London on February 8, 1819, at 54 Hunter Street, Brunswick Square, Bloomsbury, a Georgian terrace house which was not demolished until 1969.

about this absurd demand as he had only inherited a loss by his father's death. 'My Father died in 1817 Intestate; by having been for 20 years engaged in a Business on which the Commission never paid the Expence of being generous and improvident, he was in debt about £5000 at his Death.' Soon after his death John James paid off one creditor, a Mr Jones, in full. The chief creditor was 'Mr J. J. Moore'. John James informed Mr Moore in 1823 that if he would reduce his claim he, John James, would 'in some way settle it'. Mr Moore reduced it to £3,000 and John James gave him his house and fixtures as security. In 1829 he 'bought back' his house. He was therefore '£4000 out of pocket' by his father's death. (Letter from J. J. Ruskin to George Gray, December 21, 1829: Bodleian.)

FIRST FRIENDSHIP

Effie Gray's great-grandfather was Robert Gray, a Glover of Perth. He had six sons,* the fourth of whom was George, Effie's grandfather, who died in 1815, and the youngest Andrew, whose widow's narrative was given in the previous chapter. It will be seen, therefore, that although George may in the beginning of their association have been as friendly with the Richardsons as Andrew, he had died two years before John Thomas Ruskin's suicide. Andrew lived on until 1848 and John James Ruskin claimed him when he died as his oldest friend in Perth.

The Glovers and Skynners were very old and respected callings in Perth (Scott's *Fair Maid of Perth* was the daughter of a Glover). The Glovers Incorporation (Company or Guild as it would be called in England) became an extremely prosperous one, its wealth having been laid in the seventeenth century by speculation in land. For several years Robert Gray was Deacon of the Glovers Incorporation and from 1821 to 1823 Andrew Gray was Deacon, so that, although Mrs Andrew Gray was no doubt correct in saying that her husband and George Gray were partners with Patrick Richardson (Jessie Ruskin's husband) in a shipping enterprise, it is probable that Andrew and Patrick first met in connection with their original trades of Glover and Tanner (or Skynner). Mrs Andrew Gray had also stated that they were lessees of the Tay Salmon Fishings, and indeed salmon fishing on the Tay was one of the perquisites of the Glovers Incorporation.

There is no record that George Gray, Effie's grandfather, was ever a Glover—perhaps it was he who was in shipping. He married Christina Robertson, and their son George, Effie's father, was born

* See Appendix II for tombstone of Robert Gray and his sons.

in 1798. On June 18, 1827, almost ten years after the deaths of Mr
and Mrs John Thomas Ruskin, young George married Sophia
Jameson, daughter of Andrew Jameson, Sheriff Substitute of Fife.
George Gray was a rising lawyer of twenty-nine with his business in
Perth; she was ten years younger. He had just bought Bowerswell
House and after their wedding at Cupar, Fife, he took his bride
straight to their new home. She was received by her sister-in-law
who showed her the bedroom she was to occupy and told her that it
was the room in which old John Thomas Ruskin had cut his throat.[9]
Almost a year later, on May 7, 1828, George and Sophia's eldest
child, Effie, was born in this very room.

Effie's mother would not have known Patrick Richardson but she
would have known Jessie. Patrick Richardson had died on July 20,
1824, leaving Jessie with four boys and two girls. Ruskin was to
write about his uncle by marriage whom he could hardly have
remembered (being only five at the time of his death): 'My father's
sister had married, not to please herself but in a curious, patient
apathy and unwise resignation of herself—according to my unwise
Scottish Grandfather's reckless wish. Her husband was as opposite in
nature to herself as might be conceived, made of extremely common
material, with heredity taint of unhealthy constitution and a corpu-
lent habit alike of flesh and spirit, indolently unprosperous in his
tanning business and ending in sudden apoplexy, leaving my aunt
a moderate independence, and six children, with whom, leaving the
large house and river-bank garden at Bridge End, she crossed the
Tay to Rose Terrace.'*[10]

Jessie's eldest boy, James, was to die two years later, aged eighteen,
and in 1827 her eight-year-old daughter, also called Jessie, who had
been Ruskin's little playmate, died 'of water on the brain'.[11] This
child's funeral seems to have been the last occasion on which
Margaret Ruskin went to Perth. There is a story in the Gray family
that soon after George Gray and Sophia Jameson married, Mrs
Ruskin came to pay her respects to Mrs Gray at Bowerswell bringing
with her her eight-year-old son, John. This was the first time Mrs
Gray saw her future son-in-law. Mrs Ruskin refused to go into the

* On the wall of No. 10 Rose Terrace, just north of the County Library, is a
plaque stating that 'In this house John Ruskin spent part of his Boyhood'. From
her new home Jessie could have looked across the North Inch and the Tay to her
former house at Bridgend. This Bridgend house has now been demolished.

house which struck Mrs Gray as very strange since it was a social call; while she walked with Mrs Gray in the garden she took the opportunity of examining John on his knowledge of botany.[12]

The following year, on May 18, 1828, Jessie Richardson herself died, aged forty-five, eleven days after Effie Gray's birth—another bad omen for Margaret Ruskin when years later John wanted to marry Effie. At the time of his aunt's death John was nine years old. He was touring England with his parents as was their wont, in the carriage of Mr Ruskin's well-to-do partner, Henry Telford, calling on customers and seeing all the worthwhile sights in the locality at the same time. Ruskin later recalled, 'I was at Plymouth with my father and mother when my Scottish aunt died . . . and came in to find my father, for the first time I had ever seen him, in deep distress of sobbing tears.'[13]

John James Ruskin wrote on this occasion to George Gray:

> Plymouth 24 May [1828]
> I have just received your obliging Letter May 13 on my arrival here at same time with afflicting news of my sister's death—We had hoped she was greatly better and are greatly shocked and distressed at the Event. . . . It gives Mrs Ruskin and myself as much pleasure as at the moment we are capable of feeling that Mrs Gray has had a Daughter and is doing well.

After Jessie's death John James Ruskin adopted her only remaining daughter, Mary, born in 1815, who, for some weeks before going to the Ruskins in London, had stayed at Bowerswell with the Grays. Ruskin tells us that Mary 'became a serene additional neutral tint in the household harmony' and that 'though of a mildly cheerful and entirely amiable disposition, necessarily touched the household heart with the sadness of her orphanage, and something interrupted its harmony by the difference, which my mother could not help showing, between the feelings with which she regarded her niece and her child'.[14]

Mr Ruskin also helped to set up in life his sister's three remaining sons, John, William and Andrew. He asked for Mary to be taken to London about July 15 when he expected to be home. 'I have no place in my [business] House for Boys,' he wrote to Mr Gray, 'nor

can I receive any inmates in my dwelling but Mary. Andrew wants to be a farmer, therefore doesn't need much education; William for a doctor must be well schooled.'*15

Money had been left in trust for the boys and this trust was administered by George Gray. Mr Ruskin was one of the three trustees so there was frequent correspondence between him and George Gray over the affairs of these Richardson boys which kept the two families in touch after Mr Ruskin had severed all other connection with Perth. Just as it had been natural for the Grays to take Mary Richardson into their house after the death of her mother so it was natural for the Grays to stay with the Ruskins whenever they came to London. After only four years in Hunter Street the Ruskins had moved in 1822 to 28 Herne Hill, a semi-detached suburban villa at Camberwell with a charming garden. The Grays would send them seed potatoes for their garden and Mrs Ruskin would send presents to Effie. Effie had been christened Euphemia Chalmers (Chalmers to commemorate the maiden name of her maternal grandmother) but up to the age of fifteen she was called 'Phemy' by everybody; thereafter all those who had known her as a child continued more often than not to call her Phemy while to new friends she became Effie.

In August 1840, when she was twelve, Effie was sent to school at Avonbank, near Stratford-on-Avon. Mr and Mrs Gray were going to tour Germany and Switzerland that summer and they took Effie with them as far as London and left her for a few days with the Ruskin family to await an escort to school. She wrote to her mother from Avonbank on September 4, 'After you left me in London I enjoyed myself very much indeed. Mr Ruskin took me to see all the sights. I was very much pleased with the Zoological Gardens and with Westminster Abbey.' She addressed this letter to Mrs Gray care of Mr Ruskin, Wine Merchant, Billiter Street (his office in the City) for no doubt Mr Ruskin had undertaken to forward her letters abroad to save her postage.

It was during this visit to Herne Hill that Effie met John Ruskin for the first time. Mr Ruskin himself wrote to Mrs Gray's younger

* John was already grown up. After an unsuccessful attempt to carry on his father's leather business in Perth he became a wine merchant in Glasgow with Mr Ruskin's help. He became insolvent in 1841 but seems to have started again and been successful. For William and Andrew see pp. 136 and 248.

brother, Melville Jameson, who had recently joined Mr Gray as a partner in his legal firm in Perth: 'I am happy to hear that Mr and Mrs Gray are enjoying their Tour. We heard lately from Miss Gray who was very well at Stratford. I am going abroad with my family on account of my Son having injured his health by over Study.'

John it is true had been overworking at Oxford; he was also suffering from unrequited love for Adèle Domecq, the second of the five convent-bred daughters of Pedro Domecq, Mr Ruskin's Spanish partner in the firm of Ruskin, Telford and Domecq. John had first met the Domecq girls in the summer of 1833 at their parents' house in Paris when he was fourteen and Adèle twelve. The girls, with the exception of their eldest sister who was engaged to be married, came to Herne Hill for two months at the beginning of 1836. Within four days John was deeply in love with Adèle, a passion which was to last four years and be greatly augmented by her teasing indifference.*

In 1837 he went into residence at Christ Church, Oxford, as a Gentleman Commoner. His parents had always intended him for the Church and he did not entirely give up the idea of taking Holy Orders until about 1841, and even then he kept it at the back of his mind as a possibility should his other talents fail. He was not sure while at Oxford whether to take up art or writing as a profession, nor, if he became an author, whether to be a poet or a prose writer.

In the autumn of 1839 he heard to his despair that arrangements were on foot to marry Adèle to a Baron Duquesne, and when the marriage actually took place on March 12, 1840, a month after he came of age, he was really ill. He had a haemorrhage at Oxford and returned to Herne Hill for the summer. All hopes of his taking a brilliant degree were over; he was believed to be consumptive and the doctors ordered him abroad. In October he went to Switzerland and Italy with his parents, not returning to England until June 1841.

In later years he was to 'wonder mightily now what sort of a

* Adèle's full name was Adèle-Clotilde but Ruskin could find no rhyme for Clotilde when writing poetry to her. His poem, 'To . . .', intended for her and written when he was twenty, was first published in *Friendship's Offering* (1840) and is quoted in *Works*, II, 110–13. The eldest Domecq girl was Diana who married Count Maison, one of Napoleon's Marshals. In 1836, when the other four girls came to Herne Hill, Adèle was fifteen, Cecile thirteen, Elise twelve and Caroline eleven.

creature I should have turned out, if at this time Love had been with me instead of against me; and instead of the distracting and useless pain, I had had the joy of approved love, and the untellable, incalculable motive of its sympathy and praise'.*[16]

Mrs Gray's elder brother, Andrew Jameson, a barrister in Edinburgh, had also been ordered abroad in the autumn of 1840 on account of a chronic throat infection. He remained abroad for several months, and in June 1841 met the Ruskins in Turin. He told his sister in a letter of June 7 that at the inn there, 'when the travellers' Book was brought to me—I found the name of your friend Mr Ruskin as the last arrival. That evening I sent my card to Miss Richardson [Mary, whom he must have met while she was staying at Bowerswell] and Mr Ruskin sent his servant and asked me to come and see them. They were very kind. You may fancy, how pleasant it was to hear them talking about those so dear to me. Phemy seems to be a great favourite. I dined with them twice and felt much the better of their society. Young Mr R looks very delicate—His symptoms are much the same as I had—but he appears to have naturally a much weaker frame. He is no commonplace person.'†

Effie had remained all this time at Avonbank; she had not been home since August 1840 but evidently hoped to return to Bowerswell in the summer of 1841 and stay again with the Ruskins on the way,

* On their way back from Venice in April 1850 John and Effie met Adèle at a concert in Paris. 'Behind us two or three seats,' Effie wrote, 'was the Baroness Duquesne, John's former Belle; she is now much the plainest of the whole of them and I believe fashionable and worldly.' (Lutyens, 1965, p. 163.) In a letter of 1870 Effie wrote about Ruskin, 'Our marriage was *never arranged* by anybody. There was no inducement but the utmost determination on his part to marry me. Prior to his professions to me he had been devoted to a Spanish Lady and broke a blood vessel from disappointment that he didn't get her. I do not think that she wished it but religion was given as the obstacle, but he had quite got over that—and on our visiting her years after he had no feeling about her then or before our marriage.' (Draft of letter to Mrs La Touche, October 10, 1870: *The Millais–La Touche Correspondence* by M. Lutyens, *Cornhill*, Spring 1967, p. 13.)

† There are two entries in Mary Richardson's diary about this meeting with Andrew Jameson in Turin: '29th [May 1841] A wet morning. Found that Mr A. Jameson was here, who sent his card by Hughes [John's valet]; so he came to our rooms after breakfast, and sat a while with us; his health very delicate but the better for Italy, his attacks very like John's only more severe. . . . Dined at 5, Mr Jameson with us. 30th . . . Mr Jameson dined with us again to-day, and he purposes to leave tomorrow. . . . John and he had a long talk together after dinner, both mutually pleased with each other.' Mary also tells us that the inn they were staying at was the Hotel de l'Europe. (Unpublished typescript at Bembridge: original untraced.)

for Mr Ruskin wrote to Mr Gray from Milan on May 24, 1841 (shortly before he met Andrew Jameson at Turin), 'I have this moment received your kind letter of 6 May—which I hasten to reply to—It would be impossible for my dear *Phemy* to come at a wrong time to Herne Hill but such is our progress home that it will be 25 June to 30th before we are there—any time after that name for yourself and we shall delighted to see her—we also anticipate the pleasure of seeing you in July—as I think you said you would be up with your son whom you are sending to Germany. . . . My son was extremely unwell after leaving Naples but at Venice he recovered very fast and continues tolerable—though he gains no flesh and is in a precarious state—We trust however by care his life may be prolonged although he will never be fit for any arduous duties and this sits upon his mind and affects his health—We may be thankful he is no worse and that we had the power of withdrawing him from the severe winter of 1840/1 experienced in England.'

The son whom Mr Gray was sending to Germany was his eldest, George, born on October 4, 1829. Seventeen months younger than Effie, he was inadvertently to play an unfortunate part in the break-up of her marriage. By 1841 the Grays had had eight children—four boys and four girls; two of the boys had already died, and Effie's three little sisters were all to die in the course of this year 1841.

It is not clear why the Grays wanted to send the eleven-year-old George to Germany. He was destined for his father's legal firm, so perhaps it was thought that a knowledge of German would be useful in the business. He went to Wiesbaden but stayed there only a year before going to Charterhouse School which at that time was near Smithfield.

In the event it was his uncle, Melville Jameson, not his father, who accompanied George to London and to Wiesbaden, for one of George's sisters, the six-year-old Sophia Margaret, had died of scarlet fever on July 2 and Mr Gray naturally did not want to leave home at such a time. Melville Jameson and George travelled to London by steamer from Dundee because Mr Gray was a director of the Dundee, Perth and London Shipping Company which enabled him to get passages for his family at reduced rates. The journey took two days and was nearly always very rough, causing the family much misery from sea-sickness.

Effie heard the news of her sister's death while staying with school

friends at Victoria Spa* but it did not stop her visit to the Ruskins as reported by Melville Jameson to her father: 'The 13th [of July 1841] was a very happy day to me, and I have reason to think also to Phemy and George. While I was obtaining passports—calling on different people &c—Mr Ruskin very kindly accompanied them to the Tower and was back by a particular hour at Billiter St [his office] with the carriage for us. I then went with them to the Zoological Gardens and you may imagine what pleasure I had in having these two beside me, one on each side. It was amusing in the highest degree—what between George's wonder and Phemy's *experience*—She has made I think the most gratifying progress, not only in her mere school knowledge but what is of more importance, in her observation of men and things—her remarks are really excellent on many subjects. . . . There were so many objects of interest at the Gardens that we with great difficulty drove home to Herne Hill a little after six o'clock. Miss Richardson [Mary] had then returned. We enjoyed a quiet and recherche [*sic*] family dinner with some choice wines, they are really most kind in every way.'

Melville Jameson and George went that night to sleep at the Customs House Hotel near the Tower to catch the steamer *Columbine* for Rotterdam at seven next morning; they left Effie at Herne Hill. It was during this 1841 visit that she and John Ruskin became friends and Effie challenged him to write a fairy story. A few weeks later he was sent to Leamington to take a cure under Dr Jephson. Ruskin later tells us that his father and mother had heard favourably of Dr Jephson from 'wise friends . . . called a quack by all the Faculty . . . Jephson was no quack but a man of the highest general power, and keenest medical instincts. He had risen, by stubborn energy and acute observation, from apothecary's boy to be the first physician in Leamington.'[17] It is stated in another source that he had been the partner of an apothecary called Chambers and had gone 'to a University' to take his medical degree and had then made such a reputation in Leamington that by 1841 he was earning £20,000 a year and had built himself a large house, called Beech Lawn, in Warwick Street. Other doctors in the district were jealous of him but he was loved by his patients, particularly the poor whom he treated

* At Shottery, near Stratford-on-Avon, where Anne Hathaway's cottage is. This Spa was newly fashionable in 1841 and a large 'Elizabethan' hotel had recently been built there.

free, and, rich or poor, he would think nothing of visiting them
several times a day. He does seem to have been a bit of a quack,
though, because according to this authority, he had only one remedy
for all disorders and diseases—iron—and this saved him much time
and trouble.[18] He was, incidentally, the doctor for Avonbank School
according to the school's prospectus.

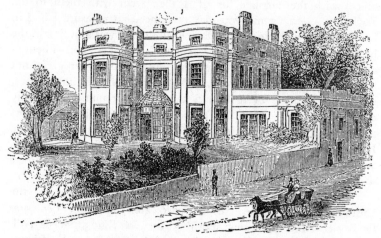

Beech Lawn, Dr Jephson's house at Leamington in 1841

While at Leamington, Ruskin wrote for Effie *The King of the Golden
River*. In his diary for September 15, 1841, he noted, 'Not much done
to day; a little Chemistry, a little music, a little history, a little
drawing . . . and a little of Phemy's Gray's fairy tale.'*

Melville Jameson left George at Wiesbaden and joined his brother
Andrew in Switzerland. From Grindelwald on July 27, 1841, he wrote
to his sister Mrs Gray: 'I suppose ere this reaches you Phemy the
dear girl will have returned—I was delighted to see her in London,

* It appears from a letter from Mr Ruskin that the fairy story was sent to him
by John between September 27 and October 5, 1841, for 'dispatch to Scotland
directly'. (Works, I, xlviii.) *The King of the Golden River; or The Black Brothers: A
Legend of Stirie*, with illustrations by Richard Doyle, was first published by Smith,
Elder on December 21, 1850, at 6/-. The advertisement for the first edition reads:
'*The King of the Golden River* was written in 1841 at the request of a very young lady,
and soley for her amusement without any idea of publication. It has since remained
in the possession of a friend, to whose suggestion, and the passive consent of the
Author, the Publishers are indebted for the opportunity of printing it.' (The story
is given in full ibid., pp. 313–48.)

and I am sure she will form an agreeable companion to you now and be of service to her little sisters . . . The Ruskins would be most sorry to part with her for she is a very great favourite—how far already she is before her old Perth schoolmates.'

But Effie had not yet returned home—she was staying with other Avonbank school friends—probably because scarlet fever was still in the house. Within a week her two other little sisters died of the disease—Mary, aged five, on August 2, and Jane, aged three, on August 8.* Ruskin knew of her bereavement for there is an entry in his diary at Leamington for September 15, 1841: 'Not much done to day . . . a little of Phemy Gray's fairy tale. Poor thing—she wants something to amuse her now.'

When it was considered safe, Effie returned to Bowerswell. She was all the more needed at home now and she did not go back to Avonbank until January 1844. An excellent governess, Miss Joanna Thomson, who had already been engaged for her little sisters, stayed on to teach her. With George away in Germany there was only one child in the house now apart from Effie—Andrew who had been born on January 4, 1840—so she was virtually an only child. There is little doubt that she felt her importance in the household at this time. In particular she was her father's companion; her mother would have sent her back to Avonbank for the sake of companionship of her own age but her father would not let her go and it was not until two more children had been born that she returned to Avonbank. She was there from January 1844 until June of the same year when she left school for good.

Effie did not see the Ruskins from July 1841 until December 1843; there is a record, however, of her brother George staying with them in 1842 on his way from Bowerswell to Charterhouse. On September 18, 1842, he told his 'dearest Papa and Mama' that a fly was awaiting him at the wharf (he had come as usual by steamer from Dundee) to take him straight to Herne Hill. 'I got there by 2 o'clock and took a delightful walk with John. This morning I got up at 7 and John taught me how to grind stones.'

A month later, in October 1842, the Ruskins moved from Herne Hill to 163 Denmark Hill, a much larger Georgian house in seven acres of ground, half a mile from their former home. Mr Gray was also prospering and in about 1842 he began to rebuild Bowerswell

* See Appendix III for the family of George Gray.

c

in its present position, just behind the old house which was pulled down. The family stayed on in the old house all the time the building operations were going on. In July 1843 Mrs Gray was to write to her husband who was returning from a business trip to New York: 'The house is getting up very fast—they are now at the upper story at the Back of the House. The Library window is finished and looks beautiful—I am more and more pleased with the whole plan—the more I see of it'; and Effie, wanting to bring two school friends home from Avonbank in June 1844, told her mother, 'we should not mind what sort of place we were put in, the old or new house'. Evidently the old house was not pulled down until the new one was completely finished.*

Effie came to London on her way to Avonbank in December 1843 and stayed at the new house at Denmark Hill for the first time. John was now twenty-four and Effie fifteen, the age Adèle had been when John fell in love with her. It seems, however, that he thought Effie was only fourteen, for when they were engaged he wrote to her, 'I believe the mistake I made—for I knew you were twelve when I first saw you—was in thinking it was in '41 instead of in '40.'[19]

John had spent the winter of 1842–3 in writing the first volume of *Modern Painters* which had been germinating in his mind for three years. The book, published by Smith, Elder, came out in the first week of May 1843 under the pseudonym of 'A Graduate at Oxford' to protect the book from being disregarded on the grounds of the author's youth. Reviews were slow to come in but when they did they were, with a few exceptions, enthusiastic. It was generally recognised as the work of a genius—of a poet and artist as well as a critic—written with such authority and audacity that he was able to put across his startlingly original views. It was a challenge to popular taste and had a profound effect on the English art of its day, bringing Turner back into public favour for one thing. Nevertheless, only 150 copies of the edition of 500 at 12/– had been sold by the end of the year. It circulated, however, among the right people—

* Bowerswell is now an 'Even-tide Home' of the Perth Corporation. Outwardly the house is unchanged and the garden well kept, though bungalows for the old people have been built in the grounds. A letter from Millais to his daughter, Mary, of January 11, 1892 (Viljoen, p. 245), gives the erroneous idea that Bowerswell was burnt to the ground on the night of January 10. In fact it was Newmill, a house Millais had rented in 1891 for four years with the shooting of Stoball, not far from Bowerswell, that was burnt down that night.

Wordsworth, Tennyson, Rogers among others—and it was highly praised by Sydney Smith; the book was, moreover, talked about so that by March 1845 the publisher was ready to issue a second edition.

Ruskin had spent part of the summer term of 1843 at Oxford to make up his residence, and all that winter he had been at Denmark Hill working on the second volume of *Modern Painters*. By December he was pleased to have some young people in the house to cause a distraction. There are several mentions of Effie in his diary:

December 8th [1843] . . . Phemy Gray came; very graceful but has lost something of her good looks. . . .

December 10th. . . . Phemy Gray begged me to ask particularly in a controversy respecting the election, whether the *ladies* were to have votes. She has seen a good deal of mesmerism by the by. . . .

December 11th. . . . George Gray came from school. He and his sister look very interesting together; she very graceful, he a beautiful boy. . . .

December 12th. Into town, in brown fog, with Phemy and George. Very dull and to the Soho Bazaar,* for the first time since I was there with [Adèle]. I did not feel it. There is no association between that paltry place and her. . . . Phemy is a nice creature; played all the evening for me; showed me the paper which was written of her by a phrenologist, singularly true—good shot he made at her father too, saying he never saw hope so strongly developed in any one. George, a fine little fellow, but lacrymose. He wanted to sit up with us all. My mother proposed his going upstairs with his sister. Her arch: "Would you like a chat with *me*, George?" and his obvious hesitation, were excessively amusing.

December 13th. At home. Wrote a little, stupidly, yet matter which must be done. Spoiled my vignette again; generally discouraged. Pleasant evening, though, with Phemy, who very playful and with a good deal of wit, but restless and desultory.

* Then the chief bazaar in London with its entrance in the north-west corner of Soho Square. It had been opened on February 1, 1816, by John Trotter (1757–1833), an army contractor, to give employment to widows and orphans of the Napoleonic Wars.

I shall be sorry when she goes for a little of light society re-
freshes my stiff brains.

December 15th. We sit horribly late, but I have had some happy
evenings with little Phemy. She is so good-natured and open,
graceful and really rather pretty. . . . Yesterday went out to
Windus's* with Mary [Richardson] and Effie†. . . .

December 16th. . . . Effie very good natured; took off her
bonnet as soon as she came in from town and sat down, though
tired, to play to me. I am really very sorry she is going.

December 18th. . . . Effie lent me a French book which I wanted
much to see—*Picciola*‡ the account of the prisoner who [page
missing]

With Effie gone his thoughts returned to Adèle and he made some
melancholy reflections in his diary on his lost love. On January 4,
1844, there is an entry: 'Letter from Effie, saying she always thinks
of me when she goes out: very flattering. Not much good in the
letter though; I wonder she does not write a better.'

A month later George Gray was at Denmark Hill on his own.
John did not find him so interesting without his sister. 'George Gray
here,' he noted in his diary for February 10, 1844, 'very amiable but
restless, and rather a bore. Still I think I do him good.'

The Ruskins went abroad in June 1844 when Effie left Avonbank
for good. In the winter of that year came another tragedy for the
Grays—Andrew, aged nearly five, died on November 24. Effie was
at home this time whereas she had been away when her three little

* Benjamin Godfrey Windus, a retired coachbuilder, living on the Green at
Tottenham, had a collection of over 200 Turner drawings and several of his oil
paintings. He also became one of the first collectors of Pre-Raphaelite pictures.
Ruskin describes his house (*Praeterita*, pp. 253–4)—'he gave an open day once a
week, and to me the run of his rooms at any time' which was 'to the general student
inestimable, and, for me, the means of writing *Modern Painters*'. Windus had made
a fortune out of 'Godfrey's Cordial' for the throat, one of the notorious opium-
based 'remedies' of the period.

† This is the first mention of Phemy as Effie. It seems probable that it was
Ruskin who decided she should be called Effie. He wrote to her during their en-
gagement, '. . . you may as well tell Uncle [Andrew Jameson] not to write to you
Phemy, or Pheny—worse still—he might as well say Feeny—which is a kitten's
name at once—'. (Letter of December 19, 1847: James, p. 78.)

‡ By Joseph Xavier Saintaine (1798–1865), published in 1836, a story of a politi-
cal prisoner in Piedmont who retained his sanity by tending a small flower growing
between the paving stones of the prison yard.

sisters died. Sixteen now, and sharing this grief with her parents, she must have felt completely adult and was no doubt treated as such. Apart from George she was more like a mother than a sister to her siblings, and even George she was inclined to patronise. She was fourteen years older than Robert, the next eldest after George, and she would be almost twenty-seven by the time her youngest brother was born.

JOHN IN LOVE

Effie did not stay with the Ruskins again until 1846 and then it was a very short visit although a momentous one because it was then that John fell in love with her. He was to write to her in 1847 during their engagement: 'When my mother said to me in October last year —Only wait this winter John—and then you shall see her—I consented (though sulkily) because I thought you were only seventeen . . . if I had known or thought of the truth—I wouldn't have waited an hour and much suffering I should have saved to myself, and a little perhaps to you—for I don't know whether you *were* or not—but you really looked distressed that night you left me at Denmark Hill.'[20]

Effie's visit must have been in March 1846 because John went abroad with his parents on April 2 before the publication—on April 24—of the second volume of *Modern Painters* which came out at the same time as the third edition of Volume One. Eulogistic reviews soon followed him abroad. The identity of the 'Graduate' was now generally known and at the age of twenty-seven his reputation was firmly established in the worlds of literature and art. On his return to England in September he found himself a lion with invitations from society hostesses as well as from the intelligentsia. His father was enchanted and began to have high-flown matrimonial ambitions for him.

Fully occupied as always while abroad, he probably did not begin fretting for Effie until he got back to Denmark Hill, and it was then his mother told him that he had only to wait the winter and he would see her again. And he did see her the following April but by that time he had most unaccountably made an offer of marriage to Charlotte Lockhart, Sir Walter Scott's grand-daughter—at least his parents believed the offer had been made. It is possible that Ruskin made the offer to her father rather than to Charlotte herself, or

even that he sent Charlotte a letter with the proposal couched in such vague terms that it required no answer. Although a great deal was written about this proposal in the following weeks there is a strange vagueness about the extent of his commitment, nor does he seem to have been at all in love with her. Had she given him the slightest encouragement he might have grown to love her but she was in love with another man—James Hope—whom she married in the summer of 1847.*

According to Ruskin he had been introduced to Lockhart in 1839 when he was twenty by Mrs Robert Coburn wife of a wine merchant in Edinburgh. He was asked to dine with Lockhart 'and see his little harebell-like daintiness of a daughter'.[21] On the strength of the reviews of the second volume of *Modern Painters*, Lockhart, editor of the *Quarterly Review*, asked Ruskin to write an article on Lord Lindsay's *Sketches of the History of Christian Art*.† Although Ruskin was 'shy' of the undertaking, as he was well aware that Lord Lindsay knew much more about Italian painting than he did, he considered that no one else was likely to do it better; besides he had another motive: 'The little high-foreheaded Charlotte had by this time become a Scottish fairy, White Lady, and witch of the fatallest sort ... I used to see her, however, sometimes, by the dim lamplight of this world, at Lady Davy's—Sir Humphry widow,—whose receptions in Park Street gathered usually, with others, the literary and scientific men who had once known Abbotsford.‡ But I never could contrive to come to any serious speech with her; and at last, with my usual wisdom in such matters, went away into Cumberland to recommend myself to her by writing a *Quarterly* review.'[22]

* Sir Walter Scott's only child, Sophia, had in 1820 married John Gibson Lockhart (1794–1854). She died in 1837. Their daughter, Charlotte, married James Hope (1812–73) on August 19, 1847. Hope's father was General Sir Alexander Hope, son of the 2nd Earl of Hopetoun by his third wife. James Hope was a very successful parliamentary barrister, already making a large income by 1847. In 1853, when Charlotte inherited Abbotsford on the death of her brother, he assumed the surname of Hope-Scott. Charlotte died in childbirth on October 26, 1858, and on December 3 the child also died. Their infant son, not yet two, died a week after the baby. Their daughter, Mary, inherited Abbotsford.

† Ruskin's article appeared in June 1847. It is reprinted in *Works*, XII, 169–248.

‡ Lady Davy, née Jane Kerr (1770–1855), was the widow of Shuckburgh Ashby Apreece and Sir Humphry Davy, Bt., the scientist. She was well known in Edinburgh, Roman and London society, was a great lion-hunter and a terrific talker. She was distantly connected to Sir Walter Scott through the Kerrs and had introduced James Hope to Lockhart.

In March 1847 he went to the Salutation Inn at Ambleside on Lake Windermere to write his review but 'hearing no word . . . of Charlotte's taking the smallest interest in the celestial hierarchies [the main subject of the first volume of Lord Lindsay's book], I returned to town in a temper and state of health in which my father and mother thought that once more the best place for me would be Leamington'.[23] Does not this 'hearing no word' rather bear out the theory that Ruskin's letter proposing to Charlotte was so obscure that she was able to ignore it? Or could he perhaps have told her not to answer at all if she could not answer favourably?

Whatever the nature of the proposal or refusal, John's parents were certainly still under the impression, when Effie came to stay at Denmark Hill in April 1847, that John's honour was pledged to Charlotte. Mr Ruskin greatly desired the match with Scott's grand-daughter; it would have been the fulfilment of all his social ambitions for his son, and he was still hoping for a favourable reply from Charlotte or her father when Effie arrived. He at once became aware that Effie's attractions were working on John to the detriment of these hopes. At the same time he believed that John was acting dishonourably in flirting with Effie while his offer to Charlotte was still open. In this predicament he should have gone to John and had the matter out with him; instead he took the tortuous course of appealing to Mr Gray to avert the danger:

London. 28 Apl. 47.

My dear Sir,

We have been friends for so many years standing that I hope our communications with each other may assume a more frank and easy and confidential form than those betwixt ordinary acquaintances usually do—We have had the very great pleasure of your Daughter's company for these few days past and what we think of her will best appear from the subject of this letter.—You know that my Son is at home—I cannot arrive at the purpose of this letter better than by giving you a short sketch of his past life—

In 1835 when he was 16* I happened to have my Partner the late Mr Domecq residing with two of his Daughters for three

* It was for the first two months of 1836 that Adèle was staying at Herne Hill. John had his seventeenth birthday while she was there.

months in my house—I believe I have already told you that most unexpectedly to us my son became strongly attached to the youngest [in fact the second] Daughter of Mr Domecq. Her father was full of affection for his own child and for mine and expressed entire approval of their being united, offering to make his Daughter a protestant. I felt this a great kindness and concession but we could not sanction a union with romanism even tho professing to cease to be so and the ample fortune belonging to the Lady though always an agreeable an [*sic*] accompaniment was no inducement to run such a risk as his Mother thought existed of her Son becoming a Roman catholic, the character of the young Lady's mother was also objectionable—The passion however was powerful and almost threatened my son's life—various journies abroad have scarcely dissipated his chagrin nor repaired his health—The only young Lady we have had about us since from whom any thing was to be feared I will admit is your own Daughter and because both Mrs Ruskin and myself were persuaded that no young man of taste and feeling could long look upon her with indifference we felt called upon immediately to consider all consequences. For myself I am of course most deeply anxious for my son's happiness but whether it was derived from Paris or from Perth, from small fortune or from great, I was disposed to let matters take their course trusting that my son would not commit any very fatal mistake if left to his own guidance in such an affair—I ascertained however that not only to romanism but to Scotland and most especially to Perth Mrs Ruskin had an insuperable dislike—she has had so much misery herself in Perth that she has quite a superstitious dread of her son connecting himself in the most remote degree with the place—With knowledge of these objections in his Mother's mind and of the power of the presence of such a young creature as Miss Gray I felt there was no safety but in flight—We *did not* fly from you last year but we gave you I fear a very cold reception and your stay was very short—Since you took Miss Gray to Scotland last year my son has been abroad and since his return he has in the society he has fallen into found a young Lady who has engaged his affections and to whom he has made proposals the result of which is not yet known—To you as a Father I make such

disclosures as under similar circumstances I should desire to be made to me.—I would not presume to say that Miss Gray cannot be daily with my son without the smallest danger to herself but I deem it more than possible from what I already see that both may fall into some danger and that very great embarrassment might arise to all of us should the favourable impression which each may be already making on the other proceed to take a more definite form—I repeat that as far as I am concerned I lay no restraint nor prescribe any course to my son—He may follow his own inclinations but as he has committed himself for the present and as his Mother if he had not seems so averse to Scottish alliances I cannot help giving expressions to my apprehensions that both you and I are placing our young people in danger and that we should at least adopt every measure of caution and safety in our power.

I beg to apologise for this long letter and for saying any thing you may consider uncalled for but I might have saved my son from many a pang had I once been as early in my fears and precautions. We join in kindest regards to you and Mrs Gray.

 I am My dear Sir
 Yours very truly John James Ruskin.*

I wish in place of burning you would return me this letter in case of my son asking at any time if a Letter were written.[24]

Mr Gray copied this letter to keep for himself and returned the original with his reply:

 Perth 1 May 1847.
Believe me that I fully appreciate the kind feeling which has induced you to enter so frankly into your family matters with the view of preventing an unhappy attachment arising betwixt your son and my Daughter and you may be assured that knowing as I now do the position in which your son stands with

* Mr Ruskin and Mr Gray never addressed each other as anything but 'My dear Sir', even after their children were married, and always ended 'Yours very truly' or 'Most sincerely yours', so the beginnings and ends of their letters are henceforth omitted.

respect to another Lady and, irrespective of this, the feeling of Mrs Ruskin to a scotch alliance, and particularly with a native of Perth, I shall use such means and influence as is within my power immediately to separate the parties which I trust will be quite sufficient to prevent the renewal of any penchant the one may have ever felt for the other—Accordingly by this post I have written my friend Mr Gadesden* who kindly requests me to allow Phemy to pay him a visit asking whether it would be convenient for him to receive her now and I have no doubt he will send for her directly—On the 18th I believe it is arranged she goes to Mrs Paget† who is then to be in London—

It strikes me forcibly that Mrs Ruskin could have quietly given Phemy a hint that John was under engagement, that this would have completely served every purpose we have in view— If I know anything of Phemy at all I think she would at once have acted on such a hint and without betraying confidence kept her affections disengaged on (as the case might be) any advance from the other side—

I know well that Phemy has always expressed herself favourably of John as a person for whom she had a high respect as a man of talent and refined manners, but I know also that she has a great deal of good sense and maidenly pride and is the very last person in the world that would either give her affections to one in John's present position or, were he entirely free, accept of him at the expense of wounding his mother's feelings—No happiness could ensue from such a connection and therefore do I feel the more obliged to you for the unreserved communication you have made me which I sincerely hope may be the means of putting an end to all our fears—I have considered it my duty to shew your letter to Mrs Gray and she intends when writing Phemy to touch upon

* William Gadesden of Ewell Castle, Ewell, near Epsom, was an old Scottish friend of the Grays. He was now retired from a prosperous business of an unstated nature. It was while staying at Ewell Castle in 1846 that Effie had first met Millais at the Lemprières, friends of the Millais family from Jersey, who lived at Ewell, but as Millais was only sixteen she had scarcely noticed him. (Lutyens, 1967, p. 33.)

† Née Ellen Tebutt, second wife of Charles Paget of Ruddington Grange, Nottingham, whom she had married in 1835. He was the father of Effie's Avonbank school friend, Mary, whose mother had died in 1834.

the subject very gently as we are both persuaded that is all we require to do—

I return your letter as desired.[25]

Mr Ruskin was anything but underhand, for, it transpires, he showed this letter to John, and no doubt he also showed him Mr Gray's reply. John must have made such a fuss at the idea of Effie's being sent away that his father wrote off again to Mr Gray in an endeavour to undo the harm he had done. Nevertheless he was very angry with Effie for not leaving the house immediately although he now begged her father not to take her away:

London 3 May 1847

I regret you should have written to Mr G. [Gadesden] or taken any steps to shorten Miss Gray's visit.

Mrs R. since I wrote to you has I find told Phemy of John's situation and even before doing so, we had no grounds whatever to think that Miss Gray was in the least interested about my son beyond the interest of one young person for another on a renewed acquaintance—If it entirely depended on the Lady I think so much of her judgement and womanly discretion that my fears would be few, but my son's poetical temperament comes rather in abatement of his Discretion—Were your Daughter a person of ordinary Character or appearance I might have been saved the pain of troubling you but I confess I dread the danger of a second and deeper impression being made where one already exists and which has led to consequences he could not escape from—My son would be shocked at my even dreaming of a possibility of his being capable of acting dishonourably and I trust in God he never will, but both his Mother and myself see every day that he is too sensibly affected by Miss Gray's presence for his own peace—Still no sudden steps can be taken without too much wounding his feelings and showing a distrust in the Strength of mind which not knowing his own Danger, he would ill brook from any one —I hope with your knowledge of the Circumstances and Miss Gray's great good sense, we may let the visit take its course— At all events you can be kind enough to leave the matter in our hands, until I write to you again. . . .

P.S.

I had written above in the City but thought I would see Mrs R. before sending it. She wishes me after seeing your letter very strongly to impress upon you that her ideas about Perth are not of recent growth and can have no personal relation to Miss Gray, indeed I think that so much does Mrs Ruskin love her that were nothing else in the way, she would herself endeavour to bring about what in Imagination she seemed to dread—I can add in Justification of her feelings about Perth and in proof of their having no reference to any family in particular, that since we left it in Decr. 1827 she has never changed her sentiments. We came to Scotland I think in 1838 but I could not get her to Perth and although we have all wished to visit the Highlands, we have not made it owing to these Impressions. During twenty years she has refused to go to your beautiful neighbourhood—and never I believe in her Life would now visit it.[26]

Meanwhile Effie was having a very happy time at Denmark Hill, believing herself in no danger of falling in love with John, yet enjoying his attentions. Mary Richardson had recently married,* so Effie was treated very much as the only daughter of the house. There is no doubt that Mrs Ruskin, lonely now that Mary had gone, welcomed Effie's presence and was truly fond of her in spite of her association with the abhorred town of Perth.

* Mary had on April 17 married Parker Bolding, a lawyer. He was a brother of the second wife of Dr William Richardson, Mary's brother.

4

JOHN AND CHARLOTTE
LOCKHART

There was already talk at this time of Effie's brother George abandoning the law and going into business in London. He was now eighteen and a half and was working in his father's office in Perth in a very junior, and no doubt boring, capacity. A few months later Mr Gray lost a great deal of money as a result of speculating in railway shares and it was felt imperative to start George on an independent career, so when Effie wrote to her brother from Denmark Hill on April 29, 1847, 'I am afraid I can do nothing for you in the way of business with Mr R', Mr Gray may already have been in financial difficulties; on the other hand George may simply have discovered that law was not to his taste. Effie continued in her letter, 'he gives me no encouragement. When I say you would be a better merchant than a writer [to the Signet] he says Ah! a merchant's life is not an easy one and Mrs Ruskin launches out on the difficulties of the same.' Mr Ruskin was beginning to feel that George as well as Effie was being thrust on him—that Effie's charms were not as ingenuous as he used to think—that she had been put up to playing a part by her father.

However, he must have hidden his feelings from her, otherwise she could hardly have been so happy as she was at Denmark Hill. Although she was meeting plenty of interesting people and going frequently into London, the extracts from her letters home given below are chiefly confined to her remarks about the Ruskin family:

April 28, 1847. I am enjoying myself exceedingly although in a quiet way, Mr Ruskin is as kind as ever and as droll—Mrs Ruskin is the same but I think she is beginning to feel old age a

good deal, she sleeps so badly during the night that she falls asleep in the evenings. She is always saying that she is afraid I will weary with her but we get on admirably and she is always giving me good *advices* which I would repeat had I not so much news to tell you. John I see very little of excepting in the evening as he is so much engaged but he seems I think to be getting very celebrated in the literary world and to be much taken notice of. On Saturday [April 24] he was at a grand reunion of Sir R. Peel's where everyone was, the Duke of Cambridge was there boring everybody with his noise. Sir Robert Peel and Lady Peel were there the whole time and extremely affable.* On Friday [April 30] John is going to a private view of the Royal Academy, the ticket is sent to him by 'Turner' who is one of the 30 Academicians who have a ticket at their disposal so that it is the highest compliment paid to any man in London. They have got home a very fine Picture by the above artist yesterday of Venice which is the largest they have and which must have cost *something*.†... The Cuisine here is conducted admirably.... Mrs Ruskin approves most graciously of my toilette, she says I am well dressed without being at all fine or extravagant.

April 29, 1847. Mrs Ruskin is at present dusting her china which operation she performs daily. We live very quietly; in the morning after breakfast I practice for two hours,‡ then Mrs

* *The Times* of Monday, April 26, gave one and a half columns to this 'reunion'. Sir Robert Peel, who was then in opposition, had opened 'his mansion in Whitehall Gardens for the reception of visitors invited to inspect his beautiful collection of works of art'. The occasion was the re-decoration of the principal rooms. Ruskin's name was not among the long list of guests although several modern artists were present. Adolphus Frederick, Duke of Cambridge (1774–1850), was the seventh son of George III.

† There is an entry in Mr Ruskin's account book on April 27, 1847: '£840 to Rought for "Turner's Venice".' This was an oil painting measuring 59 × 44 inches which was exhibited at the R.A. in 1837. It has been called at various times 'Shylock', 'The Rialto', 'The Grand Canal' and 'The Marriage of the Adriatic'. It is dominated by the Grimani Palace. It hung over the fireplace in the dining-room at Denmark Hill until Ruskin sold it in 1872 to Ralph Brocklebank for £4,000. It is now in the Huntington Gallery, California.

‡ Effie took her piano playing very seriously. She had studied at Avonbank under Charles Flavel who had for eight years been a pupil of Aloys Schmitt (1788–1866) of Frankfurt. John in 1851 was so impressed with her playing that he offered to give her 'any instruction in music' she liked. (Lutyens, 1965, p. 243.) Mendelssohn was her favourite composer. Ruskin was afterwards to write, 'I

Ruskin reads 'The Pirate'* in John's study. He draws and I knit till lunch, then we drive or walk till dinner-time at five or six after which we have tea and I play all the evening till bedtime. . . . Mr Ruskin got a bad cold at Yarmouth, Mrs Ruskin has the same and she is threatening to send John to France for his cough, he does not seem well but he has so much to do and so many engagements to keep I don't see how it can be otherwise. . . . Mrs Ruskin amuses me exceedingly with her remarks on domestic economy, none of which so far as I can see she practises. What would Mama say to paying six shillings a dozen for eggs this winter, 7/- for a pair of chickens just now, £20 a year to the cook, £18 to the other women etc. John was out at dinner yesterday early and they had asparagus, strawberries, Pineapples etc., very early is it not? Mrs Ruskin and I are in horror, for tomorrow a Mr and Mrs Liddell and, I think the Honᵇˡᵉ F. Charteris† are coming to lunch and see the pictures. John says Mr Liddell who has great talents and is one of the cleverest men in London has been such a fool as to marry lately a very fashionable dashing woman, with a pretty face and rather bold. I am rather curious to see her but Mrs R does not know what she will do with her if she is what John describes, she will look very much out of place here.‡

May 4, 1847. It is quite impossible that I can go to Mr Gaddesden's [*sic*] before then [May 12] as I am engaged here till that time with several people coming and a dinner party

might have said something spiteful about Mendelssohn, having been much tormented with him between the years 1848 and 53—by a person of whose sensibilities I have no very high opinion.' (From a letter to Mrs John Simon, November 1858; quoted in Burd, p. 76: original Cornell University.)

* By Walter Scott. Ruskin maintained that it was 'not a book that needs to be read'. (Works, XXXIV, 607.) It was written after Scott's health had broken.

† Francis Charteris (1818–1914), M.P. for Haddingtonshire 1847–83, became Lord Elcho on the death of his grandfather in 1853 and succeeded his father as 8th Earl of Weymss 1883. He was an idol of Ruskin's at Christ Church. (*Praeterita*, p. 208.)

‡ Rev. Henry George Liddell (1811–98), nephew of 1st Baron Ravensworth, was classical tutor at Christ Church while Ruskin was there; Ruskin said of him that he was the only tutor who reached his ideal. (*Praeterita*, p. 203.) In 1843 he published, with Robert Scott, his Greek-English Lexicon. He was headmaster of Westminster School 1846–55 and Dean of Christ Church 1855–91. On July 2, 1846, he had married Lorina, daughter of James Reeve of Norfolk. One of their daughters, Alice, was the inspiration for *Alice in Wonderland*.

on the 10th May, Mr Ruskin's birthday [his sixty-second].
I have not heard from Mr G yet but we drive every day and
Ewell is a very short drive from here. Mrs Ruskin wishes me to
make this my headquarters and will not hear of it being other-
wise. She desires me to tell you this with her love and as she
will not let me make any arrangements for myself I find it best
to let her settle things for me as she likes, so do not trouble
yourself about me as I will tell you all my plans in my letters.
. . . Mr and Mrs Bolding [Mary Richardson] dined here on
Sunday and seemed very happy and contented with themselves.
I liked Mr Bolding very much and do not think he talked much
at all excepting in a very sensible manner. Mary looks im-
proved in dress and appearance. Mrs Ruskin told me of John's
affaire the first night I came but I did not tell you as I thought
she perhaps did not wish it to be known but she did not tell me
who the Lady is and John never hints of her. He is the strangest
being I ever saw, for a lover, he never goes out without grum-
bling and I fancy the young lady cannot be in London. Mrs R.
says 'if my John gets her he *will* have a treasure as she is very
elegant and highbred'. Mrs R. tells me she has never seen her
and that she is in a higher walk of life than they are but she
knows her well by character.

Wednesday [May 5] But John is such a queer being, he hates
going out and likes painting all day and Mrs R. reading. He is
drawing me just now which amuses me very much as he
destroys a fortune in paper and paint and I have to sit in all
manner of positions. He won't let me see how he gets on until
he is finished which I don't think he will ever be. He is just gone
to breakfast with Rogers the poet, he then lunches at the Dean's,
Dr Buckland, he then goes to Sir Stratford Canning's and dines
at Mr Ellis's.* Mr Newton came here last night and slept here,

* Ruskin had been introduced to Samuel Rogers (1763–1855) before 1834.
(*Praeterita*, p. 91.) It was Rogers's *Italy*, with vignettes by Turner, given to Ruskin
on his tenth birthday, that had first aroused his interest in Turner. (Ibid., p. 29.)
Effie became a great favourite with Rogers and was asked to several of his famous
breakfast parties. William Buckland (1784–1856), geologist, had been a Canon of
Christ Church while Ruskin was there. He was Dean of Westminster from 1845
until his death. Sir Stratford Canning (1786–1880) was then Ambassador at
Constantinople; he was home on leave. He was created Viscount Stratford de
Redcliffe in 1852. Thomas Flower Ellis (1796–1861) was a barrister and a brilliant
scholar.

D

he amuses us beyond expression and went on with John this morning, he is a great genius.* Talking of geniuses Mr and Mrs Liddell came the other day, she is a lovely girl of 19 with sparkling black eyes and hair . . . she is very fashionable and dines often with her Majesty. Mr L is headmaster of Westminster school and one of the Queen's chaplains. I don't like Mrs L's manner and she has not a sweet voice. *Thursday.* Mrs Ruskin's sight is so bad that she does not know London at all. . . . John dined at Mr Ellis's and met Mr T. B. Macauly [*sic*] who he says is very clever but talks too much and makes a great noise.† They talk of sitting late in Perth but at Mr Ellis's they did not rise from the dinner table till ½ past 11. . . . John talks of taking me to the Opera some night but I don't think I will be able to go as Mrs Ruskin won't go herself and I suppose she would not let me go without a lady.

May 7. [Effie's nineteenth birthday.‡] Mrs Ruskin, John and I went to the Dulwich Gallery to-day but could not get in. We drove on to Peckham and took a long walk. John and I went into a Chalk Pit, the only one I ever saw, and the country is looking most exquisitely beautiful. . . . John has gone to dine with Rogers the Poet and is to meet Edwin Landseer§ and other eminent men. He and Mr and Mrs R very kindly gave me presents to-day. Mrs R. amuses me by telling everybody that they have no idea how fond she and I are of each other. I declare John will be quite and is quite jealous of me. Mr Ruskin has taken a box at the opera for Tuesday night [May 11] to hear Jenny Lind.¶ Mrs Ruskin does not approve of the

* Charles Newton (1816–94) had been at Christ Church with John. He was at this time Assistant Keeper of Antiquities at the British Museum. Effie liked him the best of all Ruskin's friends. He was knighted in 1877.

† The first two volumes of Macaulay's *History of England* were not published until 1848. He was an intimate friend of Thomas Flower Ellis from 1824 until his death in 1859. Ellis lived at 15 Bedford Place.

‡ John wrote a poem to Effie for her birthday—three stanzas of twelve lines each beginning 'Thorn, and meadow grass—sweet sister'. Under the title *For a Birthday in May* it is given in *Works*, II, 243.

§ Edwin Landseer (1802–73) was then at the height of his fame. He was knighted in 1850.

¶ The performance was postponed until the 14th and they then went to Her Majesty's Theatre to hear Jenny Lind in Bellini's *Sonnambula*. She was at this time twenty-seven; it was her first season in London and her second performance; London went wild with enthusiasm over her.

Opera and won't go but Mr R., John and I and Mr Richmond*
the painter make the four. I have not yet had the courage to
ask John who his Lady-*love* is, of the last syllable I suspect there
is little. It is an extraordinary affair and I could astonish you
were I at home to tell you about them. I suspect from what is
said that the Lady has a fortune and that love must come after
marriage. Mr and Mrs R. are always talking about marrying
for reason, rather odd, isn't it? I much doubt whether John
will ever marry her as he has not asked her yet but is bound to
marry her.† I cannot understand the affair nor I suppose can
you but at any rate if I tell you anything about them I trust
you will keep it entirely to yourselves as Mr Ruskin never told
me he had written to Papa about it. In fact Mrs Ruskin tells
me that nobody knows and she only told me in case, as she says,
that John and I should *love each other*, wasn't it good, I could not
help laughing but thanked her for her caution which however
I *did* not *require* as I consider him the same as married and
should never think of such a thing. However I think this little
gossip will amuse you but be sure it goes no further as I should
dislike it exceedingly and Papa *must* be particular in writing or
saying nothing that I write.

May 14. What you say about J's affair is very true, if he marry
the Lady it is from prudence and a false notion of duty. He has
only seen the young Lady six times at parties in his whole life
and does not love her a bit, but believes they have each quali-
ties to make the other happy were they married. Did you ever
hear such a philosophy? I think Mr and Mrs R. are doing
wrong—at least they are wishing for their son's happiness and
going the wrong way to work. He adores them and will sacrifice
himself for them, as I see too easily. Private!

* George Richmond (1809–96) whom Ruskin had first met in Rome in 1840.
(*Praeterita*, pp. 274–8.) Richmond's water-colour drawing of Effie, reproduced
p. 50, was probably not done until after she was married in 1848. It shows her
playing the piano at Denmark Hill in a pink and white muslin dress with pink sash
and black ribbon threaded through the neck.

† If John had not asked Charlotte to marry him it would certainly explain her
silence. Could it be that John felt his honour pledged to his *father* to marry Charlotte
if she would have him and that he had not yet asked her in the hope that an an-
nouncement of her engagement to James Hope would save him from the necessity
of doing so? He had seen her last at Lady Davy's when Hope took the foot of the
table. (*Praeterita*, p. 428.)

May 27. Bye the Bye, I have heard a little more about John Ruskin's affair and if he has got into a mess it is his own fault as Mr and Mrs Rn only wish for his happiness, a fact which is proved by their refusing a lady with £30,000 but then she was a Catholic,* but I have not yet found out who the present lady is but they don't talk about it.[27]

This last letter was written from Ewell Castle where Effie had gone on May 24 to spend a week with Mr and Mrs Gadesden from whom she 'experienced the greatest kindness'. She had told her mother that John was very sorry she was going as she would miss all his friends.

Effie returned to Denmark Hill on Monday, May 31 and informed her father in a letter of June 3 that 'Mr and Mrs Ruskin and John are as kind as can be. I *play* the two former to sleep (entre nous) every evening.' In a postscript to this letter she added, 'I will attend to your good advice with many thanks for having such confidence in me.' One can imagine John standing or sitting beside Effie at the piano while the old couple slept. What an opportunity for admiring glances and whispered words.

John's friend, William Macdonald,† came to stay at Denmark Hill for the night of June 3. Effie was enchanted with him, and he seems to have been equally drawn to her. 'I never met anyone so good,' she told her mother, 'in fact we all think he is too good to live . . . he appears delicate and has a bad cough.'

* The Ruskins would have had in mind Caroline, the youngest Domecq girl, not Adèle, when they told this to Effie. Juan Pedro Domecq, the girls' uncle, had, after their father's death, written to Mr Ruskin in June 1843 about Caroline who was then seventeen: 'This young lady cannot make out her mind to live in Xeres [where Mr Ruskin's sherry came from], therefore I have no hope of seeing my late brother's plan realized which was to marry her to H. Peter Domecq, his nephew and godson. It occurs to my mind she might like to live in London, in this case would it be agreeable to yourself & Mrs Ruskin to have her for your interesting & distinguished son? I would gladly not only consent to it but do everything in my power to incline her to it.' (Lutyens, 1965, p. 159.) Mr Ruskin declined the offer and a year later Caroline married Comte Maximillien de Béthune who became a Prince in 1886.

† Son of Mrs James Farquharson, one of Mr Ruskin's oldest friends and perhaps an old flame. Born Rebecca Colquhoun, she had married in 1820 General James Farquharson (1775–1834), Governor of the Windward Islands, whose mother had been Christina Macdonald of St Martin's Abbey, Perth. Mrs Farquharson's son, William, had in 1841 inherited St. Martin's Abbey from his cousin, William Macdonald, and changed his name to Farquharson-Macdonald-Macdonald.

For the following Thursday night (June 10) Mr Ruskin, accord-
ing to Effie, took a box at the French Theatre.* 'John and I went
with him,' Effie wrote, 'and enjoyed it very much.' Mr Ruskin did
not enjoy it at all. Charlotte Lockhart's father was in the theatre
that evening and John's behaviour to Effie caused Mr Ruskin to
suffer 'almost agony for fear Lockhart or any of his party by chance
could see what no human being could mistake'.[28] He was still
under the impression that John's honour was pledged to Charlotte
whereas in truth the affair, if there ever had been anything in it,
was over and Effie knew as much. As far as Mr Ruskin knew, how-
ever, Effie was encouraging and flirting with an engaged man and
he was dreadfully angry with both her and John.

In these circumstances he must have been greatly relieved when,
on June 15, Effie left them. It is known from John's letters that he
parted from her in her room at Denmark Hill, just as it is also
known that he had been in the habit while she was staying there of
waiting outside her room in the evenings to go down to dinner with
her arm in arm.[29] When she left, Mrs Ruskin took her to 11 Sussex
Gardens, where she was to stay for a fortnight with Mr and Mrs
William Gardner, friends of her parents. Effie must have keenly felt
the parting with John because by this time she was certainly in love
with him and although she must have known that he loved her too,
it is uncertain to what extent he had declared himself.

It had been arranged that when she left the Gardners she was to
go and stay with some school friends in Leicestershire, but on the
very evening of her arrival at Sussex Gardens she begged her father
to be allowed to return straight home. She told him that she had
many reasons for such a request and that her desire was so urgent
that 'it allows me to think with patience of a sea voyage which of
all things on Earth I consider the most insufferable'. 'The Gardners
I think are very kind,' she added, 'but not of so refined a class as the
Ruskins,' and two days later, 'I like the family here on the whole
very well but after being with the Ruskins it makes one rather par-
ticular. They are too fond of good dinners.' She was sleeping badly
(she was to be a bad sleeper all her life); she was not feeling at all

* The St James's Theatre where there was a season of short French plays—either
four plays each evening or three plays and a dance. The programmes for the 9th
and 11th were given in *The Times* but on the 10th it was announced that that even-
ing's performance had been postponed till the Monday; therefore Effie must have
made a mistake in saying they had been there on Thursday evening, the 10th.

well and the eighty steps she had to run up and down to her room tired her dreadfully.

Her father gave his permission for her to return straight home and she left London by steamer for Dundee on Wednesday, June 30. For the first time she was able to travel from Dundee to Perth by train as the Dundee–Perth Railway line had been opened to passenger traffic on May 24 that year, a great boon to Mr Gray's Dundee Shipping Company. It was, though, one of the railway companies which was soon to bring him to the verge of ruin.

5

OPPOSITION

John himself had already left Denmark Hill. He had gone to Oxford on June 22 to attend a meeting of the British Association, and from there sent his father such a gloomy account of himself and his health that he was ordered to Leamington to take another cure under Dr Jephson. He 'went penitently again to Jephson, who at once stopped the grilled salmon, and ordered salts and promenade, as before'.[30] The real cause of his unhappiness was that his father would not give his consent to an engagement with Effie. In *Praeterita* he makes no mention at all of Effie* and puts down his depression at this time to the loss of *Charlotte*, yet in December 1847 he was writing to Effie, 'I hardly know *how* great a misfortune it may *yet* turn out to be—that I was not permitted to engage myself to you long ago—it would at any rate have saved me from much loss of health—a loss which I think it unlikely I shall ever altogether recover from.'[31]

William Macdonald was also taking a cure under Jephson at this time. It had already been arranged that in September John was to stay with Macdonald at his hunting lodge, Crossmount, at Pitlochrie in the Highlands. This is known from a letter from Effie to her mother from Sussex Gardens: 'John Ruskin will certainly

* While Ruskin was writing *Praeterita*, which he did in instalments published separately, George Allen, his publisher, wrote: 'I often wonder in what way the Professor will jump over the married portion of his life. There will be a blank there. I believe that he intends to say nothing about it'. And a few months later: 'Entre nous—the curious who know a little are wondering how that part of his life commonly called his married life will fare in "Praeterita"—"not worthy of memory" I expect but surely it will be difficult to separate or sift some of the incidents.' (Unpublished letters of November 29, 1885, and April 2, 1886, from George Allen to John Hobbes: Pierpont Morgan Library.)

be in Scotland to stay with Mr Macdonald but you need not expect to see him at Bowerswell. He cannot come for various reasons and as you know Mrs Ruskin would be miserable every moment he was in Perth or under our roof which would be much worse. It is extraordinary to me how a woman of her powers of mind and extreme clearness of understanding can be so superstitious. Mr Ruskin has imbibed the same absurd ideas but their prejudices must give way some day or other surely. As long as she keeps from Perth the thing will grow on her.'[32]

There is one entry referring to Effie in John's diary for July 18 while he was at Leamington: 'After drawing at Warwick Castle I . . . walked some distance on the road beyond, past the sixth milestone from Stratford (thinking much more of ECG than of Shakespeare by the bye).'

He remained at Dr Jephson's until August 16 (Macdonald left sooner). Travelling to Scotland by way of Yorkshire and Berwick-on-Tweed, he reached Dunbar by the 18th. He stayed at Dunbar for three nights and was in Edinburgh on Monday, August 23. On that evening he called unexpectedly on Effie's uncle, Andrew Jameson, and was asked to stay to dinner. Andrew had had to give up the Bar because of his loss of voice and was now a Sheriff Substitute in Edinburgh.* In 1844 he had married Lexy Campbell, sister of Neil Campbell of Barnhill, Dumbartonshire. He evidently expected John to visit Bowerswell on his way to Pitlochrie for he wrote to his sister on August 25: 'Your friend John Ruskin dined with us on Monday. I was very happy to see him so much stronger than when we met in Piedmont six or seven years ago. [Turin, where they had met, was then the capital of the Kingdom of Sardinia which comprised Piedmont and Savoy.] He is a very interesting person. Lexy and Neil were greatly pleased with his conversation. His book is much thought of here. I hope you contrive to keep him at Bowerswell for some days.'

Even though Effie had told her mother not to expect John at Bowerswell she must surely have hoped that he would at least call on them, since to get to his destination of Dunkeld, on his way to Crossmount, he had to go through Perth. There was no railway then

* Andrew Jameson became Sheriff Principal of Aberdeenshire; his eldest son, Andrew, became Sheriff of Perth and, as Lord Ardwall, a Judge of the Court of Sessions.

from Edinburgh to Perth (it did not open until 1848), and he
travelled post from Edinburgh to Dunkeld, passing through Perth
to change horses. He left Edinburgh on the morning of Wednesday,
August 25, and arrived at Dunkeld that same evening so he must
have travelled in a private carriage, since there was only one
stage coach a day from Perth to Dunkeld which left Perth at nine
o'clock in the morning. He saw Mr Gray at his office, as well as
Melville Jameson and George, but this could hardly be avoided as
the office was at 14 South Street, two doors from the Salutation
Inn where post horses were kept and from where all the coaches
started.

'I passed through Perth to-day,' he wrote in his diary at Dunkeld
on the evening of August 25, 'nineteen years since I was there, and
I am very sad to-night.* It came on dark at 10 and remained grey
all day, a shower coming on just as we entered by the South Inch.
All looked hopeless and cheerless; the town smoky and ugly in
outer suburbs; the Bowerswell houses crowded and ground behind
ragged. And yet I thought Glen Farg and the hill of Moncrieff as
lovely as ever, allowing for the desperate change in *me*—but Perth
not. And I have had the saddest walk this afternoon [at Dunkeld]
I ever had in my life. Partly from my own pain in not seeing E G
and in far greater degree, as I found by examining it thoroughly,
from thinking that my own pain was perhaps much less than hers,
not knowing what I knew.'

This entry shows that he knew Effie loved him; what *he* knew
and she did not was surely that it was his parents, not his heart, that
prevented his proposing to her. In a letter to his father, also written
from Dunkeld on August 25, he reiterated his depression: 'I intended
staying here until I heard from Macdonald, for it is *very* beautiful,
but I must go on. I feel so utterly downhearted to-night that I must
get away to-morrow without going out again, for I am afraid of
something seizing me in the state of depression. I never had a more
beautiful, nor half so unhappy a walk as this afternoon.'[33] He
moved on to Pitlochrie next day, where he stayed two nights. On
the 28th he joined William Macdonald at Crossmount Lodge at
the foot of Schiehallion between Lochs Rannock and Tummel.

* In fact it was twenty years, a mistake he corrects in his letter to Mrs Gray
(p. 44). Shortly before the death in 1827 of his little cousin, Jessie Richardson,
Ruskin had been dangerously ill at Dunkeld. (*Praeterita*, p. 70.)

From there he wrote to Mrs Gray what must have been an almost impossibly difficult letter of explanation:

Crossmount, 1st Sept. [1847]

My Dear Madam,

You cannot but have thought it not a little strange that I should have passed through the main street of Perth and never waited on you but I trust that you will not think I did so without cause, or without regret. You may suppose that I could not re-enter Perth after the lapse of twenty years—and the various dispersion of all my *then* dearest interests in its many lovely localities, without feelings of pain which I should have been sorry to have intruded upon my friends—and indeed, the place and its neighbourhood have been to *me* so peculiarly and constantly unfortunate that I would not willingly associate any of my present pleasures with its hitherto ill boding scenes. I could hardly even express this to Mr Gray—for I felt severe pain at the thought of either staying in Perth—or quitting it so abruptly—and I was hardly able to speak either to him, or to Mr Melville Jameson—whom I was fortunate enough to meet in my short stay,—nor did the depression leave me until some days afterwards—compelling me even to leave Dunkeld— where I had intended staying for a day or two—but where I found old recollections still too strong for me—Since I have been here I have only delayed writing to you in order that I might be able to tell you more decidedly how far I was able to appreciate your Scotland. I thought Dunkeld, and its woods, of singular loveliness,—being not a little surprised at finding laurels and Spanish chestnuts mixed with its birches and larches—nor was I less struck with the banks of the Tummel at Pitlochrie and Killiecrankie—and thoroughly bowed down before the perfect beauty of the *bell* heather—which does not grow in Switzerland—and whose opalescent softness and depth of colour are I think more lovely than the fuller flush of the Alpine Rose. But—will you be so kind as to say to Miss Gray that I have only found five *gentians* all this time—and those of a most pitiful and disconsolate character—and that I am therefore persuaded nothing but *her* care and kindness could have brought my pet flower to anything approaching the perfection

with which she assured me it adorned Bowers Well—and that I am content it should grow under such auspices—provided it refuse—as it seems to me very proudly and positively to do—to flourish any where else—or without such peculiar favour and encouragements.

I am afraid I must not say any more about the Scottish *mountains* (as they are—by courtesy, I think, styled —) lest I should get into disgrace like Mr. Harrison,*—and—as I am not sure whether my peace is yet made in the matter of Celimène [in Moliere's *La Misanthrope*]—I dare not run any further risk.

I can hardly say at present how long I may stay here—it will depend on Mr Macdonald's movements whether I remain in the east—or return by Ben Nevis—Loch Lomond, and Glasgow—but—even if I should pass through Perth again— you must not think ill of me if I pass in the same way. I sincerely hope we may have the pleasure of seeing you all in England—or perhaps that my father and mother may be able to persuade Miss Gray to pay us another visit—and you to let her come.

I was very glad to see George looking so ruddy and well— he used to look a little paler now and then in the smoky air of Charterhouse; I wish he could tell me how to paint a little in the same way—for there is at present more reflection of English chalk than of Highland heather on me.

When you are at leisure—might I hope that you would send me a single line significative of forgiveness—and let me know how you all are—Miss Gray does not write quite often enough [to his mother]—though we have to thank her for longer letters than of old.

I have not said anything of Perth itself. I had not forgotten

* William Henry Harrison was a clerk in the Sun Life Insurance Co., Bridge St, London. He lived at 2 Langport Place, Camberwell, not far from Denmark Hill and was a frequent visitor there. From 1837 to 1841 he had been editor of *Friendship's Offering*, an annual to which Ruskin first contributed in 1835. He acted as Ruskin's 'literary master', reading all his proofs, correcting his grammar and punctuation and protesting sometimes against his sentiments. (*Works*, I, xlviii.) Effie had met him several times at Denmark Hill and he professed a great admiration for her, writing for her a poem of forty lines dated May 28, 1847, beginning, 'O Effie Gray! / 'Twas very cruel / To run away / And go to Ewell. / O sad event! / 'Twas hard to part with you, / For when you went / You took my heart with you'.

it—but the day was unfavourable—and my eyes were dim. I must beg you to thank Mr Gray for his kind forbearance, and to remember me to him faithfully. With sincerest regards to Miss Gray, and George, believe me, my dear Madam, Ever Faithfully Yours J. Ruskin.

Mr Macdonald begs to be most kindly brought to Miss Gray's remembrance. (no mere matter of form, this;)

Mr Gray would mention to you that I had the pleasure of dining with Mr Sheriff Jameson at Edinburgh—Mrs Jameson seems a very sweet person—I took them somewhat by surprise—and much hope that I did not put Mrs Jameson to inconvenience by doing so.

Miss Gray spoke of *Honeysuckle* on Kinnoul [*sic*]. For all I can see, the bees get all their honey *here* out of the *thistles*—*34

Mr Ruskin's attitude to John's marrying Effie was quite selfless. He was justifiably ambitious for his son, and would have been willing to efface himself in the event of an alliance such as he genuinely believed John's honour was pledged to. Moreover, he had certainly heard by this time from friends in Scotland that Mr Gray was in grave financial difficulties and feared that Effie was being foisted on them by her father. What more natural, to his way of thinking, than that Mr Gray should want to see his lively daughter married as soon as possible to the son of his wealthy old friend, who would no doubt be willing to take her without a dowry? Mr Ruskin could not fail to have doubts about a marriage so based, more propitious though it would have been to his own social ease.

Mr Gray was a victim of 'Railway Mania'. The proprietors of shares in the first successful railway passenger lines—the Liverpool and Manchester Railway, the Grand Junction Railway and the London and Brighton Railway—had made such dazzling profits that the public scrambled to get hold of original shares in the new railway companies springing up everywhere, operating in some cases only a few miles of line and often in competition with one another. Because the lines passed through private property each company was obliged to present a private Bill to Parliament which

* John made a beautiful drawing of thistles while he was at Crossmount. It is reproduced in *Works*, xxxvi, 426.

had to be passed before construction could begin and the raising of capital authorised, but very few of these Bills were turned down. In 1845, at the height of the boom, everything had been done to encourage speculation; Parliament had reduced the deposit required before introducing a Bill from ten per cent to five per cent of the necessary capital estimated to carry out the work; accordingly shareholders were required to complete the purchase of their shares only as the money was needed.

Mr Gray was one of the unfortunates who had been let in on the ground floor of several railway companies. As a buyer of 2,000 £25 shares in the Scottish Central Railway Company, for instance, he had had to find only £2 10s. od. per share in July 1845, with an undertaking to provide a further £2 10s. od. or £5 when 'called' upon until 1848 when the last 'call' was made. If the shares went to a premium (and many did before work on the lines was even begun or the first 'calls' made) the shareholders who sold out might double or treble their money within a few months.

But Mr Gray, like so many others, was caught in the inevitable slump. In 1846 nearly 5,000 miles of new lines had been authorised, estimated to cost well over £90 million, and during 1847–8 shareholders had to find £65 million for 'calls'. Thousands of speculators who could not meet their 'calls' were ruined, their shares being unsaleable. Mr Gray managed to hold on by borrowing, but he was not out of the wood until the beginning of 1849. By August 1847 he was in serious trouble; far worse was to come, though, when revolution broke out in France in February 1848, followed by general chaos throughout Europe.

There is no doubt that the collapse of the railway market was a very important factor in the failure of John Ruskin's marriage.

6

CAPITULATION

❋

Ruskin's depression evidently frightened his parents. Those words in his letter from Dunkeld—'I am afraid of something seizing me in the state of depression'—were ominous.* They remembered how desperately ill he had been when thwarted over Adèle. Was there a chance now that his mind, as well as his health, might give way? They began to relent. This is shown by a letter from his mother written after receiving his miserable one from Dunkeld:

Denmark Hill Augt 29th 1847

My dearest John

Confused as my yesterday's letter was [this letter has not come to light] I think you could not fail to understand that your father and I have but one wish, one desire, that of seeing you in health and capable of employing your faculties to the best purposes and of enjoying the infinite blessings placed within your reach, and that whatever you may judge necessary to promote your happiness will not merely be acceded to but acceded to with thankfulness and joy both by your father and me. I shall say nothing more of Effie until I know what your plans and wishes are. I am more than thankful you have left

* Ruskin did not have his first mental breakdown until 1878; nevertheless Millais, in his first year of marriage to Effie, wrote about him, 'I can scarcely trust myself to speak of Ruskin who certainly appears to me (now that I know all about his treatment of my wife) to be the most wicked man I have known in my life, and this I say *without hesitation* [underlined twice] and methodically . . . the only thing that can excuse him, would be decided madness asserting itself—His grandfather cut his throat here at Perth so there seems some reason to believe in family derangement for with sanity no human being possessed of feeling could have suffered a girl to live with him 7 years [in fact six] in that condition.' From unpublished letter to Holman Hunt from Annat Lodge, Perth; undated but written between February and May 1856: Huntington Library, California.)

Dunkeld, I have felt anxious and uncomfortable about you for these few days more so than during any time of your absence and could not help wishing, either that we were with you or you home again. I feel much sorrow at knowing how much you suffer at times and in particular scenes but be assured my love there is no radical or permanent change in yourself, many causes have been in operation for many years producing by degrees the distressing effects you at times labour under—these causes I trust soon to see removed, and depend upon it my Dear John you will then find yourself capable of infinitely higher enjoyment in the greater part of those things which constituted the happiness of your childhood. . . . I hope to have better accounts of you on Monday [September 3] and that your spirits and health will strengthen daily among the mountains, need I my Dear John say take care of yourself and run no risks which may be avoided, the Scotch Lakes are not to be trusted any more than the English with Sails, you know what you owe to your father and me, our dearest treasure our blessing beyond all value, God preserve you my Dear John and give you all He knows to be needful to make and keep you what He would have you to be, ever

my Love
Your affect Mother Marg^t Ruskin[35]

A few days later came a letter from his father which John himself called 'extremely important and beautiful'. In it Mr Ruskin analysed his feelings about the situation with a startling frankness and perception:

In regard to E.G.—you have taken more objection out of my manner than I had in my mind—Be sure of this that all *hesitation or pause* on my part is for fear of you—Vanity does mingle a little—but mortification I should have had double in the L. union I always knew this—but we had kept you to ourselves till marriage and I expected you might marry rather high from opportunities given and that then we must give you—up—now with E.G. I gain much—I escape also from painful communications even for a short time with people out of my sphere—as for the opinion of G Richmond and Acland, I think E.G. superior to Mrs R [Richmond], Mrs A [Acland], and from all I know

to the two Mrs Liddells*—but for you I fear a little worldly trouble of affairs and I dread any future discovery of what you seem to fear—motives of ambition more than Love—or of tutored affection or semblance of it, though I only do so from the knowledge of the desirability of the union to the Father not as you do from supposing you not to be lovable—I reckon there are not Mr Dales† number 74 but 174 in Love with you at this date 2 Sepr 1847—I cannot deliberate in an hour but in a moment I say—go on with E.G. but not precipitately—If her *health* is good and she suffers little watch her but do not *shun* her for 6 or 8 or 12 months—I do not ask you to do this if you prefer marrying at once but as I want you to stand well with Lockhart and the Intellectuals I should be sorry to let him fancy that your affections were not at all concerned in your proposals to his Child—as to your fears and opinions of wedded Life—the unhappiness is generally in the Individual—the Ladies only draw out a Temper which exists—make their husbands show their paces. A man cannot be very unhappy that in the greatest difference with a Wife never for a moment wished himself unmarried.[36]

John, with his usual sweetness and compliance over trifles, had evidently hastened to assure his mother that he would run no risks on Scottish lakes; this called forth from her the revealing letter below:

Denmark Hill
Sept 4th 1847

My Dear John
I wish I could make you know how much I am gratified and how deeply thankful I am, when I can do anything to comfort,

* Dr Henry Acland (1815–1900) had been a senior undergraduate at Christ Church when John was a freshman. They became life-long friends. Acland was at this time a general physician at Oxford. He became Regius Professor of Medicine at Oxford 1858–94 and was created a baronet 1890. In 1846 he had married a daughter of William Cotton (see p. 124). George Richmond had in 1831 eloped to Gretna Green with Julia, daughter of the architect, Charles Heathcote Tatham. The two Mrs Liddells were the wife of the Dean of Westminster (p. 24) and the wife of his cousin, the Hon. Adolphus Frederick Octavius (1818–85), youngest son of 1st Baron Ravensworth, and a Fellow of All Souls. In 1845 Adolphus married Frederika Elizabeth, daughter of George Lane Fox of Branham Park, Tadcaster.

† Rev. Thomas Dale (1797–1870) had, when he was incumbent of St Matthew's

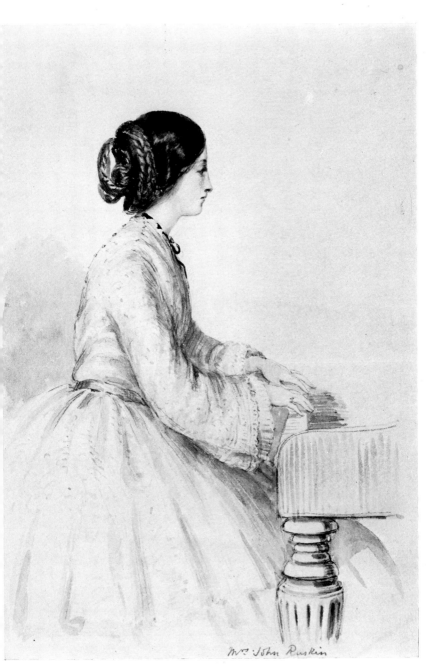

Effie Ruskin, water-colour by George Richmond, 1848.

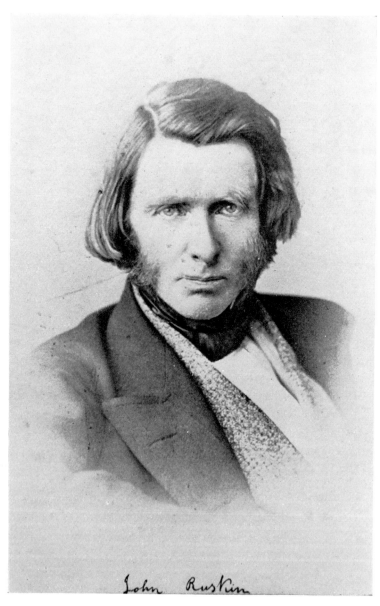

John Ruskin, photograph *c.* 1860.

or to please you and the happiness you give me in writing so openly your thoughts and feelings. The false estimate you have taken of your outward appearance and mental powers and acquirements would cause me bitter grief if I could not look forward with more than hope with almost certainty to the seeing you enjoying and rejoicing as formerly, the subjects in some degree different perhaps. I thank you my love for your kind assurance of taking care. I have as you know the greatest confidence in your prudence but I could not help feeling a little nervous about lakes and rivers and bogs you not knowing so much of their nature in Scotland as of those in Switzerland, I am therefore the more obliged by the pains you have taken to reassure me—I should be glad to day to have been able to talk instead of write to you but I must endeavour to make you understand clearly why I was afraid of influencing you in your future conduct regarding Effie. My feelings when I know you to be less than happy and peaceful are so distressing and the relief and heartfelt satisfaction so great when I see you satisfied and happy that I may not be able to form a correct judgement either of persons or things influencing your happiness. I saw you happy with Effie and all objections, all prejudices, all superstitious feelings on my part gave way, all but my fears of your doing wrong with regard to Miss L and in paying such attentions to Effie while you considered yourself bound by honour to Miss L—I will now let you know what my present thoughts and feelings on this subject are. I hope you will not think what your father *says* that I am like a weather cock so easily turning about but I do not believe he really thinks this. Many a time when I saw how happy you were together and when I looked on her I most deeply regretted your engagement with Miss L and thought how happy we might all be together so you see my change has not been so very sudden. I have reflected much on all her conduct while she was with us or rather while she was in England—and I cannot think (though she might come up with

Chapel, Denmark Hill, kept a school in Grove Lane, Camberwell, which John attended 1833–5. In 1835 he was appointed to the living of St Bride's, Fleet St; in 1843 to a Canonry of St Paul's; in 1846 to the living of St Pancras and in 1870 to the Deanery of Rochester. Ruskin describes him in *Praeterita*, pp. 82–3.

E

some plans of making herself agreeable and gaining your affections) that after she had been with us a day or two she in any one instance endeavoured to appear what she really was not—she showed great regard for you, seemed desirous of doing what you pointed out as proper and avoiding what you thought improper—how far my judgement of her may be influenced by your regard for her I cannot tell but I think very few girls at her age have equal qualifications—she has much decision of character on all occasions and in all circumstances, I could give you numerous instances of this. She is very lovely, with the least vanity I have ever seen in any one, she has much social kindly feeling, this in a wife would be invaluable to you for you cannot go out of the world altogether and in your intercourse with it she would be indeed a helpmeet for you. I think her also very prudent in her expenses without the slightest meanness, her taste in dress really good, her appearance such as we may all be proud of, her family and connections equal if not superior to our own—her temper I think must be excellent or she would not have borne so easily your fault finding and her natural abilities are much above the common, and in conclusion I am entirely convinced you may never meet with another so calculated to secure your happiness. I do not think there is the least chance of Effies growing as she gets older either coarser or in your eyes (if you marry her) losing her beauty, neither her father or mother have increased in fatness and this runs in families as it regards spareness or bulk. All the Depree family* are in proportion larger than their father, their mother as you must remember was for so young a woman immense, I was forgetting you never saw the first Mrs Depree, she was larger and more shapeless than Miss Depree—you may ask now why I am so reconciled to what I used to be so much opposed—I have seen more of Effie—I have seen more of what the highest classes are composed of, much of my till now superstitious dread of Perth has been of late removed. I can scarcely except [accept] that I have

* Mr and Mrs Duprey ('we always spelt and pronounced Depree') of Langley, near Slough, and Gray's Inn Lane, were friends from whom Ruskin had learnt to lay bricks and paving stones—'the instrument I finally decided to be the most difficult of management was the trowel'. (*Works*, XXXVI, 427.)

latterly thought of the happiness as well as suffering experienced there. I would not however like you to make any longer stay in Perth. I believe one of the chief causes of my opposition arose from my being led to think Effie was in a manner forced upon us but this was at least as you used to say a compliment paid to our desirableness. I do think her father a truly honest upright man, her mother very amiable, her mothers family all highly respectable, and then I shall not have a daughter in law (if you give me Effie) who will I should hope be unhappy with me or with whom I should be uncomfortable, and what is of the greatest consequence I feel most firmly persuaded that you will be infinitely more happy and useful married than single. I do think Effie so open, so frank and upright, that she will not deceive you, and you may tell her if she takes you and makes you happy that we shall receive her with joy and that I will study her happiness and cherish her with my whole heart. I said I should be glad you took Effie lest you might take one less desirable because when you take a liking to any one you cannot see defects or faults in them and are displeased with and think every one unjust who fear for you and endeavour to point them out to you and therefore if any beautiful face and form took your fancy you might in such an one find excuse for all faults and imagine all virtues. Your father wrote that I had lost all ambition but he is mistaken. I still as always desire most earnestly that you should associate with the high and the excellent and should be sorry that you lost sight of many to whom you were introduced last winter but you may keep some hold of good society and acquaintance without going to routs and crowded dinners—Effie will be no drawback on your entering any society you may choose—I will not read over what I have written it tries my sight more than writing I am afraid I have expressed myself very confusedly and badly but the entire meaning is what I think from my heart, Effie is fitted to make an excellent wife and you happy and if she loves you as I think she does and has done from childhood she will be most happy with you, a love growing from childhood will be lasting if any can, God bless you my beloved child and guide you to all good prays always your affect Mother

M. Ruskin[37]

Effie was evidently writing occasionally to Mrs Ruskin the kind of letters she had written since childhood, for on September 5 Mr Ruskin told John: 'I enclose an Effie and before leaving this subject I beg you will make yourself easy and do anything you feel would most conduce to your own felicity—Sooner or later regards yourself more than Mama or I who can never be satisfied but by making you happy.'38 But Mr Ruskin could not leave the subject, and three days later was writing to criticise Effie's behaviour at Denmark Hill:*

We are rejoiced to have your Mondays letter—never before having had two blank days as Pitlochrie gives us—for Sunday here and Sunday there make Fry and Tuesday no days here.

It is soon explained about E. In comparing her with Mrs A [Acland] and R [Richmond] and I mean as her Looks, presence and fair common sense—youth and Gaiety would place her before the World—but here I was behind the scenes and full of fears for her and y [torn] suspicious of her and her family [torn] of which the World knew nothing [torn] your chance good and [torn] binding with Miss L. and the conduct of E. while she believed you engaged with another, seemed like an attempt to break it for her own purposes or else a sort of abandonment of self and duty and Character to the pleasure of the moment come what would of it. If anything of this existed—she would not compare with Mrs A. but I am endeavouring now to think that you considered the Lockhart affair hopeless, and so allowed yourself to be with E in a way which if not off the other, was in my eye wrong and I now wish to believe that E. saw there was not great chance [torn] permitted herself greater free [torn] than had the other Engagement been as I thought—it would have been delicate to do—I now wish to believe that they were my Suspicions only which made me think E. acting under Orders—and staying here to create confusion and displeasure to accomplish what her family were bent upon—If her Father and Mother are good honest people and she entirely sim [torn] hearted you need not be ashamed of [torn]

* Unfortunately this letter has a large hole through it. It was folded with the address on one side, as was usual in those days before envelopes were adopted, and the stamp has been torn away.

your Choice—I wanted a [torn] to pass to see if any light [torn]
would come upon the affair but having seen great Injury done
your health by former French affair and seeing you at a time of
Life to be married and not likely to be better suited and Mama
now reconciled—I am quite agreeable to any step you take—I
would give a good deal however if E. had nobly left the House
the moment the other affair was named—Now that it is done
with I should have rushed with great eagerness to have brought
her back [torn]—She is a sweet [torn] Friends about as un-
objectionable as [torn] I felt and spoke severely because I would
give still much if I could obliterate from my mind that passage
of the history of both of you—but I repeat I may be entirely
wrong and I am not willing again from suspicions [torn] to
subject you to a second [torn] too much for your frame to
bear.[39] [A few more lines about John's marriage are too badly
torn for any coherence and the rest of the letter deals with other
matters.]

John evidently took great exception to this letter, but it called
forth from him at last one which finally cleared up the misunder-
standing between his father and himself over the matter of Charlotte
Lockhart. Mr Ruskin replied on September 13/14:

I fear you are annoyed at my alluding to E' visit. I cannot
help my opinions—they are often wrong—but I am glad to
exhaust a subject and to get to the end of trouble because
reserve, closeness—on either side—begets continued misunder-
standing. It is I assure you no easy matter to draw you out
and I am rather slow. . . . Until I drew from you this last
Letter—I could not see that you had been acting and I have
been judging under entirely different circumstances—You
acted as if you had finally done with Miss L—and Miss G
acted upon an idea *got from you* that you were no longer en-
gaged. Now I judged you as pledged to another and likely to
get another and I judged E as one knowing only this—Your
argument would be right as of Miss G's leaving the House, even
if you had been engaged, being uncalled for, if you had been to
her as to Miss Sidney* or any other Visitor, but as all the world

* Augusta and Emma Sidney were the step-daughters of Dr Grant, the Ruskins'
family doctor (see p. 141). They were heiresses, according to Effie, and had stayed

saw you were over head and Ears—and she was aware of our fears—it totally altered the case. . . . Had you openly and jocosely said '*Oh as to that affair L it is done with—and E knows better than to suppose I am engaged*'—for you tell me for the first time in your last Letter—'Knowing as she did that I had been refused by another'—I see my dearest John that I should have changed my tone. . . . Mama has changed her objections into approval—I give mine and moreover add that I deem it more likely to secure your happiness to be a married man than a single, and that I know no young Lady I should my self so much like for your wife *now* as Miss Gray.[40]

Mr Ruskin's surrender was not only unconditional, it was willing. John responded to his advice in his previous letter that he should watch Effie but not *shun* her by suggesting that she should go with them to Switzerland the following year. His mother did not approve. 'I do not know that there would be anything very improper in Effie's going abroad with us unmarried,' she wrote to him on September 11, 'but neither am I satisfied that the doing so would be either proper or wise, if I were younger or you had a sister, it would appear less marked, another objection to this plan, in my opinion, is that you would be spending part of that happiness, which ought to be kept for your married life, you will see what your father writes on this subject. I do not like that he should be disappointed, and I do not like that your happiness should be defered [*sic*], I will do what you both wish, I think if Effie were sure of your regard and you were not like to be parted again for any length of time she would be satisfied to remain quietly with me when I could not go about with her—still it would be very different if you two could go about together with propriety in such excurtions [*sic*] as were too much for your father and me, you having George, and Ann* remaining with us, we remaining where your father found himself well and comfortable and you coming to us as to a home,

at Denmark Hill in June 1847 while she was there. Mr Ruskin is more likely to have been thinking of Emma who was John's favourite as she had 'good taste for drawing, and other quiet accomplishments and pursuits'. (*Praeterita*, p. 246.) In July 1850 John and Effie attended Emma's wedding to Major (afterwards Sir Herbert) Edwardes (1819—68), one of the great Anglo-Indian soldier-administrators—Ruskin's ideal of a true knight. (*Works*, XXXI, 375, and XXXIV, 727.)

* Ann (or Anne) Strachan (1794—1871) had been in the family since she was 15

there will however be time enough to settle about this when we can
talk it over and I can point out to you more fully what might prove
to be considerable drawbacks on even your enjoyments, if you and
she could not depend on and take care of one another which of
course you could not unless you were married, by depend on I
mean being so far independent of the care of others—I am much
pleased to find you are satisfied to be alone for some time in winter,
and to bring your affairs under regular system and habits—if you
are firm and kind and never lose temper when you are asked to
break through settled rules I think there is nothing to prevent you
being as undisturbed as you desire. . . . Effie has sent your fathers
slippers very nicely sewed—he writes today to thank her.'[41]

At the beginning of this letter Mrs Ruskin praised Effie and her
family as much as John could have wished, and added, 'I think
it is quite proper that you should see as you return Mr and Mrs
Gray in their own house—you could not leave Scotland without
seeing them and *Miss* Gray'.

It is not surprising that after such encouragement from his
mother to visit the Grays, John should have written off immediately
to Mrs Gray:

Crossmount 15th Sept[r] [1847]

My Dear Madam
I should have answered your very kind letter before now, but
have been waiting until I could tell you whether I should be
able to return by Perth. I have determined to do so—and as I
do not think that my superstitious or painful feelings will be so
strong on a second visit as to compel me to run away from my

so she must have been at Bowerswell when John Thomas Ruskin cut his throat.
She became John's nurse and then Mrs Ruskin's personal maid. She went with
them on all their travels. (*Praeterita*, pp. 30–1 and 107.)

George Hobbs was Ruskin's servant. His real name was John but he was always
called George to distinguish him from his master. Ruskin tells us in *Praeterita* (p.
343) that when they came home from abroad in 1842 George 'a sensible and merry-
minded youth of eighteen' replaced Thomas Hughes as his valet. In fact George
was only seventeen in 1842 and had entered the Ruskins' service in '41. In his diary
for April 17, 1846, George recorded, 'Mr Ruskin had the kindness to give us a
small bottle of Burgundy wine to drink my health, as it is my twenty-first birthday',
and the entry for July 2, 1846, reads, 'This day I completed my fifth year of service.'
His mother, Anne Stone, had been with the Ruskins from 1821 to 1824 when she
left to get married. His sister, Hannah, Mrs Ruskin's housemaid, married George
Allen who became Ruskin's publisher.

kindest friends, I must trust to you to tell me whether you could conveniently receive me for a day in the course of the week after next. I am afraid I may have some difficulty in telling you the day, exactly—for I have some memoranda to complete at Pitlochrie which may make my stay there dependent on the weather,—but I should not, I hope, be later than the close of that week—Saturday the 2nd, unless some accident should intervene—or the weather be more than ordinarily unfavourable—Mr Jameson mentioned to me some thoughts you had of coming to Edinburgh—if the time I have named should interfere with any arrangement of this kind I should hope for the pleasure of seeing you in Edinburgh.

I have—people say—been unfortunate in my September weather—and, assuredly, I have not found it available for any sedentary out-of-door work.—and perhaps my impression of the Highlands is somewhat more bleak and damp than by rights it should be—I see that Miss Gray in her letter to my mother, speaks of my blindness to the beauty of the *blue hills*— but alas—*I* have seen only *brown morasses*. There is an ugly heap of peat earth with stones in it, behind the house here, which takes two hours work to get up, which they call Schehallien [*sic*]—and the view to the westward from the top of it is very good—the Glencoe ranges looking proud, and precipitous— but for the rest—I have seen nothing in the way of hill which is not so round and pointless—and nothing in the way of valley which is not so mossy and treacherous—that I am getting a little tired of a country where I can neither fix the top, nor find the bottom. My admiration of the heather continues undiminished, though the fire of it is fast going out—fading—like Miss Gray's riband—(please tell her that she must at any rate grant me it was ill chosen for *wear**——for there is certainly not sun enough in Scotland to affect the health of a riband with anything like a constitution) but I find a bell or two very bright

* Mrs Ruskin in her letter of September 11 had told John that Effie had 'inherited much of her mother's sweetness—or she never would have born with such temper your attack on her taste in the matter of the ribbon—never have continued to wear what she was told did not become her—never have maintained her opinion so stoutly against yours—there is more of character shown in this matter than I think you are aware of because you do not know how such things operate on female minds generally'.

still, here and there, and hare bells, (rabbit bells for the most part, I think, for the hares keep the hill top) very blue and graceful—and another flower which I had not seen before—a white star with a single heartshaped leaf—not to speak of Eglantines with hips so bright as to answer most of the purposes of roses—and barberries [berbaris]—which however—I can get better and brighter—and I fancy sooner, in the south.

The crags down beside the Tummel are very beautiful—only they have an awkward, up setting way of standing on edge—like an old saw—so [a tiny sketch]—which renders the exercise of walking one of considerable nicety—and small convenience- An Alpine torrent allows of no such capriccios in its neighbour crags—but rolls and roars them down into obsequious polish— so that the effect of the Tummel crag scenery is, to me, a good deal like the pasteboard gulphs which they drop the extra bandit into, at the end of an opera—I never can believe it is real:

Pray—if you are thinking of going to Edburgh—do not let me interrupt any of your plans even for a day—as my time is very much at my own disposal—If you are only going for a few days, I would wait at Pitlochrie until you returned—for I have a great deal to study about Killiecrankie, and the Highland air is good for me, though I should like it quite as well if—occa- sionally, the supply of it were somewhat more limited—I thought—last night, it would have blown the water out of the Tummel, and the top off Schehallien.

I am afraid—on reading my letter over—that Miss Gray will be very angry with me—and will not accept my kindest regards—but really—her Scotland has treated me very ill— and if I were not 'a good creature' I should say worse of it. Pray remember me most kindly to Mr Gray and George. I hope George's fishing was prosperous. Mr Macdonald begs to be kindly remembered to Miss Gray—though—if she were to see him now—I think she would doubt the accuracy—if not the kindness of her memory—he looks so well after his rough Highland life—for myself—I gain in strength more than in appearance—perhaps I do not so well bear being wet through every day—I must try it earlier the next time I come—I don't want to be unjust.

With many thanks for your forgiveness of my rudeness—
believe me my dear Madam, ever faithfully yours

 J. Ruskin.

I shall be here, I believe, until Thursday next—the 23rd, after
that my address will be post office Pitlochrie.[42]

Mrs Gray evidently wrote to tell him that they were not going to
Edinburgh and his visit would be welcome, for on Tuesday, Sep-
tember 28, he was writing from Steuart's Inn, Pitlochrie, to say
he had forgotten to ask whether there would be room at Bowerswell
for his servant; if not 'he can perfectly well do all I shall want
staying at the George'. He then sent a message from his mother to
'sister Effie' asking why so many days had passed without an answer
to her last letter.

Perhaps John himself hardly knew before he arrived at Bowers-
well whether he intended to engage himself to Effie or merely to
come to some understanding with her. He seems to have had no
doubt at all but that she would accept him. Watch her for six, eight
or twelve months, his father had advised; if she agreed to wait for
him and if he could be sure of seeing her next year—preferably on
a Continental tour—he might well have been content to defer a
definite engagement. His long stay at Pitlochrie after leaving Cross-
mount did not, however, mean that he was not eager to see her
again; it was simply because he had been told not to stay long at
Perth, yet could not go home: his parents were going to Folkestone
while the chimneys were swept at Denmark Hill and the 'house
cleaned and arrayed for winter'.[43]

7

SECRET ENGAGEMENT

John duly arrived at Bowerswell on Saturday, October 2, and stayed a week. He left without proposing to Effie. He found everything at Bowerswell very different from what he had expected. For one thing Effie's manner towards him had changed completely. Pride made her cold and reserved; there was not only the fact of his long neglect but of her father's financial difficulties. She was afraid that John would think—the very thing Mr Ruskin did think —that she was now a penniless girl out to catch a rich man's son. And then she may have been a little shy at John coming to Bowerswell just at this time when her mother was seven months pregnant. Moreover it was the first time John had seen her in her own surroundings and he discovered that she had plenty of admirers in Perth. She was a natural flirt, but while John was there she no doubt flirted deliberately with the young men of her circle to show him he was not indispensable.

One young man in particular—Mr Tasker, nicknamed 'Prizie', son of James Hunter Tasker, one of the engineers engaged on building the railway line between Edinburgh and Perth—was being encouraged by her parents and it is more than likely that she would have married him if John had delayed his offer much longer. John was dismayed and puzzled. He had evidently taken William Macdonald into his confidence, for he wrote to him on October 5: 'I love Miss Gray very much and therefore cannot tell what to think of her—only this I know that in many respects she is unfitted to be my wife unless she also loved me exceedingly. She is surrounded by people who pay her attentions, and though I believe most of them inferior in some points to myself, far more calculated to catch a girl's fancy. Still—Miss Gray and I are old friends, I have every reason to think that if I were to try—I could make her more than

a friend—and if—after I leave here this time—she holds out for six months more I believe I shall ask her to come to Switzerland with me next year—and if she will not—or if she takes anybody else in the mean time—I am really afraid I shall enjoy my tour much less than usual—though no disappointment of this kind would affect me as the first did—the relatives are good common plain people— Melville Jameson—though unpolished—is more than this—and I am not as well cut myself as to have any right to look for undimmed lustre in others.'[44] He added that he was staying at Bowerswell until Friday morning, after which his address would be Denmark Hill.

It seems that all along John wanted Effie to go abroad with him and his parents much more than he wanted to marry her and have her to himself. His good intentions, though, of testing her for six months went to the wind when he found how depressed he was after leaving Bowerswell:

Berwick Sunday Morning [October 10, 1847]
My Dear M^rs Gray,
I am in a sad way this morning—making myself as miserable as can be—in a little dark room looking out into a *great* dark, shut up—blank square windows and horrible street—wind howling down it most pitifully—just about to find my lonely way to church—I would put up with Mr A. and Mr G. again (and be thankful)—to have somebody to go with me—I can't read, nor write—for pure vexation—except to inflict myself upon you at Bower's Well and try to fancy myself talking to you.

I got a letter from my father yesterday forwarded by George [Gray] to Mr [Andrew] Jameson—there were many kind messages in it to you all—I got early into Edinburgh—the carriage was light—and I came fast—much regretting that I had not seen Mr Melville Jameson—but I thought I should be too late at Edinburgh—and as I knew strangers had been asked to dinner—it would not have done to have been after my time.

I met some very agreeable persons at Mr Jameson's—but they fêted me terribly—I made a round next morning among the artists—liked the men better than their things—except Harvey's*—he is both a good man—and a good painter.

* George Harvey (1806–76), figure and landscape painter; President of the Scottish Academy 1864–76; knighted in 1864.

(one o'clock). Everything wrong together—Pouring rain—melancholy old English church—about one-fifth full—nobody joining in service—fat old rector who could not speak but in gasps—so that it was well he had not got much to say. Filthy streets—filthy ramparts—No letters at post office—All dreary and hopeless—and I can't fasten my mind upon anything to make me forget myself—I am going to try the Scotch church in the afternoon.

Pray send me a single line—post office Leeds, to say you missed me a little at Bower's Well—if any letters come to Perth, they may be sent to Leeds*on Tuesday—but after that to Denmark Hill—where—God willing I hope to arrive on Thursday. I will write then—I hope more cheerfully—Kind love to all—best to Alice† and Effie—(Alice may have it all if Effie does not want any)—Kind compliments to Dr P.‡ I am thinking of sending him a little drawing in order to show Effie that *I* repent of my rudeness—nearly as sincerely and thoroughly as *she* of her kindness. Remember me most faithfully to Mr and Mrs [Melville] Jameson—and believe me with sincere regards to Mr Gray, ever, my dear Madam, faithfully and gratefully yours

<div style="text-align: right">J. Ruskin</div>

I suppose I may be permitted to say 'Effie' in writing to *you*—I pray pardon for my impertinent message. I am sure she is a great deal kinder to everybody than they deserve.[45]

John afterwards stated that he 'offered marriage by letter, to Miss Gray, in the autumn of 1847, and was accepted'.[46] How soon after his return to Denmark Hill the offer was made is uncertain. What appears to be the first letter to come to light after he got home cannot be dated because the first page is missing. The mention of Leeds does not necessarily, however, mean that it was written soon after his return; he may have been talking about the past in the

* In those days passengers had to change trains from one line to another which often necessitated night stops en route from Edinburgh to London, or other long distances.

† The younger of Effie's two sisters, aged two and a half.

‡ Possibly Dr Paterson, a 'hydropotheck' of Rothesay. Mrs Gray was interested in the 'water cure', and his photograph appears in her album. (Author's possession.)

'before I knew you cared' way that lovers do. It is undoubtedly, though, the letter of an accepted lover:*

... could hardly be present even here—she [his mother] would feel too much. You know she could not come to the Oxford Theatre when I had to recite my poem†—Sad things the cannots of this world.

I'm really a little vexed about the hair; but don't touch it— perhaps it will come all right again—better any way than artificial—I don't believe a word of what mama says about people's not caring for looks after marriage—I am only afraid— (only wait, and don't judge me till I have modified this confession) of caring too much. I am sure however that I shall be like Wordsworth in my *mode* of caring. See his two sonnets to a painter—'the visual powers—which hold their sovereign empire in a faithful heart'‡

You know I couldn't possibly help answering your letters to *me*—received at Leeds—though I felt as you do about the place—but though I had got one before, with E.C.G. this one was 'Effie'—and I could never have borne to receive two without answering. ... Are you reading French. You know we shall want it next year, God willing.—I wonder what you will think of Coutet,§—my friend and guide—and what he will

* For the history of Ruskin's love letters to Effie see Appendix IV.

† His Newdigate Prize poem which he recited at the Sheldonian.

‡ Two sonnets to Miss Margaret Gillies who had painted a portrait of Mrs Wordsworth. The lines, 'The visual powers of Nature satisfy, / Which hold, whate'er to common sight appears, / Their sovereign empire in a faithful heart' are in the first sonnet.

§ Ruskin spelt Couttet with two or three t's indiscriminately. He says that his French had been 'refined by Adèle in to some precision of accent' (*Praeterita*, p. 205), but he shows no precision in the use of accents. All the French quotations in his letters are given as written. Joseph Marie Couttet, born 1791, had fought in Napoleon's army, possibly in Russia and certainly in France in 1814. When demobilized after the fall of Napoleon he had returned to his native village of Chamonix and taken up the profession of guide; he became one of the best guides of his age. (*They Came to the Hills*, by C. E. Engel, Allen & Unwin, 1952, pp. 135–6.) Ruskin called him 'the Captain of Mont Blanc, and bravest at once and most sagacious of the old school of guides'. In 1844, Ruskin says, he had been superannuated according to law in his sixtieth year. The law was relaxed by the Chef des Guides in Ruskin's favour and Couttet came to him on the morning of June 7, 1844. For thirty years he remained John's 'tutor and companion'. 'Had he been my drawing master also, it would have been better for me: if my work pleased Couttet, I found afterwards it was always good.' (*Praeterita*, pp. 328–9.) Ruskin

think of you—I hope you will come up to his idea in one respect
—I was speaking to him one day of a lady's having gone over a
high snowy pass—incredulously—'Qu'est ce que c'a fait? said
he—elle est nouvelle mariée—la première année, elles passent
partout—apres—il leur faut une voiture!' I really mustn't
scrawl any more—Dearest love [no signature][47]

The first dated letter, November 9, begins, 'My own Effie—my
kind Effie—my mistress—my friend—my queen—my darling—my
only love,' and ends, 'Oh, when will you come to me—I can't tell
you this way—how I love you—Yours in every thought—J.
Ruskin.'[48]

The engagement was at first kept secret, although certain mem-
bers of the family were evidently told, for in this same letter John
was writing, 'Good dear Aunt Melville'*—how could you not tell
her. . . . May I not tell Uncle Andrew [Jameson]?' And three days
later, 'Don't be anxious about secret—I have not even told Mac-
donald. Be assured it shall be safe'.[49]

If it had been Mr Ruskin who had wanted to keep the engage-
ment secret for Lockhart's sake it would be understandable, but that
it should have been Effie seems incomprehensible unless she had
some reason of her own, such as a secret understanding with some
young man abroad for whose return she was waiting before making
the news public. Mrs Gaskell asserted that 'Effie Grey [*sic*] *was
engaged at the very time she accepted Mr Ruskin* he did not know of it
until after their marriage'.[50] Ruskin certainly did know all about
Effie's flirtations and entanglements. On the subject of 'Prizie'
Tasker he wrote to her, 'I have been looking at your accounts of
Mr Tasker again—I feel sure he was feeling his way that night of
the *West*—and if you had not walked so fast, he would have spoken
plainly—but you acted rightly and like yourself—and saved him the
mortification of direct refusal. But I have no patience with these
cautious men'; and later, 'Your parents were very right in all they

was mistaken here as to Couttet's age; he was only 53 in 1844, a fact which Ruskin
confirms in a letter to Effie (p. 222).

* Jessie Jameson (1815–48), wife of Melville Jameson, and daughter of Thomas
Duncan by his first wife Eliza Tuckett. The Melville Jamesons lived at Croft House,
Isla Street, Bridgend, close to Bowerswell. Thomas Duncan, of the legal firm of
Duncan & MacLean, had been Procurator Fiscal of Perth for forty years when he
died in 1857.

did. They must have wanted you to marry Mr T when they made you what you used to be with him.'[51] He also commented on her flirtations with her Aunt Melville's brothers: 'And so poor Harvey Duncan is really gone—now are you not a terrible creature, Effie —to serve Aunt Jessie's three brothers so—one after another.'[52]

But the young man with whom she was most likely to have had an understanding was William Kelty MacLeod, her favourite partner for the polka, the son of Lt.-Colonel Alexander MacLeod and his wife (daughter of Dr Andrew Kelty), neighbours who lived at Greenbank on the Hill of Kinnoull. It has been said on very good authority that this young man became officially engaged to Effie about 1845 or 1846 when he was a subaltern in the 74th Highlanders. He had gone out to India to join his regiment soon afterwards and hoped to marry her on his return.[53] If this were so he had returned by the end of November 1847, for John was writing to Effie about him on the 30th: 'You cruel, cruel girl—now that was *just* like you—to poor William at the Ball. I can see you at this moment—*hear* you. "*If* you wanted to dance with *me*, William! If!! You saucy—wicked—witching—malicious—merciless mischief loving—torturing—martyrizing—unspeakably to be feared and fled— mountain nymph that you are—"If!" When you knew that he would have given a year of his life for a touch of your hand. Ah's me—what a world this is, when its best creatures and kindest—will do such things. What a sad world. Poor fellow,—How the lights of the ballroom would darken and its floor sink beneath him—Earthquake and eclipse at once, and to be "if'd" at by you, too; Now— I'll take up his injured cause—I'll punish you for that—Effie—some time—see if I don't—*If* I don't. . . . As for poor William—you can do *him* none [no good] now—there is but the coup de grace to be given—the sooner the better—and the flower of Love lies bleeding: to be borne in his bright plume—How long?. . . think of poor William—losing you altogether, and that for no *fault* of his own—no folly either—but because he *cannot* ask you.'[54]

It was nearly three weeks before Effie gave William the *coup de grace* and then it seems to have been by letter, for Ruskin wrote to her, 'Well—now about poor William—As I think confidence so desirable between parent and child—much more between husband and wife—in fact if *they* have secrets from each other—except on things in which others are concerned independently,—I do not

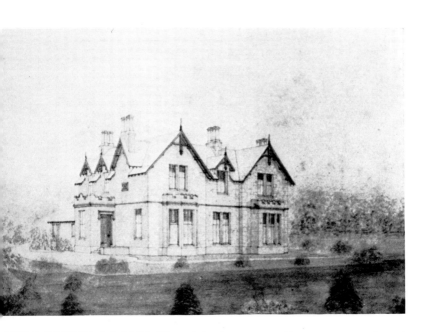

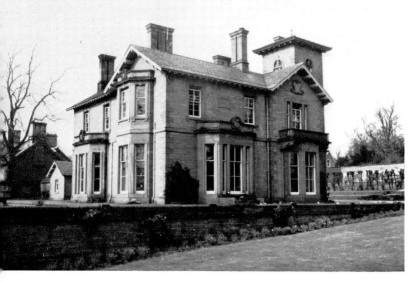

ld Bowerswell House, water-colour at Bowerswell. The house as it was when John Thomas Ruskin committed suicide there.

ew Bowerswell House, built 1842–4. Photograph of the house as it still is today.

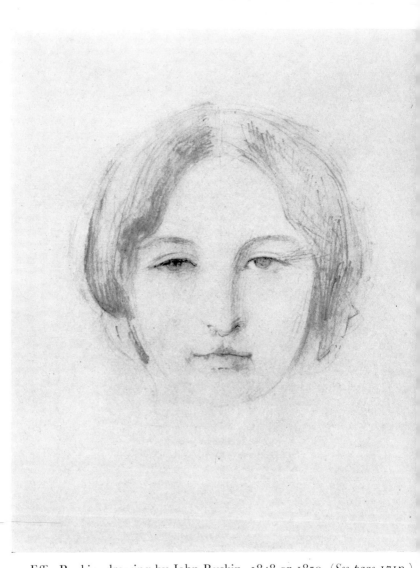

Effie Ruskin, drawing by John Ruskin, 1848 or 1850. (*See page* 171n.)

think they *are* husband and wife, properly. They are not One—
And so—I won't thank you for telling me about the letter (!!) for
it would have been wrong in you not to have told me—though—as
to *my* being a judge of the propriety of the step—I of course have
neither knowledge to go upon—nor am I a fit person to judge.
Everything depends upon your knowledge of him—and on what
you thought it necessary to tell him—and on what he said on the
Sunday—(which pray tell me as soon as you can). But I have not
the least doubt that it was perfectly right; as kind, and good, it
certainly was or you would not have done it.'[55]

Do John's complacent comments on William show that Effie
was unofficially engaged to the young subaltern or merely that
William was in love with her, no doubt with her earlier encourage-
ment? John had written, 'he *cannot* ask you'. The truth seems to be
that William never made her a definite offer because he was not in
a financial position to do so, but that before he went to India she
had given him hope of the 'one day perhaps' variety.

William's father died in August 1849 at Peshawar, when in com-
mand of the 16th Regiment. William, who had gone back to India,
returned to Perth on his father's death. Effie, then in Venice, wrote
home in November 1849: 'Remember me particularly to Willie and
tell me how he looks as I retain my sisterly regard for him and feel
much interested in all his doings.' She remained jealously possessive,
writing to her mother in September 1851, 'I am not surprized but
very sorry to hear of Willie's intended marriage. These Irish
women are the very mischief to young men in the army and out of
it. . . . I suppose Willie had been so flattered that he believes him-
self desperately enamoured . . . he will, I fear, not find he has made
a good choice as he is not fitted to form any girl's character but,
as I knew him, would have made an amiable but rather soft com-
panion for a quiet well disposed woman.' In October 1851 William
married Mary Christian, eldest daughter of J. S. Bird, J.P. He
became a Lieutenant-General.

Many years later Ruskin was to maintain: 'I married like a fool
because a girl's face pleased me. She married me for money, break-
ing her faith to a poor lover.'[56] But then he was also to deny in
later years that he had ever been in love with Effie. Joan Severn,
Ruskin's cousin who looked after him in his old age, also wrote
many years later, '—at the time E[ffie] made love to him [Ruskin]

(to save her Father from disgrace) she was already engaged to another man in India, (who was broken-hearted by her desertion of him)'.[57]

One thing certain is that Effie concealed nothing from Ruskin during their engagement; another certainty is that the eligible 'Prizie' Tasker, with every encouragement from her parents, would have got her before 'the poor lover' if Ruskin had not come along.

8

ENGAGEMENT MADE PUBLIC

❋

The journey to Switzerland was an integral part of the marriage plans and never at any moment was it suggested that John and Effie should go without Mr and Mrs Ruskin. Because Mr Ruskin's business commitments necessitated returning by a certain date they had to leave England in April; they could not get married in Lent, which began on March 8 that year, and therefore, already on November 11, Ruskin was asking Effie to fix a day for the wedding before March 8 and saying he would come to Scotland in February. So—'My own love—Only two *whole*—unbroken—interminable months before us'.[58]

Andrew Jameson had been let into the secret by November 18, for he wrote to Effie on that day, 'it was not difficult to perceive how much Mr R's thoughts were occupied with you [in Edinburgh], so I might have expected to hear such an announcement. . . . Ever since I met him so singularly at Turin, he has interested me greatly for his own sake, and now much more for yours. I think indeed that the deep attachment of such a heart is a rare treasure highly to be prized and sacredly to be cherished. That it has been no momentary affection is a good pledge for your mutual happiness. . . . He is no common mind. . . . Your secret is safe.'

On November 21 Mr Ruskin himself wrote to Effie:

I have not had the pleasure of addressing you since my son has obtained your consent to a Union, on which I feel very sincerely convinced (take place when it may) I shall have good reason to congratulate both myself and him—I have never yet seen the young Lady nor should I know where to go in search of one more likely in my mind to make my Son entirely happy or as reasonably so, as a Wise man ought in this world to expect—

I only trust he may prove as well adapted for you as you seem to be for him—you have both fine qualities and good talents and your tastes and dispositions are sufficiently alike, differing only enough to make an agreeable variety, to prevent the monotony perhaps Insipidity of entire agreement. . . .

From all you saw or might guess at here, you may fancy that my opinions have not been always what I now express and that my approval comes late—but dearest Effie—my objections were never to *one* but to *two*—I cannot perhaps correctly say two—my son never had two Loves but he certainly during your visit to London had fully one and a half and I was kept extremely uncomfortable with a double source of anxiety—my son's happiness and Honour—

The young Lady that caused my uneasiness had, happily, penetration enough to see that my Son only offered her half a heart and another Swain having fortunately brought her an entire one, the affair terminated *en regle* and agreeable to all parties—Whatever encouragement Circumstances led me to give my Son in his other Pursuit, I can truly say that I am much more satisfied now that his success has been at Perth—I never saw the young Lady in question, I cannot therefore say I admired her—now I am only restrained from declaring myself your most devoted admirer by knowing that you have much more of this stile [*sic*] of Phraseology than you care for and that my son's letters may at present be suspected to run a good deal in the same strain*—

The idea of marrying before Lent was not acceptable to Mrs Ruskin. She sent her sympathy to John who was at Folkestone for a month recovering from the effort of writing another article for the *Quarterly Review*†, and at the same time made some shrewd comments on his feelings for Effie:

* After Effie had left Ruskin in April 1854 she sent this letter to Lady Eastlake (wife of Sir Charles Eastlake) in proof of Mr Ruskin's approval of her as a daughter-in-law. Lady Eastlake replied, 'the "loves of my son" are horrid and monstrous now to think of'. (Letter of May 9, 1854, Lutyens, 1967, p. 271.) Mr Ruskin's letter is given in full, ibid., pp. 270–2.

† Review of Charles Eastlake's *History of Oil Painting: Quarterly Review*, March 1848, given in *Works*, XII, 251–302.

Denmark Hill Nov^r 27th 1847

My Dear John

I think I can say with truth that it goes as much against my will and wishes that so much time must elapse before your marriage as it can against yours but what can be done, is it not better to wait a month or two than to feel dissatisfied with yourself during the first of your married life which I think you would do were it to be passed in Lent—besides there is much in favour of our not going too soon to the Continent— Effie might feel cold—and get cold—and in crossing the Jura would lose the sight of its greatest beauty if we passed it as early as we did the last time—we cannot go to Chamonix till the middle of June and as we are to make the best of our way to Switzerland we can be there by that time if we do not leave London till after the tenth of May [Mr Ruskin's birthday] we shall then have 3 months for our Tour, quite as long as your father can with comfort or duty be away from business—I see no objection to your leaving (if you think proper) for Perth on the Saturday before Easter Sunday, you could spend your Sunday properly and it would be a rest for you—and on Monday we might get to Perth—or you might go down earlier and spend the latter part of Lent with her and marry as early in Easter week as she would agree to—Marry early in the day and leave Perth immediately after, get as far towards Keswick as you can without fatigue to either—a short time will be sufficient to give Effie a sight of all most likely to afford her pleasure about the Lakes—then come to London, carriage and all would be ready so that we could get away almost immediately—in addition to better weather, less danger from colds &c &c you would have the opportunity of seeing the Exhibitions and letting Effie be a little seen—you need accept of no invitations because it is never done so early in Marriage, no[t] till your friends have paid their visits to you—I was a little afraid you might in some degree overtask Effie's feelings and make her write too much, you know there will be a good deal to prepare and if you call for so much of her time it may throw too much of the labour on Mrs Gray—besides as you say you love her more the oftener you write to her may you not be in some degree surrounding her with imaginary charms—take care of this—If we were not

thinking of travelling in spring I should be most thankful that
you should at once go down and marry—as it is I see not what
you can do but wait till after Lent—of this however be assured
I am most ready and more than willing to receive her as soon
as you can manage to bring her to us—my best love and blessing
to her—I want to know if Mr Gray pays for parcels sent by
Steamer—I have not time to write more—I trust my love it
will please God to give you health and enable you to enjoy all
the happiness which your union with Dear Effie promises—
your father's letter to her was kind and sweet and everything
you could wish—ever My dear John

<div align="right">

Most truly your affectionate Mother

Margaret Ruskin[59]
</div>

John accepted that he could not be married until after Easter,
though with a bad grace, and, still at Folkestone, begged Effie to
name a day 'as close as can *possibly* be upon Easter Sunday'. In
this same letter he showed great concern lest Effie should catch the
influenza which her sister Alice had gone down with:

It's almost impossible that you should escape that frightful
influenza—and I must not come—yet—to nurse you. . . . But
what *shall* I do—if I hear you have it!—If I hear you are in
your room—can't write to me?—I shall be coming down—
certainly—so you had better not—And that frightful Hill
of Kinnoul.—Pray don't go up it again without someone—
take Mr Tasker or anybody—. . . I am very very sorry to see
that Mrs Gray is unwell—Pray write me a single *line* as often
as you can—to say that *you* are well and I hope, that Mama is
better, and give her my sincerest regards—and to poor Mr
Gray too. What did you say to him on Sunday night,—when
he was so sad and you broke off your letter to me so suddenly.
I'm sure *I* don't know what I should do in his place.

What *can* keep you from sleeping my pet—All night—too!
Now pray—pray don't—it is very bad indeed for you—what
are you so anxious about—one would think you were *miserable*
at the thought of April.[60]

Effie's anxiety and Mr Gray's unhappiness were on account of
his financial affairs which were far more serious than either John

or his father fully realised at this time, but when John wrote: 'I don't know what *I* should do in his place' he was referring to Mrs Gray's imminent confinement, and, indeed, she gave birth to a son, Melville, on the very day this letter was written—November 30, 1847.

John wrote to congratulate her—a letter which would have warmed any mother's heart. It is a particularly important letter, too, because it reveals something of what took place during his visit to Bowerswell in October:

Folkestone. Dec. 9th [1847]

My Dear Mrs Gray,

I sincerely trust that by the time this letter reaches Perth, the favourable anticipations of Effie's letter to my mother will have been entirely fulfilled, and that you will have been promoted to the sofa, and be in hopes of soon cheering every one by your presence in the Drawingroom. Pray accept my kindest congratulations upon the fact—announced by Miss Gray, of the little Melville's being 'very pretty'. I am generally rather incredulous of such statements respecting gentlemen of his years, but I believe—and *intend* to believe everything that Effie says, (I hope therefore she will be careful what she does say) and I am ready to accord credence to *her* assertion, even though somewhat contrary to my own general and personal experience. I have often been thinking of writing to you before now, though not in the vain idea of *thanking* you for what you have entrusted to me, Effie's happiness, and your's in her. How *could* I? or what could I say, that would render your parting with her less painful. You cannot but have *seen* how much I loved her, and you know, that with one like her, to love her once, is to love ever, and that the *much* love, which is the end with others, is but the beginning of Love, with her. Nay—the more pain you—and all her fond relations, feel, in the loss of her, the more trust you must have in her future happiness— knowing by what a close chain of affection she is ever bound to all around her. And although I do not like to speak confidently of myself, yet in this I may—I am *sure* if she can but love me half as well as I do her, and if she can put up, therefore—with what might otherwise prove a source of discomfort to her, her being almost *too necessary* to me—she *must* be happy. But it was

my sense that her happiness must depend upon the degree of her regard for me, and that in the retired life which it may perhaps be necessary for me to lead, there must be much that would be irksome to her, unless rendered tolerable by strength of affection; which *in part* occasioned the singularity of my conduct at Bowers Well, a conduct which probably occasioned you much concern, and appeared as unjustifiable as strange. Believe me, I have none of that false and selfish pride, which would prevent a man from coming frankly forward through mere fear of exposing himself to the chance of a refusal. But I felt that to Miss Gray's open and kind heart, there might be a severe trial in the seclusion from society which my health or my pursuits might often render necessary, I wished to be certain that I *could* be to her in some degree, at least, the World that she will be to me; and I was the less ready to admit the evidence I could perceive of her affection, because I could not understand how she *could* love me. (I think, always, that if I had been a woman, I never should have loved the kind of person that *I* am). And although you might think that she gave me as much encouragement, when I was at Bowers Well, as I had the slightest right to hope for—and although—had I been more a stranger—this would have been so, still, she had until then been so frank and open with me, and her manner had been so different—(I cannot tell you how—but it was), only four months before, that I felt it severely, the more so from the few words you said to me on the Monday, for I was grieved alike at the idea of *your* not being entirely in her confidence*—or—if you were—at her feelings being so changed towards me as your expressions tended to make me believe—and—if they had been,

* John wrote to Effie a few days later: 'I am ready to admit that—not having been in the habit of being communicative— you might have felt no need of support or of confidence last autumn—and I believe it is only selfishness on my part which makes me wish you had told, not indeed *all* that passed between us—for that I agree with you should be sacred between us two—but something of what I had *said*—and something—or all—of what you had felt. But it wasn't "temporary insanity", was it, love? That's what I want to know.—Ah—cruel Effie—How I *bore* with your treatment of me on Kinnoul I can't conceive—I really think I *must* be a good creature. Not to take my arm—and I to walk on quietly and bear it—I ought to have turned back at once and said I would go back to mama [Mrs Gray]— and done it too, and told her plainly what was the matter'. (Letter of December 19, 1848: James, pp. 76–7.)

in so short a time, whatever reasons she might have for re-
garding me with coldness, I could never have hoped to have
attained such a place in her affections, as I felt it necessary I
should possess, both for her happiness and mine. I think, if she
had not spoken a word or two to me, that night, in her old way,
I should have left Perth the following morning. Thank God
that she had not *quite* cast me off, and that, now, I have hardly
any fear but that my love for her, constant and grateful as I am
sure it will be—will be able to balance to her the cruel sacrifices
she must make in yielding to it. Of my *own* hopes I need not
speak. They are as high as earthly hopes *can* be, and as secure.

One thing only I could wish, both for her sake and mine
that my prospects and purposes in life were more fixed, for I
can at present hardly promise or plan anything. There is this
advantage on the other side—that there is hardly anything which
may not be contingently promised, or conditionally planned.

But I think one thing, My Dear Mrs Gray, *very* unwise in
you—and that is the keeping her with you the whole time until
April, when you will only miss her the more dreadfully. Now,
if you would only let her come to London for a month—about
the middle of February, it would break it to you, and make it
much less painful, because it would seem that she was coming
back to you for a long time. Whereas—by not breaking the
time at all, it will seem all the shorter—quite as short indeed,
to you—as interminable to me.

My mother was much gratified by your kind letter, but her
sight is I am grieved to say, so much impaired that she dares
not write, except now and then a necessary word to me. Pray
remind dear Effie of this—as I fear my mother will not be able
to answer *her* letter either. And while Effie is so much engaged,
do not let her write long letters to me. I am frightened for her,
a single word is always enough to make me happy.

I intended to tell her to ask you what were the excursions
you enjoyed so much at Chamouni.* I must see how Effie
bears fatigue before I can lay distinct plans—but I purpose at
present that she shall go up the Montanvert—Flegere—
Chapeau—(where I shall see how she can walk—it is short, but

* The Grays had been at Chamonix (Ruskin spelt it either way) on their Conti-
nental tour in 1840.

difficult.) Tapia—Pavillon—and Col de Balme—I hope also for an excursion to the Great St. Bernard—and if I find that Effie can bear heat at all—I may venture with her down to Aosta and Cormayeur—I fear we shall not be much more than a month at Chamonix,—the Montanvert will I think be visited three or four times—and besides these main expeditions—I know some ten or twelve rambles in the recesses of the valley— quite as interesting—the ravines running up to the Buet from Valorsine are all worth visiting—but everything will depend on Effie's strength—and prudence.

I hope you will fully impress upon her the *necessity* of never overtasking herself to please me—or deceiving herself as to her powers. I shall be cautious—I am sure—but if she wishes to go on—it will be very very hard for me to turn back.

Will you tell her that I am to stop here a day or two longer than I expected and that her letter—to Denmark Hill—will not now be here till Saturday morning—at least I think not— It is then no use my writing on Saturday—the letter lies in London, so I will post it early on Monday morning; that instead of getting it on Tuesday evening, *late*, she may have it on Wednesday early.

I have not time to write more, or I shall miss this evening's post. Remember me most kindly to Mr Gray and George—and with dearest love to Effie—and Love to Robert—Sophia* and Alice—believe me,

<div style="text-align:center">

my dear Mrs. Gray,

Faithfully and Gratefully Yours,

J. Ruskin.
</div>

Effie must continue now to write to Denmark Hill.

Mrs Ruskin did in fact send a very sweet letter to Effie two days after this one of John's: '. . . indeed my Love,' she wrote, 'I should have been truly glad had John brought you his Wife home with him —but for some reasons which I do not write about, but your Mama will understand—These same reasons operate against your marrying until you are on the point of setting off on your travels. . . . John, being our only child, you will be to his parents as his wife a

* Sophia (Sophie), aged four, who was later to play a considerable part in the break-up of Effie's marriage. (Lutyens, 1967.) Robert would be six in May.

treasure invaluable and I feel certain that it will be the strongest desire and delight of both Mr Ruskin and myself to promote your happiness and guard you from all that might injure or annoy you —We have so few relations to love or care for that you will come in for a tenfold share of both—all day long in whatever I have to do about the house I do nothing without some thought and reference to you . . . you know we intend you shall have your own special apartments here—that you may come to when you choose and remain as long as you like—but I do not mean to make any alteration till we can plan things together. . . . God bless you, My dear child.'⁶¹

The end of another letter from Mrs Ruskin to Effie written about this time has survived: '—both Mr Ruskin and I feel every day more rejoiced that you are (I trust with God's blessing) to be our own dear daughter—I am My dear Love your affect Mother Margaret Ruskin'.⁶²

Few mothers-in-law could have been more welcoming, and Mrs Gray was, evidently, equally so to John, for, back home from Folkestone, he was writing to Effie on December 15: 'I had to write to mama today to thank her,—why did you let her have pen and ink, Effie!—I am frightened out of my wits—indeed she should not have written such a letter so soon. But it was a delightful one, dear Effie. It says you are looking so well—and so happy,— and that you love me very much; and it says that mama has no fear for you in giving you to me, and that she would let you come and visit us now—if it were right!' He then added some lines about her flirtations: '. . . you may think yourself happy if you get out of Perth without doing any more mischief—and really, now, it is *not fair*. So long as a young lady has her hand free, if people like to run the risk of coming near her—she cannot help it—they have their chance and have no right to complain if they lose it. But you know, *now*, my sweet, you are . . . a very sufficient and entire *man-trap*. . . . It made me question myself very seriously when I heard of these two grieved hearts [William MacLeod and "Prizie" Tasker]— whether it was in my power to trust that the one which you had chosen was worth the sacrifice—I wonder if you will ever look back and think—. No—that you will not, I am sure—and it needs nothing to make me try to be all that I can to you and for you.'

Next day John continued in the same letter, 'You say we can't

expect to be always taken care of—I know we can't—and that's why I want to be while we *can*. It is so nice, Effie, not to have to take care of oneself. And yet, I must confess to you, that I have had more misgivings since I came home this last time, than before, about your being *quite* so happy as I had hoped—until we are indeed alone— There are little things that often sadden me now, in my father and mother—Still—I am always happiest when I am most dutiful— and although you may be sure, Effie love, that I will not sacrifice my wife's comfort in any degree to an exaggerated idea of filial duty —still, I think you will find you can give so much pleasure on this journey [to Switzerland] by very little self-denial, that you will not in the end have reason to wish it had been otherwise planned. . . . The little things that will be drawbacks will be little disputes which we shall not be able to prevent, not with us, but between the old people—about what there ought to be—or not to be—and such little wants of sympathy as you can better fancy than I describe— however much they love us and yield to us, and that they will— almost everything. And remember, love—we owe them *a little*—all our present happiness and our future.'[63]

On Saturday, December 18, he heard from Effie's brother George that she had caught the influenza. He was distraught. While she was ill he promised to send her a line every day. Four days later he was writing significantly, 'You are a good girl to speak so of my father and mother—though how you should think them the kindest people you ever knew I can't understand—for when you were here last—they *could* not be kind to you—they were afraid for you— more for me—afraid to ask you to stay—afraid to let us be together —much vexed with themselves—angry with me—and a *little* with you—every way uncomfortable—my mother especially at first— my father at last—I thought them thoroughly *unkind*—and I believe still you have a mistaken idea of them—and that whatever good you may think of them—you will find you get on with them *far* better than you expect. . . . I am afraid it is all up with the secret.— Never mind—it will make you let me come the sooner. It will ebb out through "best friends".'[64]

This was written two days after John had commented on her letter to William MacLeod, giving him, apparently, the *coup de grace*. It does seem, therefore, that her reason for keeping the engagement a secret had been on William's account.

On this same day, December 22, John wrote revealingly in his diary (not having made an entry in it since September 6): 'My diary has of late been in letters to E.C.G. but I should not thus neglect this. How cheerful I was on the 2nd of August, and those following days—and yet with what imperfect hope, and now—with all as I would have it, I am impatient!'

He had been at Leamington on August 2 and the days following, walking, drawing and making minute observations on individual flowers.

9

EFFIE'S LETTERS TO JOHN

1848 was to be a year of revolution on the Continent—one of the most momentous years in European history. On January 3, totally unaware of what was to come, John was rejoicing; 'only *one* whole month between us now'. This shows that a plan for their meeting in Edinburgh in March had already been arranged when Effie was anyway going there for the wedding of an Avonbank school friend.

A fortnight later John told her, 'I have been thinking a good deal over that hard question of yours—whether I shall always love you as I do now—and I still have but the same answer—it will depend upon yourself—a wife has it in her power to make her husband love her more and more daily, and so he with her, and I do so thoroughly intend to do everything that I *can* do, for your good and happiness, that I do faithfully believe I shall gain your love more and more as we live on—and I hope deserve it more and more, and if you love *me* I am certain to continue to find all my happiness in you.' He went on to say that although he could conceive of her at fifty or sixty he could not well face the fact that one day she would be forty. Then he suddenly introduced a paragraph referring to the letter his father had written the year before to Mr Gray pointing out the danger of Effie's remaining at Denmark Hill: 'I *do* mind—a good deal—about that letter of my Father's—was any copy of it taken?—for if you saw it—you must have thought *very* ill of me, and in fact have ceased to love me altogether.'[65] As we know, a copy of the letter was indeed taken (p. 28), and if Mr Gray showed it to Effie on her return home it might well have partly accounted for her coldness to John when he went to Bowerswell in October.

The following letter from John shows that they had **now** decided

to take a furnished house in London on their return from the Continent:

Monday evening. 24th [January, 1848]

My Dearest Miss Gray—[John occasionally began a letter to her with this mock formality]

I have been reading your letter over again—before I go to bed—which I am about to do —in great comfort and exultation at having so nearly succeeded in making you rude to the Gardners.* Not but that one generally is sorry for having been so, afterwards: to whomsoever it may be—but then—it does good at the time—at least to boys who think too much of themselves;—However—I must allow that giving pain is a bad way of mending people—and I didn't want you to be *unkind* to the Gardners—but to dislike them. The fact is that you like everybody—and anybody—and that's many bodies too many. I *should* like to develope some little spice of antipathy in you— and at any rate if the Gardners are in your books—to have you do as Beatrice said she would—burn your library.†—You'll be sending them cards and bridecake, next, I suppose!

That sounds very nice—and must have looked very pretty between Mrs. Schiele and her husband‡—I hope we shall be like them in our quiet tête-à-tête hours, but I have great horror of showing any such feelings to others. Before other people I purpose that my manner to you shall be habitually quiet —respectful—attentive—but cold, and just, or nearly just —what it would be to any person whom I respected and regarded—Newly married people who are much in love with each other rarely fail in making themselves ridiculous—if not disagreeable, to others, without laying some wholesome restraint upon their feelings.

Gordon went into town with me this morning—he is anxious about this Birmingham affair—but brought me some nice

* With whom Effie had stayed in June at Sussex Gardens. They had a son, William (nicknamed 'Snob'), who was a flirt of hers.

† In *Much Ado About Nothing* (Act I, Scene I), the Messenger says to Beatrice about Benedick, 'I see, lady, the gentleman is not in your books,' to which she replies, 'No; an he were, I would burn my study.'

‡ The daughter of Effie's Aunt Barbara, Mr Gray's sister (Mrs David Burns), had married W. Scheele, as it was spelt, of Newcastle-on-Tyne.

stories about Oxford.* The Dean of Westminster's [Dr Buckland] house came under discussion—dirty—or not dirty? I said it was not strictly speaking *dirty*—but only mellowed and toned. Well—said Gordon—'there was a Rats nest behind the sideboard in the dining-room that filled a barrow!'

One of the Tutors had been disturbed by a party making a noise over his head at 12 o'clock. He went up to them—they were rather rude, and he brought them up before the Dean the following morning, who asked 'how they came to be making a noise,—'Why—Sir,' said one of them—'we *couldn't* be making much of a noise—for there were but twelve of us, and we were only singing!' However—I must neither sing nor say anything more than good-night—for it is late already.

Monday afternoon [mistake for Tuesday?]—After getting your delightful letter, love, I went into town to hear Mr. Dale and walked out, in a bitter cold wind—endeavouring to fix my mind on the sermon and its subject—the conversion of St. Paul—but wandering away every now and then to my letter at home. I am much obliged for the consolation respecting my study—and your cheering prophecies that I shall like another room just as well—I doubt it not—when I am *settled* in another room—and can have it all my own way—and look forward to living in it—but in our furnished house I am sure we shall be very uncomfortable, and I shall go all day to the British Museum and only come home to dinner at Mr. Schiele's hour —four o'clock—and when I want to etch or do anything that requires light, I shall go out to Denmark Hill and get into my old room. And that will be all the more comfortable for you— for my mother says that gentlemen are shockingly in the way in the middle of the day—and so you will always be glad to see me in the evening. Not but that you may come out to Denmark Hill with me, for there we shall always have our suite of apartments—of which my study is to be one, but I apprehend you will always have to call—or be called upon—(on the days

* The Rev. Osborne Gordon (1813–83), Censor at Oxford and reader in Greek, became John's private tutor in 1839. Ruskin described him lovingly in *Praeterita* (pp. 249–52). Mrs Ruskin wrote to her husband shortly after this, 'Gordon does not go to Birmingham, they want one who has kept school before'. (Unpublished letter of February 3, 1848: Bembridge.) In 1860 Gordon was presented with the living of Easthampstead, Berks. Ruskin wrote his epitaph. (*Works*, XXXIV, 647.)

when I don't *absolutely* want you) or be busy—it will be proper that while you are in town, you should see as much of people as you can, and I should go to the British Museum. But it won't be pleasant at all—but a mere matter of duty, and friend-making and we shall not be at all comfortable until we have a real *home* in the country and can make perennial arrangements and have our parlour painted with arabesques from Pompeii—for I concede to you that flowers are out of place on walls—and our furniture of our own choosing—and everything comme il faut.

And talking of country houses—I have been thinking some time of sending you a french novel, and it is very well thought of—only the interesting ones are not fit to be read, and the one I can send is very dull. However—I send you a sheet or two—merely to be translated and rewritten—and when you have written it all, I will send you some more. It is best to make it *complete* task work; and then any little interest it may have is so much gain. It is very fine, in its way, for minute, characteristic—severe description. How good it must have been for french science of cookery—if—throughout the provinces—that is true which is said of Saumur—une menagere n'achète pas, &c*—page 15.

You ask for John Tweddale—Much the same—suffering constantly, and wasting away. Still—all chance is not gone.†

I have several other letters to write and it is near post-time—Goodbye—and take as many loves as you want, if 1000 a day won't do.—I will send you some blank cheques—you will not break me—draw as you like.

> Yours ever devotedly
> J. Ruskin.

Mr Ruskin was away from home on business in February 1848. His wife wrote to him on February 3, the day after their wedding anniversary, a letter which shows how genuinely she approved of Effie at this time:

My Dearest John, you begin your 31st year of kindness with double attentions, this is the second time I have to thank you

* 'Une ménagère n'achète pas une perdrix sans que les voisins demandent au mari si elle etait cuite à point': from Balzac's *Eugenie Grandet*.

† John Ruskin Tweddale was the son of Catherine Ruskin's brother James,

G

for two letters received on one day which I do feeling very grateful—When do you intend being home my love—we have not used the Drawing room since you went away and I must have fire early on the day you return, can you be home on Saturday [the 5th] I wish you could. If I had thought of it I would have prevented your sadness by begging you to buy me something very superior to wear the day John brings home his bride but I have the pair (kept for many years) which have been on only once at Mary's marriage [Mary Richardson's marriage to Parker Bolding in April 1847] very good and very pretty which will do perfectly well. . . . You do not say as much as I expected in praise of Effie's letter, every one she writes gives me a higher opinion both of her heart and head. The warmth of her acquaintances professions will increase now they know she is to marry a man of some name—and John has told her so—and that he is obliged to be scarcely less than rude to many who seek his acquaintance and who may endeavour to get him through her, that they must be kind but at the same time very cautious and choice in forming intimacies with any, especially where the families have numerous connextions*—I fear I may spell badly but have no dictionary beside me. . . . Do you not think that very few what are called Love letters are so purely affectionate as John and Effies, hers so loving yet so free from passion as well as Johns.[66]

Mrs Ruskin could not have said that John's letters to Effie were free from passion had she read them all. It so happened that his

therefore John's first cousin once removed. Mrs Ruskin wrote to her husband ten days later, 'John Tweedale [*sic*] suffering much yesterday, the water Bed though relieving his body increasing the suffering from the knee—they should if possible prevail on him to have the limb taken off, he might have some months ease even though his life should not be much prolonged.' (Unpublished letter of February 3, 1848: Bembridge.) Nevertheless he lived until 1897, with or without a leg. His sister, Catherine, married George Agnew and was the mother of Joan Agnew who married Arthur Severn and looked after Ruskin in his old age.

* John had written to Effie on January 3, 1848, saying that he grudged her no good friends but that 'Hundreds of people who have nothing to do but to amuse themselves—and can't do it—will be glad of your cheerful society, and others—out of mere idleness and curiosity—desire to know *me*—and to talk nonsense about art. . . . Against their inroads nothing but the most *rude* firmness protects me—and the people who cannot get at me otherwise will try and do so through you.' (James, p. 81.)

letter about friends, which he had evidently shown her, or, more probably, read aloud to her, was one of the least passionate. It seems strange, though, that he should have shown his mother any of his letters to Effie or hers to him.

Interestingly, at this point, three letters from Effie herself turn up, written on three consecutive days. (There are no letters from John to Effie between January 2 and February 23, 1848.) These three are the only letters from Effie to John ever to have come to light:

Bowerswell. 8th February [1848]

Again do I wish you many many happy birthdays [his twenty-ninth] my dearest John. I should think you would experience a melancholy kind of feeling in thinking that this is the last birthday you will have in a Batchelor state. I hope you have the sun sinking on you in greater abundance than we have for rain here is the order of the day and very disagreeable it is, this damp weather is so relaxing that it quite glues me to the fire. Mama seems to be more fortunate in Edinburgh for she writes to me of having called here and there and every place. I do not think I have yet answered your questions about stripes and spots but I have not forgotten it and I shall tell you what I think when I am more at leisure but at present I have not time to think about it. You see the children are all confined to the house yet with colds and when they are always in the nursery they weary, besides it is not good for them to be in one room for so long a time and when they come downstairs I have to amuse them. We are to have some gentlemen at dinner tomorrow and a party is always a consideration to me, not accustomed to the regulation of dinners excepting for ourselves, but I do not trouble myself much about it although I must see that every-thing is right, for Papa always says 'My dear, you always give us a very good dinner, I don't understand these things you know!' I just wish the rain would stop and let me into town. I suppose you will say the same to me: 'Effie! I wish you would not bother me about dishes and dinners, don't you know that I am particularly engaged with my third volume, and the one is a thing of very minor importance to the other. By-the-bye, Effie, you will oblige me by mending this box of pens.' Then

you will put the pens into my hand and proceed with your
writing, I will probably put the pens down, go and order the
dinner myself and come back again and mend them, that is
after I learn how! I hope, though, seriously, that your book will
get on well and I will not tease you nor come near your study
wherever that be while you are engaged in it unless you bid me.
I told Papa the other day that you said you never would be
really jealous without cause and he says unfortunately jealous
people always *find cause* which I think quite true but I hope at
heart you are really not a jealous being, and the absurdity of
your giving as a reason that my manner to you and other
people was quite the same is really the most preposterous thing
I ever heard.* You must have been thinking of something else
when you wrote that! but really John I love you so much that
I do not think much about *the* jealous part of you for I do not
believe you will be at all so after we are married and I daresay
you will allow me to ask anybody I like to take some pudding
without behaving afterwards as madly as Mr. Munn. Pray
forgive me for this scrawl, I have a pen that won't write. Give
my very kindest wishes to Mr. and Mrs. Ruskin and my devoted
love to you, my dearest from Your

 Effie Gray.

 Bowerswell. February 9th. [1848]
My dearest John
 I hope you enjoyed yourself yesterday with your friends, you
would have I think a very agreeable party, we did not forget
you, I am sure because after dinner Papa made quite a long
speech in honor of the day as if you had been here, and again
at night he had some negus before going to bed and he re-
peated the wish for your happiness. I am sorry to hear of Mrs
Moore being so poorly—what a fine expression she has! I am
very glad that Mr Moore† gave you that sermon. I think you
are coming round by degrees to the point I want you to arrive
[at] but as all great changes are—not sudden but the work of

* John had written to her, 'Indeed I *never* will be jealous of you—and I will keep
that purer form of jealousy—that longing for more love—within proper limits—
and you will soon find out how to manage this weakness—and perhaps to conquer
it altogether.' (Letter of November 9, 1847: James, p. 48.)
 † Rev. Daniel Moore, incumbent of Camden Chapel, Camberwell.

time and affected by slow degrees—I care not how long you are
in coming to his way of thinking so that you *do* arrive at the
desired end—you will only become the more steady and
certain in your conversion. So you were pleased with my
attempts at adornment on Blucher. Papa, barbarous man!
had him shot one day privately and buried under the Beech
tree;* he said he had sent it to grass for the winter. I suspected
something wrong and by various entreaties I got so far into the
Gardener's good graces that he told me he had shot it the
savage! I mourned for it most bitterly. But you promise me some
rides, now that is very good of you but I am afraid you will get
nervous about me and say "now my dear Effie don't go there
you really will be off" and Mrs Ruskin will say I am sure the
very first day after we have been out, she will tell you that my
neck is in danger and that she wonders how you can allow me
to do such a madlike thing but perhaps when she sees how
blooming and healthy we look after it she may gradually begin
to think that there cannot be so much danger in the thing after
all. I shall be so glad to get into practice again in an exercise I
am so fond of, I have not been on horseback for two years now
but when one has been trained to it from childhood it is a thing
you never can forget and I never was frightened. Robert is
quite well and has been feasting for the last few days on mutton
chops, I could no longer stand his reproaches upon soup-
maigre.

My wishing to see a Stork will quite come up to your first
notion of having me all to yourself shut up in an old Tower
where you would fly up and visit me! Papa says he cannot
understand your wishing not to be married before going
abroad. [The letter in which John wrote this has not survived.]
I quite think with you, but it would interfere terribly with
modern propriety not to speak of the pleasure. No it wouldn't
do at all! Your father is very very kind, it is certainly very
delightful to feel oneself loved. I hope he arrived in good health.
Poor Mama is getting dreadful weather [in Edinburgh], it is

* ' "Under the beech tree" was the favourite place for burying the family's
animals and when the tree was cut down in the nineteen twenties the pony's
remains were found.' (Note by Clare Stuart Wortley on her transcription of this
letter.)

pouring again but I hope that as we have had so much of it now the remainder of the Spring may be dry. I am much pleased with your description of your visit to Mrs Bolding [Mary], I shall write to her as I do not imagine she will think of writing to me. You will indeed like Mr McDuff.* Mr Macdonald and he might be taken for brothers they are so much alike in general appearance. If it were not too absurd in me speaking of any body's writing but my own I should like to imitate your writing the word *under-currents* which I have just been able to decipher—it is so 12345678910

<div align="right">

unduuuuuuuuu uts

all the same

Good bye and believe me

Ever entirely Your

Effie Gray

Bowerswell 10th February 1848.

</div>

My dearest John,

I do not know how I can sufficiently thank you for your inestimable letter this morning so full of tenderness and affection almost too kind and good, you will quite spoil me, my love, it almost made me weep with joy to think myself so beloved, not but that I was fully impressed with that before, but this morning's letter almost made me rejoice too much in thinking that so much happiness was permitted to me who am so unworthy of it. I am indeed happy beyond telling in thinking you love me so much and truly glad am I if by expressing my earnest desires for continued happiness on your part I added one moment of pleasure on your birthday to you—I wish I could have added my thoughts more fully to my wishes for you and was much dissatisfied that my letter was so unexpressive of my feelings for had you been here much much more should I have said to what I wrote. You will indeed be a kind husband to me. Many trials we shall probably have but not from want of

* Rev. John McDuff, author of *Solaces in Affliction*. His first wife, who had died in 1846, aged twenty, had been Anne Seton, daughter of Mrs George Seton, a widow and a close friend and neighbour of the Grays. It was in Mrs Seton's garden at Potterhill (now a housing estate) that Millais painted the background for 'Apple Blossom' (1859). In a letter of June 2, 1847, Effie had asked her mother, 'Please send me the Solaces in Affliction of Mr McDuff. J. Ruskin wants to see it.'

love on either part, that must be the greatest trial I think in married life, finding that the only being perhaps in the world whose affection is necessary to you as a part of your being not loving and assisting you in all your joys and cares, leaving you with the utmost indifference when you are in trouble to get out of it the best way you can, and in Joy not partaking the feeling but perhaps trying to subdue it if not in a similar mood, this would be I think the summit of wretchedness and misery. You who are so kind as a son will be a perfect lover as a husband. I meant by saying that we had much to find out in each [other] was not that I expected to find great faults in you, I think I know all that I have to expect and I shall see your coat brushed and mend your gloves and especially keep you from wearing white hats, and in order to compromise the matter with you I shall promise never to wear an *excessively* Pink Bonnet which can be seen all over the Exhibition although I suppose you have not particular objection to one of a paler hue. Pink is a very favourite colour of mine but I will subdue the shade out of respect to your superior discernment in these matters. I did not think your cousin Mary would consider it necessary to write to me so I wrote to her a few lines yesterday just to say I hoped she had no objections to the approaching relationship between us. I have numerous letters of congratulation now from all my lady acquaintances, all saying nearly the same thing, thinking I have bright prospects before me and much happiness but expressive of great disgust at you for taking me away from them all. My dinner party went off very well yesterday. Bobbie says Mr Ruskin is a very good gentleman, why can't he always stay here with you, I'll give it to him when he comes if he says he will take you away, you are never to go away (suiting the action to the word he lays on the whip to the chair with no small force, as if you were the chair or rather the chair you). Goodbye my dearest love Ever Yours in all sincerity

Euphemia C Gray[67]

This letter probably shows as much passion as Effie was capable of expressing in words. John at that time would no doubt have echoed her ideal of a happy married life.

DISAPPOINTMENT

Mrs Ruskin in her letter to John of November 27 (p. 71) had
written that they would go to Perth, and naturally the Grays
expected them to attend the wedding. Mr Ruskin had no intention
of doing so; his excuses to Mr Gray were hardly adequate:

London 23 Feby 1848

You expect that Mrs Ruskin and I should come to Perth and
nothing can be more reasonable—I at once acknowledge, we
ought to come; but with Mrs Ruskin's feelings and prejudices
I scarcely dare contend—for my own part, I am sincerely
desirous of coming, but on the best consideration I can give the
subject—I have decided to keep away—I cannot possibly tell
any person—who, most happily like yourself—may be ignorant
of all nervous affections, what uncertain poor Creatures we are
who once have been brought under the sway of such feelings—
Were I like others—well and accustomed to visit and take
up my abode in friends Houses, assuredly I should find myself
at Perth towards the end of April—but having run the gauntlet
of most of the disorders human nature is exposed to, and having
my frame weakened and my nerves unstrung by the conse-
quences, I can only exist in the absence of all excitement—
that is by leading a quiet life—It is just 30 years this 1848 since
I slept in a friend's house. [This must have been the night before
his wedding.] I take mine ease at an Inn continually and I go
on with my business pretty well—I have thought I might come
to Perth but if I were unwell—I should only be in the way—a
marplot and a nuisance.

I might merely say that if we are to go abroad with the young
people I require every previous hour here that I can get—and

besides I deemed it would be as pleasant for my son to be at Perth for a week or two and then in place of having an assemblage beforehand like the British Association—to get quietly married and steal away and leave the good folks to talk over it the next day—but my notions may follow my nature which has always been rather retiring.

I can only assure you that though I may not appear at the Ceremony I shall not be absent nor wanting in giving my Daughter in Law a warm Welcome here—We anticipate (I mean Mrs. R. and myself) the greatest pleasure and nothing else than pleasure in the meeting and all that may follow that event—I fear I shall not stand excused in your eyes, nor in Mrs. Gray's but indeed my dear Sir—there is prudence at my time of life and with my temperament in not exposing oneself to more excitement than duty renders imperative—

By this time John was getting a little annoyed with Effie because she was not as happy as he thought she ought to be. She was tired and overworked; the children had been almost continually ill and she herself was still suffering from the after effects of influenza; during her mother's absence in Edinburgh she had had complete charge of the household; she was practising the piano, struggling to read Balzac and keeping up the usual round of social life in Perth; moreover she was desperately worried about her father's financial affairs.

In the third week of February John was writing, 'I do think that ever since you left us last summer you have been managing yourself *very* ill—and I think it a little hard that your father and mother should lay all the blame on your writing to me.' Her best course, he said, would have been 'to return—as far as might be—to a schoolgirl's life—of early hours—regular exercise, childish recreation—and mental labour of a *dull* and *un*exciting character.' He complained that she had done nothing to please him in the way of the work he had suggested except the writing of her letters to him: 'Now even this last—I should not have permitted ... had I not felt—and your father himself admitted—that this was one of the points of your education which had been least regarded. . . . That you have had charge of a household—anxiety about your mother's health, agitation respecting your lovers has all been unavoidable—but it has

been most unfortunate. . . . I don't believe myself, that the going to Edinburgh will do you much good.'

In a postscript he added, 'My mother says that she agrees with Mrs Gray about the writing, but that she fears you will *really* over *work* yourself, bodily, with preparations and I don't know what—added to other things—and she says not to mind what you finish or what you don't. Pray recollect [Osborne] Gordon's—"It don't matter how much you have to do if you don't do it". My mother said going to Edinburgh will do you good.'[68]

Three days after writing this, on Saturday, February 26, news reached London which temporarily destroyed all their hopes for the Continental tour which John had been looking forward to far more than to his wedding: revolution had broken out in Paris; Louis-Philippe fled to England; it was the end of the Bourbon monarchy.

Writing to Effie, John tried to comfort himself by thinking how selfish and wrong it was to feel only for himself in 'so dark a time for thousands', and that Effie, 'contented and cheerful always, would make Cumberland as joyous as Switzerland'.[69] But the blow was heavy and no philosophy could lighten it. The news from Paris was also to add to Mr Gray's anxieties—he held shares in the Boulogne Amiens Railway Company which had now suddenly become worthless—but naturally shares on the London market were also affected.

Effie and John were to meet at the Andrew Jameson's house in Edinburgh, 10 Blacket Place, Newington. 'I intend to . . . enjoy our meeting in Edinburgh—if God permit—just as much as if it were all right in France,' John told her. ' . . . And so you are going to bargain for an unwitnessed meeting! Well, I should like it myself—but I am afraid you will not obtain your request and what is more, I think it is asking a great deal too much. You know—such a meeting is not to be seen every day—and if I were Aunt or Uncle I should positively *insist* on being by—besides—I really don't think they will be at all in the way—I don't mind them a bit.'[70]

Effie went to Edinburgh on March 1 and stayed first at 14 Charlotte Square with Lord Cockburn, the Scottish judge whose daughter, Lizzie, had been with her at Avonbank. Her other Avonbank friend, Maggie Wallace, was getting married on March 6 and Effie was to go with Lizzie Cockburn to the wedding.*

* Margaret Wallace, second daughter of Lewis A. Wallace, married William

John was determined not to be drawn into any social life in Edinburgh, and wrote to Effie at Charlotte Square:

March 2nd. [1848]

My Dearest Effie,

Now that you are, as I hope, in Edinburgh, I must again warn you to be very careful not to say when I am coming. You may say with perfect truth, that you do not know exactly when, for if I find that any body except yourself expects me on the Wednesday [the 15th]—I shall stop a day at Durham—and not come till Thursday—and you may say if you are pressed at any time that the time when I come will depend on what I have to do at Durham.

I hope you will enjoy yourself in Edinburgh—yet not too much—I cannot form the slightest guess as to the probability of our getting abroad—I am fearful of Lombardy—it is almost beyond hope that it will remain quiet—and if it rises, the French will probably throw troops into it, and Austria and France once embroiled, c'est fini:* I don't think a prison would do for us at all, my love—a Cavern—or a desert island, are very well and a desirable family property—but a mere cell, with a sentinel before the door—and nothing before the window but a flower pot or two—or even an entresol in a street at Verdun, with a permission to walk—on parole—round the ramparts before dinner—commanding a prospect of a green moat with some frogs in it and perhaps a rat or two,—and a regiment of poplars beside a straight road and a windmill in the distance—would be perhaps something too sober a way of

Scott Elliot of Arkelton. Effie had written from Avonbank, 'there are not many girls here yet. There is a daughter of Lord Coburn [*sic*] that came to Perth at the Circuit and she is a very merry girl indeed', and later, 'Miss Cockburn and Margaret Wallace and I are not allowed to go much together for fear of *Speaking Scotch*'. (Letters of January 1 and February 27, 1841.) In 1849 Lizzie Cockburn married Thomas Cleghorn, a lawyer in Edinburgh.

* Lombardy was soon to be embroiled. On March 3 the Hungarian Diet demanded a Constitution; Vienna rose in revolt on March 13, forcing Metternich, who had been Foreign Minister for almost forty years, into exile. On March 18 Milan rose against the Austrians and drove the army of occupation out of the City. Other towns in Lombardy joined the rebellion, and on March 22, a republic under the leadership of Daniel Manin was declared in Venice. By the end of the month Verona and Mantua were the only strongholds in the Lombardo-Veneto province left in Austrian hands.

passing a honeymoon—the comb would have too much of the cell in it—and too little of the sweet—No—I think rowing on Derwentwater—or exploring castles in North Wales would be a much more wise method of beginning our wedded life—but we will hope for Chamonix still.

If we were to marry directly and go abroad in a fortnight or so—humanly speaking we should probably get to Chamouni before anything serious takes place—if Austria only, and France—were fighting—we should be quite out of the way there—and there is no fear of an emeute among the good mountaineers of Savoy—We should only have to make the best of our way home in case England were dragged in. But I believe that we shall not lose—in the end—by paying respect to even the less imperative rules of our Church—and showing willingness to leave times and seasons in God's hands, and by so much the more as I feel tempted—and as it seems desirable —to infringe such requirements—so much the more certain am I of its being right to observe them. But, if peace should last— and without the immediately impending aspect of disturbance —till the end of April, and my father can leave his business then, I think Effie, that it would be wise in us to lose no time in petting each other among those Cumberland fishponds, but to dash straight at the Alps. It may be 10 years before we can cross the sea again*—and shall we then, think you—be as cheerful as we are now—even if all the blessings we now possess were continued to us—and others added—or if as cheerful— will you not care more about home than about all the Snowy Tops of mountains that light the sky from Savona to Venezia—

What a dear creature you are to take my rude—unkind despisal, (as you thought) of your flowers, so quietly.† But I do think that you have an entire trust in my love for you—and that it would take not a little to make you doubt it; I think I can see this in your writing—and it is one of the sweetest proofs

* Ten years of child-bearing? This seems to prove that John had every intention of consummating his marriage.

† With John's letter to Effie of February 28, 1848, is a small white envelope with a narrow blue border containing three primroses brown with age. This letter has no ending so the explanation is missing but it seems likely that John had sent her these flowers from Denmark Hill to show how superior the primroses in the south were to those she had sent to him.

I have of your own affection to me, but I wish you had my explanation nevertheless—and you will not get it till a day later—you will miss one day—and then get two letters the day you have this.

Do you read Dombey—ever?—it is hardly worth while—but in this last number—one of the best, there is a good description of a French road—and French driving; and there are some *very* sweet little love passages—which made me feel the four hundred miles between *us* very acutely indeed.*

Don't write much to me while you are in Edinburgh. I am afraid for you, besides it makes me jealous to hear of your being with anybody.—Countless love. Ever my dearest—your faithful.

<div style="text-align: right">J. Ruskin.</div>

Effie was in her element in Edinburgh as is shown in three letters to her parents which would certainly have made John jealous. The moment she was writing about parties and people her letters come alive. John must already have known in his heart that her love of gaiety and her lively disposition were bound to put a severe strain on their marriage. In reading her unselfconscious letters home one realises how incompatible she and John were. She was no wife for a natural recluse, no wife either for a true artist; she should have married a diplomat.

She went to a party at Lady Murray's†—'the ladies were all perfectly dressed, a great many *nobs* and Dragoons and fine uniforms, great flirtations, and splendid music. The music lasted till midnight then we had dancing till three in the morning. I got introduced to good partners and got some good polking.'

At this party Effie met John's friend Lady Trevelyan‡ for the

* *Dombey and Son* appeared in monthly instalments from October 1846 to April 1848. The part about French roads comes in Chapter 55 wherein James Carker, travelling post night and day, is pursued by Dombey from Dijon. The 'little love passages' come in Chapter 56 between Florence Dombey and Walter Gay shortly before their marriage.

† Mary, eldest daughter of William Rigby of Oldfield Hall, Cheshire, was an accomplished pianist. In 1826 she had married John Archibald Murray (1779–1859), contributor to the *Edinburgh Review* from its foundation; knighted and appointed judge as Lord Murray in 1839. They were well known for their hospitality.

‡ Born 1816 Paulina Jermyn, eldest daughter of Rev. W. Jermyn, she had married in 1835 Sir Walter Trevelyan, Bt. of Wallington, Northumberland, and

second time and reported that she had had a long talk with her. On March 9, Lady Trevelyan came to call on her at Charlotte Square. 'She seemed to think nobody like John,' Effie told her father, 'and gave me many expressions of kindness and invitations to come and stay with her. . . . I go out to Newington on Monday [the 13th] and John writes me he will be there on Wednesday afternoon.'

On March 10 she went with Lord Cockburn and Lizzie to a party at Lord Jeffrey's,* another Scottish Law Lord, and had the honour of a long tête à tête with her host on the sofa. 'I am known at these parties as the young lady who is to marry the Oxford Graduate.' At supper she sat between Lord Cockburn and Sir James Moncrieff,† yet another Judge—'. . . the latter who follows me about on all occasions at the parties being very fond of me. His sons are quite amused and Lizzie thought John would be quite jealous of so formidable a rival.' Effie had a great power of endearing herself to elderly gentlemen (Lord Cockburn, Lord Murray and Sir James Moncrieff were all over seventy and Lord Jeffrey was nearly eighty). 'I could not help laughing on entering the room at first, the man asked our names and Lord Cockburn said—say, Lord Cockburn and his second wife. The man however refused with a smile and only pronounced his name but all inside the room heard.'

These flirtations were very innocent and she evidently told John all about them. 'I am truly rejoiced to hear you are so happy, my love,' he wrote on March 13, his last letter before their wedding, 'and —don't think me vain—I suppose it to be because I am coming.—

Nettlecombe, Somerset. She was an artist and wrote stories and reviews for the *Scotsman*. Ruskin wrote in *Praeterita* (p. 457), 'I have no idea when I first *saw* Pauline, Lady Trevelyan, but she became at once a monitress-friend in whom I wholly trusted'. Effie had met the Trevelyans at Denmark Hill and described her as 'a nice little woman very quiet and rather pretty, excessively fond of painting and had some beautiful sketches done by her in Greece'. (Letter of June 7, 1847.) Lady Trevelyan became very attached to Effie but after the annulment she was one of the few people who remained utterly loyal to Ruskin. She died in May 1866 at Neufchâtel while on tour with Ruskin and her husband.

* Francis, Lord Jeffrey (1773–1850), editor of the *Edinburgh Review* 1803–29; judge of Court of Sessions 1834–50. He and his second wife, an American, née Charlotte Wilkes, great-niece of John Wilkes, kept open house twice a week at 24 Moray Place. Lord Cockburn (1779–1854), a widower, published a life of Lord Jeffrey in 1852.

† Sir James Wellwood Moncrieff, Bt. (1776–1851), of Tullibole Castle, Kinrosshire, also a Lord of Sessions. His wife, née Ann Robertson, had died in 1843. He had five sons and three daughters.

But you must not only be a very happy creature—but a very clever creature or the old Judges would not give you whole hours of tête-à-têtes. Lady Trevelyan is very kind—not that I was not sure that everybody would love you and think well of you—still, her saying that you were worthy of me is very delightful—because, you know, it is a compliment—(no—a *testimony*) to us *both*, to me more than to you, far, but it is very kind of her too; and I know no one—of whom I know so little, of whose friendship I am so desirous for you.

'Thank you also again and again for the details about the marriage—and I shall like to be surprised by your bridal dress better than if I knew it before, and I shall like something *over* silk better than silk alone, and a veil instead of the mere pendant headdress—and the rest all very nice—only I shall not see it half while we are being married—nor in the morning at all,—not that I shall look like a ghost, I hope, nor desperate—still, I shall be thinking of what I am receiving in you—and in your heart—and perhaps I shall hardly be able to look at you at all. But you shall put it on again for me in the evening—will you not? when I can look at you as long as I please—or at least until I dare not look any longer for fear I should die of joy. . . . I have only time to say that I hope the next letter I write to my dearest Effie, how long time soever may intervene—will be more fond and kind—far, than any of these—and will have for its chief purpose to express my deep joy and gratitude, in and for the more than fulfilment of all my dearest hopes: and the possession of far more than ever I hoped—though I seem to hope—yes—and to believe of you everything that is pure and lovely, and as your own *Changeless* name signifies—of good report—and if there be any virtue and if there be any praise—I think of it as in you—Ever—my dearest—and for ever—your faithful and entirely devoted lover—servant—and soon, God grant—your own husband—John Ruskin.'[71]

II

THE WEDDING

❃

The cloud of Mr Gray's dreadful anxiety was soon to come down upon the happy lovers. On March 10 Mr Ruskin had written to Mr Gray that he would in a few days be forwarding a draft of the Marriage Settlement 'for your remarks as I wish to have it agreeable to all concerned'. Mr Gray duly received the draft and sent it back, evidently telling Mr Ruskin that he was not in a position to make any settlement on Effie. Mr Ruskin was quick to reply:

London 17 March 1848.
I have recᵈ safely the Dft of Settlement and your Letter of 15 Mch which I am greatly obliged by—It is *not* likely to make the smallest difference with us—indeed if you do not, as often happens in such cases, deceive yourself or are led to plunge farther into Railroads—your situation is much better than I expected—I had no right to conclude you were without property and I therefore asked what you inclined to do for Phemy but my disposition is to look to the worst side of things and my son already knows that I feared you were entirely ruined. . . . I thought it best to prepare my son for the worst that the Information you now so kindly give me might not poison the cup of happiness I trust they are about to taste—

If you can avoid a public breaking up and continue a business of £800 a year—you are just so much better than I led John to expect but for Godsake be done with Rails and Shares —or you will not have a Business, for who will confide in Railroad people I am not clear—if it affords you any Consolation— I may lose £2000—I hope not—but I give it up and neither I nor my son are likely to touch any speculative property—

I don't think so much of my own commercial Character since
I touched these Trash—You say *you may still lose* a large sum by
Investments—have you yet calls to meet? I am awfully sus-
picious in mercantile affairs I may as well be frank with you
and say I do not believe you can recover yourself—but you
must keep a good heart and if you and George keep close to
Business I don't think you or Mrs. Gray should fret about past
losses—I could do very well at Perth now with £500 a year—
all beyond brings turmoil and slavery but you enjoy society and
feel differently—I am not well from politics and disgust at the
French and greatly disappointed about our Tour abroad—

On the same day John was writing to his future father-in-law
from Edinburgh a charming and tactful letter which must have
given immense comfort:

17th March 1848

My dear Mr Gray

It is I believe, Mrs Gray's birthday [her fortieth]—will you
present to her, and yourself accept—my best wishes for her
happiness and yours—and believe, that I will do all in my
power—(and, with dear Effie's help—this will be much)—to
render her following birthdays happier than this can be—in
which she has to look forward to the pain of the first separation.

I have been endeavouring—the greater part of the unoccu-
pied time of this afternoon—to find some excuse for my not
having written to you since New-years Day, but I have found
none—and therefore can send none.

I had the infinite happiness of meeting Effie on Wednesday
evening at her uncles—she is looking as happy—and as well—
as my love would have her—I cannot say more—and I have
already to thank her for the two happiest days of my whole
life.

As we were returning yesterday—together from Craigmillar
Castle [a fourteenth-century ruin] she touched upon a subject
which has (most unnecessarily as far as I am concerned)—
caused of late such uneasiness to both her and you. Had even
the communication which she made to me, been entirely un-
expected by me, it would have produced no other impression

H

upon me than one of gratitude for the candour and courage of the avowal—(accompanied of course—by such concern as I must ever feel for whatever cause of anxiety may occur to you or Mrs Gray), but it was fortunate, as it happened, that I was able to set Effie's heart at rest at once, by assuring her that I had known of the unfavourable posture of your affairs at the time of my first proposals to her: and even previously, and although not certain of the extent of your losses—I had always been prepared for, and partly believed the worst.

I cannot state to you the exact time at which the reports on this subject first reached my father: but he immediately warned me that they were such as he could not distrust, and this *before* my visit to you last Autumn. It was partly owing to this information that I departed from my first intention of not visiting Perth at that time,—and I find that I was right in attributing, as I did, Effie's change of manner to me, in some degree to this cause, though, not knowing how far she was acquainted with the state of your affairs I could not venture to question her, or endeavour to arrive at any certain conclusion on the subject— My offer to her was however made sooner, on this ground, than it would otherwise have been.*

Permit me however to assure you that—with whatever indifference—as far as they regard myself—I may look upon these unfortunate circumstances, believing as I do, that my dear Effie's comfort may be secured—and I trust—your hopes for her not disappointed, by the resources which my fathers kindness has put in our power; it is not without deep concern that I can think of the distress they may cause to you and to Mrs Gray,—nor without much regret that I hear it is not yet in your power to extricate yourself from a position the anxiety of which must even be more grievous than the actual losses it may still necessitate. I am too well aware of your judgement—and decision of character—to venture even to hint an opinion to you on such subjects: but I may perhaps permit myself to express my own *feeling*, that loss is better than entanglement;

* Ruskin had forgotten this when he wrote six years later: '. . . the fortnight or ten days preceding our marriage were passed in great suffering both by Miss Gray and myself—in consequence of revelations of ruin—concealed till that time, at least from *me*'. (Ruskin's Statement.)

and sacrifice than anxiety; and that the impatience which makes an *end* of evil is often a truer friend to us than the patience which makes the *best* of it. The opinion of the world in such matters is, I have heard, little to be dreaded, because it is commonly right, and grants more respect to the confession of an error, than was lost by its commission.

For the present, it grieves me much that I can be of so little service to you—; there are however modes in which hereafter I may be able to relieve you from some anxiety. This may perhaps be especially the case with respect to your two younger daughters [Sophia and Alice]—it is fortunate that they are still so young: as, before you can have any cause for care respecting them, Effie and I shall—I hope have become settled and sage people—quite fit to be trusted with one or both—if you can spare them—and should then think it desirable that they should see something of such English society as we may be able to command—I should have looked forward at any rate to this plan—as both delightful for Effie and me—and not disadvantageous for *them*. For the rest, I hope that your energy and high standing in your profession may soon be the means of extricating you from all painful embarrassment,—and at all events, I trust that both Mrs Gray and you will believe that these, in other respects unfortunate, circumstances have caused to me, selfishly and personally, no feeling but one of gladness at being enabled in any way to assure you or to prove to you how priceless a treasure I count myself to possess in the hand of your daughter.

I hope to see you before the close of the coming week—if there is anything in the packet which I believe my Father has sent to you which you wish to talk over with me—I am sorry to think it will still be time, then: I hope it is as you would wish it —I have not read it—but doubt not that my Father would have it arranged with as much care for Effie's interests as for mine—

With kindest regards—and renewed congratulations to Mrs Gray—and love to George, Robt. Sophy, and Alice, believe me
<div align="center">Dear Mr. Gray</div>
<div align="center">Yours faithfully and affectionately</div>
<div align="right">J. Ruskin.</div>

I ought however in case of your feeling uneasy at the reports
I have mentioned—to tell you that I have heard nothing
lately nor while I was in Scotland—not even a hint—from any
one—nor has my Father spoken to me on the subject since
before I saw you at Perth.

<div align="right">
Yours ever,

JR.
</div>

It must be emphasised that Mr Gray, although unable to give
Effie anything in the way of a dowry (how much happier he would
have been had he been able to to so), made no demands whatever
on Mr Ruskin. The latter voluntarily settled on Effie £10,000, the
income from which went to John. Out of this income John made
Effie a personal allowance of £25 a quarter (before her marriage she
had received £30 a year from her father which was discontinued).
Mr Ruskin also paid all their travelling expenses and gave them
numerous presents. When the marriage was annulled in July 1854
the marriage settlement also became void. Effie was told by her
solicitor that she had a claim for damages but she decided not to
press it and the £10,000 was returned to Mr Ruskin.

The young people were still with the Jamesons on March 21 for
on that day Andrew Jameson wrote to his sister:

I am very happy with the young folks. It does one good to see
their happiness and confiding affection. It argues well for
a happy union when good principles and good temper combine.
John is quite a different person. He has not now the interest of
suffering and *sadness*, which to my imagination gave him before
a peculiar tenderness. It is an interest of a different and happier
sort, and Phemy is so much improved since she was at Ayr [where
she had gone while John was at Crossmount] in every way,
that I quite value her cheerful enlivening society. I feel it as a
great satisfaction to have this *parting* visit from her and I am
sorry to think it will be so soon over.

It was a good idea of mine, you must allow—their meeting
here—there is no one to watch and pry into their movements—
and there are objects of interest around them. At the same
time, they seem wonderfully insensible to the obtrusive world—
I have asked almost no one to meet them. I'm disinclined to
interrupt their enjoyment of one another's society.

But Mr Gray had to tell Mr Ruskin that he still had 'calls to meet'.
Mr Ruskin was furious:

London 22 Mch 1848.

I have your kind letter of 20 Inst and have consulted a
person of very sound Judgement on Railroad Shares—He
considers Boulogne as mere Lottery Tickets. . . . from the
circumstance of your having bought 200 Shares in Boulogne in
which I thought myself venturous to take 25 and from your
saying you have heavy calls to meet I have no hope of your
getting clear—my Son seems to have gleaned as much at
Edinh—you desired me to keep your situation private—now—
my dear Sir it may do good to tell you that six months ago when
you were far better than you are now—you were publicly
reported to me as a ruined man. . . . —What distresses me is
not your having nothing but your having to go to Bankruptcy
and so losing confidence of the County of Perth and perhaps
2/3ds of your Business.

I am also sorely vexed at your just taking this time to disturb
the young people who cannot pay your Calls—for John knows
my Severity in money matters—that though I give where I
can—were he to be Security for a Single hundred for the best
friend he has—he should never see a shilling more of my
money—I am so upset myself at hearing of any speculation
that I would almost beg the great Kindness of you neither to
tell me nor John and, if I dare presume, nor Phemy anything
about such affairs—I am as I told you nervous and easily made
ill and my health is of some Consequence to John and Phemy yet.
I should be greatly obliged if you could postpone any winding
up—for a few months, after that I shall be prepared for the worst.

I conclude your House is already as good as gone—I am
happy to see my son's Letter pleased you—He will write in a
very different strain and feeling—but I am naturally annoyed
at all this coming on the young people—Had you frankly told
me in Octr or Novr it would surely have been better than just at
the consummation—[72]

This shows how mistaken Joan Severn was when she wrote many
years later: '. . . it was not a marriage she [Mrs Ruskin], or her

Husband ever approved—especially as about a week before the
marriage he had to pay £12,000 for the Father's debts (Mr G)—this
first started your F [iglio]* into seeing the marriage as one of conve-
nience.'73 Mr Ruskin never paid a penny towards Mr Gray's debts.

A few days later Mr Ruskin was writing again in a rather softened
mood:

London 28 March. 1848.
... I trust to your meeting the future difficulties of your
situation with fortitude and for the sake of Mrs. Gray and your
fine family, applying your great good sense and fine energies to
the preservation of a property which can never leave you, if you
give your whole attention to it—I mean your Business—as I
have allowed myself the privilege of a friend, I may once for all
mention that I have thought George's Education rather too
much varied and interrupted with pleasure for a man of
Business and his application and steadiness are now of immense
importance—I see no reason for allowing your own powers to
be lessened by suffering for the past, you are only in the
position of thousands who have tried the speculations of the
day. I have a customer who 15 years ago could have retired on
£130,000—and he can just pay everybody and not have a
shilling left. Railroads—and concerns promising 30% Int^t
have done this. The danger is your not being in vigour of mind
and Body enough to prosecute your daily affairs.—If you are,
you are still in the prime of Life and may live to be a wealthy
man—There is a proverb in Spain that *a man is never dead, till
he gives himself up*—I should hope your friends who have given
you funds will be lenient and not vindictive—If a public
exposure could be avoided—their Interests would be greatly
served for I know your genuine goodness of heart and upright-
ness and that if such a quiet arrangement could be arrived at as
to leave you possessed of an undiminished Business—they,
your Crs would I believe profit by some sinking fund you would
make from your spare profits—I speak from my notion that
part of your good Business is being factor for Gentlemen of
Landed property,—now half of this would go perhaps if the
whole extent of your late Operations were known—Whereas if

* Joan Severn's correspondent, Mrs Alexander, addressed Ruskin as 'Figlio'.

you can weather the storm although it is well known that you have touched Railroads, the Injury to your Business would be much less than a public exposure would inflict—

I do not blame you individually for bold speculation—you are in a speculative society—and country—my miscalled Cautious Countrymen are all speculative. They like amusement and getting rich without labour—but there is nothing like keeping to our *Shop* whatever it be—you are all right yet whichever way you close accounts of purchases already made if you have courage to shun any new attempt to retrieve your fortunes—

In your case I should never make but one experiment—namely—to try how much could be made out of a Law Business in the Town of Perth—Supposing your speculations had all succeeded—what would have been the mighty addition to your happiness? There is no slavery like the slavery of fashion and high life—Mrs. Gray's society is the same and your children smile as sweetly with £500 a year as £5000—and you enjoy much more of the Society of both than if you had to enact the great man which is generally done before the world and at the expense of domestic Comfort.

I suppose you will have my Son at Perth directly. There is no objection to the marriage taking place before the end of Lent if more convenient for all parties although I wrote we should prefer the end of Lent, but we leave all to them and you and Mrs. Gray—

The Grays decided not to wait until the end of Lent (Easter Sunday was on April 23) and fixed the wedding day for Monday, April 10. Mr Gray went to Edinburgh and escorted John to Bowerswell on March 29; Effie had returned to Bowerswell sooner in order to help with the preparations for the wedding.

It must have been the spectre of bankruptcy rather than the ghost of John Thomas Ruskin that haunted the wedding, which took place at four o'clock on the afternoon of the 10th. In accordance with Scottish custom the ceremony was held in the drawing-room at Bowerswell, the Rev. John Edward Touch, Minister of Kinnoull, officiating.*

* In 1933 the Marriage Certificate was given to Effie's daughter, Mary Millais,

On this same day, April 10, 1848, there was a great Chartist procession in London to present a petition to Parliament. There were said to be over five million signatures on the Petition and a hundred thousand marchers. Bloodshed, if not total revolution, was predicted and the Duke of Wellington was put in charge of the defence of London. In the event only about twenty thousand marched. Two sympathisers who joined the procession were John Everett Millais whom Effie was to marry in the same drawing-room at Bowerswell seven years later, and his friend Holman Hunt.[74] (Mr Ruskin was afterwards to give the danger of the Chartist uprising as an excuse for not attending his son's wedding.) There were some skirmishes between the marchers and the police but all real trouble was quenched in a deluge of rain.

After the ceremony at Bowerswell John and Effie drove away to Blair Atholl for the first night of their honeymoon. The next day Mrs Gray sat down to give Mrs Ruskin an account of the wedding:

<div align="right">Bowerswell
11th April 1848</div>

My dear Mrs Ruskin

I cannot let this day pass without writing you a few lines although I feel myself very unfit to do so as I am feeling the absence of John and Phemy bitterly—after such a trying fortnight in which they have both been our chief support—it was so truly delightful to see them so perfectly happy—you will have heard by this time that the ceremony took place yesterday afternoon between 4 and 5 oclock when they were most happily united as far as we poor shortsighted Mortals can judge—for certainly I never saw a couple that promised greater happiness than they do.—I think it will gratify you to hear that both John and Phemy bore up with the greatest firmness throughout the trying ceremony and both looked *remarkably well*. They had a delightful afternoon for their journey to Blair Athole [*sic*] which they expected to reach between 9 and 10

by Mr Telford, antique dealer of Grasmere (see Appendix IV). It is not on an official form but on a sheet of ordinary cream writing paper written out in two different hands. The Rev. John Edward Touch of Maderty and Kinnoull was the grandfather of Sir George Touche, 1st Bart (1920). There is a transcript of the Certificate by Clare Stuart Wortley but the original is untraced.

oclock—they will no doubt inform you how they get on as they advance in their Tour.—

The moment after they drove off the party sat down to Dinner—after which a great many toasts were given and many compliments paid to the newly married couple, as well as to those most nearly connected with them. Every one appeared to be perfectly happy and to wish John and Phemy well from the bottom of their heart.—I am glad to think every thing went off so well for John and Phemy's sake—

I now congratulate you and Mr Ruskin (in which Mr Gray heartily joins) that it is now over—and I trust that your anxiety for them is now also over and that you will have the greatest happiness in the society of your dear daughter in law—It is very gratifying to me to think you already love her so much—I hope she will be to you all that a Mother could wish.—

John and Phemy resolved upon the *convenient* fashion of *not* sending cards—I have however sent you a piece of the Brides-cake as you may wish to give a piece to some of your young friends and to your servants.—George Hobbs got a piece away with him to dream upon at which he appeared perfectly delighted.—

What a truly valuable and elegant present Mr Ruskin sent to Phemy! It was very much admired by all and prized by Phemy as a mark of Mr Ruskin's esteem.*—Mr Gray and George join me in wishing you and Mr Ruskin many many happy days in the society of your beloved son and his dear wife—and believe me dear Mrs Ruskin

<div style="text-align: right;">

Yours very sincerely
Sophia M Gray[75]

</div>

George Hobbs, of course, went with Effie and John on their honeymoon journey. They must have arrived at Blair Atholl exhausted after the tensions of the day and the long drive, especially John who had a bad cold in the head. Early next morning they were off again to Aberfeldy.

* An entry in Mr Ruskin's account book under Charities March 1848 reads: 'Necklace Mrs J.R. £48.' (Bembridge.) There is no description of this necklace and no reference to Effie's wearing it, nor is there a portrait of her wearing his necklace All her 'best' jewels were stolen in a robbery in Venice in 1852 but in describing her losses she does not mention any necklace. (Lutyens, 1965, p. 320.)

HOME TO DENMARK HILL

✳

It is well known that the Ruskin marriage, which lasted six years, was never consummated. At the time the marriage broke up Effie was to tell her father, 'I have never been told the duties of married persons to each other and knew little or nothing about their relations in the closest union on earth. For days John talked about this relation to me but avowed no intention of making me his wife. He alleged various reasons, hatred to children, religious motives, a desire to preserve my beauty, and finally this last year [1854] told me his true reason (and this to me is as villainous as all the rest), that he had imagined that women were quite different to what he saw I was, and that the reason he did not make me his wife was because he was disgusted with my person the first evening 10th April.'[76]

Ruskin had never seen a naked woman before he married; he had never been to an art school, and at that time no picture exhibited in public showed a female nude with hair anywhere on her body.* His disgust with this aspect of puberty may well have been the cause of his later obsession with young girls. It is difficult to think of any other way in which he could have imagined women to be different from what they were. On the other hand he may have trumped up this reason in order to hurt Effie, for he did not tell her this until

* This statement was made in Lutyens (1965, p. 21) and challenged by a critic who was not, however, able to disprove it; but it has more recently come to light that Ruskin had the opportunity while at Oxford of seeing erotic pictures. He wrote to his father in 1862 accusing him of pride which 'has destroyed through life your power of judging noble character. . . . You and my mother used to be delighted when I associated [at Oxford] with men like Lords March & Ward—men who had their drawers filled with pictures of naked bawds.' (Letter of August 12, 1862: Burd, p. 369.) The Earl of March (1818–1903) succeeded his father as 6th Duke of Richmond in 1860. He was at Christ Church with Ruskin. Lord Ward (1817–85) was created Earl of Dudley in 1860. He was at Trinity.

there was hatred and bitterness between them, so what she said was 'the true reason' may not have been the truth at all.

The true reason was most probably his horror of babies. Not only did he dislike them in themselves, but a pregnant wife, or one who tied him to the nursery, would have been misery to him. Had he and Effie been able to get abroad in May, as originally planned, an early pregnancy would not have been too incommoding; now, however, having been disappointed once by revolution, to be prevented a second time from going abroad by an advanced pregnancy would have been intolerable. To be in Switzerland with his parents and his wife was the acme of imaginable happiness to him.*

Moreover his ardour had cooled. Not only was he now sure of Effie—and he was one of those unfortunate beings who can remain in love only so long as he is uncertain—but circumstances had been against him. There can be no doubt that the fortnight he spent at Bowerswell before his marriage was deeply depressing from every point of view. By Denmark Hill standards the house must have been dreadfully cold and uncomfortable; he would have had no privacy and been an object of curiosity to the neighbours—the kind of society he particularly detested—not to mention his own cold in the head. Above all there was Mr Gray's despair. John himself later described how 'Mr Gray, coming over [to Edinburgh] himself, told me he was entirely ruined and must leave his house immediately. His distress appeared very great. . . . The whole family rested on me for support and encouragement. . . . Miss Gray appeared in a most weak and nervous state in consequence of this distress—and I was at first afraid of subjecting her system to any new trials—My own passion was also much subdued by anxiety; and I had no difficulty in refraining from consummation on the first night.'[77]

Effie's first letter home, from Aberfeldy where they spent their second night, showed the undercurrent of misery that had spoilt the last weeks of their engagement: 'I do hope that still things may not be as bad as you anticipated. I will write often to you and I hope that you will do so openly to me that I may have it in my power now to be of some comfort to you both. . . . Tell dear George that I will

* In 1886 Joan Severn wrote that Ruskin had 'often talked quite openly' to her about his marriage. His 'compact' with Effie was 'that for the first year of their life nothing should happen, as he had much travelling & work—and wished to run no risk of babies'. (Brantwood Diary, p. 369.)

not forget his interests and I think they are in no danger. We shall
see about him as soon as we possibly can. . . . I hope dearest Mama
that you are no worse for your exertions now they [are] over, and
that you Papa will do your utmost to strengthen your trust in God
. . . pardon me my dear Father for touching on this but repining
frets you and breaks your health, and my mother who would do all
for you is undone when she sees you in such dejection.'

It is apparent from this that John had promised, or half promised,
to ask his father to help George, either by taking him into his own
sherry business or getting him into some other business house in
London. John could perhaps scarcely have done less in view of Mr
Gray's distress; all the same, it would have been less hurtful in the
end if he had said at the outset that neither he nor his father could do
anything for George.

Effie was very upset to receive on her honeymoon a larger bill
from her dressmaker than the amount her father had agreed to pay
for her trousseau; although, as she said, she would not at all mind
paying the extra, which was £9—'good as John is I do not think the
idea would be agreeable to anyone'. Mr Gray agreed to pay the
extra, and after thanking him 'exceedingly', she added, 'I am the
more especially grieved just now owing to your present position but
you will never now have anything more to pay for me and I shall
endeavour to make it up to you in some way at a future time. If Mr
Ruskin had thought or known I had paid it, if you had not kindly
consented to do so now, it might have considerably added to the
vexation of other matters and I do hope that whenever we reach
London that I may be able to do something for George who if no
longer with you and I also gone would considerably lighten your
mind. . . . Be sure my dearest Father that I will do all in my power
to lighten your cares and had I not thought this against your interest
I would have paid the account instantly without giving you this
additional care but it will be the last, and fancy the difference for
you had I still been with you.'

After a few days in the Highlands and a week at Keswick John and
Effie returned to Denmark Hill on Thursday, April 27, and were
royally received. All the servants were lined up at the door to meet
them; the gardener presented a splendid bouquet and a German
band played outside the open window all through dinner. The young
couple were given the top of the house to themselves, and very

comfortable they found it, Effie told her mother. She also told her
that Mrs Ruskin 'bids me say how happy she is to have me here and
she hopes I will feel quite a daughter to her'.

Mr Ruskin wrote very cheerfully for once to Mr Gray on the day
after their arrival:

<div align="right">London 28 April 1848.</div>

. . . we dined together but without Company in I hope great
Joy of Heart in all. Phemy is a little thinner than when with us
last year, but very well and in her usual spirits or way which
we never wish to see changed—my son is stouter and better
than we have ever seen him in the whole course of his Life—
They are in appearance and I doubt not in reality extremely
happy and I trust the union will prove not only a source of
happiness to them but of satisfaction and comfort to us all—
Mrs Ruskin's health has gradually improved since 10 April and
I should be glad to hear of you and Mrs Gray being in re-
covered Health and Spirits. . . .

I am however strongly of opinion that your property and all
Railroad property might be raised 50 pCt by efficient, judi-
cious and strictly honest direction—Go along what line you
will you see the most absurd, reckless extravagant Expendi-
ture—not merely robbery committed on the poor Shareholder,
but very bad taste in their Extravagance—Every shed and
building connected with Railroads should be the plainest
simplest most unpretending possible and the *cheapest* consistent
with Safety. Railroads are a deformity on the face of England
and if the stations could have been invisible the deformity
would have been less, at least the Buildings absolutely neces-
sary should have been quietly set down like the small grey stone
Houses about the Lakes before the Liverpool Merchants per-
petrated their monstrosities of Mansions on that region and
disturbed the whole harmony of the District with utter ugli-
ness.—A grand Railway station is disgusting and a profit only
to Builders and carpenters. . . .

On April 29 Mr Ruskin and John took Effie to the Private View
of the Water Colour Society which she described to her mother, and
then added: 'John congratulated me on what he terms my *grande*

succès on my first appearance in public. I am sure you will relieve me from all charge of affectation in telling you these compliments myself but it is only to show you how entirely pleased Mr and Mrs R. are with John's wife which I know will gratify you and which I am most thankful for. I never saw anything so kind as they are. Mrs R overwhelms me with presents and I do not know what to say or do . . . I entreat John not to let me have so much but he says it is all right and that his mother wishes it. She always says when I refuse, my dear child, what can I do with them? You know I may as well give them *now* with pleasure for they will all be yours when I am gone and Mr Ruskin is so proud of his daughter &c and if John is not as kind as kind can be tell me! and won't I settle him! I assure her there is no need of that at present.' And two days later, 'Mr and Mrs R. are as kind as can be and I hope I am not failing in my duty to them. . . . I never saw anything like John, he is just perfect!!!!'

On May 6 they looked at two furnished houses, both too expensive. 'Mr Ruskin is extremely kind,' Effie wrote, 'but as Mrs Ruskin says he has a great deal of pride about us, John and I, he is so anxious that we should have a house that we can receive any one in that he says he will rather pay the rent himself. For my part I am very happy here and do not care where we go or stay.'

May 7 was her twentieth birthday. Mrs Ruskin gave her a little purse with a sovereign in it and Mr Ruskin 'a beautiful cameo of Jupiter and Juno' which John was to have set for her as his present.* 'Mr Ruskin is so noticing of my dress you would be quite amused,' she went on, 'he admires my white bonnet so much that he is going to take me to the Academy some day on purpose to let it be seen.'

Mr Ruskin was delighted at the invitations they were receiving. Lady Davy (at whose house John had last seen Charlotte Lockhart) had been to call on Effie on May 2 having heard of her from Lord and Lady Murray of Edinburgh. Lady Davy took a great fancy to Effie and asked them to a select dinner party on May 8 at her house at 26 Park Street. There Effie met Lord and Lady Lansdowne† as well as

* Mr Ruskin noted his presents to Effie in his account book for June: 'Effie gown £10 Broach [*sic*] 65/6'. (Bembridge.) The gown was for a reception at Lansdowne House (see p. 121).

† Henry, 3rd Marquess of Lansdowne (1780–1863), had married in 1808 Louisa, daughter of the Earl of Ilchester. She died of cancer in 1851. Lord Lansdowne was one of Effie's staunchest supporters when she left Ruskin and remained

other distinguished people. She charmed Lord Lansdowne as she had charmed the old Scottish judges. He took her down to dinner and talked to her the whole way through the meal. More people came in after dinner, including Lord and Lady Murray, whom she was able to introduce to John.

But the Grays evidently felt that amidst the gaieties of London George's interests were being forgotten. Effie received letters from home which John took it upon himself to answer:

<div style="text-align: right">Denmark Hill, 12th May</div>

My Dear Mrs Gray

I have indeed given you some cause to suppose I had in some measure forgotten Perth, and ceased to think of you. But you must not think this. I do not say that I have not been self-indulgent occasionally—and that—to a walk in the garden— or an hours reading in the summerhouse with Effie, I have not sacrificed time which had been more dutifully employed in writing to you—but whatever my faults of this kind may be— they never extend to or involve any forgetfulness of you—and for the rest, I have not since my return—been able—in the time which my utmost self-denial could secure—to answer all the immediately pressing letters of neglected friends—or the still more imperatively pressing letters of kind and forgiving ones—But the notes which Effie has received from you and George today I must hasten to answer for her: I wish it were in my power to do so in a way that would relieve your minds from the anxiety which cannot but increase day by day—and still—all that I can yet say is that you must not think I forget you—or your wishes: You—my dear Mrs Gray—cannot but see the danger that there would be not only diminishing the chance of success in Georges present object—but of involving also in no small degree—Effies happiness—if any idea—however slight—arose in my father's mind that my affection for her was made in any—even the most unconscious way—a means of obtaining advantage or undue influence over me—and through me, over him, *at this time*—When that affection has

her friend until his death. He was a great patron of the arts, and Millais's beautiful portrait of Effie, 'The Music Mistress' (1862), was the last picture Lord Lansdowne commissioned.

been more prolonged on my part—and when my father and mother have had longer opportunity of discovering—what they perceive more and more day by day, how entirely the best affection that I or they can give is deserved by your daughter—and how much my happiness is involved in hers—and secured by her—it will become their natural wish to show you their sense of this by every means in their power. But whatever I at present asked or represented—could not but be looked upon by them as prompted by the excitement of strong—and perhaps transitory feeling—and the use of my influence by you at such a time would be the surest way to diminish it. You must remain for the present trusting in my earnest desire to replace to you in the duty of a son what you have parted with in the obedience of a daughter—and to show you by every means in my power how precious to me is her affection—and how principal an object her happiness: I am deeply grieved to have no other answer than this—it looks formal—evasive—unkind: It is however the simple—and most necessary to be spoken truth—George must not lose spirit—nor patience—nor above all admit the painful and wounding thought that I can be less mindful of him among the gaieties of London than among the pines of Kinnoull—there is *nothing* here that I enjoy except the society of your daughter in our home—and it is not at such times that I am likely to forget her brother—if I go into society at all, it is for *her* sake, and to my infinite annoyance—except only as the pleasure I have in seeing her admired as *by* all she is—and happy as *with* all she is—rewards me and more than rewards me for my own discomforts and discomfitures. She has I suppose given you some account of the two parties she has been at*—other invitations are coming fast—and I wish I had time to tell you one half of the kind and honourable things that are said of her. I am especially delighted to see how quietly and gracefully she receives all marks of attention and admiration. I do not however care so much for this London society as for that which she can command afterwards in quiet

* Apart from Lady Davy's dinner party they had attended a breakfast party on May 3 with Samuel Rogers. Effie became a great favourite with the old poet (then 84) and they were thereafter invited to his house, 22 St James's Place, far more frequently than when John was a bachelor.

country houses among good people—I hope to take her to Oxford to visit the Aclands [p. 50] in the course of the summer.

I am in much haste—having several other letters to write today. Do not answer this letter to me—but to Effie. We are all much concerned to hear of the illness of my little brothers and sisters—still—it is best it should be got over thus.* Give them all—and especially George, my kindest love—and with sincere regards to Mr Gray, believe me, my dear Mrs Gray— Ever most affectionately yours J. Ruskin. Kind regards to all friends, especially Mr and Mrs Jameson and Mr Duncan [Melville Jameson's father-in-law].

Mrs Gray had the grace to make no complaint about this letter however disappointed she may have felt. On May 18 Effie was writing 'John sends his kindest love and is very glad to think you are satisfied with his letter. . . . I hope my dear Mama if there is any little thing I can send you you will not scruple to ask for it at any time either for yourself or the children because if I cannot afford it I will tell you. . . . John likes me to send you little things now and then.'

The Ruskins had more reason to be pleased with their daughter-in-law at this time than the Grays with their son-in-law.

* The children all had smallpox which seems to have been a far less dangerous disease then than scarlet fever.

I

FOLKESTONE AND OXFORD

❈

On May 23 John and Effie received an invitation from Lady
Lansdowne to dine at Lansdowne House on the 29th at eight o'clock.
'We are going,' Effie told her mother, 'and I think I shall enjoy it
very much and we shall likely meet some interesting people, it is
exceedingly kind and shows the estimation John is held in as that
society otherwise is so difficult of access, but I take some credit to
myself for John met them often before and never was asked till now:
Your party must have been very agreeable. I think Prizie [Tasker]
must have felt it a little but I am glad he was there. I never could
have been anything to compare so happy or so comfortable with
him as with John and I am happier every day for he really is the
kindest creature in the world and he is so pleased with me. He says
he thinks we really are a model couple and we don't do at all badly
together; we are really always so happy to do what the other wants
that I do not think we shall ever quarrel. He is particular with me
and takes a great deal of trouble in teaching me things, and Mr
Ruskin is also I think very fond of me and so is Mrs Ruskin.'[78] She
announced in this letter that Mary Bolding had had a son on May
23.

Mr Ruskin could not resist boasting to Mr Gray:

London 24 May 1848.
I am glad to see Phemy gets John to go out a little. He has met
with most of the first men for some years back but he is very
indifferent to general Society and reluctantly acknowledges
great attentions shown him and refuses one half. . . . I am glad
to find his acquaintance, obtained merely by fair Talent and
good Conduct, immediately took Phemy by the hand—John
some months ago refused Mr Blake of Portland Places Invita-

tion,* but they both went on Saturday [May 20] and met first
rate people and on Monday they dine at Lansdowne House—
by invitation from Marquis and Marchioness of Lansdowne—
but John would rather be in Switzerland—I hope they will
contrive to be happy and take a due share of Society and
solitude—Phemy is much better calculated for society than he
is—He is best in *print*.[79]

Mr Gray did not see why his old friends in London should be
neglected in favour of John's grand acquaintances. Effie told her
father on the day of the Lansdowne dinner party that she would call
on anyone to whom she felt she owed an obligation such as the
Gardners and Gadesdens with whom she had stayed in London and
Ewell the year before. 'No one can accuse me of vanity in my choice
of friends,' she went on, '... but a line must be drawn or else
in John's position people will come in flocks not through regard to
me but to get access to him, and the society in which we are placed
and my conduct now must be regulated by his wishes and I am
certain he will never ask me to do anything contrary to what is
right.'
We know that Mrs Ruskin felt the same on this matter of friends
and that John himself had already written to Effie on the subject.
He felt sufficiently strongly about it to take up the matter on Effie's
behalf:

[May 29, 1848]
My Dear Mr Gray
Effie seems alarmed today lest she should not be able to
write rationally enough to prove to you that her head was not
turned;—and she throws me this bit of very dirty and dis-
respectful paper, requesting me to fill it with attestations of her
heads being still turned the right way—and the hearts remain-
ing in the right place. Indeed I can assure you very honestly
that such is the fact.—She forgets none of her old friends—and

* John and Effie had met the William Blakes at the Water Colour Society Exhi-
bition on April 29 and again at breakfast with Samuel Rogers on May 3. They lived
at Danesbury, near Welwyn, Hertfordshire, and in London at 62 Portland Place.
He was a director of the British Institution. Effie described the dinner party with
the Blakes in a letter of May 22 (James, pp. 108–9.)

I believe there is indeed 'nothing of her that will fade'—or 'suffer a sea change' from the disturbing waves of the society which I doubt not she will soon command—as far as it may be right—if anything is remarkable in her character it is her indifference and superiority to all vanity of this petty kind—still— I was a little surprised by one or two expressions in your letter to her a few days ago: (which she showed to *me* as having been in some, if not in chief measure the cause of her culpability in your eyes) because they seemed to imply that she was *now* in the same relation and under the same necessities of obligation to all her former acquaintances, as when unmarried; You know no one can blame her now for her conduct in matters of this kind; as the choice of the persons whom she visits must of course rest with me—and on my head will be laid the odium of any apparent unkindness: None of her former friends will suppose that she is now free to act as she chooses—or even as it would under other circumstances have been her duty to act, nor can they at all expect that obligations incurred by her before marriage should be necessarily binding on her, when they must be returned in her husbands person as well as in her own—Whatever acknowledgment of such kindness is indeed due, I should be the last person to hinder her from paying; but that she should remain on the same terms as before with every one of her acquaintances is neither right nor possible—nor will *she* be held responsible for her choice. I trust that this choice will not— either on her part or mine be influenced by vanity, but I have not much time to give society—I enter into it only as a duty, and I am therefore scrupulous in the endeavour to render the time so devoted profitable—both to ourselves and to others— to let as little of it as may be, pass in forms or compliments— but to be among good and wise and kind people—and it is necessary for both of us at present to be especially careful in the choice of the friends whose tone and influence must affect the most important years of our lives.

I am anxious to know how things are now looking—and what chance there may be opening for your escape from your embarrassments—I trust you will let me know as soon as you see rational hope of this taking place. I have much to say to you— and Mrs Gray—*too* much to write. I think it would please you

to see Effie at present—looking lovelier than ever—and—I think also—looking very—very happy—. Lady Lyttleton [*sic*] (dowager)—wrote to Lady Davy—after her first party—'You had *indeed* a lovely bride to show us!' However—her beauty is her least gift—but I will not praise her—(if indeed I could) as she deserves lest you should begin to think her too good for me. Kindest love and remembrances to George and Mrs Gray— dear love to Robt Sophy, and Alice—and the Major* regards to all friends. Ever dear Mr Gray

Yours most affectionately

J. Ruskin.

It would appear that John's wishes and Effie's were entirely in accord over this matter of friends. Whether the Grays were satisfied with John's letter is an unanswered question; they could not, though, be less than gratified by John's praise of Effie.

Since his return from their short honeymoon John had been busy correcting the proofs of the second edition of *Modern Painters*, Volume II. During his tour abroad in 1846 he had been much occupied with architectural drawings, and whether he had gone abroad or not in 1848 it was his intention to postpone writing the third volume of *Modern Painters* to work on a book about mediaeval architecture. He felt the urgency 'of obtaining as many memoranda as possible of mediaeval buildings in Italy and Normandy, now in process of destruction before that destruction should be consummated by the Restorer, or the Revolutionist'.⁸⁰ As he could not get to the Continent he now planned a tour of the Cathedrals and Abbeys of England after a week or so at the sea and a visit to Oxford. It was only natural that Mr and Mrs Ruskin should accompany them, seeing that it had long been the plan that they should all go away together.

Effie first mentioned this tour in a letter of June 1 in which she told her mother that Mrs Ruskin wished to consult her about household linen for their London house when they got one as they thought it would be better and cheaper in Perth. 'We require sheets for three servants, ourselves and strangers room, as much as you think, the same of blankets, table cloths, napkins, towels, pillow cases and

* Effie's brother John, aged two, nicknamed 'the Major' or 'the little Major' after his godfather, Major John Guthrie. See Appendix III for Gray Children.

bolsters. . . . We should see little company if Mr Ruskin gets the house he is in treaty for. We shall take it for three years and have possession when we return from our tour so you see these things would require to be ready.'

On June 7, still at Denmark Hill, Effie described one of the few occasions on which she and John seem to have had a little fun alone together: 'You would have laughed last night to see John and I going to our garden with Mungo.* Coming to the Haystack we climbed up to the top of it and I sat on the wall but John going the wrong way slipped up to the chin in the straw which put us into fits of laughter and was a capital chance for Mungo who jumped over him and tried to annihilate him. However at last he got out of his hole, such a figure you never saw and his best clothes on, and he was so delighted with it. . . . Mr and Mrs Ruskin have been away the whole day visiting some relations. . . . Whilst they were away John and I worked all the forenoon, then we had a nice lunch of strawberries and cream and at three we went down to Dulwich to the pond where we fed the swans and Mungo swam about beautifully. Whenever he came near the swans they rose in the water and flapped their wings, and screaming showed the utmost displeasure. We went afterwards to the Gallery which I had never seen before and remained till six, when we returned to dinner.'

Three days later we have evidence of John's dislike of babies. 'I had a long letter from Mrs Bolding [Mary],' Effie told her mother, 'wanting me to go with her aunt [Mrs Ruskin] to get a dress for her and excusing John and I from coming to see her as she knows his dislike to children and she supposes I had enough of them at home which is very good of her, but I tried to enforce on John that we ought to call on her, but he won't as he says he can't bear lumps of *putty* as he terms babies, and I think as little of them excepting the little ones at Bowerswell as he does. Mr Ruskin went to see it [it was christened John Ruskin] and to hear him describe it is most amusing, it puts me into fits of laughter, and as Mrs Ruskin loves them with all her heart and her indignation against John and his father and generally me is quite as fine as Mr Ruskin's description of the child.

* One of the many dogs John had in succession. At the age of five a black Newfoundland called Lion had bitten a piece out of the corner of his mouth on the left side which disfigured it ever afterwards. 'Not the slightest diminution of my love of dogs, not the slightest nervousness in managing them, was induced by this accident,' he wrote. (*Praeterita*, pp. 67–8.)

'. . . I am exceedingly sorry to see from Papa's letter that things are no better for him.'

On Wednesday, June 14, they all left by train for Dover where they stayed at the Ship Hotel. It was Effie's first glimpse of the White Cliffs and of France. They could see Calais quite clearly through a telescope, and this made John all the more disgruntled at not getting abroad.

From Dover Effie reported that John was busy writing part of his book and studying mathematics. It seems therefore that he had already begun his next book, *The Seven Lamps of Architecture*, which was published the following May.

After a fortnight at Dover they went for one night to the Pavilion Hotel, Folkestone—a splendid hotel, according to Effie, kept by an Italian. On the day they arrived there, June 28, she wrote, 'Mrs Ruskin is reading aloud the termination of the dreadful Paris battle, what awful loss of life—15000. They say it is to be hoped that the Archbishop is not killed but I suspect there is little doubt of it.' There had been an uprising of the workers in Paris which was bloodily suppressed by General Cavaignac, French Minister of War. Monseigneur Affre, Archbishop of Paris since 1840, tried to act as a mediator and was accidentally killed on the barricades. On June 28, 1848, *The Times* gave seven columns to the battle, graphically and excitingly recounted by an eye-witness. The account ended, 'The archbishop of Paris has been wounded—I fear fatally.' The 'latest intelligence by electric telegraph' announced next day that the Archbishop had died of his wounds.

On the 29th, leaving Mr and Mrs Ruskin at Folkestone, John and Effie went up to London for the night to attend a reception at Lansdowne House and stayed at the St George's Hotel, Albemarle Street. (Mrs Ruskin gave her a new dress for the occasion.) They were then going on to Oxford for Commemoration and planned afterwards to join up with Mr and Mrs Ruskin at one of the Cathedral towns. The morning they left Folkestone a gloomy letter arrived from Perth in which the subject of George's future was brought up again. John answered this letter in the train on the way to London. One gathers that John had spoken to his father about George and that the idea of the boy's coming to London had been given short shrift.

29 June
1848

My dear Mr Gray

Effie has just received a letter from Mrs Gray—giving us somewhat sad account of your spirits—accounts which we both expected having noticed the fall in stocks*—I could not answer your last letter having nothing good to announce or to communicate. (I am writing on the south eastern railway, between Folkestone and Ashford do not therefore think me paralytic) but I do think now that I may reasonably beg you not to suffer yourself to be depressed by this *last* fall in your property. Mrs Gray speaks of the French Revolution as one of the causes of discouragement, but surely this is not a just view of its probable results. It is, I think, by much the best thing which has happened for these four months; it will give steadier force to the government— greater power to the new kindling and a wholesome warning to the other European States infected with revolutionary mania—I have not the slightest doubt that all property will immediately rise and the public confidence will be comparatively restored—Mrs Gray says that you are chiefly anxious about George—and George is just the person respecting whom you should feel nothing but confidence and joy: we were both delighted to hear what a comfort he was to his mother—and I am sure from what I have seen of him that there is no fear as to his future success.—I was grieved when I came to London to find that my Fathers views of what was right in his present circumstances were opposed to your wishes: but I think it would be well—if things continue much longer as they are that you should yourself write explaining to him the impossibility of George's doing anything in his present position— yet do not do this hurriedly—for I cannot but feel confidence in your speedy extraction—The sound of mortars and howitzers in the streets of Paris is the sweetest music I have heard this many a day not excepting even dear Effies—I regret as everyone must the fearful balance of slaughter on the wrong side— Still—it will be the severest warning: it has shown to the mob

* The market had slightly recovered by the 28th but had been depressed all the previous week. *The Times* of June 20 had stated, 'The railway-market wears an appearance of extreme heaviness, and business is declining daily.'

that they are not omnipotent and to the citizens that disloyalty
and cowardice in the beginning of troubles cannot be redeemed
by their desperation in their spring tide. Will you, for me,
thank Mrs Gray for her kind undertaking of purchases [of linen]
for us—and express to her our very admiring and astonished
satisfaction in the smallness of the account—Everything seems
to have been *most* judiciously chosen: On my own account, may
I beg very *particular* thanks for the *Rough* Towels—the house
itself which these snowy products of the Northern loom are to
decorate and illuminate, is still a castle in the *air*, I was going
to say—but more truly it may be said in the Fog of London—
We are Houseless; Vagabonds—Wandering Arabs—Nomads—
Pilgrims:—*Canterbury* Pilgrims we should have been today if
Effie had had her way—she would have gone and afforded the
encouragement and light of her lovely countenance to some
very Puseyital proceedings! I think it better she should come
to Oxford with me: and take the disease in the natural way:*
We are both much disappointed at finding ourselves on the road
to the midlands of England instead of the highlands of the Alps:
but the French are paying for it at last and we are consoled.

I beg your pardon for sending this scrawl but I might not
have been able to write at all till next week—if I had not now.
Alice's—Sophys and Robert's† letters are delightful Tell little
Aily [Alice] that we love her very much—very much love and
that we will come back to her and she shall come forward to us
Kindest love to George—sincerest regards to Mrs Gray. Ever
dear Mr Gray, and faithfully yours JRuskin I see I have not
said that Effie is a *very good girl*, so she is.⁸¹

Effie gave her mother a detailed description of the Lansdowne
House reception in a letter written from the Bear Inn at Reading on
their way to Oxford.‡ They spent the night of June 30 at Reading

* Edward Bouverie Pusey (1800–82) was Regius Professor of Hebrew at Oxford
from 1829 until his death. After Newman's secession to Rome in 1845, Dr Pusey
was the leader of the Oxford or Tractarian Movement. His High Church prin-
ciples were opposed to Ruskin's Evangelicalism. The Aclands were Puseyites but
Effie wrote to her mother from Oxford, 'You need not be afraid of us turning
puseyite for I see nothing like it and John is always arguing against it, at least he
was yesterday which was the first time the subject was mentioned.' (Letter of July
10, 1848.)
† Effie's brother, aged six. ‡ Given in James, pp. 112–14.

and went over to have tea with John's friend Miss Mitford, author of *Our Village*. On Saturday, July 1, they proceeded to Oxford where they stayed for nearly a fortnight with Dr Henry Acland and his wife in Broad Street. Henry Acland's father, Sir Thomas Dyke Acland, Bt., was also staying there, and Mrs Acland's father, William Cotton.*

Effie described their visit to Oxford as 'a continual round of festivities'. The hours the Aclands kept suited them very well— dinner at one o'clock and then freedom to do what they liked until tea between seven and eight. After a party in the gardens of Exeter College Effie told her mother, 'John was lamenting all the way home that he did not know anyone I could go to a ball with for there are capital ones every night. I think this will amuse you as I have never mentioned the subject and never thought of it but he wants me to dance and intends to take me to some dancing parties when we get to London in the winter. . . . She [Mrs Acland] is a good creature and John says she is perfection if she was not plain and didn't wear spectacles. . . . Always tell me what goes on at home about money matters for I would be very uneasy if I thought you did not tell me.'

Evidently they did tell her for on July 10 she was writing, 'I am extremely sorry to hear how dull you have been and I do not hear anything here about the funds or railways. . . . I remember the last year and know too well the spiritbreaking time you past. I am sorry for George for John can do nothing as yet and three months only are passed today, although it appears an age to you. I wish my father would try and keep like himself.'

They had intended going back to Reading to see Miss Mitford again when they left Oxford on July 13, but John had had a cough since they were at Dover which was not getting any better so they decided to go on their own to Winchester where they stayed for a few days at the Black Swan.

* William Cotton (1786–1866) was a director of the Bank of England from 1821 until shortly before his death, and Governor 1843–5. In 1812 he had married Sarah, daughter of Thomas Lane; they had seven children. Sir Thomas Dyke Acland and Gladstone were among those who had honorary degrees conferred on them at Commemoration on July 3, 1848.

EFFIE CRITICISES

❋

Mr and Mrs Ruskin meanwhile had remained at Folkestone, and by July 16 it was still undecided where they should meet John and Effie, for on that day Mr Ruskin wrote to an old friend:

I am not sure if you fully know of my Son being married to a Miss E Gray, Daughter of a worthy Lawyer at Perth—She has been long known to us—and is very pretty, lively and affectionate, about twenty years of age and I think there is every prospect of much happiness—They were married at Perth—the day in which we were in alarm in London about Chartists so that I could not leave home to be present at the Marriage and Mrs Ruskin dislikes going to Scotland—they came to us after a short Tour in Highlands and Lakes of Cumberland and have been mostly at Denmark Hill since 17 April—We are to meet them—please God—in a few days somewhere in the South as we do not return home for a month. My Son has been remarkably well till a fortnight ago, when he got cold at the Sea Side and he is not quite recovered from Cough—He has not yet entered the Church, but I know he keeps up his studies so as to be in one way qualified for it. He occupies himself with other pursuits also. Not idle quite in end or object—and he writes occasionally—The article in the last English Quarterly of April 1848 on *Eastlake* is written by him— I may have told you that before that the Article in the June 1847 Quarterly on Lord Lindsay's Christian art was by him— but as these are anonymous I tell you in confidence—you need not name the author.[82]

It is interesting that Mr Ruskin still had in mind the possibility of John's entering the Church. Proud as he was of his son's literary achievements he had no faith at this time that they would ever earn him a living.

By Thursday, July 20, the four of them were at Salisbury together at the White Hart Inn. On that day Effie wrote to her mother on paper engraved with a picture of Salisbury Cathedral, and put a cross on the top of the tower 'where John has been sketching and I have been trying it for two or three hours a day in the beginning of the week'.

During their stay at Salisbury Effie was very critical of Mr and Mrs Ruskin. It was a most unhappy time altogether. John was ill and Effie, instead of making enough allowance for his parents' anxiety, was extremely irritated by their fussing. On the 19th they had all driven over to Wilton to see the church that Lord Pembroke's son, Sidney Herbert, had just built there at the cost of £100,000 (according to Effie) as a memorial to his sister, Lady Shelburne.* As described by Effie to her mother it was 'built after Italian designs, most elaborate inside and out, the pillars of polished Sienna marble and black brought from Italy . . . and fine tesselated pavement . . . the stone carving wonderful . . . John said the church and everything about it made him quite sick, as bad as Babies before breakfast for you must know Mrs Acland brought her child into the room every morning and John said it made him sick every morning, and the idea of putting up imitations of the churches of Florence and Venice here was too bad and he grumbled all the way home. Mrs Ruskin was very angry and lectured him all the way home not withstanding the noise of the carriage which amused me very much. John's cold is not away yet but it is not so bad as he had with us and I think it would go away with care if Mr and Mrs Ruskin would only let him alone, they are telling him 20 times a day that it is very slight and only nervous which I think it is, at the same time they talk constantly to him about what he ought to do, and in the morning Mrs Ruskin begins with "don't sit near these

* Lord Shelburne (1816–66), Lord Lansdowne's heir, had married Lady Georgiana Herbert in 1840; she had died in March 1841. Hon. Sidney Herbert (1810–61), son of 11th Earl of Pembroke by his second wife Catherine, daughter of Count Woronzow, was M.P. for South Wiltshire 1832–60, Secretary of War 1845–6 and 1852–5; created Baron Herbert of Lea 1860. He was largely responsible for Florence Nightingale's being sent to the Crimea.

towels John their damp" and in the forenoon "John you must not read these papers till they are dried", and in this steaming weather George [Hobbs] has to take all his clothes to the kitchen fire to air them, and does not let him go out after dinner; we dine at half past four and from five to seven it is as warm as the hottest part of the day. John follows scarcely any of the directions and it would amuse me all this if I did not see that it makes John notwithstanding quite nervous and whenever they ask him how he is he begins to cough, then John coughs for a little and Mr R says "that cough is not going away I wish you would take care", and when I never speak of it I never hear him cough once; his pulse and general health are perfectly good. While I am writing John is out of the room and Mr and Mrs R are concocting all sorts of remedies. Mrs R is proposing *tea-papers* for his chest. They are most kind but I think all this does him harm.'[83]

Three days later she was back on the vexing subject of her brother George: 'John and I often talk about him but we can make no plan and John thinks and so do I that there is no chance of his father taking him, and it is a delicate point for us because John you see has no separate business of his own to enable him to speak independently, and again there are ten young men for one situation open in London in merchants houses and when they do get it they have to pay a sum of money each year, after this it is quite a lottery whether they rise above the situation of clerk. The first person I believe Mr Ruskin would do anything for would be Mr Watson who has been with him 39 years.* Mr Ruskin I daresay could and would get him into a house but it would cost my father more money than he could give at present, £80 or a 100. . . . I am very much obliged to you for giving me so long an account of yourselves and I am glad to think you are comfortable at times but I cannot help being distressed about you all and I often cry at night when I think what a load hangs over you and that I cannot help you in the least degree, but it would be much worse if you did not tell me for

* Henry Watson was Mr Ruskin's head Clerk who had been taken on at the age of sixteen. Unmarried, he lived with his widowed mother and three sisters in 'a house in a street of tone near the Park' which consumed all his salary. The family were very musical and frequently dined at Denmark Hill. Mr Watson had 'a singularly beautiful tenor voice'. (*Praeterita*, pp. 171–4.) According to Mr Ruskin (see p. 145) Mr Watson had been with him for thirty-one years. He died in 1865, a year after Mr Ruskin.

then I would fancy things were worse than they are. . . . John is
much better this evening but he has been in all day and having
taken strong medicine has taken some of the strength out of him
but I hope he will be better tomorrow.' This medicine was no
doubt 'the blue pill' which John was to mention in a subsequent
letter (p. 232) and which caused the first flare up between Effie
and Mrs Ruskin.

Four days later she wrote that John had been in bed for three
days but, excepting his cough, he was now much better. ' . . . he
finds himself very comfortable in bed, reading, being read to and
amused in various ways . . . the only thing I am fearful of is it
weakening him but whenever the house is ready at Denmark Hill
we are going home which we all think is the best plan. I think I am
the only person who is enjoying the place and in good health for
Mrs Ruskin has really a very bad cold and Mr Ruskin rather worse
than usual of his stomach complaints. I sit in my bedroom which
John now has to himself* with him till one o'clock sewing or talking
or reading a novel for a while aloud, then drawing and reading
French to myself. . . . I wish John would go to the Highlands, it
would be delightful, but he shrieks with horror whenever I mention
it so it is no use, and he hates England quite as much which is one
comfort to me at any rate, but you may be sure he will bring me
down to see you whenever he thinks it time.'[84]

On their last day at Salisbury, July 30, Effie informed her mother
that they had got a house, No. 31 Park Street, Grosvenor Square,
three doors from Lady Davy. It was one of those tall houses with
only about two rooms on each floor. On the top floor were servants'
rooms and 'a nice bedroom' so that George, when he came to
London to visit them, would have the 'honour of monopolising' all
their spare accommodation. 'Mr Ruskin kindly pays the ground
rent which is £300† and John and I the rent which is £200 a year.
I am sure you will think this a great deal and so do I as the house is

* When Effie secretly left Ruskin she left a letter for Mrs Ruskin telling her that
John had never made her his wife: 'Whilst we were at Salisbury, when you caused
me to be put in another room on account of an illness, which he [John] told me his
Father supposed to arise from his recent connexion with me, he used to laugh and
say his Father was imagining things very different to what they were.' (Letter of
April 25, 1854: Lutyens, 1967, p. 185.)

† According to Mr Ruskin's account book the £300 'ground rent' was in fact a
premium. (Bembridge.)

not large but extremely suitable for us and elegantly furnished, but
it is the most fashionable place in London and it is Mr Ruskins
desire that as we take it for seeing John's friends and visiting with
them it ought to be in a good situation and it is not as if we were
making our home there permanently.'

They all left Salisbury on July 31, by which time John was much
better, and after two nights at Winchester returned to Denmark Hill
on Wednesday, August 3. On arrival Effie heard from her father
that Mr Gadesden of Ewell Castle was staying at Bowerswell* and
interesting himself in George's future. Effie replied on August 3:

I hope through Mr Gadesden you may get something for
George. You see I would do anything I could for him and it
seems very strange to me that Mr Ruskin your oldest friend
here should not offer to see if there are any vacant situations
which George might fill but I see that both Mr and Mrs
Ruskin will not and cannot see the use of him coming here or
leaving Perth. They think that he could make a business in
Perth as his father did before him. I also think there may be an
under feeling as to not wishing to have him in London at all;
they like to live by themselves and I think would dislike more
relations coming about them for you see they are old now and
cannot make changes or admit of new things without much
trouble, and then they entirely treat me as John's wife and
their daughter and indulge me in every thing, but then it is a
suspicion in Mr Ruskin's mind I should think for fear I should
influence John in the least, so I am obliged to be extremely
careful in what I say regarding my own family at home for
fear he should think I took advantage in my present position,
for you see he does everything for us, and it is delicate ground
for us, especially me, to speak to him on the subject for he is
such a curious person that you really do not know what he is
meditating or devising. I think you are quite right not to send
any letter to him or rely in the least upon him for help. I
never speak to him scarcely about George for I see that both he
and Mrs R. don't approve of him doing anything but sticking

* Mr Gadesden gave Mr Gray a deodar tree during this visit to Bowerswell.
[Letter from James Gadesden to Effie, December 19, 1853.] It is still there, a huge
tree close to the house, with a plaque at the foot stating that it was planted by Mr
Gray in 1848.

to your desk, and when they talk a little I always stop for fear
of showing them that I am angry for it does provoke me to hear
them talking of what they don't in the least feel or understand,
and laying down things about what he might do for himself in
Perth which I know to be perfectly impossible, so I just let them
have it all their own way as they say they know Perth much
better than I can do, and as we never have the slightest dispute
upon any subject I think you will agree it is better not to begin
with this one; but although Mr Ruskin does this of course John
says this morning he, Mr R, would be very glad to hear of you
getting anything for George through other people so that
although I am guarded in what I say to him he has nothing to
do with my actions and you may command me in any way you
please. I will see Mr Gadesden and Mr Ewart* or any person
in London that you think could assist you and do what I can
but I shall not be in our house for six weeks yet and by that time
perhaps you will have thought of something I can do for you,
and John says I may do whatever I like. The reason I cannot
at present is that we go to France on Monday [August 7] for a
few weeks. John's cold is almost quite gone and he thinks it will
strengthen him for the winter to get a little French air, and
the truth is he has been pining so much for the Continent that
I think he is rather glad of this idea to go and I think his health
depends so much upon his feelings that doing what he has
wanted for so long will improve his spirits very much.

Effie was beginning to know John very well—at any rate this
aspect of his nature. The plan of going to France seems to have
been a very sudden one, though in her last letter from Salisbury of
July 30 Effie had mentioned that if John continued well they would
go away for another month, but there had been no hint of their
going abroad. The old couple decided not to go with them because
Mrs Ruskin in particular was not feeling at all well.

Two days before leaving London, Effie sent a letter to George
which she marked at the top '*read this to yourself first*':

 . . . I am very glad Mr Gadsden [*sic*] and you got on so well
and I hope that he may get some nice situation for you, he is a

* Francis Ewart of 3 Essex Court, Temple, a friend of Mr Gadesden and Mr Gray.

very kind person and I should think possesses influence from his former extensive business. . . . As you say I do not think Mr Ruskin wants you in London—what his reason is I can't tell but that he sees no use for it, it is a pity, but as you say it cannot be helped and I would not mind that in the least or take it into consideration for a moment in your plans, for it is not as if he or Mrs Ruskin did not like you for in fact they always speak very kindly of you and evidently like you. Mrs Ruskin only last night said that she never saw any boy so particular as you were in the house about the furniture and careful of your clothes, and the servants said they never had any one in the house who kept their room so tidy as you, and Mr Ruskin said Yes! he was always very neat and careful. Then you must recollect that it is a long time since you have seen them and I think Mr Ruskin perhaps forgets how old you are and that it is quite time for you [to be] looking about you! in short I suppose he has some crotchet in his head and I would never mind that for a moment. There is only one other thing that I trust you will not feel offended at my saying for I do not in the least intend it as a personal remark, but only as a thing I see in the world preferred, namely and what I mean gives a decided advantage in every society, a gentlemanly manner, appearance and address. In Perth where all three you must allow are eminently neglected you may perhaps sometimes think these matters of little moment and an absurd attention to such things makes a man ridiculous, but if you were here you would find it difficult to pick out the most talented high minded men who are not most particular on these points; and do we not feel more comfortable in the society of a well dressed, well bred man of good education than we do with the Ogilvies* who possessing great information on almost every point do not command in many things our respect from the neglect of the observances of society, and who from the want of them could never rise beyond their own limited circle. You possess eminently the means of making yourself agreeable by what is much valued— a handsome person and taking manners to strangers, but I would not have you overlook perfect neatness in your outward

* James Walter Ogilvie (1780–1867) was a solicitor in Dundee, an old friend of the Grays.

K

appearance and I shall always be happy to send you any thing
you would like to have that I can. Nor would I always like to
hear you suspect people unkindly, but if you were a good deal
with us in London I think you might change your opinion
when you met many of John's really good friends, and our
house would be a nice place for you to come to when you
wanted rest or enjoyment, and I would try and supply to you
some of the many wants you would feel in leaving Bowerswell. I
have your interest so sincerely at heart that you believe I hope
that everything I mention is for your own good and welfare
and happiness.

Effie's total inability to help George after evidently promising
to do so much for him must have been dreadfully galling to her and
she doubtless felt great resentment against Mr Ruskin for his
refusal to understand her father's predicament, and probably some
resentment against John too for his reluctance to influence his father.
This whole question of preferment for George was a most embittering
one between the Ruskins and the Grays.

15

THE NORMANDY TOUR

John and Effie were abroad, mostly in Normandy, for eleven weeks.[85] On August 7 Mr Ruskin accompanied them as far as Boulogne, to return next day to England while they went on to Abbeville by train. From there Effie told her father, 'you would really be quite delighted to see how happy John is in a place he likes and the raptures he is in quite amuse me'. John was intensely busy drawing throughout the whole tour, measuring and taking notes for his next book, *The Seven Lamps of Architecture*.

He wrote every day to his father. For the first fortnight he was greatly worried because his mother was ill. On August 20 he wrote to her from Rouen to thank her 'for doing what is so painful to you and seeing a doctor . . . I beg you specially to observe that though you were ill abroad, you are worse at home—and that you cannot therefore in mere prudence refuse to go with papa and us to Switzerland next spring—if we succeed in doing so, I shall not think this summer in any wise lost—for it is much better to have this moderate and deliberate enjoyment of France by itself, than to crowd all into one satiating tour: for the rest I have far, far more here to enjoy and to learn than my time admits. . . . But poor Effie would be far better off with Papa and you than with me, for I go out on my own account and when I come in am often too tired or too late to take her out so that unless she likes to come with me, always to the same place, she sometimes does not go out all day—and I sometimes cannot—for fear of cold, and sometimes will not—for fear of losing time, stop with her to look at the shops, the flowers, or the people—But she is very good and enjoys herself when she is out and is content to stop at home. Only you have certainly spoilt me, my dear mother, as far as expectations of walks are concerned—by your excellent walking—I had no idea of the effect of fatigue on women

133

—Effie—if I take her, after she is once tired—half a mile, round—
is reduced nearly to fainting and comes in with her eyes full of tears
—if however I can once get her to any place where she can rest—
she will *wait* for me three hours together—(and I certainly could not
always say as much for you). So I carry my camp seat in my pocket
—and when I want to make a note of anything—Effie sits down—
n'importe ou—not in the cleanest places always—and is as quiet as
a mouse. She is also a capital investigator, and I owe it to her deter-
mined perseverance—and fearlessness of dark passages and dirt in
the cause of—philosophy—or curiosity—that I saw the other day the
interior of the Abbaye St Armand, certainly the most exquisite
piece of wood painting for rooms, I ever saw in any country. Her
fatigue, too, depends more on the heat than the distance, and she
has been up St Catherine's with me this evening with great enjoy-
ment—much increased by finding heather and bluebells in quan-
tities at the top.'* [86]

He praised Effie again a fortnight later to her father: 'Effie and
I understand each other perfectly and she accommodates herself to
all my ways—only remonstrating when she thinks I draw too much
for my health—she is a very good girl.'[87]

If John and Effie thought they could get away from family
troubles while they were abroad they were mistaken. Mr Gray
himself had now for the first time told Mr Ruskin of his intention
to send George to London to begin a new life in business. Mr
Ruskin's reply caused deep offence:

London 24 Augt. 1848.

I do not think we need regret our son and Daughters going
to France—I have a pleasant letter from John today at Rouen.
They seem both well and happy and Mrs Ruskin would have
suffered rather more by their being at home for she fears
annoying any one and wants particularly quiet.—Your next
topic Railroads it is in vain to discuss. . . . You say Mr Burns†
will alone suffer through you—I thought you had Money of

* Murray's *Hand-Book for France* (1848 edition) states that the Convent of St
Armand had recently been pulled down and that only 'a few curious fragments
remained in the Rue St Armand'. The Mont St Catherine is a hill 380 feet high
close to the Seine.

† Archibald Burns (1802–87) was Manager of the Central Bank of Scotland,
31 St John St, Perth.

several Acquaintance also engaged—It is better for your
Business prospects if you have not—but if Mr Burns be Agent
to a Bank, he will lose his situation—but when *he* kindly
submits to wait and lose, you should do all you can to preserve
your Strength and powers of mind. This is much more impor-
tant than what the price of shares are—I have a very shrewd
Customer for Wines who lost his shrewdness in share dealing
and put his all into Edinr & Glasgow at 73 and 77 they went to
37. He never reads the share list but pushes his Wine Trade
gaily and successfully as you should the Law. Do not let your
slumbers be disturbed about your new House or about what
people will say—you perhaps have been envied and some-
times evil spoken of in your present mansion—you will be
more loved in a small and I should for one visit you with much
more pleasure in another—I don't like the Drawing so well as
the old small House and I utterly abhor Gas and Bowling
Greens*—Half your bad Dreams may come of Gas and
Cucumbers ask Phemy about Cucumbers—when they come on
Table here—

On the subject of disposing of George I would not presume
to influence or interfere but as I am ever frank with all persons
I would wish to guard you against expectations from me—I
will do all I can for Phemy but for twenty reasons I promise
nothing for George—You will of course follow the advice and
opinions of your well known friends—I only hope that in this
change of destination you are not looking at all to me and that
he is not looking to London as a place of pleasure—I name this
because I have always thought (though it may be erroneously)
that Georges Education has been one rather of pleasure and
Excitement than of work—I have said this to Yourself before—
Before taking the irretrievable step George should fully under-
stand what he probably comes here to—To a solitary Lodging
or some family in the City to whom his Board is an object—
His Sister and Brother in Law if family matters admit of it, will
not be in London 4 months a year these 7 years and when here

* Mr Ruskin had not seen the new house as he had not been to Perth since it was
finished. The drawing he refers to is no doubt the one reproduced in James (p. 40)
and attributed to Ruskin. It is inscribed in Effie's hand 'Bowerswell, Sept. 1846'.
Ruskin was not at Bowerswell in 1846 and the only year he was there in September
was 1849. The bowling green at Bowerswell is still very well kept.

they will be absorbed by Society to which though they have the will they have not the power to give him admission—as a professional man, as a Lawyer occasionally visiting London, they might, as a Brokers Clerk in the City they cannot—Then as to Denmark Hill—it has come to this, that Mrs Ruskin and myself since we came to this House are thoroughly worn out with people coming and we must either kill ourselves or shut our Doors—we have neither strength nor spirits for Society—people in the House beyond 3 Hours to Dinner when asked—are a deadweight on us—Except the French people who were thrown upon us by a Revolution* we have had no sleeping Visitors these many months—my own Cousin young Tweddale [p. 83n] never stopped a night in the House—nor does one of my Relations ever come to Dinner without special invitation—Dr Will^m Richardson,† alone excepted—his Time not being his own—my business follows me home, I write most of my Foreign Letters in Evenings—in short I will only promise George an occasional Sunday Dinner but allowing he may have many friends here with more heart and taste for society—the next question is his chance of success—You are sanguine I am otherwise—He leaves a Certainty for an Uncertainty and I do not quite like his leaving you when you may be too much overcome to manage Business—I admit all Georges Virtues and amiabilities—but there may be a whole staff of fine youths in a large Colonial Brokers—It is not the merely pleasing an Employer—There must be brought an unconquerable *will* and power to seize upon that which a hundred Competitors are

* Effie had written to her father from Edinburgh on March 10, 1848, 'The Bethunes have arrived at the Ruskins and the Countess Des Roys is expected with some of the rest. I suppose the house will be quite full. They are great Royalists so I suppose have left France.' The Comtesse des Roys was Elise, the fourth Domecq girl and the kindest; Caroline Bethune was the youngest.

† The second of Jessie's three sons, born 1811. After passing his medical examinations in 1831 and a journey to Ceylon as ship's doctor, he was established by Mr Ruskin in a small shop in the Bayswater Road where he began general practice, mostly among the poor. He 'became an excellent physician—and one of the best chess-players I have ever known'. (*Praeterita*, pp. 411–12.) At this time he had just moved into 'an immense house', according to Effie, 17 Radnor Place, W.2., with his second wife, Eleanor Bolding, sister of Mary Richardson's husband, Parker Bolding. Effie described her in a letter of June 7, 1848, as 'horribly tawdry as usual'. William's first wife had died in childbirth in 1841, leaving him with at least two children. Later he moved his practice to Tunbridge Wells.

striving to keep from you—now if this was a quality of George—
it should already have appeared in his having made a part of
the Perth Business his own—I do not prophecy however—The
great evil is an immediate Cost to you of £100 to £120 a year
and the possibility of ten years Labour with very small pay.
Neither do I like change of Profession—one very clever Edin^r
Lawyer I do know who became a Merchant at 25 and is now
in Beggary at 60. As for mere amiableness—I have a Clerk
[Henry Watson] most amiable, most honourable—who writes
a good Letter—he has been Clerk 31 years and never in my
Life will be more and yet I could not have hindered him from
being Partner long ago—had he so *determined*—Mrs Ruskin is
with me rather sorry that George has not made his presence
tell in your Business—you are sanguine about George succeed-
ing here—I am so doubtful about my son with his good Talents
doing any good in the City that to save what he has I keep him
out of the City. . . .
[P.S.] George was formerly so attached to home that he could
scarcely be got away—It is not right to leave it at a time like
this. His pride will meet with more mortifications as a London
Clerk than at Perth under the worst mishaps.

I shall probably part with my House yet before you do with
yours. John will either be in London or among Hills, and it
is only an enormous expence and Burthen on Mrs R. and me
and besides without Business John could not keep it.

Mr Ruskin's point of view, though it was sure to wound, was
understandable: he had done all in his power to emancipate John
from trade; Effie was at least the daughter of a professional man, but
for John to acquire a brother-in-law in trade would be a back-
sliding that defeated all his father's ambitions for him.

Mr Ruskin evidently told John about his letter to Mr Gray or
perhaps even sent him a copy of it. John was sympathetic to his
father over the matter. '. . . as for G.G.,' he wrote, 'I shall take care
that he shall give you no trouble nor interfere with my society—
I am very sorry he is coming and of course must be prepared for
some things that I shall not like—but I shall make him understand
his position—and, although I cannot exclude him from seeing his
sister—yet I shall keep my study inviolable—Effie will have to

choose between *him* and *me*—my duty to him in kindness I shall of course do—and although I fully feel with you that he is not likely to succeed—yet I do not think the boys *object* in coming to town is an *easy* life—I think he fully *intends* hard work—how he may maintain his purpose I know not—you have written what you always do, just what is right—and pray do not yield *any* thing, you have yielded quite enough of comfort already.'[88]

How little Mr Gray felt that Mr Ruskin had written 'just what is right' is shown in the letter below:

Perth 28 Aug 1848.

My dearest Phemy,

Your mother intended writing you tonight but as I have an hour to spare I promised to do so, and acknowledge receipt of your last letter for which I beg to thank you.

You are aware that I consulted Mr Gadesden and Mr Halket* about George and they both recommended me to get him into the office of a Colonial Broker—accordingly I asked their assistance to get him such a situation and they are both on the outlook. Last week I had a Letter from Mr Ruskin which required an answer and I thought it right to take the opportunity of letting him know my reasons for sending George to London should a suitable situation offer. He replies strongly disapproving of my plan and says if I expect anything from him I will be disappointed for while he will do all he can for you 'but for twenty reasons I promise nothing for George'. Besides he says that while you could admit George into your House and society were he visiting London as a professional man you could not admit him as a Colonial Broker's Clerk. Such ideas I am sure must shock your feelings as they have done mine. Mr Ruskins notions are so very peculiar that I am quite at loss to understand him. I distinctly explained to him that should I fail the little business which would remain for Mel [Melville Jameson] and myself would hardly support our families and George could not be assumed as a partner with

* David Halket, a London insurance broker and shipping and general agent, of 19 St Helen's Place in the City. The Halkets were one of the families Effie refused to call on after her marriage: 'Mr Halket is no doubt a worthy person . . . but his wife and family it is impossible I can visit with and were I in no society at all I would even avoid theirs.' (Letter of May 29, 1848.)

any prospect of success, therefore I was necessitated to send him to London to push his fortune there. He overlooks my reasons entirely and thinks only of George becoming a burden upon him or you, which we never dream't of, and says all he can to dissuade me from my plan. What is to be done under these circumstances I know not for I should not like to oppose Mr Ruskin and yet I see no other opening but London for George. I have used every effort to get him into an office in Edinr, but without effect.

Your Aunt Jessie is not making a good recovery and is still in a very exhausted and precarious state. Thomson and Scott see her twice a day and decline to give any decided opinion about her, the fever from exhaustion continues and till it abates and she is able to take some nourishment we will be kept in great anxiety.* Mel. has only been two hours in the office in four days. Your Mother will write to you tomorrow or next day and give you full particulars. The Scarlet fever is raging in Bridgend so that we never allow the Children to go down there. Mr Clark the maltster has lost two and a third is very ill. John Jackson's Children have had it but are getting better. Mr Runciman who used to give George private lessons died yesterday after two hours illness, it is supposed disease of the heart.† I saw my Uncle Andrew yesterday who is getting daily worse. He has lost the use of his left arm and left eye and cannot sit up in his chair but sinks down like an Infant.‡

The weather here has become showery which is retarding harvest and creating great anxiety. There can be no doubt that in England and Ireland the crops, particularly the Potatoes, will be seriously deficient which must of necessity cause an efflux of bullion to America to purchase grain and make money

* Jessie had had a son, Melville, on August 20 who died next day. She no doubt had puerperal fever; she rallied a little but died on September 26. Dr Fraser Thomson lived at 8 Crescent (now Atholl Crescent), Perth, and Dr David Scott was a surgeon druggist of 35 High St, Perth.

† Janet, eldest daughter of Thomas Clark, maltster, of 49 Commercial Street, Bridgend, had died on August 27. John Jackson was an auctioneer living in Bowerswell Rd. William Runciman was a teacher at the Perth Academy and lived at 129 South St.

‡ Effie's great-uncle, Andrew Jameson. He died at 4 Crescent, Perth, on September 17 in his eightieth year. It was his widow who narrated her reminiscences to Albert Gray.

scarce during next season—this will lower the value of all Railway property and produce much misery. For my own part I have lost all hope and cannot conceive how Burns should still be so sanguine as to carry me on. The result will be to increase my debt to the Bank but in the meantime it allows us a living. The fall in Railways during the last fortnight has been fearful.*

I am glad to hear that John and you are so happy in France and sincerely hope the change of air and society may re-establish his health. The Children are all in excellent health and Alice particularly in great spirits. We all unite in kindest regards to John and yourself while I remain my dearest Phemy, Most affectionately yours

<div align="right">Geo. Gray.</div>

No wonder Effie was reduced to tears by this letter. 'Effie has bad news from Scotland,' John told his father, ' . . . Mr Gray's affairs worse than ever—she was very low all yesterday evening—but has recovered to day—Perhaps these matters are all good for me—I am certainly terribly selfish—and care little for anything so that I can get quiet—and good pencils—and a Turner or two—it was—and perhaps still is—growing upon me—that it may be just as well that I am forced to think and feel a little for others—at least I may think—but I don't feel—even when poor Effie was crying last night I felt it by no means as a husband should—but rather a bore—however I comforted her in a very dutiful way—but it may be as well—perhaps on the other hand, that I am not easily worked upon by these things.'[89]

It is not surprising considering all Effie's worries that a few days later John was writing, 'The only thing we can find to complain of is that Effie loses her hair continually; I wish you would ask my mother or William [Richardson] or Dr Grant why this is—it is really getting serious—and besides the thing itself, seems to be a sign of bad health—it comes out by handfuls when it is brushed in the morning. It has come out in the same way ever since she went to Dover'.† [90] The advice given was evidently not acceptable: 'We

* The Railway Market had been very depressed since August 12 but there was a further sharp fall in all railway shares as a result of a serious accident on August 17 on the London & North Western Line, five miles north of Wolverhampton. Many people were injured, though none fatally.

† It seems that Effie's hair had started to come out the previous November.

will not shave,' John wrote later, 'I am glad to say it has stopped coming out since she got here [Caen].'[91]

Nevertheless she must have lost a great deal of her hair, for, in a list of their expenses while they were in Paris in October on their way home, is an item of 82 francs for 'Effie's hair' which surely could only have been for a false hair piece. They were not in Paris long enough for a course of treatment. It was probably at this time that she stopped doing her hair in plaits round her head as in George Richmond's portrait (reproduced p. 50) and wore it as in Thomas Richmond's portrait (reproduced p. 146).

(See John's first love letter to her, p. 64.) Dr Grant was the Ruskins' family physician who lived on Richmond Hill. He had only just obtained his diploma when he attended John during his illness at Dunkeld in 1827. Mr Ruskin had 'had an almost paternal influence over him'. Ruskin describes him in *Praeterita* (pp. 97–100).

MR RUSKIN'S CAREER

Meanwhile Mr Ruskin had written two more letters to Mr Gray on two consecutive days. The second of these letters is of particular interest because it contains the only first-hand account there is of Mr Ruskin's early life and struggles, and helps more than anything else towards a better understanding of this strange man.

<div style="text-align: right">London 31 Aug^t 1848.</div>

I am obliged by your favour of 29 Aug^t and as the subject is important and to both of us interesting—I will encroach on your time by enlarging on it to prevent if possible the smallest misunderstanding or unpleasant feeling being caused by my Letters. The allusion to the Society my Son and your Daughter might move in might convey an impression of very absurd and very inordinate ambition—and the exclusiveness attached to it in relation to George might seem heartless and unkind but the facts are these. I happened to make my Son a Gentleman Commoner at Ch. Church Oxford—partly to increase the comforts of a youth in delicate Health—partly to see during my own Life how he would stand such an Ordeal—partly from the vanity of showing I would give my Son the best *quality* of Education I could get for Money, and lastly because the Dean of Ch. Church* said I ought to do so. He conducted himself well—he was resolute in moderation, he was at once introduced

* Thomas Gainsford (1779–1855), Dean of Christ Church 1831–55. John went into residence at Christ Church in January 1837. His name had been down for years, for his father 'never had any doubts about putting me at the most fashionable college', but it was not until Mr Ruskin went with him to Oxford in October 1836 to sit for his matriculation that he realised the class distinctions which then existed between Noblemen, Gentleman Commoners and Commoners. (*Praeterita*, p. 184.)

to the highest men by two young noblemen whom he had met on his travels*—he showed Talent and got the prize for English Verse.† He was invited to the Duke of Leinsters and many places he refused to go to—I have not named to any one, what Company he has kept since leaving College—but I was gratified to find him admitted to Tables of Ministers, Ambassadors and Bishops but I was aware this arose from his having shown some knowledge in the fine Arts, a subject chiefly interesting to the higher Classes—How little he valued high Tables may be gathered from the fact that, not from him, but by mere chance I heard, that one of a Select Dinner Party of eight of which he was one, was Lord John Russell—John cares nothing at all about high people. He is not a Tuft hunter and values people only for Intellect and worth and associates only with people who have tastes like his own. He detests crowds and London Seasons, but the Men whose Intellects he desires to come in contact with, are only to be found in distinguished Circles or Coteries and hence he will be found in high Society just so far as it is necessary. I deem this long History due to George, that he may comprehend my hinting the probability of a divided Society. It is not George alone but Mrs Ruskin and my self are equally excluded. John has brought Lords to our Table but we are very marked in regarding them as Johns Visitors and when Sir Wr and Lady James last breakfasted here John and Effie presided and neither Mrs R nor I ever appeared.‡ I have

* Mr Ruskin may have been referring to Lords March and Ward (see note, p. 108) though they were never friends of Ruskin's. Two other members of the aristocracy who were at Christ Church with him and who remained his friends were the Marquis of Kildare (1819—87), who succeeded his father as 4th Duke of Leinster in 1875, and Viscount Eastnor (1818–83) who succeeded his father as 3rd Earl Somers in 1852. Eastnor in particular was a friend. Effie had met him while she was staying at Denmark Hill in April 1847 and had written that he was very talented and 'rather fond of queer things, such as he wanted to see a Massacre and went some months ago to Algiers where he saw two or three very good ones and has come back quite satisfied'.

† He won the Newdigate Prize early in 1839 at the third try with *Salsette and Elephanta*, a poem about Hindu conversion to Christianity (given in *Works*, II, 90–100).

‡ This was confirmed by Effie. On May 20 she had written, 'I was so sleepy this morning that they did not wake me for Mr and Mrs Ruskin's breakfast as we were to have ours at 9½ as we expected Sir Walter and Lady James. . . . John and I entertained them and they stayed till twelve and looked at the pictures etc.' John had known Sir Walter James, Bt. (1816–93), at Christ Church; he was a good

got them their House in Park St to be among their own Set—when they like to put up with Wine Merchts or Colonial Brokers they may dine here now and then—but I hope there is no undue pride in my desiring the young Couple to retain some hold of good Society. My sons inclination is rather too recluse—and there is always danger of a Recluse getting rusty and Society shaking him off as rapidly as it took him on—whether by his Book, or tastes I cannot tell—but there [is] a very kind interest taken in him, and Effie gains golden Opinions. In a Letter I have just sent him from Lord Eastnor—are these words—'I heard of your Marriage last month quite accidentally from Lady Stratford Canning* at Constantinople' I think it rather pleasant than otherwise both to you and me to have our Children spoken of by such persons—

I now come to your plans for George and really can urge nothing against such good Sense—you may expect I might allude to any chance in my own Line for George or rather if you do not expect it think I don't do much in glancing that way for any chance. I shall make my Letter as long as a Speech in the House of Commons but I must tell you that long before my Son declared for Miss Gray I told him that I knew your position but as he had been cruelly thwarted before on account of Religion—if he could get over his Mothers superstitious dread of Perth—I would not oppose his wishes merely on account of property—that if the worst happened I might when I left Business—if George could not be a Lawyer—try and hook him on to my Successors:† but as time advances—this seems not so easy—here again come detail—Mr Telford having many relations like myself rather troublesome it was an article stipulated

amateur artist. In 1841 he had married Sarah, daughter of Cuthbert Ellison of Hebburn Hall, County Durham. In London they lived at 11 Whitehall Place, where John and Effie had dined with them on May 15. He was created Baron Northbourne in 1884.

* Eliza, daughter of James Alexander, she had married Sir Stratford Canning as his second wife in 1825. Mr Ruskin had evidently not told John that he had read this letter because on September 5 John wrote to him, 'Eastnor . . . heard of my marriage, he said, from Lady Canning at Constantinople!' (Yale.)

† It seems from this that Mr Ruskin had given John authority to raise the Grays' hopes of his taking George into his business. This passage also contains further evidence that John knew of Mr Gray's financial troubles before ever proposing to Effie.

that neither should have Relations in the House. Mr Telford*
waived this for James Richardson—and it never will be waived
again. James was a good Youth but gave little satisfaction.† I
am keeping at Business whilst able because it is the only sure
way of adding a trifle to fill up the gap made by falling funds
and Railroads; but if I live to give up the firm will be annihi-
lated and Mr Domecqs Nephew or some Individual having
£20,000 will become a House, taking Watson of 31 years
standing and Ritchie‡ of 15 years as part of the Machinery,
leaving no opening for any one beyond £50 to £100 a year.
My Son I have strongly and solemnly enjoined never to put
any part of what I give or leave him, in Business. I wanted him
to be in the Church—to be a Bishop if he could, but to eschew
Commerce. I do not however urge my opinions on you as very
sound—my experience has been perhaps a sad one—I have
been often amused at people talking of my good established
Business as of something that had been entirely ready made
and would keep going on for ever without much effort or care.
Flemyng says I may set myself down with my pipe in my

* Henry Telford, a nephew of John McTaggart. McTaggart was a Colonial
broker of 6 Lawrence Poultney-hill, connected with the Ruskins in that his sister,
Margaret, had married James Tweddale, brother of Catherine Ruskin (Mr
Ruskin's mother). It was Henry Telford who had put up the money for the firm of
Ruskin, Telford & Domecq, founded in 1815. Its offices in Billiter Street were
owned by Mr Telford. He never married and was the perfect partner for Mr Ruskin
for forty-four years until his death in 1859. Mr Ruskin wrote of him, 'He was the
Kindest hearted & most gentlemanly man I almost ever knew.' (From letter of
July 12, 1859, to W. H. Harrison: Viljoen, p. 132.)

† James Richardson was Jessie's eldest son (1808–26). Ruskin wrote about him,
'My father brought him up to London when he was one—or two—and twenty, and
put him into his counting house to see what could be made of him: but, though
perfectly well behaved, he was undiligent and effectless. . . . He fell into rapid
decline and died.' (*Praeterita*, p. 140.) Ruskin was wrong about his age; it is
recorded on Jessie's tombstone that he died May 8, 1826, 'aged 18 years'; the boy
was hardly given a chance. When Mr Ruskin refused to take the other Richardson
boys into his firm after their mother's death, he told Mr Gray that James had cost
him 'two years expensive keep', and added, 'We cannot turn our Counting House
into an infant school for grown Babies. . . . If I help Women and Children I cannot
be plagued with men—I have no patience with the helplessness of Twenty one.'
(From unpublished letter of December 20, 1828: Bodleian.)

‡ Henry Richie, the second clerk. Both clerks remained with Mr Ruskin until his
death in 1864. Mr Ruskin's firm died with him and both clerks then became part-
ners in a new agency, Peter Domecq & Co. The third partner was Mr Domecq's
nephew, Pedro Domecq Loustar.

mouth and be quite easy—I shall perhaps bestow the tedious-
ness of another Letter upon you to give you and George the
history of what they call a Lucky Man for many think me
much richer than I am and that my money has been easily
got.*

My opinions about George may be biassed in two ways—I
have had a very anxious Life and I had always a hankering
after Law, not to have it dispensed to me but to dispense it to
others. I do not wonder at Mr Gadesdens difficulty—I am sure
I could not tell where to find an office for a youth.

It was from your own Words I concluded, you had more than
Mr Burns interested in your fate. You said, I think, your
friends knew how their property was staked and must take the
Consequences.

I was afraid of disturbing Effies enjoyment and kept back
your Letter till today as you said it was bad news—I am glad
I did—I now send it with news of a favourable turn which we
are happy to hear of with Mrs Jameson—I trust it has con-
tinued.[92]

London Sep[r] 1848
[endorsed by Mr Gray: 1 Sept. 1848]

As I should like you to understand what reasons I had, or
imagined I had for keeping my Son out of the City† and for not
particularly advising your son to come into it—I will follow
up my late Letters with some details of my own mercantile
Career. I came to London at 16 years of Age [in 1801] with a
Letter from my Uncle [James] Tweddale‡ to Jn McTaggart
[Note p. 145], one of the first Colonial Brokers in London and
my aunts Brother. His House took no Connections but he
promised to look out—meanwhile Mr Moore [pp. 2 and 9n] for
whom my Father was agent in Scotland, received me into his
House for Bed and Breakfast and Tea except Sundays as he was

* When Mr Ruskin died in 1864 he left his widow £37,000 and the Denmark
Hill house, and to John £120,000, various properties and pictures valued at £10,000.
† Ruskin wrote in *Praeterita* (pp. 24–5) that his mother had solemnly devoted
him to God before he was born, and his father, giving in to her as he always did
in large things, allowed him 'to be thus withdrawn from the sherry trade as an
unclean thing'. His father's ambition, Ruskin said, was only for his son. (Ibid.,
p. 379.)
‡ A wine merchant in the City.

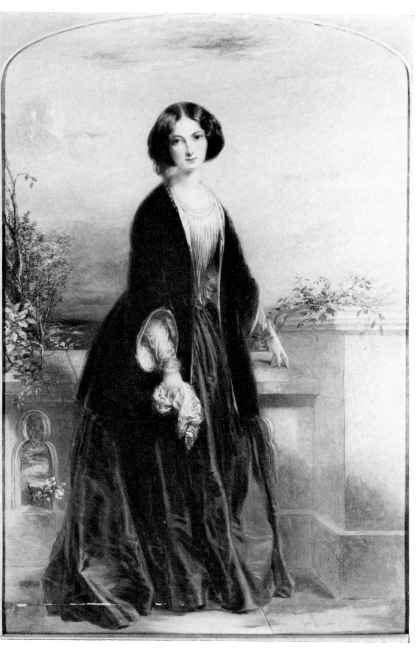

Effie Ruskin, oil painting by Thomas Richmond, 1851.

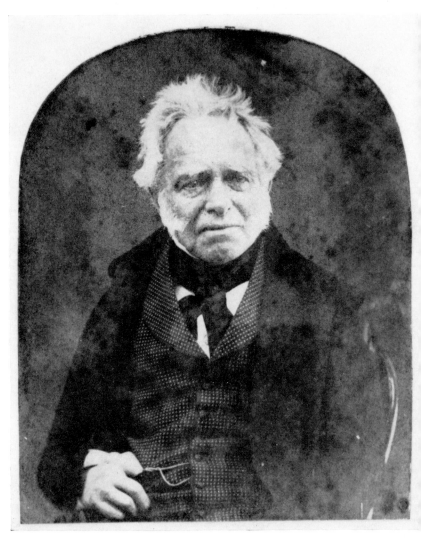

John James Ruskin, photograph *c.* 1860.

Roman Catholic—and my Father placed me with Fyfe Druggist* to wait for Mr M^cTaggarts situation. I lost 15 months waiting and went back to Edinburgh. In some months after, I was called to London to go into Amyand Cornwall Co, a German and Russian House.† Amyand, a Bank Director in The House, was in a dwindling way but out of compliment to Mr M^cTaggart perhaps they paid me £100—a year. I got nothing at the Druggists and at the end of my Seventh year in London I found my self with this £100 a year and working twice a week till 11 night, other nights 8, Saturdays 4—I plagued Mr M^cTaggart who with all his Influence could not help me, till happily for me an Irish Clerk in the then great House of Gordon, Murphy & Co‡ embezzled the Petty Cash and I was asked if I would undertake the whole Custom House Business, including the clearing out the ships for they employed no Brokers. I agreed at once but found some difficulty for every Vessel that came to us from South America, brought packages or articles contrary to Law and there was perpetual detention and memorializing the Treasury but I kept my Troubles quiet and fought on. I thought I could hardly get into a worse scrape than my predecessor who had, by a Blunder, got a Cargo worth £270,000 seized and the House had £500 to pay to get her released. I was to have £150 Salary but they were satisfied and gave me £200. I was now 23 and as my Father was by good living getting behind—I saw my only dependence was here and I seized every opportunity to make myself useful.

* William Fyfe, Druggist, of 89 Wood St, E.C. 2.

† Amyand & Co., Merchants, of 7 King's Arm Yard, Coleman St, had been in existence certainly since 1800. In 1808 the firm became Amyand & Cornewall and moved to 7 Austin Friars, shortly before Mr Ruskin left it, which was perhaps the reason why he spelt Cornewall wrongly. There was a bank, Amyand, Staples & Co. at 50 Cornhill from 1762 to 1770 which was then incorporated into Cornewall and afterwards became Dimsdale, all at the same address. (*Handbook of London Bankers* by Hilton Price: Chatto & Windus, 1876.) The Amyand Mr Ruskin knew was probably a grandson of Claudius Amyand, principal surgeon to George II, and son or nephew of George Amyand who had been a merchant in London, an M.P., an assistant of the Russia Co. a director of the East India Co. Created a baronet in 1764 he had married a daughter of a merchant of Hamburg—hence the 'German and Russian House'.

‡ Gordon, Murphy first appeared in the London directories in 1807 at 28 Great Winchester St; by 1810 the firm had moved to 26 Austin Friars, so Mr Ruskin would have known all that was going on in a business so close to where he was working at Amyand's.

L

The enormous expenditure of the princely partners Sir W^m Duff Gordon,* Colonel Murphy and Jas Farrell, and the sending abroad in the Reid Irving fashion† £150,000 in Goods for which no Return came—Murphy's Brother having gambled all away, caused pressure, and a course of discounts commenced. The Cash Keeper was a Young Man of some property and he came to Business on Horseback at 11 and 12 oClock. I was out getting Bills discounted by Gurnesy long before this. I thought I could manage Cash and Custom House too—I displaced Williams, Cash Keeper—our payments were then 1½ million a year on an average. Every morning at 9 for a long time I met the wily Duncan Hunter to exchange Accommodation Bills. I recollect a warm Saturday in July 1810 on which I had £28000 to pay and at 10 oClock I had only £10,000 at the Bankers—I raised the rest among the Jews and Quakers. Sir W^m D Gordon managed the English Correspondence with Jamaica and Cadiz but he was member for Worcester and much engaged. I heard him one night say he would write on an important subject next day to Cadiz—I knew his sentiments—I wrote a Letter at night and placed it before him next day. He read and signed and from that day I had Cadiz and Jamaica Correspondence to myself except when Farrell wrote a Letter. They raised my salary to £300 and gave me Rooms in the House with the Junior Partner where I also dined every day he was at home. Having Cash, Correspondence and Custom House I was safe enough if the House had been so—but no Business could stand £25000 for Contested Elections, £20,000 for House and furniture in Portland Place, £10,000 for Jewels to Lady Duff Gordon on her marriage.‡ I saw the House was

* William Gordon (1772–1823) was the second son of Alexander, Lord Rockville, a lord of session. In 1815 he succeeded his uncle, Sir James Duff, Bt., as 2nd baronet and assumed the additional surname of Duff; therefore, the whole time Mr Ruskin was with him, he was still Mr William Gordon.

† Reid Irving & Co. of 16 Tokenhurst yard, in the City of London.

‡ In 1810 William Gordon had married Caroline, daughter of Sir George Cornewall, Bt. There was a connection between the firms of Amyand, Cornewall and Gordon, Murphy in that the eldest son of Sir George Amyand, also called George, succeeded his father as 2nd baronet in 1766 and married in 1771 Catherine, only daughter and heiress of Velters Cornewall of Moccas Court, Herefordshire, and assumed the surname of Cornewall. It was his youngest daughter, Caroline, who married William Gordon.

Gordon was M.P. for Worcester City 1807–18, and it was Colonel Murphy who

going down—about 1813—Mr Domecq was a Clerk in the House—he was nephew to Haurie whose Wines [from Jerez] Gordon & Co sold—but Hauries and Gordon & Co quarrelled. Domecq associated only with the Foreign Clerks of whom there were six or seven. He had not exchanged ten words with me in as many months when he called me aside one day and asked if I would join him and be agent to his Uncle if he could get the appointment for us. I said only on Condition of Gordon, Murphy & Co giving me leave—when I named it Sir W. D. Gordon said he had plans of his own for me—but I was determined to avoid connection with such Extravagance. I asked a few Weeks for my Health after being 5 years there and 4 in Amyands without a Holiday, and at Gordons we were often till 12 and 1 oClock—owing to Sir Wm coming from House of Commons to City—I left by Coach for Edinr in 1813 after being in Counting House till Midnight—totally exhausted and was seized with Typhus fever at Ferrybridge* [Yorkshire] I was at Perth till 1814 [recuperating]—I joined Domecq as agents for sale of Hauries Wine—Now only observe—the first House Amyand, Bank Director, failed—the second House that was the greatest Spanish House of the day—failed, and to amuse you I send on loan and for careful return a pamphlet setting forth the Situation of the third House [Haurie's] I engaged with—you see that but by a kind of luck I escaped from £100 a year in a decaying House and again by an unlooked for offer from Domecq from a falling House, and after all when my own House began we had to struggle against the Embarrassments of the third House. The quarrels of Haurie with Gordon got me my present Business but the quarrels of Haurie and my late partner Domecq gave us constant trouble. In 1825 the Assignees of Haurie filed a Bill in Chancery against my London House asking 108 long questions as if we were parties with Domecq at Xerez. [Haurie had gone bankrupt.] I was very poorly in 1825 but I quite enjoyed answering this Bill. Knight said he never

lived at 23 Portland Place. Gordon, though, after his marriage, lived at 15 Devonshire Street, off Portland Place.

* This was in August 1813 when John James was on his way north to visit his parents in Perth. He very nearly died and was nursed by Margaret Cox. (Viljoen, p. 128.) See p. 6.

saw a Bill more thoroughly demolished. The Assignees never troubled us more. Domecq had good opportunities at Xerez. It may be Spanish Exaggeration to say as in the pamphlet that he made a fortune in 2 years but with this I had nothing to do. Domecq had a share of my London House but I had no share of Xerez profits. I kept clear of Foreign risk and defied Chancery Bills—but we had young Haurie opposing Domecq and at Daggers drawn. We have [had?] Sir W^m Duff, now Lady Duff Gordon also opposing Domecq—although the first Wines Sir W^m sent when I acted for Haurie, he sent for sale to me. So I was selling for two Antagonist Houses but I gave up Sir W^m as I could not well keep both. The opposition of young Haurie has been harrassing and the competition now from all quarters renders our Business most unpleasant—compared to former years. I run the risk of tiring you sadly with this History but you can only see by such details that what people may call a nice pleasant Business has not been arrived at with little trouble and that in fact I am more like one navigating on a plank saved from the wreck of several large Vessels—and patched up at length into a little craft for my self. Haurie's shipments had sunk to 20 Butts, there was no established Business in this—I got Mr M^cTaggarts Nephew, Telford, to bring in money, for Domecq and I had only £1500 between us. I went to every Town in England most in Scotland and some in Ireland till I raised their exports of 20 Butts Wine to 3000— but the day for that is past—I have now twice the trouble for a fourth of our former Business. Amyand—Cornwall—Gordon— Murphy—Farrell—Domecq are all dead—the present Mr Domecq [Juan Pedro] is Brother to my late partner but not partner to me.

In the Roman Catholic's [Mr Moore] I kept fast days too often—for 15 months—I then boarded at £60—till I was received into Gordon & Co's House in Austin Friars—It was a miserable life to me—therefore I pity as I said anyone likely to encounter a similar one—[93]

The firm of Ruskin, Telford & Domecq first appeared in the London Post Office Directories in 1815, at 7 Billiter Lane and then at 11 Billiter Street. Soon afterwards Pedro Domecq, Mr Ruskin's

partner, went to live in Spain to help his uncle, Juan Carlos Haurie, and thereafter Mr Ruskin ran the English agency on his own, Mr Telford being merely a sleeping partner. Haurie, who came from a French family settled in Spain at the beginning of the eighteenth century, was the head of a once flourishing wine business with vineyards at Marchamundo, Jerez (Xerez), at this time on the verge of bankruptcy. Domecq was taken into partnership by his uncle in 1816 and managed to restore the business to its former position although Haurie's continual interference led to violent quarrels. Six years later, by which time Ruskin, Telford & Domecq had become the leading London shippers from Jerez, Haurie got into trouble, was sent to gaol and his company declared fraudulently bankrupt. He soon came out of prison but died in 1828, when Pedro Domecq was able to buy the Marchamundo vineyards and start his own company, P. Domecq (as it still is today). In 1832 Pedro took his brother, Juan Pedro, into partnership and went to live in Paris. He rarely came to London although he and Mr Ruskin remained the best of friends and he was still a partner in the London firm. He made a fortune out of property dealing in Spain and when he died in 1839, a year before Adèle's marriage, left enough to provide his daughters with dowries of £30,000 each as well as his share in the lucrative business at Jerez and in the London agency. After his death his brother continued to run the Spanish firm with Mr Ruskin as his agent, and it was he who arranged his niece's marriages. The 'young Haurie' mentioned in Mr Ruskin's letter to Mr Gray was another nephew of Juan Carlos, to whom he had ceded his trademark after already selling it to Pedro Domecq—a piece of dishonesty for which the latter took his uncle to court.[94]

Mr Ruskin in his letter makes no mention of the fact that from 1808 he was paying off his father's debts (it was not until 1815 that he allowed his mother £200 a year). He never fully recovered his health after these nine years of toil without a holiday, culminating in 'Typhus fever'. It seems likely that he was often half starved as a young man, resulting in what Effie called his 'usual stomach complaints'—complaints which must in large measure have accounted for his irascible temper.

17

PLAIN SPEAKING

John was now beginning to have doubts about his treatment of Effie's family, and also about his life in London. He expressed all this to his father in a letter from Mont St Michel, the only place where they stayed in Brittany: 'Effie—however much she has enjoyed herself—seems not to be quite so entrapped as I by love of Continent, she says there is no place she has seen she would care to go back to, except Rouen. She seems to like the idea of keeping house. So should I well enough—but for the being so much away from you. How will you and my mother manage—at all—when I am so near and yet not with you in the evenings! I don't like the thought of it at all. However, you will I hope enjoy Switzerland the more from having me quite with you again. I would not go into town however on any account, but that I feel it will be a great advantage to me in many branches of study—and in some of discipline and character. Have you heard from Mr Gray again anything more about George? I believe he was very much hurt at your letter—that was natural enough—but it is far better to speak plainly: It is unfortunate that when people get into distress—they think themselves forced to do things which bring upon them rebuffs which they set down to their change of *circumstances* instead of to their change of views. I am rather puzzled in thinking over the thing as to what my real duty is to my wife and her relations—I don't mean—what they have a right to ask—or to expect—or to receive—or what they *ought* to ask—but what is *my* proper Christian duty to give or permit—what a truly good, unselfish man would do —considering justly his duty to his parents and to himself at the same time!'[95]

It was no doubt on the receipt of this letter, hearing Mr Gray was

hurt, that Mr Ruskin wrote to him the much more conciliatory one below:

London 15 Sept 1848.

... I hear almost daily from John and the Tour seems to give great pleasure—will you say to Mrs Gray that the Box of Linen has arrived here and everything found in good order—most beautifully packed and fabric superb—nothing can be better— Some of the Table Cloths would cover their Room in place of their Table but they are a handsome family appendage, and I know in Scotland they have more magnificent ideas than we have in England, because one London Dinner costs as much as would comfortably dine our friends to the same number in Scotland every day for a week—There is no account of cost— and I should be glad to have it—I have always Money of John in my hands to settle accounts for him immediately. . . .

In regard to George—I should be sorry to influence you to take any step whatever either with reluctance, or against your own Judgement. I viewed the subject and wrote upon it as you might see under a notion that George's course of Life had been for many years chalked out and laid down with your own Sound Judgement, and that he had been taught to look to the Law as his profession and that the idea of making him a Merchant was sudden and probably suggested by others who find it much more easy to advise than to aid in putting their own advice into practice—I should after all say that if you see one way more than another likely in your own unbiassed opinion to lead to George's advancement and Independence, whether that be through Law or through Commerce, you should adopt it, without minding what I or anyone says—I only seemed to feel that you might be too suddenly altering your plans from some mistaken notion of what I had in my power to do either in my own Business or in another—and I deemed it only honest to explain at once to prevent disappointment—when I found how little the very greatest Merchants in London could do, either to save my parents from Expence, or to raise me except through years of Toil and misery—it would be presumption in me to fancy I had greater power—I ran the risk of wounding your and Georges feelings by truly seeking only to

place matters in their proper light to guide George himself in
his decision—I too well remember when I was leaving my own
pleasant Edinburgh home for London—the charming but
false light with which my prospects of Life in London were
gilded by my Father and Mother—I was told of high Connec-
tions and people whose houses would be open to me—and of
pleasures of being noticed by many a friend, whose notice
was honour—but whose Houses or whose faces, I never saw. . . .
It is just possible that my late Letters in place of being taken
in their true downright meaning, may have been entirely
misconstrued and in part attributed to your altered Circum-
stances, for we get sadly sensitive ourselves when things go
wrong and make all the world say and do everything to offend
—and wound our feelings—If you have put one word of my
first, second or third letter down to your position as to wealth
you never committed a greater error of Judgement—I have
told you that I do not believe in Perth property and I know
nothing yet as to your position but I should even value you
more as a working Lawyer of £400 a year in old Bowerswell
than with a Railroad property of £4000 a year in your grand
House—I told John, Lord Gray and you had committed a
great mistake in pulling down old Kinfauns* and Bowerswell—
I may have been too explicit about George but a Boy at Charter
House and a Man are different, and John can tell Effie—that
the only serious altercation he can remember betwixt Mama
and Papa is when the latter thinks himself called on to ask
people to Dine or by chance to sleep—So far from Circum-
stances influencing me in what I say to you or George—I have
been much more plain with one of Domecqs nephews—the
Count de Chabrillan,† the Rothschild of the family—for I told
him we could not receive him at all and I did not even take
the trouble to come from Salisbury to London to see him—
and on the other hand the person most frequently dining with

* Old Kinfauns Castle, Perthshire, home of 14th Baron Gray (1765–1847), was
pulled down about 1812 and a neo-Gothic castle, designed by Sir Robert Smirke,
put up in its place. It was very grand and was reputed to have cost £30,000 which
greatly encumbered the Gray Estate.

† The husband of Cécile Domecq, the third daughter, two years younger than
Adèle and the beauty of the family. Chabrillan's father had died in August 1847
and left him £60,000.

us is only Actuary or Clerk in a Life office—Harrison [p. 45],
and this solely because his Literary turn makes his company
agreeable to John. . . . I am sorry to inflict all this upon you but
Letters are so constantly misconstrued from the haste or in-
ability with which they are written that they require Volumes
of notes to explain—

Mr Ruskin sent this letter to John to read and to forward to
Mr Gray, for on September 21 John was writing from Bayeux,
'. . . the London mail leaves this at 12. and so I can only send on
Mr Grays letter, which is excellent, to morrow. . . . All that you
say is excellent—I am very sorry to be the cause of so much trouble
to you. . . . I am very glad that you and Mr Gray have come to an
understanding—it will save much further trouble—I fancy how-
ever that I may have been wrong in saying Mr Gray was so much
hurt. Effie only thought it from some pages in his hasty letter—and
if it was the case it was unavoidable, it is impossible to speak truth
without hurting a little. I hope however—the present letter will put
all right—as perhaps the expressions respecting our inability to see
much of George may have been misinterpreted. *All I have to ask is,
that you will not labour on for us beyond our intended time—Every day that
I spend in idleness and you labour, I feel heavier and heavier on my conscience
—and I see that my notions of entire comfort and luxury are quite acceptable
on half the sum which you have given me—Even travelling and living at
expensive hotels sometimes—we are at present far within it. Park St is an
escapade. I consider it entirely as such—part of my fortune sacrificed to a
temporary object which cannot possibly in the nature of things—become again
desirable, it will be a good discipline and I will make the best of it.*'96
John wrote again the next day:

I am hardly able to write long enough to express all that
ought to be said respecting the subject of your principal letter,
one or two things I think I can explain to you better than Mr
Gray seems to have done. What is the real state of Mr G's
feelings—or what *has* been that of his expectations—I believe
he can hardly tell himself. From what I have seen of him I
think him—and I believe you do also—exceedingly upright—
but there are many expectations which we cherish without
definitely examining or confessing—and the disappointment of

which gives us a pain which we seek ground for in other causes —and which unconsciously increases the irritation caused by any supposed slight—or unkindness. I should be sorry to assert therefore that Mr Gray had no such secret hopes of George being taken into your house; but I do not believe that any such ideas were the cause of his changing his views for his son.

When Mr Gray had 25,000—of property bringing him an interest—from the mode in which it was placed—of 5 per cent, he intended leaving his business (I believe when he was 50— was the period mentioned—even supposing the period unfixed —the plan for George was the same)—and that when he retired George should continue the business under Melville Jameson. George was allowed to suppose therefore, that going into the office for a few hours each day, he would learn enough for the subordinate position under Jameson—and—in that position, would gradually get by habit into the management of a business of from 3 to 4000 a year—for his own share together with the expectation of the greater part of his fathers fortune— and the house always of course open to him—with these prospects he naturally did not give himself much trouble—nor did his father see it necessary to make him take more. But now all is changed. If Mr Gray fails—and I see now little hope of his standing—the business will by that alone be diminished— doubtless—(at least Mr G supposes so—and do not you think it likely?) to one half—Mr Grays utmost exertions will be needed to maintain it at all, and its profits will be not enough to divide with George—who will therefore be a mere burden on his father for ten years to come—for Mr Gray cannot retrieve his own fortunes—even to competency—in less time. It seems to me perfectly natural, therefore that Mr Gray should look for some other opening which may enable George to get on faster—and relieve his father of the present burden. I presume this would have been the case even if he had not been in anywise connected with us. And I think that—under old circumstances of friendship with you—and supposing I had never seen Effie, he would still have first asked *you* whether you could help him. So far for Mr Gray. Now for George. He is I believe very much like other young men in most respects, and I think

that the idea of getting into your house would turn his head and spoil him—I see no reason to hope better things from him than from James R [Richardson] or James Tweddale.* On the contrary he has just the same ideas of 'gentlemanliness', excusable enough in a handsome boy bred with the idea of a fortune being ready for him—but fatal in the present conjuncture.

On the other hand, we must not condemn him too severely for not doing what very few young men have the strength of mind to do, what would be certainly the noblest conduct in his case—that is to say, to relieve his father at once from this anxiety —and disdaining help from any one—to put on a canvas jacket for the first push in the crowd—to sink the gentleman and make the *man*. That he does not do this is no great fault—perhaps such an idea has hardly suggested itself to him in that he is too gentle—perhaps to be able to carry it out if it were. I cannot at present give you any opinion of him—because I do not know whether the predeliction he expresses for a merchants life be indeed natural—or whether he merely thinks it would be easier than another. But this I think myself—that he certainly has not the energy necessary for a lawyer—that he means well at present, and is thoroughly desirous to get forward, and that it would not be right if it were in our power to help him—to run the chance of in reality blighting and checking a career which might be successful—because—it seemed to us to have been chosen with undu [*sic*] expectations of more assistance than we can give.

Now—as to ourselves—and which to you is the most important part of yourself—me—and my prospects, I have not yet enough considered the exact position in which George would put me if he came to London, and I shall put off discussing this till to morrow for I have yet to answer Sir W. [Walter] James— and [Osborne] Gordon, to day—and I want to write to Mr Gray himself. But meantime I am inclined to think it would be excessively wrong to run the risk of injuring Georges prospects, because I did not choose to sacrifice to him some of my time—or convenience—or pleasure, and I believe to seek familiarity with circles of strangers—however valuable their acquaintance—by cutting off all connection with and refusing

* Probably Mr Ruskin's cousin, son of James Tweddale, his mother's brother.

all service to, my own relations—would in the end be as dis-
advantageous as wrong—But I will think over this for my next
letter—meantime—one thing I am quite clear of—that what-
ever inconvenience I may incur—you ought to incur none—
that you and my mother must be left at least *tranquil* as you are
to be left—more's the pity—now so much *alone* and that to
admit George into Billiter St would probably be just as dis-
advantageous to him, as certainly a source of annoyance to
you. It is not to be thought of.[97]

John evidently wrote to George himself, either instead of or as
well as to Mr Gray (neither letter has appeared), and sent the letter
to his father to forward to Perth if he approved of it. 'I am very glad
you approve of what I wrote to George—not that I should have any
hesitation in writing him anything else you liked—but because I
could not write so long a letter again in a hurry. That is very sad
indeed about young L. I believe whatever discomfort the state of
affairs at Perth may cause me, it will never be of this kind as I think
George thoroughly well disposed and that it would take a great deal
to make him go wrong.* I think the whole family thoroughly and
steadily good—seniors and juniors—down to little Alice and Mel-
ville and if either by Georges exertions or Mr Grays they get their

* Walter Scott Lockhart Scott (he had taken his grandfather's name when he
inherited Abbotsford) was Lockhart's only son, born in 1826. (An older boy,
Johnny, had died in childhood.) He was very good-looking and attractive but vain
and lacking in stability. He entered a cavalry regiment in 1846 and soon got into
debt gambling. At the beginning of 1848 he was tricked into giving bills for £1,000
to meet his debts but never received a penny of the money. The bills were passed
from one shady character to another and Walter eventually recovered them from a
carpenter at a cost of £10 and a promise to pay a further £325. He then sued to
have the promise to pay set aside on the grounds that it was obtained by fraud.
After a two-day hearing the jury unhesitatingly found in his favour but not before
he had had the humiliation of hearing himself described by one of the gang of 'bill
stealers' as 'a very illiterate, stupid fellow as green as grass'. The case was reported
in *The Times* on August 26, 1848, which no doubt prompted Ruskin's comment.
A few years later Lady Eastlake wrote to Effie, 'My thoughts have been much en-
gaged of late with my friend Mr Lockhart—some fresh occurrence has stirred the
old *thorn* and he has looked *miserable* and confessed himself so. . . . I think perpetual
and *untold* sorrow is sapping his health—That son is killing him, but I still feel
that if his heart (the lad's) could be appealed to, and if he would say, "Father!
I have sinned against Heaven and against thee"—the poor broken hearted father
would fall on his neck.' (Letter of January 10, 1852: Bodleian.) Walter died at
Versailles on January 10, 1853, having become reconciled to his father shortly
beforehand. Lockhart died in November of the following year, aged 60.

heads above water again—they will be better than they have been —after this lesson.[98]

This habit John and Mr Ruskin had of sending their letters to each other to be vetted and then forwarded direct to the recipient caused some confusion to the Grays because a letter from John might arrive postmarked Denmark Hill and a letter from Mr Ruskin stamped by some post office in Normandy. It was a habit Effie deplored and which must also have annoyed the Grays when they realised what was happening. 'I have not been from home,' Mr Ruskin wrote to Mr Gray on September 29, 'but I thought there seemed some doubt in Letters from my Son as to whether a letter or two of mine had not given pain very unintentionally and I wished my Son to see the last letter and return it, but as it waited long in some Post office abroad he sent it direct merely to lose no more time—I saw a letter of his to George forwarded to Perth two days ago.' And on October 4, George's nineteenth birthday, he wrote again: 'I am really sorry that any expressions in my former Letters should have touched your feelings—but my Letters often do produce effects which surprise myself—They are too abrupt— because I say all at once that which ought perhaps to be gradually and occasionally uttered.'

He was feeling particularly contrite because he had just heard from Mr Gray that all danger had been removed of George's becoming a burden on him in London: Mr Gray had at last found an opening for the boy in the legal firm of Ferrier & Murray in Edinburgh.

George, it may here be said, did very well in Edinburgh. He finished his apprenticeship there in 1852 and returned to his father's business, which was by that time firmly on its feet again. He went to Australia in 1856, where he bought a farm in the Murrumbridge district of New South Wales and went in for horse-breeding as his main activity. He returned to England after ten years and lived at Bowerswell, unmarried, until his death in 1924, aged ninety-five. He was quite blind for the last few years of his life.

When Mr Gray himself died in 1877, Mr Ruskin (who had then been in his grave for some thirteen years) would have been astonished to read in an obituary in the *Perthshire Courier* that Mr Gray 'was a man who could have managed with ability a nation's exchequer'.

18

DEATH IN THE FAMILY

❉

John and Effie were in Rouen again on their way home by the end
of September. There they heard on October 5 that Effie's Aunt
Jessie, Melville Jameson's wife, had died on September 26. On that
day John told his father that he had received letters for Effie*
(evidently black-edged), 'containing I suppose news which I had
not the heart to give her this morning: she had been unwell, and
was just recovering to a day of enjoyment: I will give her them this
evening when the shock is less. She loved her aunt Jessie exceed-
ingly.'[99] One cannot help feeling that it was as much for his own
sake as for Effie's that he did not break the news to her at once; and
it was two days before he told her. 'I had to tell Effie this morning
of her aunts death,' he wrote, 'and lost some of the best of the
morning—she feels it very much—her mother will *miss* her aunt
Jameson, who was her only confidential friend in Perth, very
bitterly. Mr Gray seems better since the railroads have sunk so as
to destroy all hope, and speaks now of beginning his life anew
determinedly though sadly.'[100]

Effie did indeed feel it very much. She wrote to her mother
immediately, 'never was any connection by marriage happier than
hers with our family. . . . My distress will scarcely let me write and
my tears blind me and have given me a severe headache'; and two
days later to her father:

The more I consider over this melancholy event, the more
grief it fills me with, coming in the midst of other misfortunes;
the present effects will be I suppose the whole weight of business

* To save postage, the Grays would sometimes send to Mr Ruskin their letters
to Effie to be enclosed in his to John.

160

on you for some time, a loss to my mother of her best and only confidential friend and to poor Melville and his children* what can never be made up again in this world. . . . John sympathizes with me most kindly but he did not know her and could not be supposed to understand her as he only saw her a little last year and this. He like you Papa has a great dislike to mourning and did not wish me to wear more than half mourning. I had curiously bought the enclosed dress† the other day being the fashionable color which will be very useful to me with black for the above purpose but as I told him that my feelings and that I thought Melville's also would be hurt if I did not wear it as I remember he was always very particular about poor Jessie's wearing proper mourning, tell Mama I am getting a black silk dress and black lace bonnet which John is pleased with and wishes me to do whatever is right, now I would be obliged to my mother to tell me what she thinks right and I will do it. Pardon me for writing this last which will not interest you, but now I wanted to tell you that I quite agree with you about sending about letters, and I assure you (as I think you will like always to write openly to me as it is far better) that we never sent any of your letters to Mr Ruskin or did I ever allow John, for he once asked me to copy any part of your letters to me. The only thing he ever said was when you first wrote he said to his father that you appeared hurt at what he had said. Mr Ruskin I suppose knew what John alluded to, but if this explanation still makes you wish it otherwise just let my mother or you put private before anything for John never wants to know more of your affairs than I like to tell him, so that you may keep your mind at ease completely and if you do this you may always trust me with whatever you like. Mr Ruskin did send us one of your letters and what he had written, I thought it quite unnecessary and entirely disapprove of the whole system of sending letters about, but that is their way and you know I can only do my own part right for they do not think it wrong although I do. John is quite well and making some beautiful sketches

* Melville had three children, Eliza, Andrew and Duncan. He dissolved his partnership with Mr Gray after Jessie's death, no doubt to Mr Gray's relief, and joined his father-in-law's firm of Duncan & McClean.

† Meaning a dress length of which she evidently enclosed a pattern. It took 22 yards of material to make an evening dress in those days.

here.* I am trying the painted glass which pleases him very much; we are extremely happy together and have been married half a year today. Mr Ruskin has got a Brougham for us which we pay for by the year but he kindly intends giving us wine to the amount that the Brougham costs us. I hope and trust George will succeed in Edinburgh and that you will be able to send me good news of him.

John also had something to say about the brougham in one of his rare letters expressing gratitude to his father:

I do not quite like the idea of the blue and red, but we have I am afraid no choice about the arms—they must either be in the carriage colour paler—which would make them too much of the blue boar, or else in their own gules.†
The rose and thistle will be nice—and I will admit the shamrock for the sake of its architectural character—tre-feuille. . . . I notice your kindness about the present of wine; I am afraid I do not ever thank you as I should for all you have done and are doing for me: but I always feel a kind of reluc-tance in expressing much on this subject lest it should seem like a kind of asking for more or like some sons—trying to get as much from their fathers by fair speeches as they can: I would not have you on the other hand think me ungrateful for these things—which I am not indeed: nor must you suppose that I think little of them, although I feel that there is that kind of affection subsisting between my father and me which is too close and pure to be much raised or influenced—even—in its expression by gifts of this kind. You have already sacrificed for me much more than your fortune and done for me much more that it could do. But I have certainly now more cause to thank you for these things than I ever had before: seeing that I am to

* There are four drawings of Rouen in *The Seven Lamps of Architecture*.
† Mr Ruskin had taken a boar's head as his crest 'as reasonably proud, without claim to be patrician; under written by the motto "Age quod agis" ', which can be colloquially translated as 'Keep your mind on your work'. Ruskin, on his own seal, changed the motto into ' "To-day", tacitly underlined to myself with the warning, "The night cometh, when no man can work".' (*Praeterita*, pp. 390–1.) The coat of arms, granted on January 1, 1835, is now in the possession of Luis Gordon & Co., sole concessionaries of Pedro Domecq of Xeres de la Frontera, and hangs in their office at 9 Upper Belgrave St.

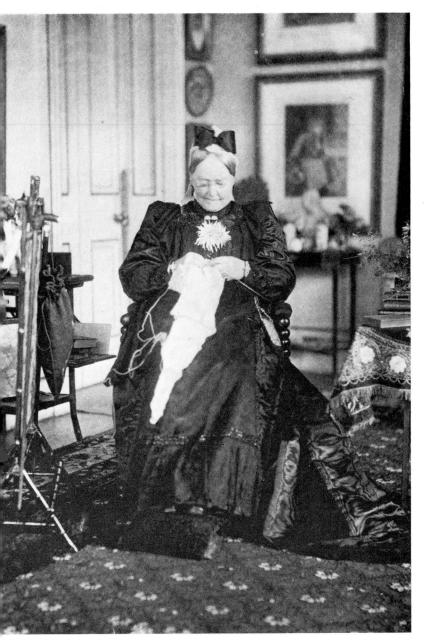

Mrs Gray in the drawing-room at Bowerswell.

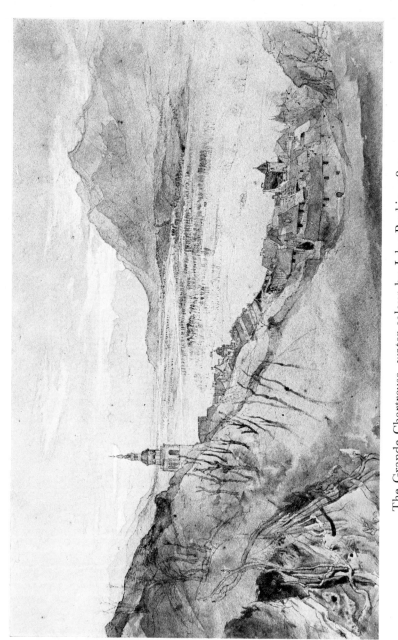

The Grande Chartreuse, water-colour by John Ruskin, 1849.

be with you less, and have caused you this increase of expence by doing what grieved you*—I will not therefore neglect any means of giving you pleasure which remains in my power—and I trust that you will not find (as they say some parents do) that you have by his marriage lost your son.[101]

Still at Rouen, Effie was writing to her mother on October 15 to say they hoped to be home on the 23rd. 'The Count and Countess Bethune,' she added, 'are to be tomorrow with Mr and Mrs R from Ireland to remain a month. This is rather disagreeable, for John wanted to get a quiet chat with his parents and I wished to arrive quietly, spend two days at Den. Hill and go to Park St as I feel far from inclined to meet strangers at present, and John has written asking his father and Mother to leave their guests and meet us at Calais: the French could easily take care of themselves but I think it would be very absurd coming such a distance in this cold frosty weather although I have not said so to John since the letter is gone. . . . John's kindest regards to you—he says he could not face a winter journey to Scotland which I knew he could not but if you wished he would send someone with me to see you, and he would have no objection, and if we go to Switzerland in spring there is no saying when I would be able to come. What say you, but do not speak of my coming yet.'

John had written to his father on the same day saying they would be at Calais on the evening of Saturday, October 21 and how happy it would make him if his parents would come there to meet him. 'You might leave Caroline and her husband in possession of Denmark Hill for two nights. I hope you will do this—as—though I am exceedingly glad to hear we are to have the pleasure of meeting them, I should like to have a quiet evening with you first. . . . For the rest I am very glad they are to be there, as it is right that Effie should see something of them, and although she dreads the introduction just now, I am sure she will be very happy with the Countess. Caroline will be kind to her I am sure and will teach her all manner of little wickednesses—How strange it will be for me.† [102]

* Effie was later to write to her father of 'Mr R's continued and never ceasing disappointment of John's marriage with me instead of Miss Lockhart or some person of higher position and more fortune'. (Letter of January 19, 1852: Lutyens, 1965, p. 249.)

† Because he might himself have been married to Caroline (p. 38n).

M

Two days later, on the way home, Effie had a last word to say about George's affairs and endeavoured to make peace between the two families: 'Just a line to say I received yours and George's; the latter John was not going to burn but at last he did so as I assured him that George wrote it in the full confidence that he would do so —he was writing to his Father and mentioned the letter, only saying that George's intentions were all good so I hope this will be the last said upon an unpleasant subject which corresponding upon has done no good, but it ought to end in each party thinking no wrong is intended on either side, and I think you ought to excuse Mr R's suspicious character when you consider the claims he has upon him every day from his relations, most teasing for him who has given so much and makes him look on the worst side, but be sure no ill was intended so there let the subject drop. . . . You must I should think be worn out with anxiety and care and I wish I could come and see you. . . . I wish the Bethunes were not there. I am not in spirits to see them or to be gay when you are all in such distress and I also feeling it so much, but it cannot be avoided unfortunately and I only hope John will stay as short a time as possible with them and get into our own house.'

Although successful for John's book, this Normandy tour had not been a happy one. John must have hated Effie's tears and black garb, and her continuing family troubles distracted him from his work, while she must have felt his lack of true sympathy, however dutifully he endeavoured to comfort her. Already at this stage of their marriage, after only half a year, he would no doubt have been thankful for her to return to her sorrowing family and give him the chance to settle back tranquilly into his study at Denmark Hill.

19

A HOME OF THEIR OWN

John and Effie were delayed at Calais by storms so they did not arrive at Denmark Hill until Wednesday, October 25. There for the first time Effie met Caroline Béthune with whom she was to form a life-long friendship. 'The Count and Countess amuse me,' she wrote two days after getting home, 'and I always speak French to them. The Count cannot speak or understand a word of English and he makes me laugh very much at his droll ideas. He has a beautiful setter with him. The Countess is like Ann* but not such fine eyes and not nearly so pretty as she, Anne, once was, size the same. I do not like her face, but hands and arms are quite perfect. She speaks a great deal agreeably without saying anything that one can remember. At Paris she goes to a ball three time a week, the intervening nights to the *spectacle* but she seems very happy here. Last night I would not dance [because she was in mourning] but she and Mr Watson [Mr Ruskin's head clerk] were dancing. I asked the Count why he did not dance; he explained what is curious that in Paris the married men never dance, the married Ladies always. The Count says what is the use of the young men but to amuse and be useful to the Ladies. The young unmarried ladies, for there are hardly any they marry so young, are taken no notice of at all, and, says the Count, if the femmes had not some amusement they would get very triste and dull. She comes out twice a day in entirely new toilettes of which however she has no credit at all for her femme de chambre dresses her, buys every thing, makes all her bonnets, caps, dresses, and treats her the same as a doll. She is foster sister to the Count and very fond of them. They are going soon to Belgium but we will stay here I suppose till they go, to help Mr and Mrs R with

* Ann or Anne Duncan, Jessie Jameson's youngest sister.

them in the evenings for their voices are so loud and shrill that it is very wearying and makes my head ache although I am amused. We were in town yesterday seeing our house and servants and found everything very nicely kept and comfortable. . . . I think you have judged most wisely about my coming down and before we go to Switzerland John and I will likely pay you a visit. I should very much like to have seen you now but I think it is better not to come without him and he is now quite well [meaning that he always got ill in Scotland]. Mr Ruskin has given me the present of a most beautiful black velvet dress [length] because he thinks I would look very well in it. Miss Rutherford is making it with a high and low body. It is exceedingly kind and I think in my own mind that he may have a little regretted the correspondence and meant this as a delicate mark of kindness which I am sure you will appreciate.* Miss Rutherford is quite delighted with the kind way they talk of me and she says they seem so desirous of making me happy. . . . I did not send George any birthday present but now instead, as I think he will like it better as he is going to Edinburgh, I send you £10—£5 to George from me, the other half is for you because I know at the end of the year you have many subscriptions for Charity, missions, etc. This should never be neglected and if you will accept this money from me and apply it to this purpose I shall be obliged to you. . . . I have only one more thing to say that *I wish you to speak* [*only*] *to me about money. John does not like to know any thing about my money after he gives it to me*, which is very delicate in him because he knows quite well *that I buy or send you* a little present now and then. He says this money is entirely my own and he would be very sorry if I had not a little over for any thing I desired and you know when I had, I had always more pleasure in giving it away than in keeping it.' In the margin of the last part of this letter she had written, 'Private remember!'

The next day she wrote again: 'John and I were talking of you this morning, he wishes me to send you what money I can but does not wish you to know that he knows anything about it which I think

* A note in Mr Ruskin's account book reads: 'Oct. 1848 Effie velvet gown £18—10'. (Bembridge). Miss Grace Rutherford was in business as a dressmaker with her sister Janet at 56, Pall Mall, London. She was a very old friend of the Jameson family who had first known her at Cuper, Fife. It was she who had over-charged Effie for her trousseau, having made dresses for her from sketches and sent them to Perth (See p. 110.)

very delicate and kind of him, but I think it right to tell you to show you how good he is and how liberal and that all that I do is approved by [him], but as I said yesterday you must not appear in any letters excepting to me to mention the subject. I think you very economical. . . . Mrs Ruskin says I look better than when I went away. The Countess says she [never] saw any person look so young. She herself is only 23 but so much gaiety I suppose makes her look thirty and sallow. She is very amusing but she and the Count chatter at dinner incessantly and if I had not been in France I could not possibly have understood them.'

On Thursday, November 2, and before the Béthunes left, John and Effie moved into their own house, 31 Park Street. Effie was delighted with the furnishings and with their brougham, which they could use when they liked as it was just round the corner at the Grosvenor riding stables. It was the prettiest she had ever seen, of dark blue lined 'with a beautiful fawn coloured damask and the glass in front round like a bow window', quite a new design. Their cook, engaged by Mrs Ruskin like their other servants, was very good at making pastry; they had roast hare and apple tart for their first dinner in their own home.

After they had left Denmark Hill Mr Ruskin wrote to Mr Gray:

I thank you for your kind Letter of 31st October and am very much pleased to hear the accounts of George's proceedings and the manner of placing him now and the prospect he has with Messrs Ferrier and Co. The Door seems just to open for him as soon as he fairly tries to get into the Law—all in future depends on the *If* you so properly put.

If he makes himself useful and indispensable in the Office. . . .

It is very kind of Major Guthrie* but I hope you do not think that because I said I would do nothing in the City for George that were you under a temporary cloud I should see him at a Loss of a small sum to get him through his Law Studies. . . .

As to your own position—I had no idea when I wrote of

* Major John Guthrie, who lived at St Leonard's Bank, Perth. He was the godfather of Effie's brother, John, aged two, and left the boy some money when he died in 1854. On November 13 Effie wrote, 'How very delicate and kind it was of the Major offering the money. When and how did he know about Papa's affairs?'

your House and Furniture being touched. I alluded to property generally, the reserve wherewith to continue Business, should include House and furniture—I only regret that you cannot by any cession of property of which the public generally can have no knowledge—check or arrest the heavy Interest running which will eat you up as it did the Duke of Buckingham—It was Interest on money borrowed which devoured this Nobleman*—but as I know nothing of your Liabilities and Shares I ought not to judge. . . .

You will have heard from the new Settlers at 31 Park Street—They seem very comfortably settled. . . . We feel very much the Loss of our Children although we have the Count and Countess Bethune in the House trying to console us—The former leaves us on Thursday† [November 9] but leaves the Countess with Mrs Ruskin for some time.

After they had been in their house ten days Effie told her mother that they dined at one 'which John finds more healthy and in every way more convenient since then we enjoy our teas at six much more. . . . John went into town yesterday [November 11] to pay some visits and I walked along the Park, a very long walk it is, accompanied by George [Hobbs] to Mrs Bolding's.‡ I met her baby at the door who looks much better. . . . John allows it to be passable for a baby because it has eyes like rats fur and he likes it a little because it is not like a baby at all, but has a black face like a mouldy walnut, which is a great deal for him as it is quite against his principles to admire any of them at all. . . then feeling quite tired and a cab passing George got up on the box and I arrived safely at home, poor John being quite horror struck at my temerity in driving into Park St in a cab and says I must never walk further than I can walk back unless he is there. I laughed and promised for it was quite

* Richard Grenville, 2nd Duke (1797–1861). When his father died in 1839 he had come into an annual rent roll of £100,000 but due to speculation in land, bought with borrowed money on which he had to pay more interest than the land was worth, he found himself in 1847 with liabilities of almost £2 million. He was obliged to sell much of his property and possessions and live abroad.

† The Count, according to Effie, was going to Brussels to find them a house for the winter.

‡ At 18 Eastbourne Terrace, running parallel to Westbourne Terrace, the street that runs along the west side of Paddington Station where now there is not a single old house left.

improper but I had nothing else for it except doing so and I had no idea of the distance or I should not have gone without the carriage.'

Next day she was writing to her father, 'John is very busy with his book but he is going to begin a sketch [of Effie] for you in the evenings which I hope will soon be ready and in time to come with the box [she was sending home by sea a box of Christmas presents] and I will get it nicely framed for you. Every person tells me I am looking so well just now and I do feel much stronger as usual with the approaching winter and the summer heats make me very pallid and weak and I am always much better in winter. I have got on hire a delightful Piano from Broadwood's and I am going to Jullien's to subscribe to his musical library.* . . . Mr R. is I think really interested about George and always asks after him most kindly.'

It was easy for Mr Ruskin to take a good view of George now that he was not coming to London and nothing was being asked of him. It is very doubtful that he was ever called upon to contribute the small sum he had offered to help George through his law studies.

On November 15 John and Effie dined at Denmark Hill. The Countess was still staying there and the next day Effie reported, 'I had on my black velvet dress last night [the one Mr Ruskin had given her] which was much admired and John was quite delighted. I had on point lace collar and cuffs with white roses in my hair. Mr Tom Richmond I suppose was so pleased that he asked John, as a favour, to be allowed to paint me. He is a portrait painter by profession.† John's drawing of me is a very pretty drawing but the lower part of the face not the least like me, so he is going to begin another tomorrow and keep the other to practice upon but I hope he will succeed and please Papa. I hope George will continue in the lodgings he is in [in Edinburgh] if they are comfortable and it seems a nice part of the town, St Andrews Square. John and I by hiring out the horse four times a week can gladly and easily save enough to pay for the Lodgings which would perhaps ease Papa a little. . . . I will send therefore £2.10 each month for that purpose to him.'

* Louis George Jullien & Co, Royal Conservatory of Music, 214 Regent St, on the east side almost opposite Conduit St.

† Thomas Richmond (1802–74), George Richmond's little-known elder brother. He had been a miniature painter in Sheffield for many years before coming to London and taking up portrait painting. His father, Thomas Richmond (1771–1837), had also been a miniature painter. Ruskin had met Thomas in Rome in 1840 at the same time as he had met George Richmond.

Now that Effie had decided not to visit her parents without John, she was very anxious for her mother to come and stay with them in London. A week later she was strongly urging this:

31 Park Street. November 24th [1848]

Mr Ruskin has just sent us Papa's letter to read along with one from himself in which he appears much pleased with Papa's which shows I think that he is not angry about the money* and I think that he will like to see Papa so much better in his spirits. Tell him I find some little excuse for him not letting you come at present just when George has left but in the course of two months namely ultimo [*sic*] John and I will take *no excuse* for I believe it is just his old dislike to your leaving home that keeps him from allowing you. We think altogether that at that time it will be better. There will be more people in town or a better set of people. John will be more able to go about with us and the evening amusements—for John has long promised to take me to see a Pantomime—will be better by that time. Mrs Ruskin is a little tired too by having to exert herself for the Countess and she would have more pleasure in seeing you then. . . . Tell Papa that if the needful were necessary he should have it from me and he should not have any feeling of independence from his daughter who owes him more than she can ever pay. . . . The very circumstance of your being *upset* about the letter shows your nervous system is not in its usual composed state, so therefore tell papa all this and a great deal more besides and say that I doubt not his suffering for your absence but that he ought to try and get over that for so short a time and that I cannot think it right his keeping you after you suffering so much for him these months past. I had Mr and Mrs George Paget† to dinner at one today and gave them sole and shrimp sauce, Pheasant and *bacon* which they always use here and in France with game, mutton and vegetables, little tartlets, custard and very fine pancakes and desert which we have every day at John's request and I find very

* The money John and Effie were paying for George's rent. Mr Gray had evidently committed an indiscretion in mentioning this to Mr Ruskin (see p. 171).

† George Byng Paget (1809–58) and his wife, née Sophia Tebbutt, of Sutton Hall, Sutton Bonington. He was first cousin of Charles Paget of Ruddington Grange, Nottingham, whose daughter, Mary, had been at Avonbank with Effie.

little serves after once beginning and John does not want any change in our usual style if any one dines with us so that our table always looks very nice. . . . John is going on with the picture.* I am going to sit for Mr Tom Richmond next week in my black velvet, collar and cuffs of point unless you can suggest anything better.†

On November 25 and 27 they dined at Denmark Hill before the Countess left on the 28th. Effie reported that 'Mr Ruskin was much pleased with Papa's letter and seemed to think that we did for George quite right [paying his rent] for he never spoke of it to John or me and he lets you know soon enough if he does not approve of anything, John says, but Papa will remember another time.'

By the beginning of December she was able to look forward to her mother's visit. 'I was so happy to find by your note that Papa had given you permission to come and see me for which thank him exceedingly with my best love. I shall be engaged at Denmark Hill from Christmas till New Year, that is from the 25th till the 5th John thinks as people will be staying there but about the 8th or 9th of January I shall be delighted to see you, but I am afraid that you will be obliged to journey alone and to postpone the pleasure of seeing George to another time for I have no room for him and no place where a bed could be put. Another reason is that after all this correspondence about him Mr Ruskin might wonder at his leaving so soon after going to Edinburgh and afterwards I could give him a bed and he would be happier and more comfortable.' She went on to say that she had an eye inflammation which was causing her much pain and she had been obliged to put off a sitting with Mr Richmond; however, she was able to sit for him for two hours on December 5. After that the sittings were postponed because Richmond had to go to Yorkshire.‡

* This is the last we hear of this drawing of Effie. There is only one known portrait of Effie by Ruskin, a pencil and water-colour drawing now in the Ashmolean Museum (reproduced p. 67). The drawing Effie mentions here may be the Ashmolean one; alternatively it could be one which Ruskin did in Venice in 1850 of which Effie wrote, 'my throat was too thick and my eyes not enough fire in them.' ('Portraits of Effie' by M. Lutyens, *Apollo*, March 1968, p. 191.) This can certainly be said of the Ashmolean portrait.

† In the first known daguerreotype of Effie (reproduced Lutyens, 1965, p. 210) she is wearing this black velvet dress with point lace collar and cuffs.

‡ See Appendix V for Thomas Richmond's portrait of Effie.

By December 20 she was able to tell her father with what pleasure she had noticed the increased confidence in the Railway market; Mr Ruskin had assured her that the settled government in France would have a very good effect on Boulogne and Amiens shares. Louis Napoleon had been elected President of France on December 10, and from that time onwards Mr Gray's financial position became more secure.

A MISERABLE NEW YEAR

John and Effie went to stay at Denmark Hill on Christmas day which fell on a Thursday in 1848. Effie became ill on the 27th and was in bed when the news arrived of yet another tragedy in her family; Andrew Jameson's wife, Lexy, had died as the result of giving birth to a son, but John did not break the news to her until December 29. 'When your note arrived and explained the cause of dear Lexy's death,' she wrote to her mother that day, 'I was not able to write to poor Andrew but John has written him a long and very beautiful letter.* . . . I am very much struck, as indeed are all here, with the very curious and almost exact resemblance of her case with dear Jessie's. How Andrew and Melville will feel for each other in this distress and so will you for you loved her very much.' She added that she was glad she had not known this aunt as well as she had known Jessie, whom she would 'never cease to mourn as one of those I loved most on earth', else she might have felt equally sorrowful for her loss 'and John would have been made unhappy in seeing me suffer as I did at Rouen. . . . It casts a gloom over us all and Mr and Mrs R who are very fond of Andrew are also much shocked and startled by this unexpected event.'

Effie's illness at Denmark Hill over Christmas 1848 and the New Year of 1849 marked a deterioration in her relationship with Mr and Mrs Ruskin from which it never recovered. On January 1, 1849, she wrote a short letter to her mother: 'I am suffering very much from cold and cough. Last night I passed wretchedly, burning hot in the skin and shivering whenever I moved in bed. Today I got up and

* On the day of Lexy's funeral, January 2, Andrew wrote to his sister, 'Mr Ruskin has written me a kind letter—one of the kindest I have received.' The baby, christened John St Clair, survived.

although my cough is no better I am not so feverish and do not feel so ill. . . . They have a large dinner party to day of Mr Turner, the Richmonds and other nice talking people but I shall only be able to go down in the evening.* . . . I am extremely dull about poor Lexie and Andrew.'

And on the 4th: 'My cold is the same and cough very trouble-some. Unfortunately Dr Grant who knows nothing of my condition doses me with the rest, *not John*, with all kinds of remedies which I never took before. Some I take as anything for a quiet life and you may fancy how dull and weak I felt when I tell you I have not tast-ed meat for a week and during that time only tea and beef tea and today nothing at all. I asked leave to remain in my room today which John and I thought the best thing but I was not allowed, and again today, as almost every day this week, company six o'clock dinner and not in bed till between twelve and one. It is against all common sense to suppose that either John or I can be well with such a total change of life from our early hours and moderate habits, and at present my appetite is quite gone. If I had been at home and managed myself I do not think such would have been the case but it cannot be helped with these people in the house and nobody can under-stand I suppose why I am dull. I hope to see you next week when two days and quiet at home will I hope make me quite better before you come which will make me still better. John's cold in the head is very bad and Dr Grant entirely disapproves of all that Dr Richard-son has been giving me so one does not [know] what to say when Doctors differ.'[103]

And next day: 'I am much obliged to you for thinking of the cough mixture. I have sent for a bottle and think it will do me good as it did when I took it before. I have been taking more messes which as I knew would do me no good, and Epicacuahana (I can't spell the word) and Laudanum Pills last night and this morning together when I was feeling better with Spa water had made me so sick this morning that I can scarcely write. I have taken these merely to please Mrs R and Dr Grant and not to make a fuss but I am thankful

* According to Mr Ruskin's diary the dinner party on January 1, 1849, con-sisted of 'Turner, Severn, T. Richmond, two Sidneys Dr Grant John—*Effie not down till Eveng*'. Severn was Joseph Severn (1793–1879), artist and friend of Keats, who was then Consul in Rome. John had met him in Rome in 1840 at the same time as he met the Richmond brothers. The two Sidneys were Augusta and Emma, Dr Grant's step-daughters.

to say that they seeing I was getting on so very slowly asked if I would like to go home tomorrow [Tuesday, January 6] and John and I both wishing it we go and I am sure with early hours I will be well in a day or two. You know I never could stand medicine and that, with loss of appetite, have made my limbs and arms so thin that you would hardly believe it and John was amazed, but I hope you will come the first day you can. Seeing you and going about with you will do me all the good in the world.'

It appears from the above extracts that John was completely understanding of Effie's illness but when it came to his own account of it he was not so sympathetic. It was to be many months before Effie regained her health and she was never to regain any affection for Mrs Ruskin.

Mrs Gray duly came to London in the second week in January. She came by the usual steamer from Dundee and had a dreadful passage although Effie had begged to be allowed to pay her train fare. Mr Gray accompanied his wife to Dundee and then went on to Edinburgh to see George. On his return home he wrote to Mrs Gray on January 11 that he had dined with George 'on a haddock and the cold beef most comfortably—it put me so much in mind of my own style 30 years ago—Mr Dickson told me he never saw a more steady obliging boy and augurs well of him'. He told her that 'all the Bairnies' were well at Bowerswell.

Two days later he was writing to Effie, 'I have received your note and John's in the Office this morning. . . . It grieved me so sadly to hear your cough is no better and you are suffering so much for want for sleep which of itself I know from experience to be very wearing out—I shall be anxious to hear more about you from your Mother. . . . Be sure and tell her to drop me two lines *every day* till you are better.'

Mr Gray wrote regularly to his wife while she was in London and she preserved his letters whereas he did not keep those she and Effie sent him. In his letter of January 21 he said he was glad 'Phemy' was better and able to go about again as usual. 'I don't like her getting so thin,' he added, 'and would advise her to abstain as much as possible from evening Parties where she is kept till a late hour as nothing is so destructive to health particularly those of a weakly constitution.' This is the first we hear of Effie being considered by her parents to have a weakly constitution. 'The children have all got

a little cough but are otherwise quite well,' he continued. 'Melville's [Jameson] are still very much colded and the Doctor thinks taking the whooping cough.' These were sinister words for little Robert Gray was soon to die as a result of whooping cough. Mr Gray already knew that all the children had whooping cough at this time but did not want to spoil Mrs Gray's visit to London by telling her so. Instead he told her what must have cheered her greatly that 'the share List has been improving for some days past'.

On January 25 he wrote that he had been to the City Hall 'to hear a Lecture on the Electric Light and see it exhibited—I felt much interested to see how far it was likely to supersede the Gas but came home with my mind quite relieved of all anxiety—it will never do for domestic purposes and I question whether for anything practical.'* This was a particular relief to him because he was Treasurer of the Old Gas Light Co. in Perth. He admonished his wife in this letter, 'Do not spend sixpence you can avoid,' and finished up, 'I am very glad that John and Phemy propose paying us a visit before going to Switzerland. It is just what they ought to do. I am sure Phemy will enjoy seeing all her old friends again and I must say I am wearying to see her.'

But suddenly Effie decided to return to Perth with her mother at the beginning of February without John. Her reason for doing so is never made quite clear, but may best be attributed to her state of health. The expensive Park Street house was left empty except for the servants, for as soon as Effie had gone John returned to live with his parents at Denmark Hill and was able to get back into his old study where he could work undisturbed. Ever since their return from Normandy he had been busy writing *The Seven Lamps* which he hoped would be out in time for his father's birthday on May 10.

The old Ruskins were evidently puzzled by Effie's departure and very critical of her. Mrs Ruskin, the day after her wedding anniversary, sent her husband, who was away from home on business, a

* It was reported in the *Perthshire Courier* for February 1, 1849, that on January 24 Mr Pepper on behalf of the Anderson Institution had delivered a lecture 'illustrated by a variety of beautiful and successful experiments, exhibiting this wonderful light in its various forms and media'. The experiments then described were so complicated that it was no wonder Mr Gray thought it would never do for anything practical.

letter which shows how completely her attitude towards Effie had changed since that same day the year before (p. 84):

Denmark Hill Feb[r] 3d [Saturday] 1849

My Dearest John

I agree entirely in Lady D's [Davy's] opinion that Effie is unwell with regard to the causes of her illness I dare say we as entirely differ but be the causes what they may I am certain John has nothing for which he can blame himself—I think she will be the better of change and therefore going to Perth will be of service—but if she does not manage herself or allow others to manage her in a very different way from what she has done and been allowed to do health both bodily and mental will be sacrificed. I do not think at present John can urge her with good effect to do or refrain from any thing against her own wishes or inclinations—he intends writing to day I believe but I thought you would like to have a line from me for Sunday to let you know that after I have been your wife for thirty one years I could not had I to begin them anew and could from all that has occurred during those years change my lot with that of all that earthly greatness can give I am my Dearest love

Most truly yours

Margaret Ruskin[104]

Two days later Mrs Ruskin was writing again, 'I did not know you expected to hear from Effie. I daresay she will very readily give you some account of the parties she was at after she gets to Perth. John had a letter from her this morning, she intends sleeping at York tonight, and getting to Edin tomorrow. You know her memory is very good, you need not therefore fear but she will be able to give you very fully the accounts you wish for.' She went on to say that William Richardson, the doctor, had dined with them the day before and was 'sure nothing serious need be apprehended from Effies present state of health. The turn in her father's affairs will I trust do her good every way[105].'

Mr Ruskin did not return home for John's thirtieth birthday on February 8. On the 9th Mrs Ruskin wrote to him at Liverpool, 'I hope you are not doing too much, I need not assure you that your

return will be most welcome and will increase greatly the happiness
I have in having John with me.'[106]

They were now to have John to themselves without Effie for
nearly nine months while Park Street remained empty.

Mrs Gray and Effie travelled by train (perhaps it was the expense
of this journey that had to be accounted for to Mr Ruskin) and
stayed for a few days in Edinburgh on their way to Bowerswell. Mr
Gray had now become seriously alarmed by the condition of the
children—not so much by Robert's as by Melville's, for he was not
yet sixteen months old. 'I ought perhaps to have told you ere now,'
he wrote to Edinburgh on February 6, 'that all the Children have
had Hooping cough for the last three weeks but as none of them
seemed to show anything like dangerous symptoms and were passing
thro' the complaint as favourably as could be wished I did not like to
give you unnecessary alarm and interrupt the pleasure of your visit.
The cough is still pretty severe and they are still more or less reduced
in flesh. . . . The only one about whom I feel at all uneasy is Melville
as the teething and hooping cough combined is very severe on him.
Yesterday morning he looked very ill indeed and I was dreadfully
frightened but when taken out of bed he rallied.* . . . I think you
should not remain any time in Edinburgh. Phemy should just do
whatever is agreeable to herself.'

Mrs Gray naturally returned home at once, although the children
had an excellent nurse, Jeannie, who had been with them since
Effie was born. Effie stayed in Edinburgh until February 10 when
her brother George accompanied her to Bowerswell.

From two letters from Mr Ruskin to Mr Gray we hear of Robert's
continuing illness and subsequent death. In the first letter, dated
February 20, 1849—mostly about the discovery of gold in California
which had excited Mr Gray very much and left Mr Ruskin quite
unimpressed—he wrote, 'We are glad to have your reports of all the
Children except Robert, your account of whom does not at all

* Melville, who had been born November 30, 1847, during Effie's engagement,
lived to be almost ninety-nine. Before he was twenty he went to New Zealand to
become a sheep farmer but returned to Perth in 1911 and lived at Bowerswell until
his death on June 7, 1946. On February 11, 1939, he married for the first time at the
age of ninety-one, Ada, aged fifty-six, daughter of Rev. Churchill Julius, Arch-
bishop of New Zealand. They had originally met in New Zealand and always
remained in touch. Her brother, Sir George Julius, invented the Totalisator.

satisfy us.' The second letter was one of condolence. Robert had died
on March 1 in his seventh year. He was the seventh of the Gray's
children to die young and seems to have been a particularly brilliant
and lovable child.

After this tragedy it was only natural that Effie should want to
remain with her stricken family, but it appears from Mr Ruskin's
letter of condolence that she had decided to remain at Bowerswell
while John went abroad with his parents even before the tragedy
occurred:

<div style="text-align:right">London 4 March 1849 [Sunday]</div>

We have all been greatly distressed by the account of
Roberts Death—I had not seen him but I felt a deep interest
in the child, still I had little or no hope of his recovery for the
fever continuing unsuborned and unremitting, seemed to tell
that the Disease would overcome him—It seems very strange
and sad that I have so frequently to address you under circum-
stances so painful and afflicting. We may sympathise and offer
our condolence, but what can our sympathies do? They cannot
assuage the grief that must fill your Bosom and wound your
heart—at the Loss of such a Child. We can only join you in
praying to the Lord for help and support. . . . You seem to be
afflicted beyond the ordinary Lot of Man, in the Loss of so
many sweet Children and the thoughts of these things darkens
my very soul. . . . I become half persuaded that the Angelic
Host are permitted occasionally to visit the Earth and to chuse
for themselves companions from the lovely and engaging
children of the Earth and that your House has been especially
favoured and that all that is cause of mourning, might if,
rightly understood be only a source of infinite rejoicing—
looking beyond time to Eternity—We feel much for Mrs Gray
and you however in being deprived for a time of such a com-
panion—I would in all humility nevertheless venture to point
out to you the vanity of all our hopes and our anxieties—I
daresay your greatest sufferings for the threatened diminution
of your fortune have arisen not in fear of your own privations
but on account of your family. I wish to God you could come to
persuade yourself that it may be registered in Heaven, that on
condition only of your ceasing to vex and disturb yourself

N

about your worldly fortunes, will the Health and Lives of your remaining Children be preserved. I am glad Phemy is with you—it is good for you and Mrs Gray and good for her—for I never heard more sensible or feeling lines read than some few my Son read aloud from her letters—

I hear she may remain with you a few months—whilst my Son goes abroad—I should disapprove entirely of this, were my Son going abroad for his pleasure—but it seems as much a matter of Business as my travelling to Liverpool. I daresay Phemy had enough of this in Normandy and since her Illness at Xmas—I am sure she is not this year able for Swiss Excursions—

I hope my Son will accomplish all he wants this Summer to complete his work and become less of the Labouring Artist—in future—It may be his pleasure but to be with him is other peoples Toil—out of Doors at any rate—They must however arrange their comings and goings with each other—They will no doubt settle down very delightfully at last pleased with some house at Home and I hope allow you and me to come to hear them in chorus singing Dulce Dulce Domum—

In later years Ruskin was to write that the work done on this 1849 tour was 'chiefly necessary to the fourth volume of *Modern Painters*',[107] but in 1849 he still believed that he could complete *Modern Painters* in only one more volume, the third. Switzerland had been his original inspiration for the book, nature being to him the basis of all art, and of all nature he loved best the Alps, and of the Alps, Mont Blanc.

THE ALPS AT LAST

John was busy with his book up till the last moment of setting off for Switzerland on April 18, 1849. Indeed from Folkestone he sent back some of the last pages to William Harrison to be corrected, and he was still working on two of the etchings after he and his parents got to France (all the illustrations for the first edition of *The Seven Lamps* were not only drawn but etched by him). George Hobbs and Anne Strachan went with them as usual on this journey. For the first time they set off in two carriages. No doubt this plan had been devised when it was thought that Effie was to travel with them and it had so appealed to John that they kept to it even though Effie was not with them. 'They gave me a little brougham to myself,' John wrote, 'like the hunting doctor's in *Punch*, so that I could stop behind, and catch them up when I chose.'[108]

His diary for the five months they were away was unusually full, mostly of notes and observations for the next volume of *Modern Painters*; a diary kept by George Hobbs conveniently fills in the details of their daily activities. Fourteen letters from John to Effie covering this period have been preserved but none at all from her although they wrote to each other at least twice a week. Her state of mind, however, and the deterioration in her relationship with John and his parents while they were away can be clearly followed in John's letters, supplemented by several from Mr Ruskin.

As recorded in George's diary, they left Denmark Hill on the morning of Wednesday, April 18, and went by train to Folkestone with their carriages on a truck at the back of the train as was customary in those early railroad days. They were travelling post, so would hire horses en route for distances not serviced by a railway.

The weather at Folkestone was so bad—it snowed most of the

time—that they could not cross to Boulogne until the following Monday. On their last day at Folkestone, John wrote to Effie:

 Folkestone. Sunday [April 22, 1849]
My dearest Effie,
 I am beginning to weary for a letter sadly: and I hardly know how I shall do at Boulogne tomorrow: for Boulogne is especially associated with my dearest wife, I having never gone there but that once with you:* and it seems but a day since we were walking about the town in search of worsted: and choosing the pattern *the* pattern which cost us such worlds of trouble, afterwards: the boat leaves at ½ past eight tomorrow morning: I dispatched yesterday the final packet of revises to Smith & Elder: and I hope the book will be out about the 7th May [Effie's twenty-first birthday]: I believe you will like *it*—but I don't know about your liking the plates: they are horribly coarse, several at least, and plate IX was totally spoiled in biting as well as part of plate 5th† and I had not time to do others: I will do very different things next time: Your mother will like a note at the end: if she likes nothing else. ‡You will also find considerable use made of the notes you helped me to write in Normandy:§ and a great deal about Rouen which will probably not be uninteresting to you. I was looking to day by the bye at some portions of your diary at Dover and Oxford: I see in one part it is stated that John said what you had written

 * On the Normandy tour, John and Effie with Mr Ruskin had stayed the night of August 7, 1848, at the Hotel des Bains, Boulogne, but Mrs Ruskin was staying at Boulogne for the first time. On the 1848 tour the railway had just been opened from Boulogne to Abbeville. The Abbeville–Paris line had been open since 1846 but in 1849 there was still no line between Calais and Boulogne.
 † Pl. IX—*Tracery of the Campanile of Giotto at Florence*; Pl. V—*Capital for the Lower Arcade of the Doge's Palace*. (Pp. 94 and 81 of 1st edition, and *Works*, VIII, where the original plates are reproduced with the same numbers.)
 ‡ There are seventeen notes at the end of the book. The last one of all is probably the one he refers to in which he quotes Coleridge's *Ode to France* and calls it 'noble verse but erring thought' and then contrasts it with George Herbert's poem beginning: 'Slight those who say amidst their sickly healths, / Thou livest by rule. What doth not so but man?'
 § In a letter to his father of September 10, 1848, John wrote: 'Effie is sitting by my side just now . . . she has written nearly all my diary for me from my dictation —saving my eyes for the present much.' (Links, pp. 46–7.) He had complained of his eyes at Leamington in the summer of 1847.

was absurd: I do not think so now, by any means: and it was
very foolish of me to think so then, and still more *to say so*—as it
probably discouraged you from going on with your nice diary:
I will give you another book when I come back, D V, and you
shall write it steadily: but of this book I have taken possession,
as my old one was nearly filled, and yet not so well filled as that I
liked to order a new one* Mama bids me say to you with her love,
that if you want any flowers for bouquets or gardens, you have
only to write to Lucy† and she will send you boxes of them.

If we get over to morrow—we shall not go if it is bad
weather, I will send you a line from Boulogne to say we are
safe over.—Kindest regards to your father and mother from us
all—Ever my dearest wife, your devoted husband

<div align="right">J Ruskin</div>

They managed to get across on the Monday. The carriages went
with them on the Channel boat. Ruskin described how they were
'lashed on the deck, one sat inside, either for dignity or shelter'.[109]
They spent Monday night at Boulogne and started off early next
morning by train to Paris. It was the first time Mr and Mrs Ruskin
had done this journey by train and Mrs Ruskin in particular found it
very comfortable with tins full of hot water to keep their feet warm.
In Paris they stayed as usual at the Hotel Meurice in the Rue de
Rivoli.

Ruskin did not write to Effie from Boulogne. In his diary at Folke-
stone he noted that he had a bad cough and a slight feverish feeling.
He crossed to Boulogne 'with desperate cold in head coming on',
and sat in the carriage going over. He also recorded that he had a

* 'In the fifth volume of his own series of diaries Ruskin wrote: "This book
begins with 14 pages of Effie's diary . . . beginning at Dover and going on to
Abbeville. . . . Then 15 more pages of Effie's diary . . . continuing to January
1849 when I took possession of the book." Almost forty years later Ruskin must have
returned to his diary for the writing of *Praeterita* and found Effie's handwriting in
it unbearable. "Cut out—1885. J.R.", he wrote against the first reference to her
diary and: "These also cut out 1885, J.R", he repeated against the second refer-
ence.' (Links, p. 47.) He also tore out everything in his diary Effie had written to
his dictation.
† Lucy Tovey, the Ruskins' 'perennial parlourmaid' who had come to them in
1829 and remained until the Denmark Hill household was broken up in 1871. Her
sister, Harriet, had become housemaid in 1834. (*Praeterita*, p. 343.) It was these
two sisters whom Ruskin installed in his model tea-shop, opened in 1874 at 29
Paddington St. (*Works*, XXVIII, xviii, 204, 661.)

bad cold during the railway journey to Paris and sat by himself but
was 'very happy'.

That evening he wrote to Effie from the Hotel Meurice:

Paris. Tuesday 25th April ⎡mistake for⎤
⎣24th, 1849⎦

My dearest Effie,

I could not write a letter from Boulogne yesterday worth
sending: I had so many business letters to write: nor can I to
night a long one, for I have a bad cold and must get early to bed:
We rose at ½ past 5 this morning: and got off from railroad
station at eight: got here at four: the country does not look
quite so lovely as when you and I were here, but Paris much
gayer: still—this only in the main thoroughfares—the back
streets all full of shops and shut up—and they say they are to
have another revolution soon—I am most thankful to have got
thus far and to have the prospect of getting out of this town on
the Alp side to morrow: our horses are ordered at eight: and
our beds at Sens—Montbard—Dijon—and Champagnole for
tomorrow and the next three days. You will easily fancy how
much I thought of my dear wife as I passed Abbeville—and the
unlucky station at Amiens—and the happy one at Clermont,
when I changed my mind.* I wish however you could see Paris
as it is now: but that must be for next year: I am very anxious
about Venice just now: if the blockheads stand out, it may be
all destroyed. Brescia I am sorry enough for, though it was one
of the Italian towns I could best spare: if they knock down
Venice, I shall give up all architectural studies: and keep to the
Alps: they can't knock down the Matterhorn.† I expect a line

* They had stopped in Paris on their way back from Normandy in October 1848.
They were on their way from Beauvais to Calais and found when they got to the
station of Clermont-sur-Oise, where they had to change, that they must wait 3
hours for the train to Amiens where they would have to change again. The train
to Paris, however, was on the point of leaving and John made a sudden decision to
get into it. (Links, pp. 80–1). By the 'unlucky station at Amiens' John meant that on
the way back from Paris, when they changed at Amiens, they sent George to the
post office to pick up letters and come on by the next train. He left all the luggage
behind, thinking they had taken it, while they thought he was bringing it. (Ibid.,
p. 86.)

† After a year's respite the Austrian counter-attack on Venice had begun from
the mainland at Mestre; it was not, however, until July, after the Austrians had

from my dearest love to morrow at Sens: Do you know, pet, it seems almost a dream to me that we have been married: I look forward to meeting you: and to your *next* bridal night: and to the time when I shall again draw your dress from your snowy shoulders: and lean my cheek upon them, as if you were still my betrothed only: and I had never held you in my arms. God bless you, my dearest.

<div align="right">Ever your devoted
J Ruskin[110]</div>

He did not write to Effie again until they got to Dijon. In his diary he recorded that all those evenings at Sens, Montbard and Dijon he was working at his 'last plate of Giotto' (Plate IX of the *Seven Lamps*). 'At Dijon,' he noted, 'I had some difficulty in getting wax and nitric acid; had to flatter a poor engraver and persuade a queer chemist who could hardly put the fraction $\frac{1}{5}$ into ounces.'

That evening he wrote lovingly:

[Hotel de la Cloche] Dijon.　27th April [Friday, 1849]
My Darling Effie

I have your precious letter here: with the account so long and kind—of all your trial at Blair Athol—indeed it must have been cruel my dearest: I think it will be much nicer next time, we shall neither of us be frightened—you will be wondering much mine own—at my seeming neglect of you, these several days back—but I was really ashamed to make any more apologies to you: and I could do nothing *but* make apologies— you know I told you how I had been plagued with my plates: well—I stopped at Folkestone chiefly that I might take great pains with the last I had to finish—that it might redeem all faults in the others. I sent this plate away [from Folkestone] on the Friday evening [April 20]: and on the Saturday evening I got down a proof of it.* It was absolutely good for *nothing*: I had

captured some islands and forts on the railway causeway, that they launched an intense bombardment on the city. In March 1849 the uprising in Brescia had been put down with such cruelty by the Austrian Field-Marshal Haynau that it had earned him the nickname of 'the Hyena of Brescia'.

　* If he had sent his plate by train to his publisher, Smith, Elder & Co in London, he would surely have sent George with it, yet it is known from George's diary that he did not leave Folkestone. It seems incredible that posts, excellent as they were

over laboured it, and it was as black as a cinder. I could not bear to put off our journey—so I took a plate with me: and set to work at Boulogne on Monday: the only clear *day*light I had: that was the reason I did not write to you.—Tuesday we were all day on railroad: and we have come about 280 miles over bad roads from Paris here: I had but bits and scraps of time in the morning and evening and I have but half an hour ago sent off in a flat little box the new plate to Cornhill [65 Cornhill was Smith, Elder's address]: it ought to be there on Tuesday—and if the book *can* be out on your birthday [May 7], in spite of this delay, it shall be. The new plate cannot I think be very much out of the way though it may be harsh and scratchy: and very different from what it could have been if I had had more time: However—I am now quite clear of the whole affair: and though I have been much annoyed these last few days: I have not suffered: my eyes feel quite strong and I look forward to a glorious campaign of sketching among the Alps. I will really write you some decent letters now, though you must put up with this shabby one to night: as we start early tomorrow and I have quantities of litter to put away. Goodnight my dearest dearest bride. Kindest regards to Papa and Mama—

<div style="text-align:right">Ever devotedly and entirely yours</div>
<div style="text-align:right">J Ruskin.</div>

A copy of the book will be sent to you and to George: I think this will give more pleasure and be of more use than if I sent one to your mother or father, you know my copies are *limited* when I make bargains: and I have not half a dozen left from my written list.[111]

According to George Hobbs' diary for Saturday, April 28, they left Dijon at 8 a.m. and arrived at Champagnole at half past six in the evening. Ruskin wrote in his diary: 'Saturday was a desperately wet day as far as Poligny, where it cleared, showing me, to my infinite delight, the clouds touching the hill in the ravine above the town and presently afterwards, a rosy light among the sweeping pines. How happy I was—Ah, if I could but keep the feeling!'

in those days, could have been as rapid as this, but there seems to be no other explanation—the plate must have gone by post, there and back with the proof copy, within twenty-four hours.

The next day, Sunday, he was writing to Effie, obliquely criticising her behaviour towards his parents:

[Hotel de la Poste] Champagnole. Jura. 29th April [1849]
My dearest Wife—

I did indeed think of you, both at Boulogne and at Paris as you will see by my letters: and much here today: walking in one of my favourite places, as you will see described as it appears now—(I came here to see it again), in the opening of the sixth chapter of the Seven Lamps*—indeed we often and all think of you, and I often hear my mother or Father saying—'poor child—if she *could* but have thrown herself openly upon us, and trusted us, and felt that we desired only her happiness, and would have made her ours, how happy she might have been: and how happy she might have made us all.'

And indeed I long for you my pet: but I have much here to occupy me and keep me interested—and so I am able to bear the longing better perhaps than you, who have only the routine of home: I hope next summer I shall be able to make you happy in some way of your own.

Continue to address Hotel des Bergues, Geneva:† I hope your Cold's better sweetest; I have still rather a bad one myself—and am not able to write much to night: but I hope the sight of Mont Blanc to morrow will put me to rights: It is of no use to describe any of these places to you as I have been at them a dozen times and have tired you with speaking of them already—I have no plans almost to tell you. I hope to meet Richard Fall‡ at Chambery: to show him Chamonix and the valley of Sixt, then to join my Father and mother and stay three weeks at Vevay [as it was then spelt]: and then the rest of the time my Father can spare, at Chamonix: I hope to write to you the day after to morrow from Geneva—Ever, mine own
 Your loving Husband
 J Ruskin[112]

* *The Lamp of Memory*—'Broken masses of pine forest which skirt the course of the Ain, above the village . . .'—a most beautiful description.

† The façade of this hotel, opened in 1834 and still one of the best in Geneva, is unchanged.

‡ Son of the Ruskins' closest neighbours at Herne Hill. Richard was a year younger than Ruskin and his only boyhood friend. In August 1841 Ruskin had been

Later, writing up his diary, Ruskin described this day at Champagnole: 'I very happy, though very unwell and colded, and coughing and generally headachy. Starved that day [the 29th], and in the evening the landlady, who noticed my illness, made me some syrup of violets; whether it was fancy or chance, or that the thing did me good, I got better, thenceforward; and I have, thank God, had no cold since.'

On this same Sunday (the Ruskins never travelled on a Sunday if they could possibly avoid it), Mr Ruskin was writing to Mr Gray:

> Champagnole Jura
> 29 April 1849
>
> I have neither written to nor heard from you for a long time—I hear through my Son of your all being well except that Phemy's cold continues in which her Husband seems to sympathise by bearing along with him a similar malady and I sincerely wish they were both rid of it—your weather can hardly have been worse than ours—Even Saturday week was miserable, cold, at Folkestone the whole preceeding week wet and wintery and our first day in France we had a deluge of Rain—Tuesday the second day became fine and the weather warmer. Yesterday another deluge. To day fine but cold and windy. We are however 1500 feet high—I can scarcely believe we are abroad without Phemy but we are too early here to have made it wise in her being brought and if my Son did not come very much as a matter of Business in his particular pursuits I should have said that in so cold and backward a Season the end of May would have been better for him. He continued in excellent health to within a week of leaving home and got cold he does not know how.
>
> I was not sorry to be taken quickly from Paris My Son not at all inclined to Parisian Life—we arrived at 5 p.m. and left next morning at 8—We were within a few hundred yards of magnificent Dwellings where we should have been welcome but we did not come abroad for the purpose of paying visits at

going on his first independent tour with Richard to Wales, but, falling ill, had been sent to Dr Jephson's at Leamington instead. This present tour with Richard was to make amends for the lost Welsh tour. (*Praeterita*, pp. 138–9, 299, 440.)

Paris. I hope Mr and Mrs J. R will some day do this for us.*
I was not at any rate in a humour to sojourn there. I stood
aghast at the altered mien of this (in itself) beautiful City. It
stood bright and beautiful in the morning sun but the people
looked as if the Earth had opened and cast them up from the
Infernal Regions. They make you feel a horror and a dread
lest some swift Destruction may yet await this devoted City—It
seems impossible to conjecture what can change or amend such
a People.

We came to Paris by Railroad—I wish I had been able to
discern any signs of the Boulogne Line [in which Mr Gray had
shares] being a paying concern—It seems a sleepy affair—but
for Travellers safe and steady not too fast. . . .

Geneva. Monday Evening 30 April 1849

We got here thank God safely after a fatiguing week and
coming over the Jura amongst the Snow—It was at 6 feet deep
on the Road over the Jura—Mrs Ruskin became alarmed with
snowy Roads and bad horses and I am glad Phemy has post-
poned her Swiss Tour to a better Season—There is scarcely a
Leaf out here and the aspect is very wintery but we had a
pleasant Sunday walking to a Scene near Champagnole de-
scribed by John in the Lamp of Memory in the Volume soon
coming out—His cold continues on and off—very obstinate
but I trust the mountain air will do good. He has a letter from
Phemy here—dated St Martins.† I am sorry she remains so
colded but it is an unusually cold Spring and no one almost
escapes.

I am pleased with the tranquil beauty, and order and decency
of the people moving about the City—This too is a Republic—
but a good strong rather despotic Government—not a fast or
loose, anything or nothing, sort of a Government like that of
Paris. They expect in France that moderate and conservative

* The 'magnificent Dwellings' belonged to the husbands of the Domecq girls—
the Chabrillans at 19 Place Vendôme, the Béthunes at Hotel Choiseul, Rue St
Honoré. John and Effie did visit all the sisters on their return from Venice in April
1850. (Lutyens, 1965, pp. 161–8.)

† Effie was staying at St Martin's Abbey, Perth, with Mrs Macdonald, née
Grizel Miller, daughter of Sir William Miller, Bt., and widow of William Mac-
donald from whom John's friend, William Farquharson Macdonald, had inherited
St Martin's and Rossie Castle, Forfarshire.

men chiefly will be returned, but the whole of Paris may be on Fire before an Election comes—for it swarms with miscreants— I rejoice to see the austrians are likely to keep their ground in Italy. The French have a delicate game to play in going against a popular Government at Rome—but the poor people will in time discover that a feeble Government is better than none at all*—

We are not going to wander much about this Country, but remain where my Son has work to do—Our address I believe will be Geneva to Monday 7 May inclusive and then Vevay. . . .

My Son requires me to say he will write to Phemy tomorrow.

George described the journey from Champagnole to Geneva on April 30. They left Champagnole at 8 a.m. and were 'safely housed at the Hotel des Bergues about six o'clock'. Ruskin recorded in his diary for the same day that his mother was so frightened by the snow and a restive horse in their carriage that she got into his carriage as far as St Cergues. In this diary entry for April 30, he added: 'It is deserving of record that at this time just on the point of coming in sight of the Alps, and that for the first time for three years—a moment I had looked forward to, thinking I should be almost fainting with joy, and should want to lie down on the earth and take it in my arms—at this time, I say, I was irrevocably sulky and cross, because *George had not got me butter to my bread at Les Rousses.*' George makes no mention of this lapse in his diary.

John, as promised in his father's letter, wrote to Effie the following day:

<div align="right">Geneva. Tuesday. 1st May [1849]</div>

My dearest Effie

I believe this will reach you before your birthday—and my next, though it shall be sent as soon as I can write it from

* The French elections, based for the first time on so-called universal suffrage, took place at the end of May. The new National Assembly met for the first time on June 2, having elected André Marie Dupin as President the day before. After an uprising in Rome the previous November Pope Pius IX had fled to Gaeta in the Kingdom of Naples. In February 1848 a Republic was declared in Rome and the Pope appealed for aid. The French, as anxious to keep the Austrians out of Rome as to restore the Pope, sent a force under General Oudinot which landed at Civitaveccia on May 2. The French were kept at bay until June 29 when Oudinot entered Rome.

Chambery may not until after your birthday: so I must trust my fondest wishes and dearest love to this one: and my hopes that we may never be separated any more on that day: I went this morning to M Bauttes to buy you a bracelet, which shall be sent as soon as may be: when you want a *set* of Geneva ornaments you must come with me to buy them I cannot trust my own taste.*

I do not like to write you letters about my doings here—lest it should grieve you that you are not with us: and I cannot write about the Alps or express my feelings to you, because really I do love these places so much that I should only distress you by showing how hopeless it was ever to wean me from them. We leave this to morrow for Chambery: where we hope to go up to the Grande Chartreuse: there Richard Fall comes to us— and I shall take him to Chamouni and so down to Vevay, but my letters are all to be sent here as the post offices are uncertain elsewhere. I changed my mind after I had written to you about the plates in the copy of the book that comes to you—as I have no duplicates of such proofs I was afraid of them being hurt in the binding: and have kept them loose: so that your impression, though one of the best, will not be unique: but as it will be a good one: and I am not able to write your name in it—and as your father and mother wish to have one, leave it with them: and I will give you another when you come home. You seem to have been happy with Mrs Macdonald [at St Martin's], and to have made her so, it is very good for you to be there.

I am very sorry to hear your cold is still so obstinate: mine has not shown itself beaten till yesterday: but it is quitting the field. I hope Spring will come at last—wretched though it will

* Ruskin wrote in *Praeterita* (p. 325): 'Virtually there was no other jeweller in Geneva in the great times . . . One went to Mr Bautte's with awe, and of necessity, as one did to one's bankers.' The firm had been started by Jean François Bautte (1772–1832), a specialist in very thin watches. Murray's Hand-book (1846) states that in Geneva, 'The largest and most celebrated establishment for jewellery and watches was that of Bautte and Company.' By the next edition, of 1852, the name had disappeared.

When John returned to Geneva with Effie in 1849, they changed this bracelet for a green enamel one in the form of a serpent 'with an opal head crawling in a flower made of a single opal with green enamel leaves'. They also bought a matching brooch which Mr Bautte said was 'the most beautiful in his collection'. (Unpublished letter from Effie to her brother George, October 14, 1849.) Effie is wearing this bracelet in her portrait by Thomas Richmond, reproduced p. 146.

be after these killing frosts—and will make us all well. Kindest regards to your Father and Mother. Ever my dearest love. Your devoted

<div align="right">J Ruskin[113]</div>

George recorded at Geneva on May 1 that for the greater part of the day he was busy with the daguerreotype, 'trying experiments etc, got a tolerable one of the Mont Saleve'. Ruskin had made use of daguerreotypes to correct his drawings since 1845 but this was the first time he had brought with him a daguerreotype apparatus of his own; there is no evidence though, that he ever handled it himself. George 'busied' himself with it continually, prepared the plates, developed them and carried all the equipment.

ALPINE EXCURSIONS

❋

On Wednesday, May 2, they all started out at eight in the morning for Chambéry, but in the evening Ruskin found time to write to Effie:

Chambery. 2nd May [1849]

Darling Love,

We have had rather a fatiguing drive to day: reaching however our furtherest point, at ½ past five: when I may now turn and look back to my dearest wife, and wish her many happy returns of her birthday and one happy return of her husband in due time. But I am afraid my pet that you could not have managed to travel with us at the pace we have come, at all. Let me see: Monday, up at six, off at ½ past 8—days rest at Boulogne. Tuesday, up at ½ past five, off at eight, for Paris, get there at four [at 5 according to George]. Wednesday up at six, off at eight, get to Sens at six—evening—Thursday, off at ½ past eight, eleven hours to Mont Bard. Friday, off at 10, seven hours to Dijon. Saturday, off at eight, 10 hours to Champagnole. Monday off at ½ past eight and nine hours to Geneva—one whole day at Geneva—off today at eight. 9½ hours here. I find I can't write to night, too sleepy. 3rd May —It is a lovely day—all the peaks of the mountains as clear as crystal, and I have got a cluster of gentians cut up with their turf yesterday which I am going to make observations upon for my next book.* I like my plates better than I thought I did

* There are three water-colour sketches of gentians on one page of Ruskin's diary at Bembridge (Vol. 6) with a note in his writing in the top right-hand corner: 'Star gentians carried to Chambery and drawn there 3rd May'.

when I look at them quietly, I think they will rather make a sensation.

Miss Sidney ought to be married to day*—poor girl—isn't it a sad thing Effie dear! that young ladies ever will allow it. Well, I hope she will manage her husband and that it will be for his good.

—Ever my dearest Love. Your devoted Husband
J Ruskin

A thousand loves and fond wishes.

Chambéry was the capital of Savoy which was then, with Piedmont, part of the Kingdom of Sardinia. Charles Albert, King of Sardinia, who had built up the only well-equipped army in Italy as well as introducing a Constitution, had been the one hope of the Italian patriots in 1848. He had defeated the Austrians at the battle of Goito in April 1848 but had been finally routed by them at Novara on March 23, 1849. On April 3 Charles Albert had abdicated in favour of his son Victor Emmanuel who, twelve years later, was to become the first King of United Italy. The remnant of Charles Albert's army, back from the wars with Austria, were then stationed at Chambéry. Ruskin had something to say about them in his next letter to Effie:

Chambery. 3rd May [1849]

My dearest Love

I have been writing you desperately shabby letters—and I fear I should continue to do so, unless I write to you a little of what I should otherwise note in my journal: trusting to your kindness to excuse, or to miss what does not interest you and to keep the letters carefully, that I may refer to them when I want them.

This place is full of soldiers, returned from the last battle: shabby fellows the Savoyard troops were always and look none the better for their campaign: and as the government cannot afford them new clothes, though it is getting them into some order again as fast as it can, they look slovenly and melancholy:

* Augusta, elder daughter of the late James Sidney and step-daughter of Dr Grant, married on May 3 at St Mary's, Bryanston Square, the Rev. Thomas Hayes, late curate of Waldegrave, Oxon. The curate of Richmond, where Dr Grant lived, officiated.

more beggars on the road than ever, and the people seeming
hard put to it—but a quiet and gentle people, and one that with
a good religion, might be everything: we were talking to an
old man as we climbed a hill path that led through his orchard:
he took care to tell us that he was the Proprietaire of the land
for some distance on each side—nevertheless he had many
holes in his old coat, and many patches of the largest size on his
short trousers, he complained grievously of the taxes: said that
things were very cheap, bread $1\frac{3}{4}^d$ the pound wine $1^d\frac{1}{2}$ the
bottle but that they were eaten up by the taxes and the clergy:
What—we said—did not he like, *aimez*, the clergy: He said he
loved God, and the Sainte Vierge, and Christ—those were his
three masters, but for the clergy—he thought nothing of them
—they got all they could from the poor and were very rich. He
gave my mother a lecture upon going too fast up the hill, said
that people heated themselves and caught the pthisè [phthisis =
consumption]: that he had come up the hill often enough and
always went gently, and he was eighty two and ought to know—
He accompanied us some way to the top, showed us which way
to turn and made us his bow: All the people here seem good
natured. I was out after dinner for a walk by myself—and
having gone up a kind of place a good deal like the walk where
we had 'serious conversation' at Falaise,* found myself stopped
by a gate into a peasants grounds: the man was at it—digging
or weeding something or other: I asked him whether there was
any path by which I could get up the crags behind his house:
Very often under such circumstances—whether there be or not,
people answer shortly no—there isn't, but this man said—yes—
there was a path that the children went—but he feared it was
'trop mechant pour Monsieur—ce n'est que la petite police
qui va la—' I did not care particularly to run the chance of
being turned back by anything accessible to la petite police: so I
took his advice—and turned down as he recommended by some
little houses in the valley, at the door of one of which a woman
was sitting spinning, of whom I again asked whether there was

* They had been at Falaise from August 25 to 31, 1848. One afternoon they had
gone up to the Castle of Robert le Diable (father of William the Conqueror), 'sat
on the grass, and walked in the sunny orchard under Talbot's Tower. . . . And so
we rambled about all day.' (Letter from Ruskin to his father, August 29, 1848:
Links, p. 35.)

o

any path up the rocks—She said—oh—yes certainly if I would take the trouble to climb over her garden wall—indicating to me the lowest gap in it she went on with her work. The gap, with some little damage to the coat in the Craigmillar fashion,* was surmounted, and I got up the rocks and had a lovely view over the lac de Bourget.

Chambery. 5th May. Yesterday we started at six oclock for the Grande Chartreuse—drove about twenty miles to a small country inn [at St Laurent du Pont]—where mama made herself as comfortable as she could for the day: and *I* breakfasted, and my father sat looking on and telling me to make haste: then we got two bad mules—no—one, and a horse: and my father and I rode up to the convent—half the road made well, by the government: the other half not made at all, by the monks: I never rode up a worse *road*: I have often ridden over broken ground, wherever I could get a mule to go—but I never went over such a surface of *road* yet: nor often up a nobler ravine in its way: only you can form no idea of an Alpine ravine, Effie: tell you of it what I might—you recollect the look of the grey building under the purple hills in the Cosmorama:† the hills are far finer in reality: but have snow among their pines just now: the part of the building you saw in the picture [sketch] was only the entrance: behind it there is a regular little town of various buildings—little walled gardens:‡ one to each monk and a cell to each—with its window looking straight

* No doubt he had torn his coat when they visited Craigmillar Castle while staying with the Andrew Jamesons in March 1848.

† The Cosmorama was at 209 Regent St—then on the west side, just north of Conduit St, and opposite Jullien's Conservatory of Music. It was one of the last of the series of public spectacles which began with Robert Barker's full-scale 'Panorama' of Edinburgh in 1789 and ended in 1863 when Decimus Burton's 'Colosseum' in Regent's Park eventually closed after thirty years of exhibiting panoramas. Ruskin thought highly of these predecessors of the cinematograph, particularly that of John Burford (partner of Robert Barker's brother) in Leicester Square. He had been 'partly prepared' for the view from the roof of Milan Cathedral in 1833 'by the admirable presentment of it in London, a year or two before, in an exhibition of which the vanishing has been in later life a great loss to me'. (*Praeterita*, p. 118.) In 1867 he wanted to see 'the now exploded panorama and diorama' restored to places like the Crystal Palace (*Works*, XIX, 218), and in 1878 the work of two painters was compared unfavourably with 'the real old Burford's' which 'was worth a million of them'. (*Works*, XXVI, 567.)

‡ Ruskin's drawing of the Grande Chartreuse, done on this visit, is reproduced p. 163.

on to his neighbours dead wall—set on a sloping green bank—d [sketch], over which if there were windows at the *ends* of the cells they would have a lovely view of the mountains, but the window is turned to the back of their neighbours premises. We were shown over the house by a lively monk; I had a bit of an argument with him on the propriety of his shutting himself up with his brethren in such a place and letting the world fall into all manner of mischief—but having a dampish great coat on—and fearing to dry it upon me, could not have it out, but had decidedly the best of it.

Sunday morning [May 6]. Richard Fall arrived here in the night. I have been out walking with him, showed him an Alpine gentian or two in their homes, we return to Geneva tomorrow where you may still direct Hotel des Bergues. While we were up at the Chartreuse my mother was making herself as comfortable as she could in the country inn below—she partly succeeded: and the people were mighty obsequious in a disagreeable way: the bill very much like our friends at Honfleur.* One of the serious items on it was a little bottle of the Elixir de la Chartreuse—a kind of liqueur distilled by the monks—very like the strongest whisky with sugar candy [in] it: a very satisfactory compound, said to be good for all kinds of complaints: especially that of over sobriety. I have therefore bought a whole bottle of it for my wife: enclosed in another bottle of pine wood, and sealed by the monks.

Take care my love that you be not cramped for want of money, you can always have anything paid in London by writing to Mr Watson or Ritchie at Billiter St, indeed I left £40. with Ritchie for any occasions of the kind: but if you want more money at Perth and can let me know, I will tell them to send it.

I am getting better every day and my limbs are beginning to feel good for something. I hope soon to be in fair Alpine training. The cough only now troubles me a little in the morning: [word obliterated] been very obstinate and if I had not been careful I think it might have been worse than the Salisbury one.

* The Hotel d'Angleterre at Honfleur where they had stayed the night of September 28, 1848, described in Murray's *Hand-Book for France* (1847) as 'clean and good cuisine, with much attention'. George had noted in his diary for September 28, 1848, 'Abominably expensive hotel here opposite the ferry, the most exhorbitant in their charges.' (Links, p. 66.)

purple hills in the distance: the [...] are true
[...] in reality: but how snow among their pines
just now: the part of the building you saw in
the picture was only the entrance: behind
there is a regular little town of various buildings
little walled gardens: one to each — like
a cell to each — with its window looking straight
on its his neighbours dead wall — set on a sloping
green bank. — & over which if there
were windows at the ends of the
cells, they would have a lovely
view of the mountains: but the
window is turned to the back
of their neighbours premises.

We were shown over the house
by a lively monk: I had a bit
of an argument with him on the
propriety of his shutting himself
up with his brethren in such a place
and letting the world fall into all
manner of mischief —, but having a
dampish greatcoat on — and fearing to
dry it upon me, could not have it out,
but had decidedly the best of it.

Sunday morning. Rich & Fall arrived here in
the night. I have been out walking with him. showed
him an Alpine gentian or two in their homes.
We return to Geneva tomorrow. where you may
still direct Hotel des Bergues.

While we were up at the Chartreuse, my mother was

George has been making enquiries as to the condition of the poor soldiers here—the regiment lost four hundred men at Novara— they threw their shakos away, and fought in their caps, the consequence was the utter loss of the shakos which are not yet replaced and they walk about in their undress—they have only two meals a day—soup and bread one, soup and four ounzes of meat the other: never enough: 3 sous a day now that they are on war rations—about four sous a week generally. They all look robust fellows—though brought up so remarkably like Oliver Twist. Richard has come through Italy with hardly any serious inconvenience only he has been obliged to miss Venice: being stopped for an hour or two at town gates or frontier custom houses, and the nuisance of disagreeable reports was all he had to put up with.

I will write again as soon as I can: but I shall be rather busy going with Richard for some ten days. Kindest regards to your father and mother

Ever my dearest wife
Your devoted Husband
J Ruskin

I had nearly forgotten to ask you, love, whether it would be very irksome to you as you read Sismondi* to write *every word* that bears in the remotest degree on the interests or history— of Venice? as I want to get at all the facts of Venetian history as shortly as I can, when I come home. Note every *man* who is a Venetian, wherever he appears: and make references to the places distinctly in a little note book kept for the purpose.[114]

After a quiet Sunday at Chambéry the whole party, including Richard Fall, returned to Geneva on Monday, May 7, and George immediately went off to get passports. 'We cannot even go as far as Vevay by the steam-boat,' he wrote in his diary, 'without getting and showing our passport and giving it up again when we leave

* Jean Charles Léonard Sismondi (1773–1842), Swiss historian of Italian descent; his *Histoire des Républiques Italiennes au Moyen Âge* in 16 volumes was published 1803–18. *The Stones of Venice* had been advertised in the first edition of *The Seven Lamps of Architecture*, therefore Ruskin intended it to be his next book but expected it to be a short one because the advertisement announced that it would be uniform with *The Seven Lamps*, a book of only 197 pages.

this for Chamouny, it is a great nuisance but it cannot be helped.'
He meant that they had to get their passports signed by the Sar-
dinian Consul (at 2 francs per passport) when they went anywhere
in Savoy, and Chamonix was, like Chambéry and Annecy, in Savoy.
A great deal of smuggling went on, especially across the French-
Savoy border, but it was strange that they should have had to have
their passports countersigned when going from Geneva to Vevey,
since both places were in Switzerland. As the Swiss-Savoy boundary
line ran through the Lake of Geneva there was perhaps danger of
smuggling on the lake steamers themselves. George was more
valuable to the Ruskins than any courier, for not only did he see to
the passports and pack the carriages but he accompanied John on
most of his walks, carrying his sketching things as well as the heavy
daguerreotype equipment.

As recounted in his diary, he went with Ruskin and Richard Fall to
Vevey by steam-boat at nine o'clock on the morning of May 8 in
order to see the Castle of Chillon, and the next afternoon returned to
Geneva by steamer to be there in time for Mr Ruskin's birthday on
May 10.

John found awaiting him at Geneva a letter from Effie which
obviously exasperated him:

Geneva 10th May [1849]
My dearest Love

Returning from Vevay yesterday where I had been with
Richard Fall, I found your nice long letter from Bowerswell of
4th May—I am very sorry however to hear that the weakness is
returning upon you already: since the weather surely cannot
be very hot yet in Scotland: we have had it as cold as it is
possible at this season, and the snow is at this instant shining
in bright patches, forty or fifty yards over, on the green slopes
of the Mont Saleve which I see over the bright roofs of Geneva.
Tomorrow I leave with Richard for Chamonix, and then it is a
question where we *can* go among the hills, the snow being yet
deep all round the valley: I am sorry you have been so plagued
by the difficulty of your drawing:* it must indeed try your eyes

* Ruskin never succeeded in teaching Effie to draw although Millais when he
started teaching her wrote, 'it is wonderful how she gets on' and 'she gets on in a
manner reflecting great disgrace on me for having been so long in painting as I do

exceedingly but you will profit by it and find the other things easy if only you could recover your general strength. I cannot understand what it is that is now the matter with you: as you have everything to which you are accustomed, and have had, I should think, a good deal of pleasant society and excitement. Your friend Miss Boswell* must be a nice clever creature: but it seems to me she has a good deal more cleverness than judgment or discretion, or she would understand the very simple truth that it was not *I* who had left *you* but *you* who had left *me* —Certainly I never wanted you to leave London, but you could not be happy unless you went to Perth: and away you went much more to the astonishment of *my* friends in London than my departure for Switzerland can be to the suprise of yours in Scotland: I wonder whether they think that a husband is a kind of thing who is to be fastened to his wife's waist with her pincushion and to be taken about with her wherever she chooses to go.† However, my love, never mind what they say or think: I shall always be glad when you can go with me and always take you with me wherever I think it safe for your health that you should go, when it is not, you must be prepared to part with me for a month or two as I must either follow my present pursuits with the same zeal that I have hitherto followed them, or go into the church. I am glad there is a chance of your seeing Miss Wedderburn in Edinburgh: I sent her a letter to London which I hope she has received.‡ Do not vex yourself because the

now'. (Letters from Millais to Holman Hunt, July 24 and August 14, 1853: Lutyens, 1967, pp. 71, 78.) Effie's exemplary pencil copy of Millais's portrait of her with foxgloves in her hair is reproduced James, p. 120.

* Jane Douglas Boswell, second of the five daughters of Hamilton Boswell who had married Jane Douglas, heiress of Garrallan, Old Cumnock, Ayrshire. Jane Boswell lived with her widowed mother at Garallan. She detested Ruskin and made as much mischief as possible between him and Effie. She stayed with them for three weeks shortly before Effie left John in April 1854. (Lutyens, 1967, pp. 160–3.)

† During their engagement he had written to her on January 19, 1848, 'I shall have no more independent existence than your shadow has—I feel as if I should faint away for love of you—and become a mist or a smoke, like the genie in the Arabian Nights—and as if the best you could do with me would be to get me all folded up and gathered into a little box—and put on your toilet table.' (James, p. 84.)

‡ Jemima Wedderburn, a painter, mostly of animals. The following year she married Hugh Blackburn, Professor of Mathematics at Glasgow University. Ruskin had started his very long letter to her while sitting in his carriage crossing

Raffaelle drawing puzzles you—you happen just to have pitched upon the most difficult one of the whole set—because the closest in line: the one of Jacob and Rachel—of the finding of Moses, or of the blessing of Jacob would have been easy in comparison:* but rather give the thing up than plague yourself about it: remember there is a great difference between pride and resolution: I think in *general* that not to give up a thing because we '*will* not be beaten' has more of bull dogism in it than of sense: There are times when we 'must not be beaten': as the Duke said at Waterloo: but there are other times when we ought to be beaten, when the victory is useless: as it would be in this case if it cost too much: I should recommend—and would have done so at first had I had time to write anything, that you should only copy from these pictures a feature here and there—a hand, foot—head, arm—bit of drapery—or of foliage—taking the easiest—that is to say that which has fewest lines, the first—Do not however think your time lost over this Abraham, as your hand will gain steadiness with every line you draw.

I received to day word of the arrival of the plate I had to send from Dijon and that the book will be out on the 14th, D.V. so that you should receive your copy on the 16th. I leave, as I said, for Chamonix to morrow, whence letters only go on the Tuesday and Friday—if I can I shall post a line on the road to morrow, otherwise you cannot have a letter until the one I shall send on Tuesday [the 15th] makes its way down the ravine of the Arve and to Geneva and so to Paris and Perth, a journey which would take it some time. I trust however that, once

to Boulogne on April 18, 1849, and finished it at Champagnole on April 28. In it he castigates her picture of a pair of horses being frightened by a train: '. . . you ought to be whipped till you give up painting railroads. There is no nourishment in them.' It was because he had such a great respect for her talent that he felt she was worthy to receive such a letter (given in *Works*, XXXVI, pp. 96–100). Effie would not have been pleased to know that he had written such a very long letter to Miss Wedderburn when he could find no time to write to her during the journey to Switzerland.

* Ruskin had no doubt given Effie a set of Raphael engravings although in 1845 he had considered Raphael 'though a great fellow, the ruin of art'. (*Works*, IV, xxxii.) By 1853 he averred that Raphael executed his pictures 'with the precision up till that time unseen'; it was 'pre-eminently the age of drawing'. (*Works*, XXII 109.)

settled at Chamonix you will have your letter, and I mine, twice a week.

All is quiet and happy here: and at Chamonix—In the Pays de Vaud much vexation about church of which I shall have probably something interesting to tell you during my proposed stay at Vevay. My Father and Mother send their loves. Ever my dearest Wife, Your devoted Husband

<div style="text-align:right">J Ruskin</div>

I believe Mr March is a better judge of where his charity should begin and end, than Miss B [Boswell]—[115]

If John posted a letter to Effie on the road, it has not come to light. George, however, described their journey to Chamonix. Apparently Joseph Couttet (Note, p. 64), John's Chamonix guide, had come to Geneva to travel with them; meanwhile Mr and Mrs Ruskin were left behind in Geneva. They were all to join up again at Vevey in a week's time.

When Ruskin and Richard Fall, with George and Couttet, got to Sallenches, Mont Blanc was covered in cloud. The Hotel du Mont Blanc at St Martin where they usually stayed was not yet open so they stayed at the Belle Vue at Sallenches. In those days the road from Cluses went along the left side of the River Arve to St Martin and thence over the beautiful eighteenth-century stone bridge to Sallenches half a mile away. St Martin was therefore a very busy place at that time whereas to-day it is a neglected hamlet.

From Sallenches there were two rough roads to Chamonix, both impracticable except for mules or char-à-bancs. A char-à-banc was a bench placed on four wheels surrounded by leather curtains which could be closed in bad weather. It was said to be like a four-poster bed on wheels which could be drawn by one or two horses. It was very strong and light, could carry two people inside and one outside with the driver, and, being so low, the passengers could jump off and on when going up hill without stopping the horses; it jolted abominably, though.

After one night at Sallenches they proceeded by 'char' to Chamonix, going by way of St Gervais on the right side of the river. The Ruskins always stayed at the Hotel de l'Union at Chamonix, the only one, according to Murray's Hand-book, that had 'hot baths'—i.e. warm mineral baths coming from a hot spring (the car park now

occupies this site). They spent two quiet days at Chamonix and then
Ruskin took Richard Fall on an expedition to the Montanvert with
its view of the Mer de Glace—now hardly more than a stream of
mud compared to the glorious glacier of Ruskin's time. Couttet and
George accompanied them. The inn at the top of the Montanvert
belonged to Couttet's brother, David, who, according to George,
followed them up and 'got his keyes, opened the house, made some
fires and brought some wine from out of the ground where it was hid.'

That evening John gave Effie an account of this Montanvert
expedition:

<div style="text-align:right">Chamouni.　14th May [1849]</div>

My dearest wife

We got here from St Martin's [actually from Sallenches] on
Saturday evening in very lovely weather which continued all
yesterday and this morning till twelve: we have just now come
down from the Montanvert about which your mama will tell
you: it is now entirely under snow: and we were plunging
through the snow for more than an hour before we got up:
being the first people there this season—We slid nearly all the
way down on our backs Richard averring that it was worth
going up for the fun of this alone: he did not think it quite so
good fun however when we came to the shallow snow where we
had to walk and broke through every other minute into holes
among the rocks; However—in spite of a good deal of this work
which is I think more disturbing to ones equanimity than any
bothers one can encounter, and a little fairish scrambling and
letting ourselves down by the pine trunks, we got down the
whole height from the Montanvert to the source of the Arveron
in three quarters of an hour. It is 2000 feet perpendicular so
you may fancy what nice fast sliding we must have had.* It was
a very nice little first lesson for Richard: and he will not find
anything he has to do very difficult after it. I wish whenever I
am at these places that I had my wife with me, but you cer-

* Describing this descent years later in *Praeterita* (p. 441) Ruskin wrote, 'we slid
down the two thousand feet to the source of the Arveron, in some seven or eight
minutes'. To this he added a footnote: 'Including ecstatic or contemplative stops;
of course one goes much faster than 200 feet a minute, on good snow, at an angle
of 30°.'

tainly will be able to get very little about here my pet and I must take care not to keep you here too long—

Everybody here who knows me, enquires for you very anxiously and it is a great disappointment to Coutet not to see you. I think you would have made rather a sensation in the Valley. It is rather curious that my book is as I suppose published on the day that I have my first Alpine excursion: and open the house on the Montanvert for the travellers of the year. All the guides but Coutet said we should not get up: but Coutet never fails for mere timidity—if the thing becomes dangerous he stops, and not till then.

I am surprised to find the inhabitants of the valley, secluded though it be—so entirely unaffected by the troubles of Sardinia; no additional conscription took place, and of the people of the valley who were previously in the army only one or two have been killed, in short they have not felt the war with Austria anymore than one of their winter avalanches carrying away a shepherd. All that they want is more travellers. I was amazed on looking over the travellers book at the Montanvert* to see the enormous number that pass there, usually in a year and not less suprised at the vast averages of fools that compose their numbers: there is hardly a single person who writes his name there who does not commit himself—I think the air of the ice— or the looking down for the first time from a great height at the valley, turns their heads—for the world could not go on if there were so little wit in it: The chief thing seen in them all is intense vanity: desire of distinction at any price and for any thing:—mixed with various forms of other vulgarity: and it is very droll to see the self-complacency manifested by people in their vague ideas that they have done something more wonderful than any of the two—three—or four thousand who have perhaps preceded them in the same year. I have half a mind to see whether Coutet [David] will lend me some of his books: to publish it, it would serve the people very right. One or

* The inn was built in 1840 to supersede the eighteenth-century *Temple de la Nature*, one of the oldest refuges in the Alps, which has been preserved as a national monument. The shell of David Couttet's inn can still be seen—a stone bungalow consisting of four bedrooms, dining-room and kitchen. The present hotel was not built until 1880.

two sensible entries were refreshing: one quiet one among a
great quantity of balderdash pleased me

　　　　　William Stokes, Manufacturer, Sheffield.

I doubt not he enjoyed and probably felt the thing as much as
any of them. I will make some extracts in my next letter from
the travellers book *here*: they may amuse you.*

　　I hope you are getting my letters now in regular time
　Kindest regards to your father and mother
　　　　　　　　　　　　　　　Ever my dearest Wife
　　　　　　　　　　　　　　　　Your devoted Husband
　　　　　　　　　　　　　　　　　　J Ruskin[116]

Write now to Hotel des Trois Couronnes, *Vevay*,† *Suisse.*

　Ruskin no doubt continued to write to Effie twice a week but we
have no more letters from him for a fortnight.

* Murray's Hand-book states: 'At Chamouny and elsewhere, the travellers'
books at the inns are great sources of amusement. . . . A most disgraceful practice
has too often prevailed, of removing leaves for the sake of autographs.'
　† This hotel was described by Murray as 'one of the best inns in Switzerland,
comfortable and clean: a very large house and a civil landlord'.

MUTUAL MISUNDERSTANDING

✳

George's diary records that on May 17 they left Chamonix and went on mules by way of the Tête Noir to Trient, and so to Martigny where they spent the night. George and Couttet had to lead the mules most of the way through torrential rain with slushy snow still thick on the ground. It seems to have been a miserable expedition with every view shrouded in thick cloud. It took eleven and a half hours, hardly stopping at all, and shows what remarkable physical stamina Ruskin had when engaged in any occupation that interested him.

They started off again early next morning, going through the valley of the Rhône as far as Villeneuve where they took the steam-boat and were at Vevey in half an hour—'Mr and Mrs R glad enough to see us all safe back,' George reported, 'as they had not heard but once since we have been away, the letters that were posted at Chamouny on Tuesday had not then arrived, but in the evening they all came in a mass'—so, evidently, John had not neglected to write every day to his father even during this short trip.

As it had rained again all night and was a very dull morning, Richard Fall decided to leave them next day, the 19th. 'After a long delay for a mule,' George wrote, 'the animal about ½ past 11 made its appearance led by a miller, and a very sorry looking beast it was too. After some preparation and a struggle to get his legs over the bag, at the back of the saddle, Mr F started, pole in hand, to the amusement of many people standing by, one of whom, asking where he was bound to, and told to Thun, said "Est-ce qu'il croit d'aller à Thun avec monture la?" He certainly did look anything but noble, with, such an animal.'*

* Ruskin's memory was at fault here in *Praeterita* (p. 442): 'Little I thought, in clasping Richard's hand on the ridge of the Jaman that spring,—he going down into

On this same day Mr Ruskin was writing to Mr Gray:

Vevay 19 May 1849

I cannot delay replying to your kind Letter of 9 May and expressing the great delight I feel and offering my sincere congratulations on your having emancipated yourself from the Thraldom in which you were held by Railroad and unsettled Bank Accounts. Nothing is so wearing as suspence and my former Letters would show you that I eagerly desired any kind of termination to your late troubles in preference to your hanging on, looking for what might never happen—to the entire discomfort of yourself and family—undermining your health and destroying half the powers and faculties of your mind which can be used in general so much to the advantage of yourself and all around you. . . .

If I understand your arrangement, it is that you are left with a Debt to the Bank due in 3 years subject to Interest of $3\frac{1}{2}$% till paid—but in no event with any other liability and entitled to any surplus that the Bank may realise over and above the £3000 should Shares recover themselves. I think it a far better settlement than the state of the market warranted and it gives me an Impression of great liberality on the part of the Bank and the friendly consideration shown by Mr Burns. It speaks highly both for the Bank and for you, as I cannot imagine the Bank would so treat persons generally. They know you and value you evidently and show judgement and discrimination in thus favouring you. . . .

I am concerned to read your account of Phemy. By a few words, now and then read to us by John from her Letters, I should guess her to be full of Health and spirits of vigorous mind and Body and I cannot but hope that the sense of weakness felt by herself and apparent want of power to take Exercise an entirely nervous and so far a delusion as most nervous complaints are—though there must be some cause even to produce the feeling and conviction of weakness. There

Simmenthal, I back to Vevay,—that our companying together was ended. . . . My father and mother were waiting for me at Geneva.' Richard married and became a partner in the mercantile firm of Palmer, Mackillop, Dent & Co. He died in 1878.

is always the comfort of knowing there is no great mischief doing—no permanent Injury to the frame. All these feelings may be dissipated in a day and I trust a Visit to Edinburgh and Ayr and Horse Exercise will come in aid of Recovery.

This is the last we hear of Mr Gray's financial worries which had caused such anguish to all the family and had such an adverse effect on Effie's marriage. It was by no means the end, though, of Effie's 'weakness'. The chief reason for her visit to Edinburgh, mentioned by Mr Ruskin, was to see Dr Simpson, who was at that time Professor of Midwifery at the University.* Effie had evidently told John all about her visit to Dr Simpson, and he sent off an extremely irritable reply:

Vevay, Sunday, 27th May [1849]

My dearest Effie

I have your letter from Ayr, with account of dinner at Farquharson's etc: You may well say, not that Mrs Farq.† but that Mr Wedderburn had 'no manners' I never heard of anything more vulgar than his making the poor old lady uncomfortable at her own table: you are always telling me of peoples *wit—I wish* [underlined three times] I could hear something of their *feelings*. We have a line—my mother has at least—from Mrs Gray—of which the contents might be summarily expressed in the sentence—'you see I was right'—it tells us what you told me of Dr Simpson's opinion: but does not so much as hint at any probable means of your recovery: However you may tell her when you write that she was right, and that now if she will give me any advice as to your management I shall receive it with respect: I should like to hear what she supposes brought it on in London—as it was not the influenza, and you had it months before: I have been thinking over all you told me and it seems to me in the first place that your chief complaint is a nervous weakness preventing you from taking exercise enough to bring on perspiration—you would faint before you would perspire—you will not I think get out of this but by forced

* James Simpson (1811–70) had introduced the use of chloroform in 1847 and was created a baronet in 1866.
† Mrs James Farquharson, mother of John's friend, William Macdonald.

exercise to utmost of your strength every day: until you are able to take enough to put you into a heat: and then you will get well fast enough if you take it regularly: riding will I suppose be an intermediate means of gaining strength: spare no expence that may promote your recovery.

I am engaged in a philosophical inquiry into the various forms of vanity—my own as well as other peoples. I hope it may do me good—The Montanvert books are good in a small way; as I told you: Mrs Bolding is very ill, William [Richardson] was quite mistaken in her complaint at first—anybody might have been—Dr Locock* agreed with him and said there was nothing serious; so there was no occasion for his feeling any shame at his first mistake: Nevertheless now that he has found it out he does not confess it—but finds all manner of excuses— or avoids the subject. My mother from the first said there was something very serious the matter—now that it has turned out so, I think the delight of being right has quite consoled her, for the present, for the illness, although she loves Mary exceedingly: her feelings of regret taking generally the turn of violent animosity against William. In the same way your mother appears quite happy at discovering that you have a disease that may make you miserable for years. Your letter does not say a word of what Dr Simpson said was the cause of your complaint. I should like to write to him myself—what is his address! or if I write will you be in Edinburgh again so as to be able to send the letter with a fee?

I send this to Perth—not knowing exactly where to address. It is not easy to find out the truth about the church here, but everybody I have spoken to says that the clergy have been to blame—(or at least very foolish) not the Government.

Direct now, again, Hotel des Bergues, Geneve.

Ever my dearest Effie, your affectionate Husband

J Ruskin[117]

* Dr Charles Locock (1799–1875), created a baronet 1857, was first physician accoucheur to Queen Victoria and attended the birth of all her children. It seems therefore that Mary Bolding's complaint was gynaecological. Locock was one of the two doctors who examined Effie after she brought a suit of nullity against Ruskin and declared her *virgo intacta* on May 30, 1854. (Lutyens, 1967, p. 219.)

The old Ruskins surely had more reason to be perplexed by Effie's condition than their son, and a week after receiving Mrs Gray's letter Mr Ruskin answered it to Mr Gray:

Vevay 4 June 1849

I wrote about fourteen days ago—I send a few lines now to beg of you to express for Mrs Ruskin, her best thanks to Mrs Gray for her kind letter giving an account of Phemy's visit to Dr Simpson and his opinion which was satisfactory and gave us hopes of speedy Improvement but we were greatly concerned to hear from John that by a letter just received no Improvement has taken place and that Mrs J.R returns to Perth scarcely so Well as when she left. It is the nature of these Complaints that whilst they are never Serious they are the most difficult to cure—because nervous patients never submit for a week together to either medical treatment or Control—It is impossible for Baths to effect any change on the functions of the System—instanter—Some regular course of Diet—Baths—and Exercise will require to be persevered in for some time—It appeared that Phemy was best with the Horse Exercise at Perth, and I hope this will be resumed but always in moderation—overfatigue is Injurious—in task work or over Books or Drawing—a pleasing division of pursuits pursued with Interest —will be medicinal—however it is easy to advise—the difficulty is to make any one troubled with nervous weakness, persevere in any thing. I should be greatly obliged by your own opinion of Phemy's Health and how she appears compared with her appearance when she came down to Perth in Feb^y. . . .

We have not heard a word from Scotland except from a friend at Glasgow of John's Book. I should like to have a few frank Opinions—If Railroad Directors ever trouble themselves with such work, I should like to hear their notion of it.

We have just received favourable accounts of Mrs Bolding who you may have heard has been Seriously ill.

The first batch of cuttings, all favourable, arrived the very next day, sent by the publisher, and others, even more laudatory, with a few exceptions, followed throughout July and August. Nearly all the critics, however, condemned the plates, an opening given to them

by Ruskin himself who, in his preface, had apologised, 'for their hasty and imperfect execution'.

John stayed with his parents at Vevey until June 6. The weather improved—in fact it became very hot—and they made several excursions. George was surprised how far and how well Mrs Ruskin was able to walk. George himself was often 'busy with the daguerreotype' and on several evenings he fished in the lake and they had his catch for supper. Early on the morning of Wednesday the 6th, he and John started by diligence for Sallenches which they reached at about half past three in the afternoon. On arrival George took four daguerreotypes of Mont Blanc. Mr and Mrs Ruskin were to join them the following Monday and they were all to go on to Chamonix together.

John did a great deal of sketching during these few days alone with George at Sallenches. George recorded on the 10th, 'Entirely different manner of living here to what it is at home. I rise every morning at 5, breakfast at 6, dine at 12, supper at 7 and go to bed about 9. Mr R has put his watch back two hours, to make it out he gets up at 7 and so on'.

On Monday, June 11, they crossed the bridge over the Arve to St Martin where they found Mr and Mrs Ruskin and Anne already installed at the Hotel du Mont Blanc. It may be remembered that this inn at St Martin was not yet open when Ruskin was there with Richard Fall a month before. In *Praeterita* Ruskin names a chapter *L'Hôtel du Mont Blanc* and calls it 'certainly, of all my inn homes, the most eventful, pathetic, and sacred'. (The site is now occupied by a school.) The next morning the whole party started out for Chamonix in two 'chars', in terrible weather. The day after they got there Mr Ruskin again wrote to Mr Gray about Effie:

Chamouni 13 June 1849

I have written to you lately but I address you again to repeat the expression of my sincere regret at the continuance of our Daughters bad state of Health, and farther to inform you of the trouble we are all in from not knowing what should be done if anything can be done, on our part to bring about an amendment—It is evident to me that my Son also suffers from not being able to make out what his wifes entire feelings and wishes are. After all the encomiums heard about freedom, reserve and discretion I am of the opinion that much of the unhappiness of

the World arises from persons not freely writing or speaking out their mind and this more especially with those Beings who are the most unlikely to cherish sentiments or feelings to which they would hesitate to give utterance.

It must be your desire as it ours to see our Children as happy as the world can make them and I wish to God that we could at once learn or divine the cause of the least interruption of their peace or their enjoyment and that we could be the means of removing it. It is in part a consolation to me to be able to say that all our anxiety at present is on your Daughters account for except the uneasiness which my Son experiences from Phemy's lingering state of health, I never saw him so well in his Life, nor so capable of following out his pursuits either independently, or with any share of sympathy that his nearest and dearest, or his friends or acquaintances may be kind enough to afford him. These pursuits are at least respectable and innocent, whether they be useful or not we must leave others who are better able to judge, to pronounce. About your Daughter both Mrs Ruskin and myself must continue to be anxious and as I use no reserve I will confess to you that the feeling is mingled with sorrow and disappointment: The chief aim of our Life when your Daughter became ours was to make her and my Son happy—all the young people that ever came about Mrs Ruskin have clung to her with Love and respect and I have heard from all of them, expressions of gratitude for kindness and advice received that have evinced the depth of Impression made. We have by chance met a Lady here, now above 40 years of age, that told me that she owed most of any good she had done to advice given to her when 16 years of age by Mrs Ruskin.* We had fondly flattered ourselves that Phemy had

* This lady was Miss Sybilla Dowie. Ruskin tells us that she was twenty when he was twelve—'the most beautiful girl of pure English-Greek type' he had ever seen. She was the niece of an old friend of Mr Ruskin's in the earliest Herne Hill days, the motherless daughter of a sea-captain. Mrs Ruskin was her only confidante in her love affairs 'consisting mostly of gentle refusals'. When she was about twenty-five she fell in love at last but was too proud to give the young man any encouragement. Mrs Ruskin advised her to go away for a time; if the man loved her he would surely follow her. This she could not bring herself to do so she stayed near him, yet treated him more coldly than any other friend. He eventually went away and died of cholera. After his death his sister told Sybilla that he had loved her but dared not speak. When the Ruskins met her at Chamonix, she was so changed that

some attachment to us all—I even thought as our House was agreeable to my Son that she might have stayed for a time with us, until they had formed some plan of a permanent residence— The Foreigners [the Béthunes] who were with us and who live much with their parents, expressed their surprise that she did not, but I quite approved of their taking the London House, because I wished them to cultivate the best Society. I mean best by Intellect and Birth, which if left alone they had opportunity of doing, but which with us they could not do to the same extent, but could I be otherwise than surprised that before they had been three months settled, the arrangements of the House were changed, Mrs Gray sent for and a return to Scotland planned and executed and all the great expence of a Town Residence entirely thrown away. I could in no way account for this proceeding because I had seen no strong attachment to Perth in Phemy before, indeed one of my fears before the union was that from her so frequently leaving her home, her habits might be less domestic than might be desired—Her health was delicate but as the result has proved, I foresaw no great probability of that being much improved by a separation from her Husband and it was well known both before and after the union that my Son would not make Perth even a temporary Residence.

Phemy was prepared for this and indeed always knew he had no partiality for Scotland. I think much better of her than to believe that the country which she so often left before marriage, is now to be preferred to her Husband. I excuse her from not being able to sympathise in many of his local attachments, they come from early association and peculiar pursuits: ninety women out of a hundred would soon tire of this place and would prefer what I have heard Phemy say she would, the flying over a Desart on Horseback, but I would expect from her great good sense and talents that she would see that her ambition of which she has too much mind not to have a good share, could be little gratified by her Husband abandoning the Haunts where his Genius finds food and occupation, to seek for stirring

they did not recognise her. She fell into 'a rapid decline' and died two or three years later. (*Works*, XXIX, 426–8.) George spelt her name Dewie, which was perhaps how it was pronounced.

adventures which might end in more mishap than profit. I am quite aware that his pursuits to ordinary people may appear absurd but Phemy is not one of these ordinary people. I fully expect her to comprehend that however absurd or useless her Husband's present pursuits or productions may appear to many around her, his being able to follow them out and to complete them affords the best chance of her ambition being gratified and his own character's aim and ends being understood and his Independence being established for he has the ambition of working out some independence for himself. The few who trouble themselves about him, are very much mistaken if they think my Son is here for pleasure only or even to accompany his Father and mother. He is here for hard work and which it would be a great loss to him not to finish. In fact my Business or the arrival of Mr Domecq might bring Mrs Ruskin and me home in a fortnight but we should not think of letting him come with us unless his work were done—and if Phemys Letters were to bring him home before his time—the effect on her might not last a fortnight and she would get worse by thinking that she had interrupted his plans. You may tell her that Mrs Ruskin and I, although the change was unexpected, can entirely forgive her rejection of our kindness or good offices but we do expect from the Love which we hope and believe, she bears my Son that she will try to make his pleasures hers, to like what he likes, for his sake, and to hear of the places which he loves with pleasure, and if I might take the liberty of prescribing for her own comfort and amendment, I should urge an effort to be made to sacrifice every feeling to duty, to become interested and delighted in what her Husband may be accomplishing by a short absence, and to find a satisfaction in causing him no unnecessary anxiety, that his faculties may be in full force for the purpose to which they are devoted—I trust we may all yet understand one another and that there will be perfect love and happiness between our Children—I do not in the least wish to interfere—I studied to leave them when in their own House, entirely to their own guidance but I now speak to prevent misconceptions increasing and in the hope of your telling us what your own opinions are, or wherein you think we can do any good—[118]

The next day, in a letter to Effie, John showed his state of depression and anxiety which had no doubt prompted Mr Ruskin's letter of the day before:

[Chamonix, Thursday, June 14, 1849]
Darling Effie

I send you a line—with nothing to tell you but that it is as bad weather as bad can be; and we live in a world of clouds and rain, with ranges of pines coming through at intervals—but always most beautiful—I went out to day and walked for two hours in the rain, about one of the glaciers; which is in a curious state, the river which has its source in it breaks out at the edge of a cliff some 600 ft high and after crashing down this with a fury which I never saw a waterfall equal, again disappears under the ice below; and comes out at the usual place the 'source of the Arveron', only crevassing the glacier the whole way as it passes under it, more than I have ever seen it do. The fall however is the fine thing—for it is so wild and irregular that it never keeps the same form an instant—but comes in broken masses—crashing and bounding in every direction. I expect a letter to morrow evening at nine oclock—I trust it may enable me to pursue my work here with greater peace than I can have at present in thinking of your illness. Have you any plans or thoughts for next year. I suppose not, for in your present state of mind you will be able to look at nothing with any pleasure. However, as, when we expected much—we were much disappointed, so now, when the future seems somewhat dark, we shall probably find it brighter as we advance. I have not the heart to write more till I know how you [are]—I cannot write cheerfully while I think you are ill, and I would not write sadly for that would do you no good—so I will only write that I love you, my dearest—and am your most devoted husband
J Ruskin

Perhaps those words 'I love you' were the only ones Effie wanted to hear from him. No doubt she believed that John's failure to consummate the marriage meant that he did not love her, and she was suffering more from a sense of unrequited love than from sexual frustration. In those days, sexually satisfied wives must surely have

been very much in the minority however lusty their husbands; it was believed that the bearing of children satisfied all a woman's physical and emotional needs. A woman feels what she is expected to feel by the society in which she lives, and Effie, though really wanting to be reassured of his love, was beginning to feel that she would be satisfied if she had a baby.

Mr Ruskin's letter of June 13 arrived in Perth on June 20. Mr Gray took two days to answer it. Only the draft of his letter has survived—five and a half untidy pages containing many deletions—and although apparently the fair copy did not differ much in essentials, some of the phrases in it were more hurtingly worded.

Perth 22 June 1849

I was only favoured with yours of the 13th two days ago and as you may suppose the contents have given Mrs Gray and me very great pain and anxiety. I have not communicated the receipt of your Letter to Phemy as in the present delicate state of her health the consequences would I feel certain prove most injurious to her and I dont suppose you would willingly urge me to take any step likely to have that effect—In matters of this delicate nature Phemy is peculiarly reserved, so much so that altho' her health is suffering and her spirits depressed in consequence of the coldness and reserve which exists between her and your family she has never till within the last two days opened her mind to me on the subject—I have now taken the opportunity when alone with her in the garden, tho' without alluding to your Letter, of asking her how it was she never received any Letters from you or Mrs Ruskin as well as John and thereby drew her out upon the causes of misunderstanding which for some time past has alienated you from each other—I do not mean to repeat a word of what passed between us for the same reason that I have not told her a word of what you have stated to me—My object is solely and entirely to bring about a reconciliation in the best way I can and that will be accomplished more effectually by neither party being called upon to rise up and explain what had passed but by both endeavouring to conciliate the affection of each for the time to come—That you both misunderstand each others feelings and desires is as apparent to me as the sun at noon day—and that

there is no substantial reason for this is equally clear—Phemy has the greatest affection for John—Her earnest wish is to have the same for you and Mrs Ruskin—Do not then I most earnestly pray and beseech you continue for a moment to foster those opinions of her which you express in your Letter—I shall not allude to them further than to say that I am convinced you are mistaken as to her feelings and misinterpret her actions—You do not make allowance for her state of health which has had no small share I imagine in what may have been attributed to a wilful disposition, neither do you consider that her natural manners are thoroughly scotch by which I mean that she makes no display of feeling even to those to whom she is much attached—She hates hypocrisy and will never be tempted to practice it—I could write you as fully as you have done me in vindication of the particular charges you bring against her but I forebear to provoke a correspondence upon matters of so distressing a nature—If I may be permitted to hint a word by way of advice it would be simply that Mrs Ruskin and you should leave John and Phemy as much as possible to themselves —married people are rather restive under the control and supervision of Parents tho' proceeding from the kindest and most affectionate motives. Do not take amiss what I say for I have but one desire and that is to see you all happy and your minds disabused of hatred and uncharitableness towards each other—these feelings are too easily aroused and most difficult to allay—they embitter the cup of life even when it overflows with all other earthly blessings—

In my conversation with Phemy I have done all that a Parent can possibly do and I trust with good effect. Do let Mrs Ruskin and you meet her half way—forget and forgive.

I am afraid to trust myself writing upon this subject but before I close I can assure you that Phemy has no desire to disturb John in following out his pursuits neither does she in the very least sympathise with those persons to whom you refer as treating these with levity—Her pride in John's productions are precisely akin to your own and altho' she naturally feels his absence and may long for his return I am quite sure that no selfish desire on her part would induce her to wish him to return till he has accomplished the objects for which he went abroad—

It was impossible for Mr Ruskin not to take this letter amiss, especially as there was one sentence in the fair copy, preserved by Mr Ruskin, far stronger than in the draft (see p. 230). Perhaps it is a pity that Mr Gray did not read Mr Ruskin's letter to Effie before replying.

PARENTAL INTERFERENCE

❊

Meanwhile the weather at Chamonix had improved and John went quietly on with his 'pursuits'—as is shown by the long extracts in his diary—sketching, measuring, making geological surveys, taking angles of the slopes, and going on long expeditions with Couttet and George, who was usually occupied with the daguerreotype. There is a note in John's diary for June 21, 'I am very late to night, having been writing to Effie'. This letter has not been traced, but three days later he was writing to her very tenderly after having evidently received a most conciliatory letter from her in answer to his of June 14 in which he had asked her whether she had any plans for the following year:

Sunday evening [June 24, 1849]

My darling Effie

I have been thinking of you a great deal in my walks today, as of course I always do when I am not busy, but when I am measuring or drawing mountains, I forget myself—and my wife both; if I did not I could not stop so long away from her; for I begin to wonder whether I am married at all—and to think of all my happy hours, and soft slumber in my dearest lady's arms, as a dream—However I feel—in such cases—for my last letter and look at the signature, and see that it is all right. I got one on Friday; that in which you tell me you are better—thank God; and that your father is so much happier, and that Alice is so winning and that you would like a little Alice of our own, so should I; a little Effie, at least. Only I wish they weren't so small at first that one hardly knows what one has got hold of: I have to thank you also very much for what you say about Vevay: &c: Your father writes to mine that he thinks one

winter there would cure me of my fancy; I wonder if he thinks
that I am in the habit of taking 'fancies' of so serious a nature,
without remembering that there *is* such a thing as winter—or
whether he supposes I should be willing to leave my country,
and my friends; and all the advantages I have in London, for a
fancy of any kind: However, you may as well assure him that
winter, where the vine grows wild, is a very endurable season,
and that I know by experience that the climate on the top of
the Simplon in the end of October is exactly that of Pitlochrie
in the beginning of September.

I have for seven years thought over the various topics oi
dissuasion which you mention—nor have I yet come to any
conclusion—but I asked you for your own feelings, as their expres-
sion would in some sort turn the scale with me—not affirma-
tively indeed—but negatively: as, if you were to tell me that you
would be unhappy, living in Switzerland, I should dismiss the
subject from my mind; while if you told me you could be
comfortable there, I should retain the thought for future
consideration, as circumstances may turn out. I wanted there-
fore to know, not so much whether you thought you would
like places of which you can at present form no conception, as
whether you had any plans or visions of your own respecting
this matter—any castles in the air which I could realise—or
any yearnings which I could supply. I myself have for some
time wished to have a *home* proper, where I could alter a room
without asking leave—and without taking leave of it after it was
altered—however we may as well wait a little and see what
comes of the Russian descent upon the south*—and whether
any body is to have a home anywhere. We get so few papers
here that what do come I don't read—I get out of the way of
thinking of news at all: however I have had great delight in
M. Le D.R's exit through the broken pane: and subsequent
arrest: I should like to put him in a cask and roll him over the
aiguille du Midi, here, that he might have revolutions enough
to serve his turn: or hang him to a smoke jack.†

* The Austrians, with so many of their troops engaged in putting down revolts
in Italy, had, at the end of April, asked for Russian aid to quell the revolution in
Hungary. The Russian Emperor sent a large force and after fierce fighting the
Hungarians capitulated at the end of September.

† Alexandre Auguste Ledru-Rollin (1807–74) had taken a prominent part in the

Poor Venice—I saw they were bombarding it last week.* How all my visions about taking you there; and bringing you here, have been destroyed: Well, it might have been too much happiness to be good for me; as it would certainly have been more than I deserved—I mean in the common human sense, —since all our happiness is actually more than we deserve. I reconcile myself to your absence only by baking myself in the Sun, and thinking 'Effie couldn't have stood this'. And we have enough certainly just now—thundery and scorching: the snows melting at a tremendous rate—tremendous, that is,—in the form of the resulting torrents, which are furious.

Monday:

It is a lovely morning with broken clouds and one [paper torn] the great snow precipices of Mont Blanc—itself as high as [paper torn] cliffs of Dover, though merely in the thickness of the snow, shows through a gap in the cloud like what one might fancy a piece of the moon, if one could break it up when it was new: there are such lovely snow lines beside it, too, white and waving—I don't know what they are like in the world, unless it be my Effie's shoulders.

I am getting on with my drawing, I think well: so do other people and so does Couttet—who affirms that I am 'beaucoup plus habile' than I was when I was here before. He is a noble active fellow—though 58—I happen to be going in a char this morning and not to want him till one oclock, this made him look marvellously blank: until he bethought himself that I wanted to know what the rocks were at the head of a ravine just 2,100 ft above the valley—so he offered to go and fetch me

revolution in France of 1848. He had been re-elected to the Legislative Assembly in May 1849, but, disagreeing with France's foreign policy, had attacked the Government on June 11. Next day he marched his party out of the Assembly to the Conservatoire des Arts et Métiers where they sat as a rival assembly hoping for the defeat of the Government. It was they, however, who were defeated by the arrival of troops. Ledru-Rollin made an undignified exit through a window. Many of his party were arrested but he managed to escape to England and remained in exile until 1870.

* The Italians had given up Fort San Giuliano, an island in the Lagoon, on May 26, and it was from there that the final bombardment of Venice took place. In July the Austrians were to attempt aerial bombardment from balloons but most of the bombs exploded in the air or dropped into the lagoon or were even blown back by the wind to explode amidst the Austrian garrison. The worst damage to Venice was done by guns mounted at an angle of 45°.

specimens: and is just off: he will be up in two hours; hammer-
ing an hour or so—down in an hour—and will carry my
sketchbooks and meet me, up the valley, at one oclock. Better
that, he says than stopping here 'to let the flies eat him'.

Pray go on doing all that D^r Simpson tells you: I hope I shall
have another line tomorrow evening, but this must go tonight.
Kindest regards to Papa and Mama—Ever mine own—Yours
most devotedly— J Ruskin[119]

John's spirits may have risen at the fine weather. He made a diary
entry for this same Sunday, June 24: 'This has been an idle day I
am sorry to say. I have been sauntering through the fields. . . . The
day has been desperately hot. . . . Learned some of Revelations,
however, and have had some happy—I hope profitable thinkings.'

Four days later he again wrote to Effie:

 Chamouni. 28th June [1849]
My darling Effie
 I could not answer your two kind and cheerful letters the day
I got them—for we received at the same time [on the 26th] the
news of my poor cousin Mary's [Bolding] death: and I did not
like to write to you in the mood it put us into: it has been a
great trial to my father and mother as the breaking of the last
close link with the memory of my father's sister—for William
and Andrew and John are of a different character and besides
have been less with us: Mary was with us for 19 years.
 I am most thankful for your cheerful letters—only vexed
that you have not got your horse: after taking it for so long a
time they ought to have got it for you immediately; I mean the
horse dealers—or stable keepers—or whatever they are;—my
father is very angry at their not keeping it for you—your
dissertation on women is very amusing: only do not fancy that
I judge—or conceive—*altogether* from books: you say my mother
is strong—but if you were to pass one of my mothers nights, you
would remember it some time—often she has to sit up in bed
for hours together with pain all over the body: when she was
your age she was weaker than you—literally, once, unable to
lift a cup to her lips: she was made strong by being made to rub
furniture: Well—there was poor Mary—not strong certainly—

for she has now sunk like a reed—but she used to walk with me in this very place—as far as *I* could—and I never heard her complain of depression in my life—though she had often cause enough—for kindly as we all tried to treat her you spoke truth when you told her she never had so happy a home as you: Well—I saw at different times a good deal of the Domecq's— they, however, I grant you, *were* strong: naturally:—then I saw a good deal of Mrs Acland's sisters [the Miss Cottons]—not I believe bodily strong—but on the Alps, all exultation and as unfatiguable as birds—then my friend Miss Corlass* who used to spend her holidays always at Herne Hill—she by the bye could not walk—and used to show nervousness in fiery temper —but she was always hard at work nevertheless—then there was my poor cousin Bridget—who died of decline at Sydney— yet of whom my most distinct recollection represents wading in the Tay like a fish wife—then there is my cousin Margaret— disturbed in the spine—and has lungs all disease—her cough continual—building houses, making business—managing to her hearts content her husband—children and father—and most people besides who come in her way,† and I could go on with the catalogue further if I had time—only I have to defend Shakespeare—you know the personal experience of the two great writers only makes their testimony stronger—since it was given in contradiction to their own exceptional fortune: But Shakespeare has given all kinds of women—from the noblest to the vilest—

* Sarah Corlass, born January 1810, was the daughter of Robert Corlass, wine merchant of 78 Longate, Hull, who had been a customer of Mr Ruskin's before his death in 1830. His son, Robert, born 1807, now carried on the business. The family had been wine coopers and then wine merchants in Hull certainly since 1790. Miss Corlass lived with her widowed mother in Hull. Ruskin wrote some letters to her about education (Huntington Library, California) so it is possible that she started a school or became a governess. It seems from his reference to her that she was a cripple.

† Mrs Ruskin's younger sister, who had married a baker of Croydon, George Richardson (1782–1861) (no relation to Mary Bolding's father, Patrick Richardson, the tanner of Perth), had left four sons and two daughters when she died in 1830—Margaret, born 1804, and Bridget (1814–48?). In *Praeterita* (p. 88) Ruskin writes that Margaret 'in early youth met with some mischance that twisted her spine and hopelessly deformed her'. Bridget, who had been lively and quite pretty, used to stay at Herne Hill and go with the Ruskins to stay with the other Richardson cousins at Perth. Their eldest brother, John, had emigrated to Australia where he died, so probably Bridget had joined him.

Mine own pet—I have written the rest of this letter on another sheet by mistake, and hav'nt time to rewrite it—so I will keep it and send next day and you can put the two together and go on.—it was very full of love—or should have been if it had expressed what I felt for you, but I can't write more this morning. I ought to write to Macdonald* and to Mr Brown† and can't get an instant, the weather is so lovely I am out all day—and rest on the moss. I am getting some most valuable studies—and much strength—I hardly feel now in walking as if it were exertion at all, the ground seems to pass from under me without my knowing it: and I find myself first in one place and then in another without knowing how I came there, only sometimes under the hot sun I begin to recognise my pedestrian existence as different from that of the crows and hawks: but I wouldn't change with the *butterflies* at any price— I constantly see *them* knocked up, and dying on the snow poor things: the flies which are a great pest—seem strong creatures— but they keep to the woods mostly. The only things that take the shine out of me are the gnats: I mean of things in any wise dependent on legs.

—A thousand loves. Every my dearest your most devoted
Husband. JRuskin

With Effie and John both so much happier, it should now have been comparatively easy for Effie to effect a reconciliation with her in-laws—Mary Bolding's death could greatly have facilitated this —but Mr Gray's unfortunate letter of June 22 reached Chamonix on the 30th. Mr Ruskin took four days to consider his reply and as usual there is not a word crossed out in his letter. He evidently wrote with immense fluency, for considering the length of his letters it is hard to believe he made a draft of them.

Chamouni 4 July 1849
I have your esteemed Letter of 22 June and am very sorry to cause you and Mrs Gray a moments uneasiness—I never thought of troubling you till I saw there was something different

* On the occasion of his marriage. William Macdonald had been married on June 26 at St George's, Hanover Square, to the Hon. Clara Brownlow, sister of Charles, Lord Lurgan, 2nd Baron.

† Rev. Walter L. Brown had been Ruskin's tutor at Christ Church—'the only

from usual in Phemys Letters to my Son: you may suppose that very little of her correspondence escapes from my Son but he could not conceal his uneasiness and finding it arose to some allusions to feelings not at all explained but almost mysteriously pointed to, as causing suffering, and coupling this with the unaccountable estrangement of your Daughter to Denmark Hill—I wrote directly to you, entering my protest against Reserve merely to call your attention to the subject, for what with one thing and another I feared we were all getting into a Labyrinth of misunderstanding that though it might make a pretty subject for a Novel in three Volumes, was to be greatly dreaded as most disastrous to all the parties concerned in it— It just happened that the tone of Phemys Letters changed from the date of the last of a series that caused my writing to you, but though you and Mrs Gray have felt what I said too keenly, which I must always regret, I have at once gained a great deal by being open on the subject for you have done vast good by speaking to Phemy even to the limited extent you have, her Letters I believe are again all that my Son seems to wish and she has written a very sweet Letter to Mrs Ruskin, a perfect specimen of the sort of Correspondence that ought always to have existed between them. I get no praise however from you for the open system, for you reply to all my disclosures chiefly by an assurance that you mean to conceal everything—As I have told you that I believe concealment to be the very cause of any trouble arising amongst us, in fact it must be if none of us are evilly inclined, you cannot wonder at my preferring an opposite course. In my poor judgement your Letter itself proves that nothing short of the most perfect frankness and fullest explanation of feelings and wishes can entirely terminate all difficulties. You say you will hint a word of advice, that Mrs R and I should as much as possible leave John and Effie to themselves because married people are restive under the supervision and Control of parents and expect to be independent and feel chafed by the Curb—now what a mischief does the concealment involved in this passage do—If there is one thing that I am duller at, than another, it is at taking a hint. For

one of my old masters from whom I would or could receive guidance'. (*Works*, XXXVI, xxiv.) They corresponded frequently until his death in 1862.

want of an explanation of any thing wherein I had interfered
and which I should be rejoiced to avoid repeating, I am left
hopeless of correcting myself from the simple unconsciousness
of having in any instance sought to interfere or control or curb
either my Son or his wife—I know only from your hint that all
my endeavours to avoid this are fruitless. I thought I had even
made it a study to ensure the Independence of both in a manner
that not every Father likes to do, before his Death, and so far
from thinking of their being restive (which by the bye is not a
characteristic of well trained children like our Son and
Daughter) I gave them credit for generosity enough to bear
with me the more meekly in any humours and peculiarities of
habit I may have—but your hints are enough to make me
imagine that unless I mind more what I am about, we may
have, besides the three Volume Novel—part of the Tragedy of
King Lear acted in the family. Seriously, my dear Sir, I wish
you and Phemy to believe that wherever I have erred in any
way interfering—it has been in ignorance—I am impressed
with a wish to avoid it and I tried to do so—I would not have
gone to the expence I have done but to place the young people
beyond our Control—I do not think I exercised my taste upon
one single article they had occasion to buy—I never dined or
drank Tea in their House, adhering pointedly to the non
interference system—What Mrs Ruskin has been about I
cannot tell—we don't always know what mischief our wives
do—I saw Mrs Ruskin very much put about on one occasion—
but the Interference seemed to be mutual—Mrs Ruskin had
seen to a Dressing Room being made comfortable for John
having to leave his own Bedroom in Winter—He was removed
to one without a fire place—in order to turn the one prepared
by his mother into a Room for Visitors, although it was thought
to be settled that they could not afford to have a spare Bed-
room.* I daresay a little previous explanation or a little more

* Effie had mentioned when they first got 31 Park Street (p. 128) that there
was room at the top of the house where George could stay, 'monopolising all their
spare accommodation'. No doubt when her mother came to stay, Effie had put her
in John's comfortable dressing room and moved him to the top of the house. This
altercation over John's dressing room may have been the reason why Effie decided
to return to Perth. She may well have felt that Mrs Ruskin had slighted her mother
by expecting her to be relegated to the servants' floor.

allowance for the anxiety of a Mother for the safety of her Son, on Phemys part, would have saved all misunderstanding—I cannot either without further explanation guess where the Curb is felt—I know of none at Denmark Hill except that we keep to our old known ways—My son does not seem hurt by the Curb for he brought us here against his Mothers intentions and to my Inconvenience, and a more simple, happy, joyous Creature at the age of thirty I never saw—You say circumstances have occurred to prevent Phemy as she said herself having esteem and affection for Mrs Ruskin and me—now my good Sir how in the world are these Circumstances ever to be removed on the concealment System—I cannot guess or dream of them. I desired to love Phemy—I sought to love her—she seemed happy with us enough as Miss Gray. The time spent with us since Marriage was not pleasant, but the causes of this were accidental—and not all to be put to our account—We went on a most unfortunate Tour—at Dover my Son and I believe his Wife were out of humour at not getting abroad—this was partly our fault—we feared our Sons being in mobs and a creature like your Daughter being exposed to the gaze of Ruffians. My Son got cold at which my good humour vanished —they left us—he got worse and at Salisbury was so ill that I thought he was going into a decline—I was totally miserable and I daresay Phemy felt the whole Tour as I did, painful and unhappy. We got on pretty well on their return from France— They came to Denmark Hill about Xmas and Phemy being unwell, I daresay Mrs Ruskin wanted to exercise her Medical Skill—Phemy does not brook this and got out of humour so that other people than we expressed suprise and sorrow to see a change in her deportment from what it used to be—I am aware that Mrs Ruskin gives Lectures and being above 60 will speak to a very young person in a way that is not pleasant before others. I can fancy Phemy Schooled by some Wordly Wise people like the Boswells to be sure to assert at once the full authority of a married person and especially against that awful personage, a Mother in Law, to have been unusually sensitive and to have winced under some of Mrs R's plain speeches—but Mrs Ruskin hurts nobody—she often provokes me by making speeches to me that I am not flattered by but esteem remains

the same on both sides—We were wrong in not making allowance enough for Phemys ill-health—but we thought with all that, a little more effort on her part to be pleased and happy with us, would have helped her Health—We wanted no display—and judged from neither English, nor French models, but judged Phemy as she was by Phemy as she had been— Mary Richardson never professed—but she was not an hours uncheerful in all the 19 years she lived in our House—

The whole purpose of this Letter is to show you that I have not the most distant idea of why we are not on far better terms with Phemy—and the tone of it is produced by the conviction that all the causes of the Estrangement must be utterly absurd— your Letter of reserve has let out much more than my most open confessions, for I did not think Mrs Ruskin and I had not still your Daughters Esteem and affection—we only knew some misunderstanding existed, somewhere—about something we knew not what—The Ideas you express about married peoples Love of Independence, makes me sore afraid that these very ideas, instilled into Phemy and encouraged, have been the cause of all the mischief—one thing I am sure of that had Phemy thrown herself entirely on our generosity and sought no independent authority, her Dominion over all our affections would have been greater at this day, and of all I know of my Son, her authority with him would have been great exactly in proportion as she had not sought to establish it on the exclusion of that of his parents—His love and esteem would have been enhanced by the Love he saw her bestow on those whom he regarded and the absence of the petty jealousies which so beset young married women in their struggles for a childish authority would have certainly increased his Respect for his wifes Character—As for Mrs R and me we wanted an entire Daughter—Let Phemy come to us, as such, trusting, confiding and non exacting and see if she would not be far happier than in following the vulgar and worldly maxims which all her worldly wise friends can teach her—I send a separate Letter and one from Mrs R to Phemy.

I have every hope of seeing both the junior and senior branches of our family united and happy together and in Mrs Ruskin joining me sincerely in wishing such to be the Case and

with kindest regards to Mrs Gray and you—I mean this letter for no more—I am [etc]

In answering this letter Mr Gray denied that he had made a certain statement in his previous one of June 22. This is known because nearly eighteen months later Mr Ruskin wrote to him, 'I have for a long time carried in my Pocket Book two pieces of your Letters which will prove to you that I had not accused you of using any words but the very ones you had used',[120] and he enclosed these two pieces, in Mr Gray's writing, roughly torn from his letters. The first piece was taken from Mr Gray's letter of June 22: 'Phemy has the greatest esteem and affection for her Husband. *She would wish to have the same for you and Mrs Ruskin but hitherto circumstances have occurred to obstruct what she assures me is the ardent wish of her heart*'. The second piece evidently came from Mr Gray's reply to Mr Ruskin's letter of July 4: 'You say that I state in my Letter to you "*circumstances have occurred to prevent Phemy having affection for Mrs Ruskin and you*"—I have no copy of my Letter but certain I am no such sentiment ever passed from my lips or pen. If I did say so I must have been writing in the dark and when I was asleep. Phemy never said so to me, but on the contrary expressed a very anxious wish to do everything in her power to secure the affection of you both.'[121] (It appears that the words in italics were underlined by Mr Ruskin.)

If Mr Gray had turned to the draft of his letter of June 22, he would have seen that he had worded this passage more tactfully and may well have believed that he had not altered it in the copy he actually sent. In the draft it reads: 'Phemy has the greatest affection for John. Her earnest wish is to have the same for you and Mrs Ruskin.' But alter it he did and the unfortunate passage, torn from his letter, was kept by Mr Ruskin as evidence. It was no good his protesting that he had never written those words.

There is one more passage from his reply to Mr Ruskin's letter of July 4, written on the back of the piece preserved by the latter: 'reserve and concealment as tending to foster those feelings on both sides which have caused you so much uneasiness—The truth is I enter into no explanations because I can think of nothing to write about—when I say leave the young people to themselves and all will come right—all I mean is that there has been no real ground

or cause for offence on either side and the less said about the differ-
ences which are now passed the better—I could not for my life tell
you in what respect you could do more.'

Mr Ruskin's hurt and bewilderment at this time certainly appear
completely sincere and it was a fact that Effie as Miss Gray had
loved staying at Denmark Hill; and even when she stayed there at
first after her marriage—before the unfortunate visit to Salisbury
—she had been extremely happy basking in Mr Ruskin's admira-
tion, enjoying all the gaieties of London and expressing no wish
to move from the comfort of Denmark Hill into a home of her own.
The evidence shows that not only was she spoilt but that her parents
stood in some awe of her.

If at this stage Effie had confided in Mrs Ruskin the truth about
her marriage, what, one wonders, would have been the result.
Mr Ruskin begged for complete frankness; could he have stood the
truth? His advice might still have been that if Effie 'could have
thrown herself openly upon' them, 'trusting, confiding and non
exacting', physical consummation would have followed—and he
may well have been right. It is very doubtful whether the physical
aspect played such a large part in the failure of the marriage as has
been thought. It is also doubtful whether John was being hypo-
critical, as the Grays believed, when he took up the cudgels for
his father:

Chamouni. 5th July. 49
My dear Mr Gray
Having heard the late correspondence between you and my
father, I think it well that you should know from myself my
feelings respecting Effie's illness as this knowledge may more
straightly direct your influence over her: I have no fault to
find with her: if I had it would not be to her father that I
should complain: I am simply sorry for the suffering she has
undergone: and desirous that you should understand in what
way your advice may prevent its recurrence.

If she had not been seriously ill, I *should* have had fault to
find with her: but the state of her feelings I ascribe now, simply
to bodily weakness: that is to say—and this is a serious and
distressing admission—to a nervous disease affecting the brain.
I do not know when the complaint first showed itself—but the

first that I saw of it was at Oxford after our journey to Dover: it showed itself then, as it does now, in tears and depression: being probably a more acute manifestation, in consequence of fatigue and excitement—of disease under which she has long been labouring. I have my own opinion as to its principal cause—but it does not bear on matter in hand.

I was not however, at the time, at all prepared to allow as I should have done for her state of health—and in consequence—when, some week or so afterwards, she for the first time showed causeless petulance towards my mother, I reproved her when we were alone. The matter in question was one indeed of very grave importance—being a wish on my mothers part that I should take a blue pill [p. 128] when I went to bed—the first use—as far as I remember of 'influence' on her part since our marriage—It was however also the first time that Effie had heard herself blamed: and the effects upon her otherwise excited feelings were permanent—and disposed her—as I think, to look with jealousy upon my mothers influence over me, ever afterwards.

I was at this time, very sufficiently vexed, for my own part—at not being able to get abroad—as well as labouring under severe cough—so that I was not able to cheer Effie or support her, just at the period when she began first to feel her changed position and lament her lost home—It was a sad time for her therefore altogether—and the mental and bodily illness were continually increased. No further unpleasantness however took place between her and my mother: we got abroad at last: I had hoped that this would have put us all to rights—: but whether I overfatigued her in seeing cathedrals—or whether we drank too much coffee at night—her illness continued to increase—It was probably not much bettered by the necessarily distressing tone of her home letters at this period: (that of Mrs Jameson's illness) but be this as it may, I ascribed her general depression to natural causes—and perhaps did more harm by endeavouring to distract when I ought to have soothed her—So she returned worse than she went: and I still in entire ignorance that there was anything particularly the matter with her—

When we returned, the Bethunes were staying at D. Hill:

Effie wished excessively to avoid them—but this was not possible: nor was I at all sorry for this impossibility, for I wished Effie to know Mme de Bethune—and I thought she would be happy in doing so—I do not know whether she was or not—but doubtless the noise and excitement increased her illness—and it came to something like a crisis. The depression gained upon her daily—and at last my mother—having done all she could to make her happy, in vain, was I suppose—partly piqued—and partly like myself—disposed to try some serious reason with her: Finding her one day in tears when she ought to have been dressing for dinner, she gave her a scold—which if she had not been ill she would have deserved.* Poor Effie dressed and came down—looking very miserable—I had seen her look so too often to take particular notice of it—and besides thought my mother right: Unluckily Dr Grant was with us—and seeing Effie look ready to faint thought she must want his advice—I—being thoroughly puzzled about the whole affair, thought so too—and poor Effie, like a good girl as she is—took —to please me—what Dr Grant would have her—weakened herself more—sank under the influenza—and frightened me at last very sufficiently—and heaven only knows, now, when she will forgive my mother. So far as I know them—these are the causes—and this was the progress of her illness—and of her change of feeling towards my parents—you know better than I what is likely now to benefit her—but I look forward with confidence to her restoration to health by simply physical means—I am delighted to hear of the shower bath and the riding and the milk stead of tea—and the quiet: when I have her to manage again, I hope to do it better—and not to reason with—nor blame, a physical weakness—which the course of time will, I doubt not, entirely cure.

In all this, however—you will perceive that I look upon the thing as a purely medical question—not a moral one. If Effie had *in sound mind* been annoyed by the contemptible trifles which *have* annoyed her; if she had cast back from her the kindness and the affection with which my parents received her, and refused to do her duty to them, under any circumstances

* This was at Christmas time. The Béthunes had left and only the Boldings were staying in the house.

whatever but those of an illness bordering in many of its features on incipient insanity, I should not now have written you this letter respecting her. I do so in order that you may not encourage her in those tones of feeling which are so likely to take a morbid form.

I dread your doing so—in consequence of the passage of your letter in which you deprecate my fathers interference—God knows that *his* only interference from the beginning has been a consistent endeavour to do Effie every kindness in his power— and that my mothers only interference except in the two above instances has been sometimes a successful endeavour to induce me to think more indulgently of Effie than I otherwise should have done—But grant they *had* interfered—have they not every right? Having nourished and brought up their child with every care and thought and energy of their lives devoted to him— have they not a right to expect to be cherished by him in their old age—to be consulted in such matters as may interest them or please them?—to be obeyed in such as they may think it wise to command?—have they not every right also to expect that his wife should aid her husband in this, as in every other duty— and to be borne with by both if sometimes differences of temper should render that duty less than a delight? Or do you rather think that all this is to be done for a son—that all that is in the power of the father to do should be done for son and daughter— that this father should go on working into the after hours of life merely to provide them more abundant means of happi- ness—and that the only return for all this should be a demand that he should stand out of the way—that he should hint nothing—ask nothing—blame nothing—and expect nothing— and that a request to come down to dinner with a happy face should be considered a tyranny?: I should indeed dread to think that such were the deliberate principles on which my wife intended to act—or was encouraged to act by her parents —and I hope to see her outgrow with her girls frocks—that contemptible dread of interference and petulant resistance of authority which begins in pride—and is nourished in folly— and ends in pain—'Restiveness' I am accustomed to regard as unpromising character even in horses and asses—I look for meekness and gentleness in woman.

One other point startled me in your letter as it has grieved me in Effie, you speak of 'reserve' as a part of her character— If you mean an absence of expression of affection—I have never seen it nor felt it in her—I have seen her face opening in the most radiant sunshine to those whom she loved: and I have only seen it clouded in the presence of those whom I had no reason to suppose she loved: But if you mean the deliberate reserve or non expression of thoughts—this is no part of character—it is a simple bad habit—partly owing in Effie to her not having been accustomed to take the trouble to arrange or to remember her thoughts—partly to their not having been enough enquired into—owing to her frequent residence among strangers during childhood: It is one of the parts of her educational character which gives me most concern: and which I should be most grieved to see encouraged.

You now know exactly how matters stand—and how I feel— I repeat that I do not blame Effie in the least: but I regret most deeply many of her feelings—and should do so more deeply still—if I did not think they were likely to pass away: if they should—and she can prevail upon herself without irritation, to bear what may be something irksome to her—or to cease to feel that irksome which affords her the only opportunity she has of proving the unselfishness of her love to her husband, she—and all in her, shall be most happy—if she cannot, she will be the chief sufferer. I do not know that she can ever now establish altogether the place she might have had in my parents affections—but I am sure that if she does not endeavour to do so, she will one day or other vainly and remorsefully feel its value. I was much gratified the other day by her letter to my mother, and by the tone of her letters to me—I am led to look for a speedy recovery of her health—and with her health, I doubt not also of her usual good temper—good sense—and cheerfulness—These are all that are needed—I would not have her an hypocrite. I would have her, if she cannot be *more* be at least what she used to be in my mothers house—when no duty called upon her to be either patient or cheerful.

With sincere regards to Mrs Gray—and dearest* love to

* The word 'dearest' was added afterwards.

Effie if at any time you think proper to show her this letter, which—for my part—you may read to the whole world—

Ever, my dear Mr Gray, very faithfully Yours

JRuskin[122]

John wrote this letter on a wet and windy day according to his diary—'a most unlucky day, vainly trying to finish my brown study from the window'.

Poor Mr Gray, to receive two such letters from father and son on consecutive days; did he realise the harm he had done his beloved daughter? One wonders whether he ever showed John's letter to Effie. It was preserved at Bowerswell in a plain white envelope on which was written in Mrs Gray's hand: 'Remarkable Letter of J. Ruskin's in which he artfully puts down his then so-called *wife's* unhappiness to any thing but the real cause which he himself only knew. S.M.G. [Sophia Margaret Gray].'

ZERMATT

John and his parents stayed at Chamonix for almost a month—from June 14 until July 11. There is an entry in John's diary for their last evening: 'I . . . have much to thank God for, now and ever. May it please him to permit me to be here again with my Father and Mother: and Wife.' On their way back to Geneva they spent three nights at St Martin, and on their last evening there John walked with his father 'up to the vine-covered cottages under the Aiguille de Varens', and later was to recall that this walk 'virtually closed the days of youthful happiness, and began my true work in the world—for what it is worth'.[123]

On the morning of Saturday, July 14, they left for Samöens and the Valley of Sixt, an alternative route to the one via Bonneville which they usually took. They had a tiring journey in 'chars' to Samöens where there was only one inn. 'When we got there,' George recorded, 'there was not much choice of rooms, as there were several people stopping there, who had got the best rooms; however, after all setting to work and Mr John for his part washing down the stairs, we managed to get things pretty comfortable for them.'

This washing down of the stairs made such an impression on Ruskin that years afterwards he referred to it twice. He wrote: ' . . . the quite happiest bit of manual work I ever did was for my mother in the old inn at Sixt, when she alleged the stone staircase to have become unpleasantly dirty, since last year [it was in fact three years since they had been there]. Nobody in the inn appearing to think it possible to wash it, I brought the necessary buckets of water from the yard myself, poured them into beautiful image of Versailles waterworks down the fifteen or twenty steps of the great staircase, and with the strongest broom I could find, cleaned every step into its corners. It was quite lovely work to dash the water and drive

the mud, from each, with accumulating splash down to the next one.'[124] A few pages later he corrects his mistake as to the place where this happened and writes of 'The little inn at Samoens, where I washed the stairs for my mother'. And in *Sesame and Lilies* he was to write, 'I have myself washed a flight of stone stairs all down, with bucket and broom, in a Savoy inn, where they hadn't washed their stairs since they first went up them; and I never made a better sketch than that afternoon.'[125] (Murray states that the inn at Samöens, the Croix d'Or, was cleaner than most in Savoy.)

After two nights at Samöens they reached Geneva on the afternoon of July 17, and then on the 21st they all returned again to St Martin. John spent five nights there with his parents before starting off on the 26th with Couttet and George for Zermatt, leaving Mr and Mrs Ruskin to return on their own to Geneva and wait for him there.

On the way to Zermatt they did an extremely arduous tour on mules of the south-east side of Mont Blanc, travelling for twelve hours one day and nearly sixteen on the last day, staying in two dreadful hotels with garret rooms and vile food—one night at Capiù and three at Courmayeur where John was laid low with a bad sore throat. They got to Martigny late on Monday, July 30. John's own carriage was brought to Martigny from Geneva by a courier, and Couttet's daughter, Judith, came from Chamonix for the purpose of taking the mules back there. The next day they went by carriage to Viège (Visp) where they left the carriage and then hired horses to take them up to Zermatt next day.

There was only one inn at Zermatt, kept by the village doctor, but fortunately there were very few tourists. The week before there had been more than thirty people staying at the inn and many of them had had to sleep on the floor. The day after their arrival John started to draw the Matterhorn.* For the first four days out of the nine they were there it rained and John was very depressed. On August 5, a Sunday, he wrote in his diary:

I have had one of my low fits upon me all day, and have not known what I would be at. I note this for after-instruction, when, some day, I should be thinking that all would be right

* A drawing of the Matterhorn done during this visit, and one of Chamouni, also of 1849, are reproduced in Ruskin's published diaries (Volume 2). They are now both in the Fogg Art Museum.

with me if I were at Zermatt. This depression, however, has been partly the consequence of some very painful self examination which I went through in the forenoon; partly of my feeling this journey drawing to a close, almost before I can feel it as well begun: and looking back to my sojourn with my Father and Mother, it seems *so* happy. One forgets so fast what was painful—the anxiety for letters, the disappointments when they came, the sorrow about poor Mary [Bolding], and hundreds of minor inconveniences or vexations, always bad and thundery in the afternoons. When I begin in the same way looking back to my enjoyment here, let me remember that I would most gladly have exchanged my lonely afternoon among the mountains and chalets for a walk through Dulwich with Mungo, and an evening in our Turnered drawingroom, chatting with Mr Ritchie or Watson. I hope to read this entry some day when it may do me good.

Yet two days later he was writing, 'I have enjoyed this day, however, more than any I have ever passed among the Alps, but I am too sleepy to do anything but note my specimens'. Fortunately George gives an account of this happy expedition:

7th [August 1849]. Beautiful morning, so started with Mr John and Couttet for an excursion to the Riffel Berg, a mountain with a view commanding the fine range of many mountains, the Monte Rosa, Breithorn, Matterhorn, and the noble glaciers coming down from those mountains. We had an easy ascent of about $3\frac{1}{2}$ hours, when the whole of the fine view opened to our sight, the Matterhorn [or Mont Cervin] is a conical shaped mountain standing by itself and rising above the glaciers, to the height of upwards of 10,000 feet [14,780 above sea level]. It is reckoned amongst the curiosities of the Alps, and no one has been able to climb it.* After sketching a little† Mr John went on to the other side of the mountain [the

* Edward Whymper (1840–1911) made six attempts to climb the Matterhorn between 1861 and 1865 and succeeded at the seventh (and first from the Italian side) on July 14, 1865, when four of his party were killed and Whymper's own life saved only by the breaking of a rope.

† Drawing by Ruskin of 1849 of the Matterhorn from the Riffelhorn is reproduced in his published diaries (Volume 2): Ruskin Museum, Sheffield.

Riffelberg] to try to reach the top, as on this side it was quite impracticable. So we scrambled down over the broken rocks, walked along the other side and there began to ascend, after some rough work, we came to a steep precipice which seemed to block up the way altogether, but Couttet whose temper was a little up went up like a cat. I followed and got half way up, but there I stuck. I looked down and the scene was so awful, that I could scarcely get down again, meantime Couttet was out of sight altogether; but presently Mr John came up to where I was and whilst looking about, fancied he saw what looked a little like a path, though very little indeed, so taking off his boots he started and I followed him, and after about half an hours scrambling over the worst piece of mountain that ever I have been on, we reached the top,* and the scene was most beautiful, we saw the Oberland mountains and others miles away, it was a beautiful evening and after leaving our names on a piece of paper, we turned to come down, but which was not the easiest thing imaginable, however we did do it and after a nice walk down we reached the Hotel about 7 o'clock.

George had evidently taken the daguerreotype with him for he wrote next day that in spite of all his pains his plates had not succeeded; therefore he started alone that morning, August 8, to make another attempt, covering the same ground as the day before. He was carrying eleven and a half pounds of baggage on his shoulder and had great difficulty in getting up. He managed to take his views but only one was a success—that of a lake with the Matterhorn directly behind it and the reflection of the mountain in the water. It was the first 'sun picture' of the Matterhorn ever to be taken.

Years later Ruskin wrote of 'George indefatigably carrying his little daguerreotype box up everywhere, and taking the first image of the Matterhorn, as also the aiguilles of Chamouni, ever drawn by the sun. A thing to be proud of still, though he is now a justice of peace, somewhere in Australia.'[126] It is satisfactory to know that George must have read this tribute to himself, for his brother-in-law,

* By 1861 there was a hotel on this spot, the Riffelhaus, run by Dr Lambert, the proprietor of the Hotel Monte Rosa at Zermatt where Ruskin was staying. By 1861 there was also a second hotel at Zermatt, the Mont Cervin, but the Monte Rosa remained the favourite.

George Allen, who became Ruskin's publisher in 1871, sent out to him in Australia in 1887 the second volume of *Praeterita*, in which this quotation appears. The year before, George Allen had written to George, 'A few days ago he [Ruskin] said in a letter, "I have always been afraid to ask after John Hobbs—fearing he was dead. Tell me what has become of him." I replied that you were well when last I heard and telling him that you were a C.P.S. and what news I could, also that you were a J.P. To this he had a nice reply, here is a quotation "I am very thankful that John is alive and well —though I think it is quite shocking that he should be a Justice of the Peace—and I only an ex-professor. It's ridiculous and socialism and all the rest of it. . . ." If you could furnish any little incidents I am sure it would be useful as the second 20 years of his autobiography will bring him of course to the time you were with him. Did you lose that nice journal written during those travels with him.'[127] George had emigrated to Australia in 1857 and died there in 1892. He was married twice and had twelve children.

John decided now that he wanted to return to Chamonix, a sudden plan to which Mr Ruskin agreed with great reluctance because it would keep him yet longer in Geneva, where he was already bored and restless. John got back to Chamonix, via the Tête Noir, on August 15 and remained there a fortnight, spending the nights of the 22nd and 23rd at the inn at Montanvert. On the 22nd he noted in his diary, 'I think I never enjoyed an evening so much in my life, unless it were the one at Champagnole in 1845'. He had been abroad without his parents for the first time in 1845 —a great adventure although he had had Couttet and George to take care of him—and had found himself at Champagnole in the first week of April 'dining on a trout of the Ain . . . with Switzerland and Italy at my feet—for to-morrow'.[128]

But now he had England and a return to married life ahead of him. On August 31 he rejoined his parents in Geneva and they immediately set off for home. He could not have foreseen that in a little over six weeks he would be back again in Switzerland—this time with Effie.

FURTHER GRIEVANCES

Meanwhile there had been yet more unpleasantness with the Grays. Apparently Mr Ruskin had written to suggest that instead of John going immediately to Perth to fetch Effie when he arrived in England, Mr Gray should bring her to London. The Grays did not approve. There had been gossip in Perth due to John's long absence, and by parading John and Effie together, the Grays hoped to show their neighbours that there had been no rift in the marriage. Mrs Gray must have written to Mrs Ruskin suggesting that John's reluctance to go to Perth was in some way connected with Mr Gray's financial difficulties, for on the day John and George were enjoying their expedition to the Riffelberg, Mr Ruskin was writing to Mrs Gray:

<div align="right">Geneva 7 August 1849</div>

I cannot lose an hour in replying for Mrs Ruskin to your kind letter of 2 August as she is naturally anxious to remove from your mind any idea of our Son's reluctance to come to Scotland, at all arises from circumstances connected with Mr Grays affairs: John has never expressed a word to us about the subject to lead us to suppose he was made a moments uncomfortable for himself, I am sure he was not: he was distressed I daresay at seeing Phemy take these matters to heart. He seemed himself only pleased at the confidence Mr Gray placed in him and you may rest satisfied that this and all troubles of the kind disturb him very little—

I believe if his Father and his Father in Law—in place of living in good Houses, were reduced to humble Cots His visits would be perhaps only the more frequent and paid with as heartfelt pleasure—In place of troubling himself about worldly

affairs I think he only wonders at other people troubling them-
selves so much—I am quite sure that his dislike to Scotland is
simply from finding he cannot be well in it and because he can
do nothing there to any purpose.

I do not wonder at your being annoyed at his being so long
away and you are right in expecting him to come immediately
to Perth—it was wrong perhaps in me to suggest Phemys
coming up with her Father and my error came of my hearing
something said of her coming out to Switzerland with her
Brother. I thought as this was an offer to leave Perth to come a
long way, I might ask her to come a short way in her Fathers
Company to save her Husband from Injury—for the proba-
bility is he will get a cold that will last him for the winter—I
do not understand how this is so totally overlooked. It is nothing
new—My Son was wretchedly ill at Edinburgh in October
1847*—He was ill at Crossmount with Mr Macdonald—I
might ask why he is expected to stay at Perth? are you or I
to mind the idle talk of a set of silly people who sit in Judgement
on peoples doings and think he ought to be sauntering up and
down George Street and making forenoon Calls on them—I
am sure when he comes to Perth that to all such people he will,
from his habits, give ten times more offence than by staying
away—I do myself think both John and Effie wrong in each
going where the other could not come, but as I never was
consulted—I neither give my opinion nor interfere—I see they
are most attentive to each other in the frequency of Corre-
spondence—I am sure my Son is very fond of his wife and I am
sure he will not lose a moment he can help in coming to her—
I hope you will make allowance for his Father and mothers
fears about his health—we can never agree with other people
on this point—John's Brain is too busy always to let his Body
be strong—we know many say he ought to rough it more—
He has tried this and failed—his last attempt at roughing it
was at Oxford last summer† and he joined us at Salisbury as if

* This is the first we have heard of John's being ill after he left Bowerswell in
1847. He was ill in Edinburgh in August 1847 on his way to Crossmount so perhaps
Mr Ruskin had got the dates muddled.

† When he had stayed in a perfectly comfortable house in Broad Street with the
Aclands, suffering no apparent hardship beyond 'Babies before breakfast'.

R

going into a decline—He must be taken as he is—we may be thankful to God that he is spared to us at all—He will do anything that strength permits to please Phemy and you and Mr Gray but stay at Perth or in Scotland he cannot and I trust you will kindly resign all notion of it: but even here I keep to my plan of non interference—If he and Effie agree about it— Let him—try. I cannot promise to hear of his Health suffering, with indifference but I impose no commands and trust to the good sense and affection of the young people determining this matter to the satisfaction of us all—

I am sorry you were not properly apprised of Mary Bolding's Death—It was a strange neglect of her Brothers—My nieces Death came from severe cold caused by setting out in cold Weather causing internal inflamation and which none of her Doctors knew the exact nature of—She might however (even if they were not far wrong) have lived many years had not a second Cold brought on rapid decline which took us all by Suprise—Her first serious illness was got in Scotland, visiting her Brother [John] at Glasgow—In all the 19 years she was in our House she was never for one entire day confined with Illness. I am sure all who knew her well grieve for her—What Mrs Wedderspoon* may know of my Nieces complaint I know not—none of us know what the complaint really was—

John is at Zermatt I hope quite well—I am not sorry to be from home a little longer than intended as our Surrey Side of London is very sickly with Cholera.† Mrs Ruskin still suffers from depression—

There is a postscript to this letter in Mrs Ruskin's writing from which it rather appears that Mrs Ruskin still expected Mr Gray to

* Probably the wife of David Wedderspoon of 2 Marshal Place, Perth, partner in the firm of W & D Wedderspoon, solicitors.

† An outbreak of cholera, originating in India, had swept all over Europe. There had not been such a bad epidemic in England since 1832 although that of 1848 had been very severe. In the British Isles the 1849 outbreak had started in Wales in May; from July to September it raged in London, particularly on the south side of the river, Over 55,000 people had died of it in England and Wales before it abated in December. It was not until the '80s that the cholera bacillus was isolated and it was discovered that it was carried by polluted water, not by 'miasma' as had been thought for decades. (*King Cholera* by Norman Longmate: Hamish Hamilton, 1966.)

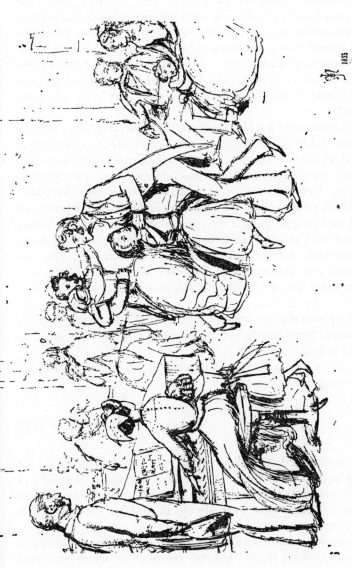

The Gray family—*Party at Bowerswell*—drawing by John Everett Millais, 1853.

This drawing was made by Millais from imagination but, according to Ruskin, was an excellent likeness of all the Grays. It shows Effie playing the piano with Alice cuddling her and her father standing beside her. George is dancing with Sophie while Mrs Gray sits on the sofa with a neighbour, and John at her knee.

bring Effie to London: 'Dear Mrs Gray, I can assure you with the utmost certainty that the pain Mary used to suffer before she married had nothing to do with what has caused her death. I do not know more than what Mr Ruskin has mentioned. When I see Effie which I hope now to do shortly she shall hear all particulars and will I know write them for me. My best love to her and the children and remembrance to Mr Gray whom it will give me much pleasure to see again I am Dear Mrs Gray your very truly Margaret Ruskin.'

Mr Ruskin could not resist rubbing in the fact that Mary Bolding had caught her death of cold in Scotland whereas she had never had a day's illness while under *his* roof. He seemed to think nothing of John's 'roughing it' in the various atrocious inns he stayed at in the Alps. Knowing how John scrambled about the mountains, took off his boots to climb the Riffelberg and journeyed by mule for twelve or fourteen hours a day, it is difficult to take his 'bodily weakness' very seriously, or to believe in his coming to much harm at Bowerswell, cold and uncomfortable as the house doubtless was compared with Denmark Hill. Nor does Effie seem to have been leading quite the invalid life one might suppose. A letter written at this time by Mr Gray to his wife, who had gone away on a visit, tells of a round of social activity at Perth with Effie frequently playing hostess 'very prettily' at Bowerswell. She had also been on another visit to Edinburgh.

The day after Mr Ruskin had written to Mrs Gray, he wrote to John telling him more or less what he had said:

Geneva Wedsy 8 August 1849

. . . I enclose a Letter from Mrs Gray which I answered for mama and so as to please her. I said worldly affairs did not trouble you and had nothing to do with your not coming to Scotland—simply you were always ill and had nothing to do in Scotland—and so on.

We cannot make people see with our eyes. They want you to stay and be with them—natural enough—*we* want you don't we? and it is natural they should desire to see you come for Effie—I am only sorry to see them mind the idle tattle even

more *than I do** and I am sorry they don't think about your employment—I told Mrs Gray you would be out of your Place quite sauntering about George Street—but she looks at one duty—I at another—Your Mama and I were ready so far to put you from us as to get you into the Society fitted for you and my difference with these Perth people is that they are not satisfied to do so and, totally blind to their own wants, they expect to make you one of them, to exhibit you among their set and seem besides to set no value on the Intellectual or wellborn people, unless in the Scotch way they are using you and Effie as a ladder by which to mount in it themselves— They are right only in wishing you to be more with their Daughter—you must remember that we are as much in Effie's way as her Father and Mother are in yours—If you understand each other, this is a small Crook in your Lot—I admitted to Mrs Gray that perhaps it was wrong in each of you going where the other could not come—I wish Effie would scamper over Hills as some Ladies do—she has the spirit if she would turn it that way —Mama thinks you should not notice anything in Mrs Grays letter—They are only desiring what we desire to have, more of your Company, and they cannot see the meaning of your pursuits—I anticipate a great change in Effie and that you will be very united and comfortable—I wish the parents would consider your health and what was good for you. . . . Your Montanvert [Chamonix] plan all right—only it seems a long time—I cannot get mama about much—She will not even look at Montblanc—We were thinking of Vevay—the noise [here] is so great but I daresay we shall remain as we are—[129]

This, for Mr Ruskin, was an extremely optimistic letter, showing that he was willing to make a new start with Effie. Effie, however, was deeply hurt by the suggestion that she should go to London with her father instead of John coming to Perth to fetch her.

* The 'idle tattle' became vicious when later on anonymous letters from Perth were sent to Mr Ruskin. (Lutyens, 1965, p. 67.) Mr Ruskin had written to John on October 4, 1847, 'On the subject noted in one of your letters on our different regard for public opinion, this is a malady, or weakness, with me arising from want of self-respect.' (*Works*, XXXVI, xix.)

She must have written to John to tell him this in terms which called forth a most stinging reply written on the way home:

Champagnole, Jura
Sunday. 2nd September [1849]

My dearest Effie,

I received about a fortnight ago at Chamouni a letter of yours—(from Viège [forwarded]), expressing your surprise at my having wished you to come to London with your father. There was much in the letter that would have displeased me, if I had not known that you were little used to weigh—or to consider, the true force of written phrases: and therefore— like my cousin Andrew's [Richardson]* letters, yours some- times take a tone and colour very different from that of your own mind when you wrote them, and bear a sense often quite different from that which you intended. However, putting the kindest interpretation I could upon it, there was still enough to cause me to delay my answer all this time, lest I should too hastily write what might give you pain: more especially your imputation of underhand dealing to me, as if I had expressed to you—as my own plan and wish, what was indeed a plan of my fathers. I never do anything of this kind—if it had been my fathers plan I should have told you so; —it was mine†—and for the reasons which I gave you in my letter: and you supposing it to be anyone else's was doubly foolish—first because it imputed to me an artful conduct towards you; of which you have never found, and shall never find, the slightest vestige in me: and secondly, because it supposed my father and mother either had less sense, or were less disposed to be kind to you, than I am: the fact being that they are continually pleading with me in your favour—begging me to write to you—and reminding me of my duty to you: and it is in fact only in obedience to their instances that I am coming home just now,

* Andrew Richardson, born 1818, the youngest of the three Richardson brothers. He was, according to Mr Ruskin, 'a drunkard and a fool', and constantly tried to borrow money from his uncle. He was learning farming in Scotland and later emigrated to Australia where he died.

† All the same, Mr Ruskin himself in his letter to Mrs Gray of August 7 had said that it was wrong perhaps for him to have suggested the plan, so Effie had every reason to think that it had originated with the father.

instead of staying a month longer, and perhaps going to Venice. I am indeed not a little struck with the contrast between their acting and feeling towards you—and yours towards them; as both have appeared lately—they always doing all they can to increase my respect for you—dwelling on the best parts of your character—never speaking or thinking of you without affection, and often persuading me to write to you instead of to them, while you are watching their every word with jealousy, and suspecting their every act, of unkindness: All this however is natural enough—it is on your side at least what you very properly express as the 'Common feeling of Humanity', and I am not going to blame you for it—you can hardly help it at present, and suffer from it, as people always do from ungenerous feelings, quite enough without any addition of pain from me. As for your wish that I should come to Scotland—that is also perfectly natural—nor have I the smallest objection to come for you: only do not mistake womanly pride for womanly affection: You say that 'you should have thought the first thing I should have done after eight months absence, would have been to come for you.' Why, you foolish little puss, do not you see that part of my reason for wishing you to come to London was that I might get you a couple of days sooner; and do not you see also, that if love, instead of pride, had prompted your reply, you would never have thought of what I *ought* to do, or your *right* to ask, you would only have thought of being with me as soon as you could; and your answer would have been that of Imogen—'oh, for a horse with wings'—Look at the passage [*Cymbeline*, Act III, Scene II]. Her husband sends a word he is to be at Milford on such a day —She does not 'think he might have come nearer' or think that she is a princess and ought not to go travelling about the country with a single servant. She only thinks—only asks— How far is't to this same *blessed* Milford and how far she can ride a day: Your feeling on the other hand, is some more of the *common* feeling of humanity, which I am perfectly willing to indulge: though I should have been much more so if it had been more temperately and modestly expressed: I once wrote to you that you 'would not have a *proud* husband' and on my word, you seem to have calculated thereupon to some extent; I

have however at least so much pride that I do not intend to allow you to dictate to me what is right, nor even to take upon you the office of my mistress in knowledge of the world—If you knew a little more of it, you would be more cautious how you wrote impertinent letters to your Husband.

The whole affair however is too trivial to occupy me longer—and I am not going to treat you like a child, and refuse you your cake because you don't kiss your hand for it properly: I shall come to Perth for you as soon as I get home: only have your calls and ceremonies over, as I shall not stay there: I hope to be at Dijon tomorrow and home in about a fortnight—I am keeping my father out as long as I can—(and but for his feeling that I ought to be with you—I could keep him longer), for fear of the cholera—which I somewhat fear for him, as he is nervous and obliged to be in infected neighbourhoods; for myself—I would sleep in a cholera hospital as fearlessly as at Denmark Hill. Write Hotel Meurice, Paris, I hope you have received my last letter from Chamouni, as it contains a curious story*: by the bye—did you ever write to Thun: I sent to the postoffice there, but got no letter.

Evening. There are passages tonight in the journals about cholera in France, which make our movements somewhat doubtful—I am not sure whether we may not come direct home: at all events, it is of no use risking letters to Paris; you had better address anything you have now to say to Denmark Hill—I will write you the day after tomorrow from Dijon, D.V.—with more certain information—but at all events I trust to be with you soon—and that we shall not be again so long separated. I am ever your most affe Husband

<div align="right">J Ruskin.[130]</div>

How could Effie have allowed him to come to Perth for her after receiving such a devastating letter? Perhaps she felt that if only she could get him to herself, right away from his parents, she would be able to win him back; and this she did manage to do in some measure.

* This letter has not been found but it was about a ghost seen at Chamonix. (Letter from Ruskin to his father, August 26, 1849: *Works*, XXXVI, 102–3; and Lutyens, 1965, p. 49.)

27

HOME AND AWAY AGAIN

The Ruskins had come to Champagnole from Geneva by way of
Thun: they missed Bourges because of John's long stay at Chamo-
nix* and from Champagnole travelled the usual road to Paris via
Dijon. They arrived in Paris on September 6; two days later John
was writing to Effie his last letter of this tour:

<div style="text-align: right">Paris. Sunday 8th [September, 1849]</div>

My dearest Love,

When I arrived here and found no letter from you I was
beginning to wonder what in the world I could have been
thinking of—and where I could have told you to write:† but
your Bourges letter [i.e. forwarded from Bourges] came in
yesterday morning, and your direct one to day, relieving me
from some anxiety, which that from Bourges caused me owing
to its ancient date. I am thankful that you think your illness
depends chiefly on the stomach—as however painful,—it will
be more manageable than I had lately hoped: but I fear you
will suffer much, and that not only it will be long before you
are cured, but that a perfect cure is impossible: But at least be
very careful at present, and take care to eat no fruit and very
little fish until the autumn is over: I well know the kind of
depression which is caused by disorder of the stomach—having
at one time been hardly able to eat anything except bread and a
little tender meat—and the whole world and all my prospects

* Mr Ruskin was to write to John on October 3, 1849, 'I have quite a disease
about changing plans—and am sure my illness was increased by constantly chang-
ing my plans in the last month of our Tour—missing Bourges ect I got quite a
contempt for myself & this increases jaundice.' (Viljoen, p. 242, n. 23.)

† In his previous letter he had told her not to risk writing to Paris.

<div style="text-align: center">251</div>

in it appearing to me as dark as pitch: I only recovered from
this state by Jephsonian training:* and I fear that with your
weaker constitution, the same kind of discipline is impossible—
but you must be content with the times of relief which caution
will always prolong: and during periods of suffering, you must
reason over the depression and bear it as bravely as you do
physical pain. I am very very sorry to hear that poor Lizzie
[Cockburn] has been so ill—and much surprised as well as
grieved at the state of Miss [Anne] Duncan. I did not know
that this disease extended itself to young women.

I am very glad you have seen Sir Walter and Lady T
[Trevelyan] in Edinburgh—I may perhaps, if the weather is
not too cold—and they are at their place, find a single day
wherein to call upon them as we come south: if they are not
then at home my chance is over for this year†—as I must
settle down to put some of my materials into form directly: I am
afraid you will be very dull in London, as I see a vast quantity
of work before me and as I am sure that when once I begin it,
it will take up my mind very entirely for the greater part of the
day—so that I shall be much less with you than I have been
hitherto able to be—hardly more perhaps than if I went every
day to business—My mother suggests—(you see I tell you
what are her suggestions) that you should ask some one of your
companions to come and stay with you: I have not the smallest
objection to this—and if during the dull winter months you
can get any one, whom you like, to live with you and keep you
company in the middle of the day—and walk with you, it will
perhaps save you from many moments of suffering—if not of

* The Jephsonian treatment took six weeks, staying in lodgings—'salt water
from the Wells in the morning, and iron, visibly glittering in deposit at bottom of
glass, twice a day. Breakfast at eight, with herb tea—dandelion, I think; dinner at
one, supper at six, both of meat, bread, and water, only;—fish, meat, or fowl, as I
chose, but only one dish of the meat chosen, and no vegetables nor fruit. Walk
forenoon and afternoon, and early to bed.' (*Praeterita*, p. 300.) This confirms that
Dr Jephson's main remedy for all disorders was iron, but he was said to have no
belief in the curative properties of the Leamington waters. These were principally
salt, but he evidently allowed his patients to drink them, perhaps in order not to
make himself too unpopular with the proprietors of the Spa.

† Ruskin did not go to stay with the Trevelyans at Wallington, their place in
Northumberland, until June 1853. He then went there for a week with Effie and
Millais. (Lutyens, 1967, p. 52.)

illness: I feel just now—more decidedly adverse to all ordinary
usages and customs of the Englyshe in 1849 than ever—and
more misanthropical—and I will not see anybody when they
call on me, nor call on anybody, I am going to do my own work
in my own way in my own room, and I am afraid you will
think me a more odd and tiresome creature than ever: so if you
can prevail on any one to come and cheer you or amuse you,
do: it will bore me a little in the evenings: but I don't care
much about this as I shall then be generally resting: and shall
just lie back in my chair and hear you chat or read, or play.

Only of course I trust to your judgement to choose some one
whose ways of thinking will not worry me and who will not
put me out of my way, or I shall put *them* out of my way.

Apropos of work—do you think the Louvre is not enough to
find me employment, my Effie, without the grave responsibility
of going to choose bonnets to make my pretty wife proud?—I
will fetch you one, certainly my pet, as you ask me; but you
know there is nobody here just now—and there will most
assuredly be nothing in the way of bonnets but refuse of last
winter and spring—and things intended for the bourgeoisie.
I have not the least hope of getting you a proper one—but I
will do as you bid me, for there is nothing I hate so much as
after sending people commissions—being told that they
'thought they had better not do them'—Mantels [page torn] I
suppose to be hard always, we will try.* But as for not having
anything to do; I was in the Louvre by the time the doors were
open yesterday—remained there writing as hard as I could
scratch—and thinking harder, till I was turned out at four;
ran home and dined, and then wrote steadily till eleven o'clock
at night, without putting down all that I wanted.†

I do indeed think of you and of our Norman pleasures often,
love: and I trust that the next tour we have will be pleasanter—

* Effie later wrote from London to her mother, 'The things John brought from
Paris are quite beautiful. The bonnet crimson velvet with little feathers on one side
and white flowers on the inside, very open in the front. The cloak very thickly
wadded and quilted in a broad pattern all round, extremely warm and quite light.
Two scarves for evening, one a white crape, and the other rose and white checked
silk, very curious.' (Letter of September 30, 1849: Lutyens, 1965, p. 42.)

† Ruskin's notes on the Louvre amounting to about 9,000 words, written on
September 8 in his diary, are given in full in *Works*, XII, pp. 456–71.

still: that we shall travel in a pleasanter way; stay at better
inns—and be in happier state of body and mind—both of us.
I am glad to know however that you can look back even to
that somewhat mismanaged one with pleasure.

Sincere regards—to your father, and mother, when she
returns—You may send me a line in answer to this to Ship
Hotel [Dover]—you know where that is, and please enclose
me a time bill of the Perth to Edinburgh Railway*—

Ever my dearest love

<div align="right">Your most affectionate Husband
JRuskin</div>

And so after an absence of five months from England (and eight
months away from Effie) John returned home, more estranged from
his wife than when he left, less loving and far more uncompromising.
It is obvious that he was irritated by her illness as much as by any-
thing else and certainly he did not attribute the illness to any fault
of his own. Later he was to write, 'I never liked invalids, and don't
to this day.'[131] The idea of having a semi-invalid on his hands for the
rest of his life must have depressed him deeply; worse than anything
she would be a grave handicap on his Continental journeys.

It is not known which day he arrived in Perth (he was at Calais
on September 16) or how long he stayed there, but by September
24 or 25 he had left Bowerswell with Effie and all their plans were
changed. Effie, showing a new wisdom, had asked him to take her
at once to Venice and he had agreed with alacrity.† In a letter of
September 22 from Bowerswell he evidently asked his father's con-
sent to the new plan. Mr Ruskin sent his answer to the Post Office at
Leeds where it missed John and was forwarded on to Park Street:

<div align="right">London 25 September 1849</div>

My Dearest John

I am delighted with your kind Letter of Sunday [the 22nd]—
If I fail in answering it properly—attribute it to my having

* This would be the first time he had travelled by rail from Edinburgh to Perth.
The line had only been opened on May 23, 1848, and he had not been to Perth
since his wedding.

† He afterwards wrote, '. . . when I came home I found my wife much better
and very desirous of some change of scene. She asked me to take her to Venice, and
as I had need of some notes for the sketch of Venetian art which you would perhaps

given it to Mama who came here, Billiter St, with me and is
gone to Mrs [William] Richardsons—

I quite approve of your going to Venice—to keep out of
London till Feby but as both Cholera and Typhus have been
horribly bad at Venice consequent on the sufferings and
privations under Bombardment, allow me to suggest your
going quickly over the Cholera French ground—Paris included
—till you reach Montbard, shew your Wife Champagnole, and
shew her at Chamouni to Coutet etc—for a few days so as to let
Venice get cleansed, and then Novr to Feby would be delightful
there—The only objection to your plan and preference I should
have given to Malvern arise from the regret of your not having
rest to put down your Impressions of the Alps and the fear that
carrying on these notes with the new and exciting work of
gathering materials for the Stones of Venice may hurt your
Brain and health—you better know your strength now and I
must trust to your not letting the Fascinations of Venice (which
will not die this year or for many to young people) draw you
into a double task and an accumulation of Labour dangerously
heavy. Think of it, both of you, and take your own way. Mama
and I can bear any privation that your Happiness or your fame
impose upon us. So let that consideration aside—I rejoice to
hear of your both liking this plan and the person of a Compan-
ion—By your description Miss Ker is just made for the occa-
sion*—I will attend to anything you require done here in your
absence—so I beg of you to go where your Health and your work
and pursuits lead you—If you are well and able to do for
Venice what I think you will I may say Go where Glory waits
thee—and now I am going to carry my feebleness to business
for a few hours—I am like a person just out of fever—that

see advertised by Smith and Elder, I was glad to take her there.' (Letter of Decem-
ber 11, 1849, to Rev. W. L. Brown: *Works*, XXXVI, 104.) *The Stones of Venice*
had been advertised in *The Seven Lamps*.
* Charlotte Ker was the companion Effie had chosen to spend the winter with
her in London who would now go with them to Venice as the perfect stodgy foil
to Effie's quick brilliance. She was the daughter of Robert D. Ker, Secretary of the
Scottish Central Railway, the line running between Edinburgh and Perth. Her
brother, Charles, had driven the special train from Montrose to Perth in which the
Queen and Prince Albert travelled by rail for the first time from Aberdeen to
London, spending the night of September 29, 1848, at the George Hotel at Perth
(hence the Royal George).

means, however, I am better—What mama may have to say
I must tell you tomorrow to Leeds unless you give another
address—Mama would join her most affec Love to mine to you
and Effie—I am My dearest John

<div align="right">Yr most affect Father
J.J.Ruskin[132]</div>

Surely a more generous, selfless, letter can seldom have been
written; much of the glory of *The Stones of Venice* should go to John
James Ruskin.

Before receiving his father's approval for the new plan, but evi-
dently taking it for granted, John, on the way south, was writing
happily to his mother-in-law. It is striking how warmly disposed he
always felt towards the Grays after being with them.

> York. Thursday evening [September 26 1849]
> My Dear Mrs Gray.
>
> I could not answer your kind note before—we had a fatigu-
> ing day at Edinburgh: though a happy evening with George—
> I was particularly pleased however with dear Dr Simpson: and
> I believe now that I understand what Effie needs—whether of
> care or of management—her complaint being one from which,
> I long suffered myself: I was however so delighted by his direct
> confirmation of our Venice plans that I quite forgot to ask
> about the water cure—I trust however by the time we return
> that her health will be entirely recovered: I was really sorry to
> leave Perth—and to cause so much distress to you all—I pray
> that your grief may not be increased by any further loss of
> health to poor Effie: She seems to me decidedly better and
> stronger than when we last travelled together: and with caution
> and watchfulness I think I shall see her gaining health every
> hour: I take her to Park St on our arrival to morrow: and will
> save her all the fatigue I possibly can:—she will be at Geneva,
> I trust—almost without knowing she has left Paris—the crossing
> is the only thing to be feared. I was very sorry to see so little of
> Andrew [Jameson] yesterday [in Edinburgh]: and the little I
> did see, made me somewhat despondent respecting the prospects
> of the protestant church in which he and you and I are all
> equally interested—for I was sorry to see him so warm in his

indignation against minor abuses and likely rather in his present mode of feeling—to promote movements—schisms—and sorrows in the bosom of our own church than to arrest the advance of our enemies—What with over hot good men—and over cunning wise men, and over cold middle men—the cause of Love and truth may lie by.

—I enquired—apropos of the Volcanic style of divinity— for Mr Miller—the first thing yesterday morning, but alas, he was in the north—and not to be home for weeks.*

We were very glad of Mr Gray's escort to Stirling: and I had —a little lecture on political economy from him which was very useful to me: Pray tell him that I found a delightful book upon Ghosts at Dr Simpsons: and that when we meet again, we will have it out respecting wraiths and reciprocity [of trade]. —Our best loves to Sophy—Alice and John and Papa

Ever, dear Mrs Gray
affectionately yours
JRuskin

The young couple did not stay at Park Street the first night as John had promised. Mr Ruskin met them at Euston Square Station on their arrival in London on September 29 and took them out to Denmark Hill. 'Mrs Ruskin looking well, Mr Ruskin very ill,' Effie reported to her mother next day, 'but both quite delighted to see us and to let us go to Italy and quite delighted that Charlotte was to go with us. Next morning we had some talk about our arrangements and I had some private conversation with Mr Ruskin; what an extra-ordinary man he is; he was quite delighted that I spoke to him, evidently, and said he had nothing to blame me for and thought I had behaved beautifully. I begged him to tell me what he was not pleased with. He said there was nothing but he thought sometimes John could not make me happy which was a new light certainly on the subject. However we settled it all in the best possible manner, but who can know what such a man thinks!! ... By the way, a capital joke Mr Ruskin heard when he came home that the report

* Hugh Miller (1802–56) geologist and editor of *The Witness*. Ruskin did not meet him until November 1853 when he was in Edinburgh giving a course of lectures. He then described him to his father as one of the most remarkable men of his time. 'Couldn't refuse to go and see his Edinburgh fossils, and hear how Edinburgh looked in times of Ichthysauri.' (Letter of November 27, 1853: Yale.)

was that I was so unhappy with John that proceedings were institu-
ted for a separation. He was fearfully angry.'[133]

Surely up to this point Mr Ruskin had made his thoughts abun-
dantly clear, and if Effie could write 'who knows what such a man
thinks' it could only mean that her father had not shown her Mr
Ruskin's letters nor the one from John of July 5.

John decided that they should travel in two carriages—the light
brougham again for himself and a heavy one, which would require
three horses, for Effie and Charlotte Ker. Effie begged her mother
not to tell 'the gossips' about this arrangement 'in case they think
that although John and I intend going abroad we are not to travel
together'. No thought, it seems, was given by either John or Effie
to all the expense involved for Mr Ruskin—Park Street was to be
empty again for another seven months with servants on board wages,
and it is more than likely that all Charlotte's expenses were also paid
by him.

On Wednesday, October 3, 1849, they started off. It was to be
the first of two journeys to Venice where they were both to be
happier perhaps than at any other time of their lives. Effie was
accepted in Austrian and Venetian society and was able to exercise
to the full her really remarkable social gifts under the protection of a
husband who put no curb on her, trusting implicitly to her sense of
propriety, a trust well founded.

As for John, he was happy because he was released from both
emotional frustration and parental supervision. Showing his wife
the minimum of attention—far less than he would have had to show
his mother—he was able to get on with his work, the only thing in the
world he really cared about.

THE RICHARDSON TOMBSTONE IN
GREYFRIARS' BURYING-GROUND, PERTH

Richardson–Ruskin
Sacred to the memory of Mr Patrick Richardson,
who died 20 July 1824, aged 50. Also Janet Ruskin,
wife of the above, died 18 May 1828 aged 43. Also
their children, Margaret died 9 January 1817, aged
16 mo. Catherine, aged 4 years. Patrick aged 8
years. Helen aged 3 weeks. James, died 8 May 1826,
aged 18 years.

On the back of the monument is carved:

In memory of James Richardson, brewer of Perth,
who died 4 Jany 1777, aged 56. Also Mary Grant,
his spouse, who died 7 Nov 1811 aged 68.

TOMBSTONE OF ROBERT GRAY IN
GREYFRIARS' BURYING-GROUND, PERTH

Under this stone are deposited the remains of Robert Gray, Glover of Perth, born Sep 1721, died Sep. 1795. Jean Prinie, his spouse, born 1730, died April 1813; and the following members of their family:

John, b 12 July, 1772, d August, 1774
James, b 15 August, 1760, d. June, 1783
Patrick, b September, 1756, d February, 1785
George, b 7 May, 1763, d 22 June, 1815 [Effie's grandfather]
Robert, b 7 October, 1766, d March, 1818
Jane, died 31 May, 1840, aged 63 years
Andrew, b 8 December, 1768, d 17 Sep, 1848

Also Christian Robertson, spouse of the said George Gray, b 12 October 1759, died 5 January 1834. And Jean Gray, their daughter, spouse of John Monteath, Physician in Perth, b. 23 October 1793, died March 1818. Robert and Ann, infant children of Robert Gray, died 1810. Mrs Ann Smith, spouse of the said Robert Gray, died May, 1840, aged 70 years.

THE FAMILY OF GEORGE AND SOPHIA GRAY

GEORGE GRAY, b. February 17, 1798, d. January 5, 1877; married June 18, 1827, Sophia Margaret Jameson, b. March 17, 1808, d. May 28, 1894.

 They had fifteen children:

EUPHEMIA CHALMERS, b. May 7, 1828, d. December 23, 1897; married John Ruskin April 10, 1848; marriage annulled July 15, 1854; married John Everett Millais July 3, 1855.

GEORGE, b. October 4, 1829; d. unmarried December 27, 1924.

ANDREW, b. March 12, 1831, d. November 22 same year.

ROBERT, b. November 13, 1832, d. June 4, 1835.

SOPHIA MARGARET, b. September 10, 1834, d. July 2, 1841.

MARY, b. July 17, 1836, d. August 2, 1841.

JANE, b. April 5, 1838, d. August 8, 1841.

ANDREW, b. January 4, 1840, d. November 24, 1844.

ROBERT, b. May 25, 1842, d. March 1, 1849.

SOPHIA MARGARET, b. October 28, 1843, d. March 15, 1882; married James Caird 1873.

ALICE ELIZABETH, b. March 29, 1845, d. October 23, 1882; married George Stibbard 1874.

JOHN GUTHRIE, b. April 29, 1846, d. Melbourne July 24, 1920.

MELVILLE, b. November 30, 1847, d. June 7, 1946; married Ada Catherine Julius (1882–1949) February 11, 1939.

ALBERT, b. October 10, 1850, d. February 27, 1928; married 1895 Sophie Williams, widow of Hon. Thomas Grosvenor (son of Lord Ebury); K.C. 1905; knighted 1919.

EVERETT, b. March 19, 1855, d. May 27, 1928.

RUSKIN'S LOVE LETTERS TO EFFIE

Seventeen of Ruskin's love letters to Effie and three of hers to him written during their engagement have come to light and are now in the Bowerswell Papers. Fifteen of Ruskin's, with the omission of some passages, and two run into one, were published in James. The two unpublished ones are given in this book, pp. 81–3 and 93–5.

These twenty letters have a mysterious history. Ruskin's last home, Brantwood on Lake Coniston, was not broken up until 1931 on the death of Arthur Severn, widower of Joan Severn (née Agnew) Ruskin's cousin who had looked after him in his old age and to whom he had left his property. In July 1931 there was a three-day auction sale in the garden at Brantwood, conducted mostly in the pouring rain, of all those items that had not already been sent to London to be sold. Included in these items were some bundles of letters, not in the catalogue, among which was one lot bought for 50/– by Mrs Thomas H. Telford who, with her husband, kept an antique shop at Grasmere. The late F. J. Sharp, a teacher at Barrow Technical School and a life-long devotee of Ruskin, went to Telford's shop soon after the sale, saw these letters and recognised their importance. Mr Telford was willing to let him have them for £15 but this Sharp could not afford, so he immediately informed Effie's brother, Melville Gray, whom he knew slightly, of their existence. Melville Gray told two of Effie's daughters about them, Mary Millais and Mrs Stuart Wortley, and Mary at once sent Sharp a blank cheque asking him to buy the letters for her at any price. When Sharp returned to the shop he found that seventeen of the letters had been sent on approval to a business man in Newcastle and three had gone to America. The business man returned them at once when he heard the family wanted them but there was great difficulty in getting back the three from America, and it was not until October 1932 and the payment of £100 that all the letters were in the hands of Effie's daughters.

Thomas Telford explained to Mary Millais the omission of these letters from the Brantwood catalogue: 'The printed catalogue was very inadequate, and at the time of the sale, many uncatalogued items were added. Apparently a good deal came to light as the

house was dismantled. All the letters were in sealed envelopes, without description or number, and were sold as Ruskin's own autograph letters. Actually the parcels varied greatly; one or two parcels contained numerous letters from Mrs La Touche to Ruskin, as we found after we had bought them. The letters were put up just before the books, and, also, numerous portfolios of drawings, probably fifty lots in all. It was just a matter of luck what one bought. One portfolio had two Turner drawings, others were full of Pear's Soap advertisements.' (Letter of February 21, 1933: BP.)

It is easy to think of an explanation of why Ruskin should have kept these letters. After Effie left him in April 1854, bringing against him a suit of nullity, he drew up a Statement of Defence for his lawyer in which he gave his reasons for not consummating the marriage, and then added: 'The letters written to Miss Gray before our marriage are all in my possession and will show that I had no intention of this kind [refraining from consummation] previously. My wife asked me to give her these letters some days ago—I fortunately refused, thinking she would mislay them, but she doubtless intended to destroy them.' Ruskin always maintained that he could prove his virility at once and no doubt believed that these letters would help him to do so. The question of his impotence was brought up again years later when he wanted to marry Rose La Touche and it is possible that he showed these letters to Mrs La Touche as some proof of his virility. It is understandable, therefore, that he should have kept them and even taken them with him to Brantwood when he moved there in 1871, for Rose did not die until 1875. But why have only seventeen of them come to light? He wrote at least three times a week during the five months they were separated so he must have written well over sixty letters.

According to an article in the *Evening News* on January 14, 1948, reporting an interview with Miles Wilkinson, nephew of Ruskin's gardener, Joe Wilkinson, the letters were found by Miles Wilkinson himself under the floorboards about a fortnight before the Brantwood sale. By that time Miles Wilkinson was the caretaker at Brantwood and had very much the run of the house and was in the entire confidence of Violet Severn (Arthur and Joan Severn's daughter), who had to deal with the sale. (Letters of 1931 from Miles Wilkinson and Mrs Joe Wilkinson and Mr H. C. Adams: Bembridge.) Wilkinson told the reporter that while moving a bookcase in a corner of the old dining-room the floorboard underneath caved in from dry-rot and that from between the joists he picked up 'a decayed looking wooden box' which he found to contain four

bundles of letters, each in an envelope and tied up with blue ribbon. After examining them and seeing how personal they were he asked Miss Severn what he should do with them. 'Oh, just put them in with the other library stuff,' she told him, and this he did 'little dreaming of their significance or value'.

The assumption was that Ruskin had hidden them under the floorboards himself, something extremely hard to imagine, for it would be so out of character. Is it possible that Miles Wilkinson, recounting the story after seventeen years, had embroidered it a little by mentioning the decayed box? If, in fact, the letters were found in bundles and not in a box one could find quite a plausible explanation for their survival: Ruskin might have kept all his love letters to Effie and stuffed them into a drawer of the bookcase; a few bundles might have fallen out at the back and remained there unnoticed when the rest were taken out after his death to be destroyed in order to obliterate all evidence that he had ever loved Effie. The person most likely to have destroyed them was Joan Severn, who is known to have made a ceremonial bonfire of Rose La Touche's letters to Ruskin and his to her. When Miles Wilkinson moved the bookcase and some of the floor boards caved in, the letters lying on the floor might have dropped into the gap, giving the impression that they had been hidden there—only a theory, but it is unlikely that the mystery will ever be satisfactorily solved.

THOMAS RICHMOND'S PORTRAIT OF EFFIE

This is the last we hear of these 1848 sittings to Thomas Richmond. The oil portrait of Effie by this artist, reproduced on p. 146, was exhibited at the Royal Academy in 1851; at the same time a chalk drawing of her by G. F. Watts was exhibited. Effie complained to her mother on April 4, 1851, 'Mr Richmond's finishing my picture for the exhibition and Mr Watts ditto have bothered me especially, taking up so much time.' On April 8 she described the Richmond portrait as 'the most lovely piece of oil painting but much prettier than me. I look like a graceful Doll but John and his Father are delighted with it but I like Watts' much better.' Mr Ruskin gave Thomas Richmond 20 guineas in wine for the picture according to his account book (Bembridge), but when he got it home he was not at all pleased with it. He hung it at Denmark Hill opposite George Richmond's first portrait of John (1842) and wrote to John in Venice, 'Tom, I regret to say, cannot hold a candle to George. He is second rate or lower.' (Letter of September 28, 1851: Bembridge.)

Thomas Richmond's portrait had disappeared but was eventually traced in 1967 by the present author through the help of the artist's grand-daughter, Mrs Charlotte Shepherd. At some time it had been returned by Mr Ruskin to Thomas Richmond, probably after the annulment of Ruskin's marriage in 1854. On the back of it is pasted an old label on which is inscribed 'Portrait of Mrs John' and then a blank where the surname has been carefully cut away. It descended through the Richmond family and was sold at Sotheby's by Thomas Richmond's great-grandson, Nicholas Wollaston, on April 3, 1968, and bought by Leggatt's for £1,100.

The jacket Effie is wearing in the portrait was described by her in a letter from Venice in January 1850: 'I had on . . . my Jacket of blue velvet trimmed with black lace which I wear always in the house and is very elegant and warm. It hangs open in front.' She is also wearing a brown silk skirt. It may be remembered that she had told her mother (p. 171) that she was going to wear her black velvet dress with the point lace collar and cuffs for her first sitting with Richmond in the autumn of 1848. Although it is probable that

Richmond made use of these early sittings for the 1851 portrait and that there is, therefore, only one portrait of Effie by Thomas Richmond, it is quite possible that there is another portrait of her in existence wearing the black velvet dress—enough of a possibility at any rate to make it worth looking out for. Thomas Richmond seems always to have signed and dated his portraits which facilitates the search.

SOURCE NOTES

❀

Unless otherwise stated all the letters in this book are from the Bowerswell Papers, Pierpont Morgan Library, New York, and are, to the best of my knowledge, unpublished at the time of going to press.

All extracts from Ruskin's diaries are from the published version, selected and edited by Joan Evans and H. Howard Whitehouse (Clarendon Press, 1956). The original diaries, which I have consulted, are at the Ruskin Galleries, Bembridge School, Isle of Wight.

Quotations from George Hobbs are from his unpublished diaries in the Pierpont Morgan Library.

ABBREVIATIONS

BP: The Bowerswell Papers, Pierpont Morgan Library.

Bembridge: The Education Trust, Ltd, Bembridge, Isle of Wight.

Bodleian: Sir Albert Gray's Papers, Bodleian Library, Oxford.

Brantwood Diary: *The Brantwood Diary with Selected and Related Letters and Sketches of Persons Mentioned*, edited by H. G. Viljoen (Yale University Press, 1971).

Burd: *The Winnington Letters*, edited by Van Akin Burd (Allen & Unwin, 1969).

James: *The Order of Release*, edited by Admiral Sir William James (Murray, 1947). The originals of the letters quoted in this book are in the Bowerswell Papers.

Links: *The Ruskins in Normandy* by J. G. Links (Murray, 1968).

Lutyens, 1965: *Effie in Venice*, edited by Mary Lutyens (Murray).

Lutyens, 1967: *Millais and the Ruskins* by Mary Lutyens (Murray).

Murray's Hand-book: *A Hand-book for Travellers in Switzerland, Savoy and Piedmont* (Murray, 1846).

Praeterita: Volume XXXV of the Library Edition of Ruskin's works (see *Works* below). *Praeterita* was first published between 1885 and 1889.

Ruskin's Statement: Ruskin's written statement to his lawyer of

April 27, 1854, given in facsimile in Whitehouse (see below) and published in Lutyens, 1967: original Bembridge.

Stuart Wortley: Copies made in 1938 by the Hon. Clare Stuart Wortley, Effie's grand-daughter, of five letters, some unpublished, from Mrs Ruskin to John Ruskin, lent to Mary Millais, Effie's daughter, by the late F. G. Sharp (transcripts in the collection of Sir Ralph Millais, Bt.; originals in the collection of Professor Viljoen).

Viljoen: *Ruskin's Scottish Heritage* by H. J. Viljoen (University of Illinois Press, 1956).

Whitehouse: *The Vindication of Ruskin* by J. Howard Whitehouse (Allen & Unwin, 1950).

Works: The Library Edition of the Works of John Ruskin, edited by E. T. Cook and Alexander Wedderburn (George Allen, 1903–12).

Yale: The Beinecke Library, Yale University

The information about Ruskin's grandparents in the first part of Chapter One (Tragedies at Bowerswell) is taken from Viljoen, the most reliable source, deeply researched. A revised family tree, two miniatures of John Thomas Ruskin, one of Catherine Ruskin and one of Jessie Ruskin are reproduced in Viljoen; also the marriage certificate of John James Ruskin and Margaret Cock.

1. *Praeterita*, p. 607.
2. Bodleian.
3. *Works*, XXIV, 668.
4. Viljoen, p. 130.
5. Ibid., p. 153.
6. There are two MS accounts of Mrs Andrew Gray's reminiscences, both written down by Effie's brother, Sir Albert Gray. The first account is signed by him and dated 1 September, 1877, which, he added, was the last time he saw her. She died the following December, aged 91. The second account is slightly abridged and although undated was evidently written some years later. Sir Albert included in this second version a brief account of the Ruskin marriage. Both accounts are in the collection of Sir Ralph Millais, Bt.
7. *Praeterita*, pp. 62 and 65.
8. Ibid., p. 127.
9. Typescript based on the reminiscences of Effie's cousin, Eliza Tucket Jameson (1843–1928): BP.
10. Viljoen, p. 74: original Yale.
11. *Praeterita*, p. 70.

12. Eliza Jameson (see Note 9).

13. *Praeterita*, p. 71.

14. Ibid., pp. 71 and 131.

15. Over fifty letters, written between 1825 and 1852, from Mr Ruskin to Mr Gray about his nephews' affairs are in Bodleian. They were deposited there in 1938 after the death of Sir Albert Gray's widow with the proviso that they were not to be seen for 30 years.

16. *Praeterita*, p. 228.

17. Ibid., p. 299.

18. *The Spas of England* by A. B. Granville, M.D. (Colburn, London, 1841), pp. 243-4.

19. James, p. 57, where this letter is dated November 21. In fact the letter containing this passage about Effie's age is in another letter undated because the beginning is missing. James has run the two letters into one.

20. James, p. 63.

21. *Praeterita*, p. 249.

22. Ibid., p. 422.

23. Ibid., p. 423.

24. This letter, given in James, pp. 21-3, is a copy in Mr Gray's writing. Mr Gray returned the original to Mr Ruskin as requested and it has not survived.

25. James, pp. 23-4.

26. Ibid., pp. 24-6.

27. Most of these passages are quoted in James, pp. 28-36, with the addition of her more social activities.

28. Letter from Mr Ruskin to John, Sept. 1847: Lutyens, 1965, p. 12.

29. Letter from John to Effie of December 19, 1847: James, pp. 73 and 75.

30. *Praeterita*, p. 423.

31. Letter of November 30, 1847: James, pp. 63-4.

32. Letter of June 18, 1847: Lutyens, 1967, p. 9.

33. *Works*, XXXVI, p. 75.

34. Quoted in James, pp. 39-40, with omission of beginning and end, and of paragraphs 4, 5, 6, 7 and 8, without any indication of omissions.

35. Unpublished: Stuart Wortley.

36. Letter of September 2, 1847, partly quoted in Lutyens, 1965, pp. 10-11, with slightly faulty transcription: original Bembridge. Ruskin attached a note to this letter: 'My Father to Crossmount. Extremely important and beautiful. Not for

autobiog.' The first page is torn off, Ruskin noting that he used it for *Praeterita* when writing about Sir Walter Scott.

37. From typescript of unpublished letter at Bembridge: original in possession of H. R. Wilkinson.

38. From unpublished letter: Bembridge.

39. Unpublished letter of September 8, 1847: Bembridge.

40. Given in full in Lutyens, 1965, pp. 11–3.

41. From Stuart Wortley: given in full in Whitehouse, pp. 35–9.

42. Partly quoted in James, pp. 43–5.

43. Letter of September 11, 1847, from Mrs Ruskin to John (see Note 41).

44. From typescript at Bembridge. Apart from the comments on the Gray relations, which are unpublished, this extract has often been quoted.

45. Unpublished: Bodleian.

46. Ruskin's Statement.

47. Undated letter (first page missing) quoted in James, p. 48, with omission of beginning about Ruskin's mother.

48. Letter of November 9, 1847, given in James, p. 48, with omission of a last paragraph about Effie's aunt and uncle.

49. Postscript to letter of November 11 and 12, 1847, omitted in James where rest of the letter is given, pp. 48–52.

50. Letter of May 17, 1859, from Mrs Gaskell to John Forster: *The Letters of Mrs Gaskell*, edited by J. A. V. Chapple and Arthur Pollard (Manchester University Press, 1966), p. 287.

51. Letters of November 11, 1847, and January 19, 1848. Although James gives these letters (pp. 48–50 and 83–4) he omits these paragraphs about Mr Tasker.

52. From letter of December 15, 1947: James, p. 68.

53. Letter in *The Times Literary Supplement* from Malcolm D. Kennedy (William MacLeod's grandson), March 30, 1967.

54. From letter of November 30, 1847: James, pp. 58–9, where William is not identified.

55. Letter of December 19, 1847. Although James gives this letter (pp. 73–80), he omits this whole paragraph about William.

56. From unpublished letter from Ruskin to Rev. F. A. Malleson, November 28, 1872, from transcript at Bembridge: original F. L. Malleson.

57. Brantwood Diary, p. 369.

58. From letter of November 11, 1847: James, p. 49.

59. Stuart Wortley; given in Whitehouse, pp. 40–1, but with different punctuation.

60. From letter of November 30, 1847, given in James, pp. 58–60, with omission of this last paragraph about Effie sleeping badly.

61. This letter of December 11, 1847, is given in full in Lutyens, 1967, pp. 272–3.

62. Unpublished extract in collection of Luis Gordon & Co.

63. From letters of December 15 and 16, 1847: James, pp. 66–70.

64. From letter of December 20–2, 1847: ibid., pp. 78–80.

65. From letter of January 19, 1848: ibid., p. 83, with this last paragraph omitted.

66. Unpublished: Bembridge.

67. These three letters from Effie are in BP. (See Appendix IV.) The last part only of the letter of February 8, beginning 'I told Papa the other day', was given in James, pp. 93–4. The letter of February 9 is unpublished. The letter of February 10 is given in James, pp. 94–5, with omission of the last part beginning, 'I did not think your cousin Mary . . .' These three letters had been put into plain white envelopes and numbered by Ruskin 59, 60 and 61. This confirms the number of letters that passed between them and shows that she wrote almost as often as he did.

68. From letter of February 23, 1848, given in James, pp. 84–7, with omission of postscript.

69. From letter of February 28, 1848: ibid., pp. 87–90.

70. Ibid.

71. Letter given in full in James, pp. 91–2.

72. Letter given in full in Lutyens, 1965, pp. 17–18.

73. Brantwood Diary, p. 369.

74. *Pre-Raphaelitism and the Pre-Raphaelite Brotherhood* by W. Holman Hunt (Chapman & Hall, 1913), I, pp. 69–70.

75. Bembridge. Partly quoted in Burd, p. 76.

76. Letter of March 7, 1854, given in full in Lutyens, 1967, pp. 154–7.

77. Ruskin's Statement.

78. Letter of May 24, 1848, given in James, p. 109, with omission of the two sentences about 'Prizie' Tasker.

79. Given ibid., p. 102.

80. Preface to the First Edition of *The Seven Lamps of Architecture*.

81. Unpublished: Bodleian.

82. From unpublished letter to Miss Corlass: John Rylands Library.

83. Letter of July 20, 1848. The last part about John's cold is quoted in James, pp. 117–18.

T

84. Partly quoted ibid., pp. 118–19.
85. A topographical account of this tour, in conjunction with George Hobbs's diary and *Murray's Hand-book for France* (1848), is given in Links.
86. Partly quoted in Links, pp. 27–8: original Yale.
87. From unpublished letter of September 3, 1848, from Mortain: Yale.
88. Unpublished extract from letter of August 29, 1848, from Falaise: Yale.
89. Letter of September 4, 1848, from Mortain, partly quoted in Links, p. 41: original Yale.
90. From letter of September 9, 1848: Links, p. 45; original Yale.
91. Unpublished extract from letter of September 27, 1848: Yale.
92. Given in James, pp. 130–2, except for the last two paragraphs, and wrongly dated August 1.
93. Extracts from this letter are quoted in Viljoen, largely in the notes.
94. From notes by James Dearden for a lecture at the Ruskin Conference at Brantwood, Lake Coniston, in March 1969.
95. Unpublished extract from letter of September 11, 1848: Yale.
96. Unpublished extract: Yale.
97. From unpublished letter of September 22, 1848, from Caen: Yale.
98. Unpublished extract from letter of September 27, 1848, from Caen: Yale.
99. Letter of October 5, 1848 (wrongly dated by Ruskin October 6): Links, pp. 72–3.
100. Unpublished extract from letter of October 7, 1848, from Rouen: Yale.
101. From unpublished letter of October 8, 1848, from Rouen: Yale.
102. Unpublished extract from letter of October 15, from Rouen: Yale.
103. Partly quoted in James, p. 137.
104. Unpublished: Bembridge.
105. From unpublished letter of February 5, 1849: Bembridge.
106. From unpublished letter: Bembridge.
107. *Praeterita*, p. 437.
108. Ibid., p. 438.
109. Ibid., p. 437.
110. Last passage of this letter quoted in James, p. 138.
111. This letter is partly quoted ibid., pp. 138–9.

112. Passage in first paragraph quoted ibid., p. 130.
113. Beginning of this letter quoted ibid., pp. 139–40, but Mr Bautte's name given as Beautier.
114. Two passages from this letter and the postscript, all run together and dated May 3, are quoted ibid., pp. 140–1.
115. Two passages from this letter, run together, are quoted ibid., pp. 141–2.
116. Passage about the 'travellers' book' quoted ibid., p. 143.
117. One passage about Effie's 'nervous weakness' quoted ibid., pp. 143–4.
118. Three passages quoted ibid., pp. 144–5, but the letter there is undated and headed Vevay instead of Chamouni.
119. First few lines and two short extracts run together are quoted ibid., pp. 145–6.
120. Letter of December 10, 1851: BP.
121. It is Professor Viljoen who found these two scraps in BP which were meaningless until she put them in their right context.
122. The first half of this very important letter is quoted in James, pp. 146–8, leaving out some paragraphs without any indication of omissions.
123. *Praeterita*, pp. 434 and 437.
124. Ibid., p. 428.
125. *Works*, XVIII, p. 184.
126. *Praeterita*, pp. 452–3.
127. Unpublished letter of April 2, 1886: Pierpont Morgan Library.
128. *Praeterita*, p. 341.
129. Unpublished: Bembridge.
130. Given in Lutyens, 1965, pp. 35–8.
131. *Praeterita*, p. 88.
132. Unpublished: Bembridge.
133. Lutyens, 1965, pp. 41–3.

INDEX

❋